Portraits and Persons

Portraits and Persons
A Philosophical Inquiry

Cynthia Freeland

OXFORD
UNIVERSITY PRESS

Great Clarendon Street, Oxford OX2 6DP

Oxford University Press is a department of the University of Oxford.
It furthers the University's objective of excellence in research, scholarship,
and education by publishing worldwide in

Oxford New York

Auckland Cape Town Dar es Salaam Hong Kong Karachi
Kuala Lumpur Madrid Melbourne Mexico City Nairobi
New Delhi Shanghai Taipei Toronto

With offices in

Argentina Austria Brazil Chile Czech Republic France Greece
Guatemala Hungary Italy Japan Poland Portugal Singapore
South Korea Switzerland Thailand Turkey Ukraine Vietnam

Oxford is a registered trade mark of Oxford University Press
in the UK and in certain other countries

Published in the United States
by Oxford University Press Inc., New York

British Library Cataloguing in Publication Data

Data available

Library of Congress Cataloging in Publication Data

Data available

Typeset by SPI Publisher Services, Pondicherry, India
Printed in Great Britain
on acid-free paper by
Clays Ltd., St Ives plc

ISBN 978-0-19-923498-1

1 3 5 7 9 10 8 6 4 2

ACKNOWLEDGMENTS

I am pleased to thank various people at OUP who have helped with this book, including my editor Luciana O'Flaherty, general trade editor Matthew Cotton, assiduous picture researcher Sandra Assersohn, and the dedicated production and publicity staff.

The earliest stages of research for this project were supported by an NEH grant as well as by a Faculty Development Leave from the University of Houston. The University of Houston also provided a subvention grant to assist with costs of image reproduction. I gratefully acknowledge these sources for their support. I am especially grateful to the University of Houston's Honors College and Dean Ted Estess for providing generous research stipends that enabled me to visit museums in Chicago, Amsterdam, Madrid, London, and Copenhagen.

Many students and colleagues have heard various versions of the ideas for some of the chapters here, and I am grateful to all of them. I owe a special debt to students in my graduate seminar on Narrative in Spring of 2009. Two students in particular assisted with my research: Carolina Fautsch, who had the support of a University of Houston 'SURF' (Summer Undergraduate Research Funds) grant for research on the facial expression of emotions; and Lynn Watts, who worked through articles on the self with me and did helpful picture research. Tzachi Zamir provided detailed comments on Chapter 1. I am also grateful to Susan Feagin and Ismay Barwell for sharing their work in progress on narrative.

Previous versions of some of the chapters were read at various universities and conferences, and I would like to thank the hosts, audiences, and commentators who helped me articulate and refine my ideas. Chapter 1: American Society for Aesthetics at the Central Division APA (organizer Angela Curran and commentator Jen Everett) and Wesleyan University (host Lori Gruen and fellow speakers Allison Argo and Frank Noelker). Chapter 2: West Virginia University (host Beverly Hinton), University of Minnesota, Duluth (host Alison Aune), University of Vallodolid, Spain (host Sixto Castro), Oberlin College (host Katherine Thomson-Jones and commentator Patrick Maynard). Chapter 4: London conference *Beyond Mimesis and Nominalism: Representation in Art and Science* (panel organizer Dolores Iorizzo of Imperial College) and University of Cincinnati Conference on Art and Mind (organizer Jenefer Robinson). Chapter 5: APA Pacific Division (commentators Marya Schechtman and Sarah Worth); and Furman University (host Sara Worth). Chapter 6: Michigan State University Suter Lecture (organizer Jim Nelson, and attendees Marilyn Frye, Al Cafagna, and Robert Stecker).

My Houston friends Mary Ann Natunewicz and Lynn Bliss have been steadfast supporters and helpful listeners, as have my parents, Alan and Betty Freeland.

Finally, I would be remiss in not mentioning the wonderful support of my online community of friends on the photography website Flickr, particularly those who share my interest in animal portraiture.

CONTENTS

LIST OF ILLUSTRATIONS

Colour Plates

INTRODUCTION

Philosophers have neglected portraits, a fact I find surprising for several reasons. First, portraiture is one of the most universal and long-standing art forms, dating back to the ancient civilizations of Egypt, India, China, Athens, and Rome. Philosophers have studied many other issues about art, including the nature of representation, aesthetic experience, realism, and the very definition of art; but they have not pondered portraiture. Yet this is a genre that seems well worth study, since—and this is my second reason—portraits represent the serious efforts of some of the world's best artists to study people (others or themselves). Hence, portraits might reasonably be thought to embody accumulated cultural wisdom about what it is to be human. While it is common for philosophers interested in personal identity to cite literary sources, rarely, if ever, do they ponder the reflective products of visual artists. But why should we grant that Tolstoy has insight into the self, and not Rembrandt?

This leads to my third, perhaps deepest, reason for devoting philosophical attention to portraits: in portraiture both artist and viewer confront the perennial philosophical problem of the mind's relation to the body. The portrait artist is an alchemist who seeks to make inert physical material 'live' and show us a person, an actual individual whose physical embodiment reveals psychological awareness, consciousness, and an inner emotional life. How can artists ever succeed at this mysterious project? What enables them to convey 'truths' about a person—and what would constitute such truths?

1

Of course portraiture has been very much studied by art historians, who may worry that my search for a philosophical account reflects snobbish disciplinary bias. Far from it: many art historians have written philosophically about portraiture (notably Shearer West, Michael Podro, Hans Belting, and Richard Brilliant), and I have learned from them, as from the many specialists who have authored monographs on the particular artists I discuss in this book. Art historical studies of portraiture often raise philosophical questions about such issues as the inner vs. outer person, social performance, gender identity, and the relevance of cultural frameworks for defining the self. I hope to provide a bridge between the specialists' expertise on particular artists and time periods and some current philosophical discussions, citing work by philosophers who seem not well known to art historians, such as Daniel Dennett, Marya Schectman, Patrick Maynard, Kendall Walton, Martha Nussbaum, and David Velleman. I will consider treatments by these and other thinkers of the definition of persons, the nature of emotional expression, narrative accounts of the self, and the distinction between manifestation and representation functions of pictures.

My approach here is also informed by recent research in evolutionary psychology and cognitive science by experts like Michael Tomasello, Paul Ekman, Ellen Dissanayake, Patricia Churchland, and others. An adequate theory of persons, as well as of consciousness and the emotions, should reflect the facts about human evolution and biology. And since there are important ancestral links between humans and other animal species, I have also extended my treatment of portraiture in this book to animals, a topic not typically included in studies of portraiture by art historians. In part, I confess, this is prompted by my own history of photography devoting special attention to

my companion creatures, cats. My project is equally motivated by a long-standing fascination with pictures in our family album showing both distant ancestors and people I remember well and still miss. We are probably all intrigued by portraits to some extent because of a basic human interest in retaining contact with people we can no longer see, except in facsimile.

My book begins with a chapter on animals, where I offer a definition of both portraits and persons. Chapter 2 focuses on one of the most important reasons we value portraits, for preserving contact with the dead. In Chapter 3, I survey how portrait artists represent the external appearance and individual manner of the persons they depicted. This includes a discussion of what differing kinds of portraits indicate about the self and the nature of a person.

Chapter 4 examines artists' efforts to provide more expressive indicators of internal life to convey the psychological characteristics and emotional qualities of their living subjects. Chapter 5 considers self-portraiture, focusing on three artists, Rembrandt, Cézanne, and Kahlo, who pursued lifelong projects of visual self-scrutiny. I use their work as a test case to challenge the plausibility of a very popular current theory of the self, the narrative view.

Chapter 6, Intimacy, examines artists' portraits of the people they know and can presumably best represent, their loved ones—children, parents, partners, spouses. In Chapter 7, I address challenges to standard accounts of the self by recent artists in traditions of postmodernism or those using new scientific methods in their explorations of identity.

Finally, in the Epilogue, I return to the 'alchemy' issue mentioned above, attempting to dissolve the paradox of portraiture by explaining how inert matter can be transformed by artists so as to exhibit personality and life.

Animals

Introduction

Can there be portraits of animals? Millions of people would say 'Of course'—at least if one is to judge by the numbers of pet portrait artists advertising their services on the Web. Their advertisements pledge to create 'unique and original' portraits based on snapshots, portraits that will reveal the 'individual expression' of your pet cat, dog, bird, or horse. In an age in which people in developed countries commonly regard pets as family members, it would not be surprising to find their pet pictures collected as means of sharing pride of kinship or of helping to ease the pain of loss by preserving memories of their beloved animal companions.

But we do not need to turn to the common or kitschy to find a positive answer to my question of animal portraits. Among some of the greatest artworks of the past and present there appear many revealing and expressive portraits of animals—from Goya's cats lurking behind a young nobleman to Oudry's rhinoceros and Stubbs's horses, on up to the contemporary

dachshunds, whippets, and Weimaraners that are frequent 'stars' in the works of, respectively, David Hockney, Lucian Freud, and William Wegman. In fact, it was not even until the time of Poussin that the term 'portrait' became specialized enough to be restricted to human (as opposed to animal) subjects.[1] But despite the popularity and prevalence of animal portraits, few if any texts on portraits by art historians include them, indicating that there does seem to be something distinct about such portraits. In this chapter I examine some of the key issues that arise when we think about depicting animals in portraits. As I proceed I will state and refine a definition of portrait that makes clearer the ways in which animal pictures should be counted, along with other ways in which they should not, because they cannot meet one important condition for portraiture.

Conditions for Animal Portraits

My book looks at the large issues that arise concerning relationships between portraits and persons; but can animals count as persons? There are, not surprisingly, complex and ongoing philosophical debates about what is entailed by personhood. This chapter will help pave the way into such debates, and in subsequent chapters I plan to examine some of the most prominent contemporary theories of persons. I propose to begin the search for what counts as a portrait with this definition: a portrait is a representation or depiction of a living being as a unique individual possessing (1) a recognizable physical body along with (2) an inner life, i.e. some sort of character and/or psychological or mental states. Each of these criteria needs to be examined to see whether and how it can be applied to animals.

We typically do regard certain animals, especially those we live in daily proximity with, as unique individuals, and this suggests that they can fulfill both conditions for being the subjects of portraits. They have particular bodies which their human companions, at least, can recognize and identify, as well as inner lives involving consciousness or mental awareness, along with some forms of outward expression. In this regard, animals are quite different from plants or rocks, as well as from other inanimate beings that sometimes receive names and even have behaviors attributed to them, like wildfires, hurricanes, or volcanoes.

Still, the first condition, physical recognizability, quickly prompts the question, 'recognizable to whom?' People who live and work with dogs, horses, cats, sheep, cows, and birds typically can distinguish them. (I remember once my uncle making me laugh by telling me that I could identify his favorite white goose 'Honk' in the flock at his pond because 'he's the one with the really pretty neck'.) The recent popular film *March of the Penguins* depicted an environment in Antarctica populated by literally thousands of penguins, each of whom could recognize his or her mate and offspring—a task that would daunt us humans. But perhaps for zookeepers or wildlife specialists, identification of their individual penguins is possible. Zoo and aquarium personnel do tend to give names to many of the animals in their care, even identifying their various octopi according to their personalities.[2]

But the task of recognition becomes even harder (and thus, the possibility of finding portraits smaller) concerning the so-called 'lower' animals, such as lizards, turtles, snakes, or insects. Only the most anthropomorphized examples (like Charlotte the spider in *Charlotte's Web*), or perhaps the beloved pet cricket of a

lonely child, might be possible exceptions.[3] Frogs, turtles, and fish do bear distinguishing characteristics, especially some valuable or treasured instances like the remarkably patterned and expensive koi kept in some Japanese fish ponds. A recent nature documentary tracked the amazing 9,000-mile voyage from Mexico to Japan of the loggerhead turtle that researchers had named Adelina.[4] American artists like Winslow Homer have painted fine watercolors of trout, just as Asian artists have depicted goldfish; but these are more likely to be trophies from sporting expeditions or symbolic exemplars rather than true portraits of individual fish. For people who collect koi or who keep iguanas or snakes as pets, perhaps these animals are individuals that are recognizable. To their caretakers, such an animal may even have a certain 'face' or posture that expresses character and mood. Perhaps, similarly, certain scientists or those who work closely with insects, like beekeepers, can also recognize at least some individuals in their group.

For now I will postulate that recognizability means that a living being can be seen and re-identified 'by the general human viewer of portraits'. Portraits are, after all, not created by and for animals themselves, and this rules out some of the illustrations I have mentioned above. But it seems clear that at least some animals do satisfy this first condition for portraits, physical individuality and recognizability.[5] I shall illustrate this and offer examples below.

The second condition for portraiture, the depiction of an inner life or mental states, is more controversial in application to animal portraits and must be dealt with in more detail. To meet this condition requires that, in addition to a distinguishable physical identity, the animal in a portrait both possess and reveal internal mental or psychological states. (Recall that the pet

portrait artists promise to reveal your pet's 'individual expression'.) This issue raises key questions about the nature and varieties of animal consciousness, as well as about animal emotions and expression. Philosophers have varied widely in their answers to such questions. Some thinkers have even denied that animals possess consciousness—most notoriously Descartes, who baldly stated that 'brutes are automata'. For this French philosopher, consciousness was only associated with souls or thinking substances, and thus was denied to (presumably) non-rational creatures. What might *appear* to be forms of animal expression, e.g. screams of pain, were considered to be instead mere automatic reflex responses of a machine-like organism, like the groaning of tree branches in a storm. Even now there are philosophers who would deny that animals truly have inner states. (To complicate things, some philosophers also deny that humans do, either!)

Still, many philosophers would count at least some animals as having minds and selves or distinct identities.[6] In many cases this is because they accept a theory of soul that allows for reincarnation in different bodies over various lifetimes. Pythagoras and Plato along with adherents of Hinduism and Buddhism would recognize animals as having souls. The inclusion of animals in the scope of theorizing about the self is made very explicit in a recent book on the topic by Richard Sorabji, who defines the self as 'an embodied individual whose existence is plain to see; who has or owns psychological states as well as a body and bodily states. Note this applies to humans and also to higher animals.'[7]

For other philosophers there is evidence of animal awareness, particularly of pleasure and pain, which shows that they possess at least some degree of consciousness. They might agree with the utilitarian Jeremy Bentham's way of putting it, 'The question

is not, "Can they reason?" nor, "Can they talk?" but rather, "Can they suffer?" "[8] Contemporary proponents of animal rights like Tom Regan maintain that animal consciousness provides the basis for their having moral status. Peter Singer has provocatively argued that the higher animals may indeed deserve more moral consideration than human beings who are in a persistent vegetative state.

To determine whether my second criterion for depiction in a purported animal portrait has been met, we must answer two distinct questions affirmatively. First there is a question of metaphysical (or perhaps scientific) fact concerning the existence and nature of consciousness or inner life in various animals. Second is a question concerning animals' expressiveness: are the external manifestations of internal states of animals sufficiently visible and recognizable to others so that they can be depicted in a painting or photograph? If your Fluffy or Fido has been lost for a year and then miraculously returned, dirty and much thinner, could you still recognize him or her by their unique expression or 'air'? Next I take up both of these questions in turn.

Animal Consciousness

We can trace the sources of human emotions back along basic evolutionary paths to developments that served the fundamental needs of all living organisms: to find food, avoid danger and predators, and reproduce. Because these needs are varied and distinct, experts now argue, there are diverse emotion systems in the brain, rather than some one area devoted to the processing of a single group of feelings or mental states that can uniformly be dubbed 'emotions'. Of course, other organisms, including

animals, shared the human being's need to carry out these same functions successfully, and thus they also have brain areas devoted to similar emotion systems, e.g. pursuing potential mating opportunities (or feeling 'desire'), avoiding danger (feeling 'fear' and 'anxiety'), and seeking food.

There are some important differences, though, in human brains in comparison with those of other animals. Our brains are very much larger in proportion to our overall size, and also have much greater development of the cerebral cortex and in particular of the prefrontal cortex.[9] This area is coordinated with the development of language and also with memory and so it is typically held to be involved with the grounds for higher states of consciousness.

Do other animals have consciousness as well? Here is what the brain scientist Joseph LeDoux has to say about the subject: 'To the extent that other animals have the capacity to hold and manipulate information in a generalized mental workspace, they probably also have the potential to be conscious.' LeDoux's formulation allows the possibility that some other mammals, especially (but not exclusively) some other primates, are conscious.

LeDoux goes on to make a number of important points. First, language alters the nature of our consciousness in major ways. This means that 'whatever consciousness exists outside of humans is likely to be very different from the kind of consciousness that we have.' Furthermore, animals can have a 'special way' of being conscious that allows them to think and reason without being aware that they are doing so. And finally, living beings with awareness can have feelings, but these too will be quite different in creatures without linguistic abilities. 'The difference between fear, anxiety, terror, apprehension and the like

would not be possible without language.'[10] These varying levels of self-awareness will become important later in the chapter, so I plan to return to this issue below.

There are other approaches to the issue of consciousness and there is still controversy about animal consciousness—whether it exists at all and, if it does, its nature. For example, a prominent contemporary view in philosophy is the 'HOT' theory of higher-order consciousness, and some critics have argued that this view is committed to the denial of animal consciousness.[11] Some theorists distinguish the sort of consciousness typical of humans from a kind of cruder 'phenomenal' experience that would not involve any ability, say, to distinguish one experience from another.[12]

Support for such a distinction comes from the animal ethologist Temple Grandin, who considers it important to distinguish fear as a feeling that many animals experience, down to certain types of fish or squid, from other higher emotions, even from so-called 'primitive' emotions like pain.[13] Grandin says,

As one travels back in evolutionary time, there is a point where an organism does not have sufficient central nervous system capacity to experience fear or pain. The brain circuits that process fear are more primitive than the circuits that process pain. For example, fish experience fear but their pain perception may be limited.

Of course, humans may treat animals differently, not according to the actual facts but rather in relation to our own *perception* of their abilities to feel and express emotions. Some animals just seem 'cuter' than others and we might conclude they have greater complexity or deeper awareness than the not-so-cute animals with ugly big teeth or scaly skin. Since views about the nature of animal consciousness and emotions have varied a good

deal throughout history and among different cultures, it is not surprising that artists too have adopted quite different attitudes toward the depiction of animals in art. Presumably some recent arguments by animal proponents have disposed many people to regard formerly threatening animals like wolves more kindly, just as *Gorillas in the Mist* might make one sensitized to gorilla emotions. Suppose that a person I know has the ability to recognize and individuate a type of animal that I know little about—say, a raccoon or an iguana—and that she studies it closely or lives with it as a companion animal, differentiates it from others of its kind, and can describe its mood and emotions based on external signs. Then I would be happy to allow that she could create portraits of this animal and that I could learn to 'read' them. We probably all believe that we can tell our pet's emotions better than others can, so that a particular swish of the tail or drooping of the ears might signal unhappiness to us when another person would not even notice it.[14] But this leads us into the next key question about animal portraiture: the outward expression of inner states.

Animal Expression

Typically, human portraits show not just a human individual as such but also relay aspects of the person's inner life or emotions. Or, in a phrase I will discuss in Chapter 2 below, the best portraits manifest a person's 'air', their unique essence or inner character. The human ability to 'read' these features in a portrait depends upon our innate capacities not only to recognize faces but also to differentiate the facial expressions of other humans. There is a great deal of research indicating that this ability is an

evolutionary development common not just to us humans but to our various ape ancestors. As primates lived in more complicated social groups, it became important for them to be able to communicate effectively, not simply to grasp indicators about food and predators, but also in order to signal relationships of dominance and friendship. Primatologist Suzanne Chevalier-Skolnikoff has commented as follows:

Darwin's central hypothesis—that the facial expressions of non-human primates and man are similar—has been strikingly confirmed, strongly supporting his theory that human facial expressions have evolved from those of man's non human ancestors.[15]

Brain research indicates that the recognition and interpretation of emotional expressions is so important that it led to developments in specialized regions of the brain:

The brain of the macaque monkey has a distinct area dedicated to recognizing faces, according to a new study.

'When we put an electrode in, it was clear from the very first day that every single cell just responded to faces,' said study co-leader Doris Tsao, a neuroscientist at the Harvard Medical School in Boston. The study is reported in today's issue of the journal *Science*.

Like humans, monkeys are social animals. They benefit from recognizing other individuals in their group and from deciphering their peers' facial expressions.[16]

The question to raise next as we investigate possibilities of animal portraiture is whether humans can read expressions across the species line. It would not be surprising if we could detect, or imagine that we detect, the emotional expressions of monkeys. And the danger signals of various animals are clearly

known to us, presumably again as part of our evolutionary heritage: humans know to back away from a snarling lion or hissing snake. But can portrait artists really deliver what so many promise to do, the unique expressiveness of an animal like a cat or parrot? How is it we are able to decipher expressiveness in a dog or horse? Does saying that we can do so involve unacceptable forms of anthropomorphism?

In his ground-breaking work on emotional expression (*The Expression of the Emotions in Man and Animals*), published in 1874, Charles Darwin aimed to show that there are very clear and strong links among the expressive behaviors of humans and animals. Thus for him, expressive signaling was further support for his views of evolution. The book represents in many cases his observations of his own pets or zoo animals, as well as reports from others about both human and animal examples. Clearly Darwin believed that we humans are able to discern and differentiate a wide variety of emotional displays across many species. His book includes pictures of emotional expression across a wide variety of animals including cats and dogs as well as a hen, a swan, and a chimpanzee. Darwin thought that for apes at least, facial expressions are similar enough to ours that we readily understand them. (Subsequent experts have argued that in fact, here he got things wrong.) Darwin wrote in considerable detail about the various means through which dogs, among other animals, express emotions. These include the position of the head and mouth, of the tail, and of the whole body. He noted that some dogs even seem to express pleasure by grinning (120–1). Dog expressive behaviors also include, as most people already know, jumping, snarling, and barking. Cat behaviors include arching the back when expressing fear and pushing on the forefeet ('making biscuits') when pleased. Horses, he says, when anxious or fearful raise their necks high and dilate their nostrils wide.

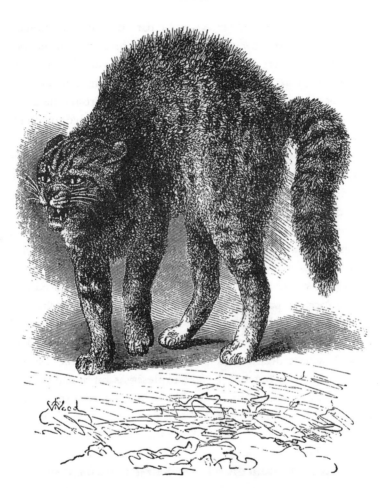

Fig. 1.1 *Cat terrified at a dog*: illustration from Darwin's *The Expression of the Emotions in Man and Animals.*

Darwin was especially interested in the expression of emotion in monkeys, partly because he wanted to determine similarities with human expressions. But some of these were difficult to discern. He remarked, 'It is not possible to distinguish in monkeys, at least without more experience than I have had, the expression of pleasure or joy from that of affection.' (131) A friend of his reported to him that orangutans both smile and laugh, and Darwin thought he had observed that chimpanzees also smile (132; but see also 134: Darwin was wrong in construing a smile-like expression of a Niger macaque as expressing pleasure; in fact, it typically expresses fear instead).

Perhaps animal portraits simply satisfy a human need to believe that we can understand representatives from other species. It is possible that instead of actually expressing inner states, and doing so accurately, such portraits instead show the animal in question as particularly cute or lovable in a way that we humans respond to. This could be especially true in dog and cat portraits since we have co-evolved with these domesticated pets. I will return to this possibility below. I think there is something to it, but first I want to describe a third important condition for portraiture that will prove to be unique to humans (and adult rational humans, at that).

Animal Self-Awareness and Self-Presentation

Suppose that we grant that the two conditions I have cited as essential to portraiture are met. That is, portraits of animals can succeed at depicting their individuality or distinct physical embodiment, as well as at conveying the expression of inner states. This means that yes, there can be portraits of animals.

However, another important factor comes into play in the portrait process, namely, a certain sort of relationship between the artist and subject. This is so significant that it leads me to posit a third condition for portraiture, namely, the stipulation that both participants are aware of the process. Here the concerns I mentioned above about how self-awareness and language create or shape animal consciousness will become central. I hold that both the artist and subject of a portrait must participate knowingly in its creation, so that the resulting image can manifest their differing desires and attitudes about it. For the subject, portraiture involves an act of posing or of self-representation. When people have their portraits made, they are aware of the process and typically have a desired outcome. This varies with age and mental condition, obviously; but the awareness of being photographed seems to develop quite early in young children. They learn early to pose and tend to put on what I call their 'say cheese' expression, with teeth bared in a big fake smile. People being portrayed 'put on' an identity before the artist, and artists, in turn, face challenges in reconciling the patron's wishes with their own conception of the person being depicted (and of course, with their broader artistic aims).[17]

My point is that in the human case at least, besides the two initial requirements that I have said a portrait must meet— physical delineation and indication of interior states—there is a third condition: the subject consciously presents a self to be conveyed in the resulting artwork. And I baulk at saying that animals (or animal portraits) can fulfill this third requirement. For in addition to presupposing that an animal can actually have a self-concept, in addition we are expecting the animal to share with us some concept of artistic representation.[18] Even if the former possibility is realized by some (presumably advanced)

animals, as I think it is, I do not believe that any animal can present itself to an artist with the aim of posing for or taking part in the creation of a portrait.

On the first point, it does seem clear that many animals are self-aware and possess some sort of self-concepts. Scientific researchers hold this to be true of some among what we often call the higher animals, such as dolphins, chimpanzees, and perhaps elephants.[19] At least one elephant has been able to pass what is now the standard measure of such self-awareness, the mirror test.[20] 'The mirror test asks something quite hard,' says Patricia Churchland, a professor of philosophy at the University of California at San Diego. 'The animal has to say, "I'm here, that is a perfect replica of me, but it isn't me".'[21]

On the face of it, however, it seems implausible to impute even to these animals enough self-awareness to be able to recognize the nature of the interaction and the general aim of portraiture. Animals simply do not create art, or at least, not this kind of art.[22] In the case of animal portraits, the interaction between the two parties to the process will be quite different from the portrayal of humans. It is probably much simpler and, we might say, more one-sided, than it typically is in the case of most human portraits. The photographer Jill Greenberg, an artist especially well known for her glamorous celebrity images, confirms this point in commenting about a project she undertook called *Monkey Portraits*. She found it difficult working with monkeys as portrait subjects in one way, since they could not communicate easily and got bored and distracted. However, in another way the process was much easier, because they had none of her usual clients' worries about 'looking beautiful' for the camera.

If some response is brought by an animal to the portrait encounter and thus revealed in the resulting picture, it will

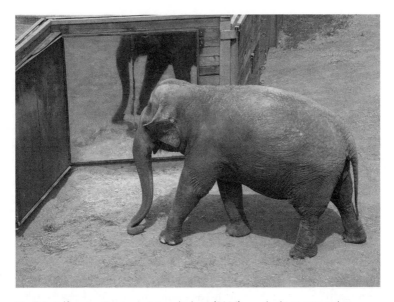

Fig. 1.2 *Self-recognition in an Asian elephant* (2006), an elephant passes the mirror test.

probably reflect the particular and often unusual conditions of the portrait studio or situation rather than the animal's aim of self-presentation *in a picture*. I would say just the same thing about portraits of very young babies, people in comas, or, in certain cases of elderly persons with severe dementia. The animal (or baby or adult) may display emotions about the encounter, such as anxiety under the bright lights of a photography studio, happiness about being with a companion at the center of attention, distraction by reflections off a camera lens, etc. Hence it might behave in the studio in particular amusing or intriguing ways. But this does not amount to 'posing'. Obviously, animals interact with people, and they can present themselves in a

certain way to humans—in different ways at different times or to different people. Champion show dogs are often said to love the attention and to bask in an audience's applause. An animal in a zoo might also regard its visitors in certain ways and act out positions in relation to them—threatening or begging ones, for example. And such deliberate-looking poses could occur in the process of creating a portrait. Still, in none of these cases is it plausible to suppose that the animal has enough awareness of what is going on for us to be able to infer that it offers us or desires to convey a certain kind of self-presentation.

This leaves open the possibility that the person who is a portrait artist (like the zoo visitor) perceives and even depicts an animal *as* presenting itself in a particular way. We humans do tend to experience our interactions with some animals as emotional, and this is as likely as anything else to affect the portrait process, not least from the side of the artist/ portrayer. The requisite emotions or attitudes brought to an artist–subject encounter in the case of portraits of animals might embody human response to an animal's nature either as an irreducibly mysterious and alien 'other' or as a familiar, easily understandable close friend. The former attitude tends to result in exoticized representations of animals, just as it led to colonialist and exploitative depictions of 'primitive' or 'savage' human beings in earlier times. I shall look at a few examples of this below; such images might depict a lone stag, camel, or cheetah as a romantic subject amid exotic settings of mountain or desert. The latter sort of case, involving too much familiarity, can result in anthropomorphized, kitschy images or caricatures.[23] Think of Grandville's famous depictions of animals clad in human attire who sit around smoking or card-playing. Anthropomorphism can also inflect photographic portraits of animals as well. This

is made explicit in Greenberg's *Monkey Portraits*.[24] The artist comments in her introduction, 'What became apparent as I was making my selections after each shoot was that I was attracted to the images where the subjects appeared almost human, expressing emotions and using gestures I thought were reserved only for people.' Greenberg adds:

> They are us and the opposite of us at the same time since they share none of our cultural constraints on behavior or appearance. They seem to be looking back at us, sometimes judging, sometimes in shock. Is it something we've done? (Introduction, unpaginated)

Such anthropomorphism is unabashedly evident in the titles the photographer chose for the portraits, such as 'The Misanthrope', 'Crestfallen', or 'Oy Veh'.

Another way to describe my third condition on portraiture is to state that the portrait subject must actually 'look back' at the artist, allowing itself to be viewed. Here, things become tricky, though. In many cases animals do look at humans. In pictures they can appear to be gazing at the viewer much as a human subject would. To spell it out more, in some portraits of either humans or of animals, there is a face turned toward the viewer with eyes wide open, creating the appearance that they can observe us just as we observe them. (The icon is of course the clearest and best instance of this; we will look more at examples in Chapter 2.) If the portrait subject is depicted as looking back at us, this both replicates the original encounter with the artist and extends it beyond the frame to us as viewers who are now confronted by this alternative subject's gaze. And this point seems very important in assessing the nature and merits of portraits, whether of humans or of animals. To say this is,

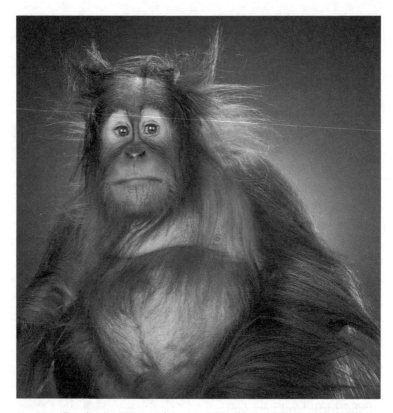

Fig. 1.3 *Offput (Rocky, Orangutan)*: human-like expression in an orangutan.

obviously, to neglect the role of the artist in creating that vivid sense of reciprocity. I do not mean to overlook the artist, but for now I want to focus on the phenomenology of the viewing experience.

The exchange of gazes in humans' visual encounters with animals has been discussed by John Berger in his interesting

1977 essay titled 'Why Look at Animals?' Berger notes that for many people, our chief encounters with animals today occur in zoos, which 'came into existence at the beginning of the period which was to see the disappearance of animals from daily life'.[25] When first established, according to Berger, zoos manifested an imperialist ideology since they aimed to demonstrate a great nation's ability to explore, conquer, and raid the natural riches of other lands. Zoos are still enormously popular and attract millions of visitors per year, but Berger thinks that our curiosity about zoo animals is hard to explain given the typically disappointing encounters permitted by zoo enclosures. In zoos the animals often seem too crowded or dirty, or their unnatural existence renders them inert and dull. And so Berger says that, 'in the zoo the image is always wrong. Like an image out of focus' (21). Zoos marginalize animals and transform them into unnatural creatures dependent on their keepers. '[N]owhere in a zoo can a stranger encounter the look of an animal' (26).

Of course, Berger acknowledges that we have numerous technological aids to enhancing our own examination of animals, in the form of the video or film camera, the telephoto lens, the infrared detector, etc. (Documentary films like *Winged Migration* or the turtle and penguin movies mentioned above would be good examples.) Yet Berger feels that these kinds of observational techniques reduce animals to things to be observed: 'the more we know, the further away they are.' He appears to yearn for an earlier time when peasants had more intimate exchanges with animals and animals were able to 'look back'.

This 'looking back' is an intriguing notion that, as I mentioned above, can be fostered by certain portraits. If an artist succeeds in fulfilling all of the conditions of portraiture, then we would as a result be able to ponder an image that shows the

subject as a recognizable individual with an inner mental state and an expressive air. And in certain cases it is even true that the animal looks back at us. But I still deny that animal portraits meet the third condition of portraiture: willing participation in the portrait process, in the creation of a self-depiction. At best the most skilful artists evoke in viewers some strong sense that this has been the case, that in their interaction with the alien subjectivity of the animal, some pact has been observed.

Consider for example the series of portraits done by Jean-Baptiste Oudry from 1739 to 1745 depicting the various exotic animals collected in the Royal Botanical Garden at Versailles. The collection itself represents the attitudes that Berger targets in his essay: the colonialist appropriation of other territories and their natural resources, everything from cassowaries to hyenas. And perhaps the reasons for commissioning the artist to depict this menagerie were dark ones that involved pride of possession and aristocratic competition. But even so, the images themselves are a different matter. In his painting of Clara the Indian rhinoceros (see Plate 1), for example, Oudry shows this large beast with its body extended a considerable distance across a huge and imposing canvas, every detail of hide and hoof lovingly depicted. (She is a very clean and tidy beast.) A focal point of the painting is Clara's eye. Though not large in proportion to the rest of her, this little eye shines brightly and furthermore, it appears uncannily focused upon the viewer. Oudry's painting is huge: ten by fifteen feet. Its large size lends the subject both greater majesty and, I would argue, dignity. Clara has presence; here we can definitely experience an animal that 'looks back'. In actual life this poor animal was treated quite badly, hauled all over Europe for seventeen years to be put on display before eager mobs. But a different, more respectful attitude is made

manifest in Oudry's painting, which almost appears to show her as a queenly being posing to be recorded for history.

It has been claimed that the Oudry animal paintings give evidence of the rise of a new science of natural history that began to prevail in the nineteenth century with the works of scientists like Buffon.[26] Perhaps our human curiosity about zoo animals is not as sinister as Berger considers it, reflecting something more naive and innocent rather than an appropriative gaze. 'What are these other lives like?', we might ask while watching the lions or polar bears at the zoo. This kind of an interest can be contrasted, just as Oudry's paintings can, with the over-dramatized, fictionalized vision that is shown, for example, by a painting like Rubens's *Hippopotamus and Crocodile Hunt* (1615–16). This painting, like many of Rubens's other hunting scenes, was commissioned by one of the wealthy men who had imported exotic animals from foreign lands, in this case, Maximilian, the Duke of Bavaria.[27] The diagonal composition along with the animals' snapping jaws, dilated nostrils, and fierce combat all concentrate the tension and drama of the scene. This is quite different from Oudry's more dispassionate observation of details of the animal who is posed by herself, calm and even stately.

In other instances, the humans who depict animals bear a close relationship to them and are forthright about what they are doing in portraying their companions in an intimate manner. For example, David Hockney responded to someone who commented, 'Oh, you're painting your dog,' with the correction, 'No, I'm painting *my love for my dog*.'[28] Hockney's remark brings the pet–artist relationship into the realm of intimacy that I will discuss later (Chapter 6) for artists in the depiction of certain subjects very close to them, such as wives, children, or mothers. It is

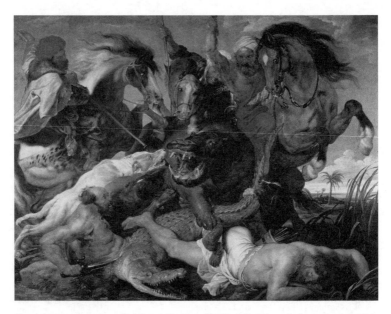

Fig. 1.4 *Hippopotamus and Crocodile Hunt* (1615–16), Rubens's depiction of an exotic and ferocious animal battle.

telling that many of Hockney's paintings of his dachshunds depict the dogs sleeping. Hockney makes these comments in the foreword to his book:

From September 1993, I painted and drew my dogs. This took a certain amount of planning, since dogs are generally not interested in Art (I say generally only because I have now come across a singing dog). Food and love dominate their lives.

I make no apologies for the apparent subject matter. These two dear little creatures are my friends. They are intelligent, loving, comical, and often bored. They watch me work; I notice the warm shapes they make together, their sadness and their delights.

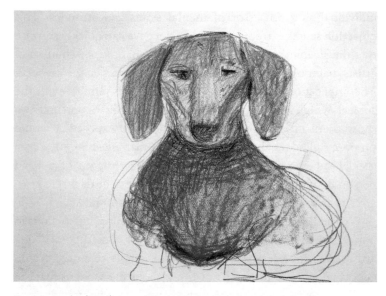

Fig. 1.5 *Stanley* (1994), one of David Hockney's beloved dachshunds.

And, being Hollywood dogs, they somehow seem to know that a picture is being made.

In fact, it is not unusual for painters to show someone (or some being) with whom they live or are intimate asleep. Picasso comes to mind as a pre-eminent example of this, since he often depicted himself awake, watching a sleeping woman (and he also often assumed minotaur form in doing so).[29] Or, in the contemporary world, Lucian Freud has often painted humans who are sprawled nude and defenseless on a bed or on the floor. And they too are often accompanied by his favorite dog, the whippet, who looks much the same.[30]

Images of either people or pets asleep might not actually seem to meet my second criterion for portraiture, showing the

individual as a possessor of mental states and attitudes. This objection seems extreme, however, since we can quickly surmise that the sleeping subjects, whether women, dogs, or children in artists' paintings, are capable of waking up and being conscious. The implication of intimacy is that the artist is familiar with the subject when alive and alert and is taking this opportunity to show them in another way, unguarded and exposed. I would propose calling the depiction of these intimate sleeping subjects a special sub-genre of portraiture. (Whether images of a dead person count too as portraits is another issue, dealt with separately in my next chapter on contact and immortality.)

We can find more possibilities of human–animal interactions in portraiture by turning to work from another contemporary 'dog artist', William Wegman.[31] This is an example of an artist who adopts an attitude of humor or irony about the whole situation, invoking a visual pretense that the animal does knowingly pose and participate in portrait-making. (Wegman actually had an established reputation well before beginning to photograph his dog, and despite his success, he should perhaps not be blamed if he should resent being known mainly for his dog images.) Despite dressing his dogs up in human attire, or even adorning them with false eyelashes (as with his dog Fay in the portrait *Fay and Andrea*), Wegman denies that he is anthropomorphizing and insists upon his respect for the animals as co-creators. He does not see the dogs as human but insists that he pays considerable attention instead to *their* ways of perceiving the world.

'I don't feel lonely when I'm around them,' he says. 'But I love also listening to them. I always make sure I spend some time just seeing what they're really doing. Especially outside, you know, when you're alone with them. Because so many people including myself

fill in a whole vocabulary for them that is ours and not theirs. I remember spending some time for the first time with Man Ray, my first dog. I didn't talk that day. I just listened to what he was listening to, the whole aura of smells and sounds and sights and things that he was picking up on during that day. Most people who have dogs see them as their dogs: 'Come on, boy,' or 'Fetch' or pat, pat. But they're really teeming with their own thoughts.'

Wegman's by now well-known photographic portrait series of dogs began with his Weimaraner named 'Man Ray' who simply

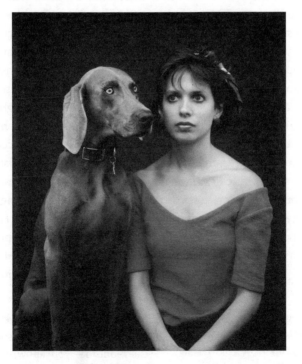

Fig. 1.6 *Fay and Andrea* (1987). Wegman's dogs appear to adopt quite human-like poses.

wanted to be part of the action in the studio. The artist increasingly came to feel that Man Ray enjoyed being portrayed and participated willingly in the process. He even speaks of what was done then as 'our work'.[32] It would be stretching things to assert that Man Ray had a desire to be depicted or any awareness of 'how he looked in pictures'. It is unlikely that the dog really understood what was going on in terms of being portrayed or presenting himself to the artworld as a character of a certain sort. One could equally well hypothesize that Man Ray simply enjoyed being the focus of attention, and like many other dogs, liked to be around his human companion. Dogs seem to arouse and respond to human needs for companionship in especially strong ways that might make portraits of them an almost unique category in art. That is, they are often so willing to please that their appearance of participating in the portrait process is something natural to them, enabling us to infer that they are willingly 'posing' for their human. And Wegman seems to be invoking this feature of dogs in his portraits of Man Ray and his successors (who were also his children and grandchildren).

In fact, some reviewers have construed Wegman's images as appealing to viewers for just this reason: because they highlight for viewers a fundamental feature of the human–dog relationship, the dog's eagerness to please. One critic has put the point in this way:

> The strongest images in *Man's Best Friend* seem to be pulled from this underground terrain, where dogs, the most domestic and tractable of all animals, have a psychological power that no other animal can match. In the pictures where the camera gets to within inches of Man Ray's face, and his eyes look up into ours and appraise us with a stare worthy of Iago, Wegman suggests the insidious side of a dog's ceaseless desire for closeness. These

images feel as if they come from Ray's depths, and as if Ray, speaking for all dogs, says, 'We know you—we always have.' In these close-ups, and in the pictures of his bowed head and especially in 'Dusted,' Man Ray is as much of an individual, a presence we feel we know, as any animal in the history of art.[33]

By contrast to this sort of ambivalent closeness people share with dogs, I suspect that feline fans would typically imagine that their cats are 'posing', if at all, not in order to please their human companions but in order to enable us to spend time in admiration of their beautiful sleek selves. In other words, the cat takes on an attitude not to show how much it knows and understands about our nature, but rather because it seeks and expects to find our admiration for its (presumably loftier!) nature. It is interesting that the cat's wide-eyed gaze is sometimes so frightening (a common trope in horror films), but I think this is almost precisely because cats do not reward us as dogs do by reflecting back to us a gaze of friendly cooperation. Cats can enter into staring contests with humans but just as often they appear to see straight through us as they muse upon their own imponderable mysteries.

Examples from Art History: Cats

Having laid out a general view about issues concerning portraits of animals, I now turn to consider some examples from art history, assessing whether and how they fit in with my account of when something counts as an actual animal portrait. Since dogs, cats, and horses have featured in particular in the work of artists in the West, I will pay special attention to such works. I will argue that, surprisingly perhaps, most of the best-known

paintings that depict these animals should *not* really be counted as portraits. In a nutshell, this is because the animals are either employed as symbols or as mere pieces of property, rather than as unique individuals bearing an inner life and personality.

Cats are the other best-known species of domesticated companion animals, so let me begin with a word about them. Of course, cats have played a major role in art of various cultures and time periods (think of Egyptian cat-gods like Bastet or of cats in various famous Japanese paintings and woodcuts). There were even mummies of cats in ancient Egypt. However, in most historical examples of artworks when cats appear they play a certain kind of symbolic role rather than being presented as distinct individuals. For example in the Dutch genre paintings of everyday life we will often see the cat which stares at fish or meat on a table or even manages to steal some of it. Here as elsewhere the cat's symbolic value is fairly negative, indicating greed and crafty pursuit of self-interest. The cat often seems cruel in its predatory activities and in much art, as in literature and history, the cat (especially if it is black) is associated with witches. We see this for example in some of Goya's engravings about madness and witch gatherings. The black cat with an arched back, as if hissing, shown at the feet of the notorious and controversial *Olympia* by Manet may play a similar role of implying that she has certain illicit powers. Similarly, the cat is said to symbolize the threat of human evil that threatens innocence in Goya's marvelously strange portrait of a small boy holding a magpie on a string while three cats crouch in the background. The cats' large eyes loom out of darkness as they stare at the bird, waiting to pounce, in some sort of indication of a future threat.

Even when cats are depicted in more positive and affectionate manners, for example in paintings by the Impressionists like

Bonnard and Renoir, they still seem to possess a symbolic association that is somewhat shadowy, since they tend to connote sensuousness and pleasure-seeking. So frequently cats are present in images of women or young girls, but a relatively rare occurrence in depictions of men. Renoir in particular seems to convey clear connections between a cat's soft sleek fur and the tender flesh of the nubile beauties he loves to paint.

Dogs

Dogs have appeared in art since the earliest cave paintings, where at least one image depicts a dog assisting a man in hunting a deer. Dogs are shown in Egyptian friezes, Greek vase-paintings, and ancient Pompeian mosaics. During the medieval period, dogs were symbols of fidelity and were often depicted at the feet of dead knights in tomb sculptures. Similarly, they were often shown in early Renaissance marriage portraits, as in the famous *Arnolfini Wedding* of Van Eyck. This aspect of the dog continues as a prominent element even in more recent images that highlight a romanticized, even sentimentalized, version of the dog's loyalty to humans. This is true for example in the memorials to individual dogs like Greyfriars Bobby, whose sculpture stands today in Edinburgh's Old Town. Bobby was famous and immortalized because of his fidelity to his master, demonstrated by the dog's daily visits to the man's gravesite over many years.

Sometimes dogs in art seem to act as a sort of stage setting or means of portraying aspects of a human subject. Edgar Peters Bowron, in an essay on the early history of dog painting, explains

that gender patterns held concerning the depiction of particular types of dogs:

> In the sixteenth century dogs adorned portraits in a variety of ways intended to reflect the character, strength, and nobility of their owners ... lapdogs represented as exclusively female companions, large hounds depicted as attributes of male virility.[34]

We can think, for example, of the soft silky lapdogs shown in many of Titian's portraits of women, such as the *Venus d'Urbino*, by comparison to the large and more muscular hunters that were more typically featured in his portraits of men.

Bowron also explains that, as with cats, dogs began to be portrayed by northern artists in the seventeenth century as part of a new genre of depicting everyday life with naturalistic details. It remained true in such paintings that the dog, like the cat, served as a sort of 'emblem' with specific meaning associated with it, just as the flowers in a still life symbolized *vanitas*. Bowron comments,

> Thus the problem of interpreting the meaning of individual dogs that appear in Dutch and Flemish seventeenth-century art is not easily solved. Dogs are commonplace animals that were a part of everyday life in the Netherlands for several centuries, but their appearance in the emblem books of the sixteenth century and later has created vexing problems of interpretation.[35]

It was an artist of this period who first began painting individual dogs. Bowron explains,

> Frans Snyders, the Flemish painter of animals, hunting scenes, and still lifes, developed a new genre of dog painting that focused on the animal alone, without the presence of humans ... Snyders' role in the history of dog painting is tremendous. He anticipated

the nineteenth-century habit of investing animals with human characteristics...[36]

Another example of an animal who appears to be depicted with human characteristics is Goya's sad dog in the altogether bleak painting *Dog Buried in the Sand*.

Picking up the tradition, artists in France and England also began to portray individual dogs, typically at the bequest of wealthy patrons who wanted their pets or favorite hunters immortalized. These dogs were often the favorite pieces of valuable property of wealthy individuals like kings and queens. Sometimes, exotic and rare breeds were preferred. These ranged from the King Charles spaniels that were lapdogs of queens to the greyhounds, foxhounds, and bloodhounds that constituted the breeding lines of kennels owned by wealthy aristocrats. William Secord further explains how this gave rise to various types of dog portraits:

> Eighteenth-century England saw the evolution of three distinct types of dog paintings, usually of purebred types, which became fully developed in the nineteenth century: portraits of sporting dogs, of pets, and of purebred dogs. In the convention of sporting-dog portraits, it is not necessarily the appearance of the dog that is important but rather how it performs in the field.... The purebred-dog portrait depicts the animal in a very specific pose, standing in profile, often with its head slightly turned toward the viewer. The pet portrait—a more general category—often positions the dog in a domestic interior, its only purpose being to please its master.[37]

George Stubbs and Anthony Wardle were two of the artists who acquired fame and success by depicting groups of hounds for their wealthy owners. Stubbs, the eighteenth-century animal

artist who was best known for his horse paintings, also produced *Five Staghounds in a Landscape* (1760), and Wardle painted *The Totteridge Eleven* (with smooth fox terriers) in 1897. Both works feature an unnatural grouping of stiffly posed dogs shown all in profile so as to emphasize their conformation.

A nineteenth-century artist who excelled at the pet portrait genre was Sir Edward Landseer, who painted a number of portraits of Queen Victoria's favorite pets, including her spaniel Dash, Prince Albert's greyhound Nero, and the Scottish deer-hound Hector, along with the Queen's parrot Lory. They are shown in one wonderful painting in an interior setting with plush brocades in rich colors, their feathers and fur glowing with health. Dash, in particular, appears quite pampered, seated on a velvet footstool trimmed with gold tassels, a sort of royal personage in his own right.

Horses

Like the dog, the horse in art history was often a form of symbolic statement about aspects of humans. In ancient Greek and other art, horses are sometimes depicted in struggles with predators like lions. They could represent nobility and courage, a trait often transferred to their trainers (as with Hector's epithet 'tamer of horses' in *The Iliad*), but horses sometimes also symbolized human vices, as was typical in their depictions as centaurs.

In later periods of art history, horses mainly appeared as the mounts of important figures such as kings, warriors, aristocrats, and generals. There was a coding system for equestrian portraits in which certain points about the rider were indicated through

the positioning of the horse. For example, in baroque art in Spain, the rearing horse in a *levade* position, on its haunches with forelegs in the air, symbolized the exquisite riding ability of the person atop the animal along with the fine training and muscle control of the animal:

> The equestrian portrait was a form rich in historical associations, and in the seventeenth century the sitter's horsemanship alone— that is, his ability to ride well—could in both a literal and a metaphorical way say much about his station and character.[38]

The art historian Walter Liedtke distinguishes three common themes indicated by the equestrian portrait: imperial, Christian, and ruler-ship themes. Velázquez painted a variety of illustrations of prominent members of Philip IV's court showing the relevant expertise, which even extended to the enthusiastic and apparently talented young Prince Baltasar Carlos at the tender age of 6. Unfortunately the painting's optimistic forecast of his ability to rule by the symbolic value of his excellent horsemanship did not become realized since he died at age 16 before reaching the throne.

Horses could also be 'feminized' in art in the sense not just of being bridled, ridden, and controlled by male riders, but by themselves being shown as graceful and beautiful creatures with delicate legs and flowing manes—manes akin to the lovely long hair of the female in the Venus or Mary Magdalen tradition. It would more likely be well-bred horses of aristocrats depicted in such poses rather than rough working draft animals of peasants. Horses shown to bring out this kind of 'feminine' beauty would also typically be shown as clean and pure, not as sweating, dirty, or plagued by flies. Often the horses in this mode are shown with one forefoot delicately raised, a pose akin to that

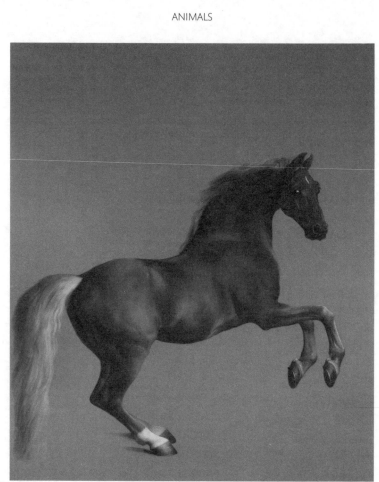

Fig. 1.7 *Whistlejacket* (1761–2), George Stubbs's life-size portrait of the handsome stallion.

used in imagery from art from ancient Rome until today's fashion images to emphasize the beauty of line of a female form.

Other artists in Europe at and after the time of Velázquez pursued similar kinds of paintings in which royalty or aristocrats

were shown with horses in activities that emphasized their status, power, and wealth—whether hunting, racing, or simply surveying their estates. The most important artists of this time who showed horses were the Flemish painters Rubens (1577–1640), and van Dyck (1599–1641). Through them, this sort of horse painting was introduced to England. As one historian has remarked, 'Despite English reverence for, and reliance upon their equine partners, horses rarely appeared in English art until Rubens and van Dyck introduced them early in the seventeenth-century.'[39]

It was not until fairly late in art history that a horse was depicted on its own, without any accompanying rider or owner. This occurred in the paintings of British artist George Stubbs (1724–1806). Stubbs had spent considerable time dissecting horses and he produced a definitive work on horse anatomy. As a painter he became very successful and secured numerous commissions from members of the new aristocracy who wanted to demonstrate their wealth in terms of kennels or stables by having individual dogs and horses immortalized. The most famous and remarkable painting of a horse that Stubbs created was his life-sized portrait of the stallion Whistlejacket in 1762. The handsome horse is shown in the *levade* position, like so many of the royal mounts that Velázquez painted. Unusually though, Whistlejacket appears on his own with no rider, highlighted against a completely blank background. It is as if he himself may be enough to count as royalty.

Despite Stubbs's obvious interest in depicting horses in their own right, we might still question whether this is actually a portrait that reveals a distinct personality in addition to the famous horse's actual appearance. I tend to be reluctant to admit the image's status as a portrait because of how formulaic

it appears. Perhaps instead of being royal in his own right, Whistlejacket is simply awaiting the appropriately powerful rider or a king. The rearing horse on its own has such a history of symbolic associations with human riders that it is somewhat difficult to assess how accurate or revealing this painting is of the 'real' personality behind the animal's sleek beguiling surface.

Strikingly, however, this picture was once selected as the '*Guardian* [newspaper] portrait of the week'. So apparently the newspaper's editors had no doubts like mine. They printed a copy of the painting along with the following commentary (in part):[40]

> Stubbs's picture is a portrait of an animal on the scale usually reserved for kings. A portrait is a study in individuality, at its most primitive an attempt to discover what makes someone recognisable as themselves.... Yet this attention to external features is only one part of what makes this a great portrait. Stubbs is interested in the inner being of Whistlejacket, his character, his self, and that is what he captures here: the incredible tension, energy and sensitivity in the way the horse rears, the electricity in the taut muscles, the look of something that might be terror in his face.[41]

It may also be worth noting that in anecdotal history this image was lifelike enough that it caused another stallion who saw it to rear and attempt to attack it.

Conclusion

To sum up then, I have argued that there can be portraits of animals in a limited sense, since there are pictures of them that meet my first two criteria for portraits, representing a

recognizable living subject in an image that also expresses consciousness and inner states. I expressed doubt about just how far down the animal kingdom such depictions can go. I am also skeptical about the chance that animals can fulfill the third criterion required for portraits in the fullest sense, which can be met by adult humans, the factor of posing or of self-presentation. Even though in many pictures the animal appears to look back at the artist and subsequently at us, the viewers, I have argued that it is implausible to say that they are full participants in the process of portraiture. Finally, I have surveyed some examples of paintings of the cat, dog, and horse, to emphasize the rarity of actual portraits of animals despite their prevalence in imagery throughout art history.

2

Contact

Introduction

Late in life my grandmother went into a long decline in an Alzheimer's-like illness that robbed her of her personality, leaving behind only a sweet bland vagueness. One of the photographs I took of her during that time is still disturbing to look at because she simply seems 'absent' in it, her characteristic vivacity missing. After my grandmother died in 2005, we held a memorial service in her honor, and for the occasion my mother assembled a collage of photographs. Pointing to one particular image, my mother asked, 'Isn't this one just really *her*?' I knew exactly what she meant, and yet it was a puzzle. Why was that one image so revealing and not the rest, which were also indisputably Grandma? In that image, the photographer had caught some essential truth of my grandmother's expression. The result was what the greatest artists aim to achieve in portraits: a picture that shows how an actual person really *was*. In this chapter I will continue my study of the relationship of portraits to persons by focusing on this special way in which portraits seem

to provide us with an essential revelation of persons, of their very nature.

The use of photographs in funerals and memorials has become commonplace. It speaks to one of the primary reasons why we value portraits and care about having them: they sustain our connections with people, offering up a kind of immortality and contact with loved ones when they are absent. Often a photograph stands in for the deceased person if there is a cremation or closed coffin service. Sometimes—perhaps most of the time—the photographs on display span a lifetime and mourners are invited to review the lost person's entire life history, compressed into a pictorial digest. If one especially 'true' image emerges to enable us to see that lost relative or friend, it helps everyone assuage their grief.

What was captured in the image of my grandmother, that continuing contact that my mother and I responded to, has been given the helpful and non-technical label of the 'air' by philosopher Roland Barthes. His book about photography, *Camera Lucida*, is both a broad reflection on the medium and a moving personal essay which he was prompted to write in reflections on loss after his beloved mother's death. Barthes mused over the ways in which photographs preserve the past, bringing us into the direct presence of people who are long dead. Sadly, their deaths seem to be foretold in these images. Barthes seeks the truth of the person he had loved as companion for so long in the pages of a photograph album. Suddenly he discovers her, 'the real her', in an image taken of her as a young girl. He feels that he had finally found his mother *authenticated* in that image, which he calls the Winter Garden photograph. It captures what Barthes describes as her 'air'. A person's 'air' is unanalyzable, he says. Clearly this is not the same as whatever is recorded of the

outward appearance that shows someone's legal identity, as in a passport photo. The air has more to do, Barthes says, with 'the expression, the look'.

If pressed to describe my grandmother's 'air' as shown in that special photo of her, I would say that it had to do with the way in which she combined a witty and observant twinkle with a slight ducking of the head. She seemed to be on the verge of giving way to a broad wink of humor to accompany a penetrating observation, but to be cutting it off out of politeness or decorum. Barthes says more to explain what he has in mind by his label the 'air':

> The air is not a schematic, intellectual datum, the way a silhouette is. Nor is the air a simple analogy—however extended—as in 'likeness.' No, the air is that exorbitant thing which induces from body to soul—animula, little individual soul, good in one person, bad in another.[1]

Naturally, readers are curious to see the Winter Garden photograph, but Barthes does not publish it because he thinks it will only have resonance for him, the person who knew and loved his mother in a special way. I am not sure he was right about this. Surely there is something in great portraits from history that holds our attention just because we *do* seem to see in them a person's very essence, their 'air'. Ultimately, Barthes wonders whether, 'Perhaps the air is ultimately something moral, mysteriously contributing to the face the reflection of a life value?' (110). This phrasing seems right to me and the point can be applied more generally to the greatest portraits: they interest us because they reveal someone's essential nature or their character in a very deep sense. Consider, for example, how Velázquez's well-known portrait of Pope Innocent X or Lucian Freud's recent (and controversial) portrait of Queen Elizabeth II convey these powerful figures' strength and force of character.

The Pope has the air of someone cunning and ruthless; the Queen, in this unflattering depiction, appears stubborn as a bulldog with locked jaws, but nevertheless admirably majestic, someone now aged comfortably into her stately role.

For most of us now, as for Barthes, photography rather than painting is the medium that represents people from our past who are now lost to us. But this has not always been the case. The roles of sustaining contact and preserving outward appearance have been played by artworks in many other media. There are reasons to doubt the claims advanced by both Barthes and others about the special 'realism' of photography. Barthes claims that photographs provide 'contact' and enable us to see the past. This is the magic and wonder of his final magical photo of his dead mother, as of the special links we all feel with photographs of our loved ones after their deaths. Although Barthes feels that photography alone has this power to 'wound', as he puts it, by showing a person whose death is already anticipated in the image, I want to argue here that the function of such striking, 'magical' images can be fulfilled by other sorts of portraits as well. The general idea that photographs are manifestations of their prototypes has been defended by other writers, perhaps most fully by Kendall Walton in his article 'Transparent Pictures: On the Nature of Photographic Seeing'. Walton asserts the thesis of photographic realism in a bald and startling way by saying that we literally see the objects in photographs, even long-dead people or vanished distant stars. 'With the assistance of the camera, we can see not only around corners and what is distant or small; we can also see into the past. We see long-deceased ancestors when we look at dusty snapshots of them.'[2] When we have contact with someone through a photograph, Walton maintains, we fictionally see that person or get 'in touch' with

him or her. Such contact is why we care about certain images—even if they are blurred and fuzzy.[3]

But I disagree; this is *not* the unique business of photographs. Other kinds of portraits have served to satisfy our human desire to foster the kind of immortality through images that facilitates ongoing existence after death and contact with absent loved ones. Consider, for example, ancient Egyptian mummies (see Plate 2). In burial ceremonies the person's entire body was carefully preserved, along with a painted representation of them and various important possessions and accessories for the afterlife. Surely, looking at such an image in its place upon the coffin lid would also fulfill a strong function of 'contact' with a seeming realism. The image presents that very person, the important Pharaoh, queen, or priest, to the viewer who shows mourning and respect. In fact, portraiture in general is thought to have originated from the desire to preserve likenesses of the dead, both to assure them a kind of ongoing life and to enable us to maintain contact with them. Some of the earliest portraits known to exist are funerary portraits from ancient Roman Egypt, which were probably done with the aid of wax death-masks.[4] More recently, artists in the Renaissance as well as early American artists like Gilbert Stuart created their portraits after taking life masks of their subjects. (This is true for instance of Stuart's well-known portrait of George Washington.) A mask, painting, or sculpture created from a person's face will bear an uncanny resemblance to them; one could even argue that it enables us to 'see' that person more realistically even than in a photograph, since the image is three-dimensional.

The rituals and ceremonies associated with the revelation, viewing, and treatment of portraits can also enhance the viewers' sense of contact with the dead. In China, for example, there were long traditions of recording imperial images on silk

Fig. 2.1 Mummy Portrait of a Man, Egypt, Fayum region, Roman, c.150–200. Ancient funeral portraits are among the earliest, presenting lifelike memorials of the dead.

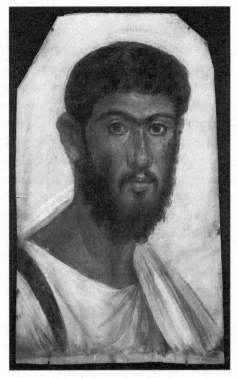

scrolls. These images were very standardized in style and format, presenting the royal figure enthroned in yellow imperial robes. They were kept hidden and only brought out and presented on certain highly significant occasions, to a select audience, in ceremonies accompanied by incense and lamplight.[5] Such circumstances would no doubt be treated as revealing the ancestors' presence and they would foster the contemporary viewer's feeling of contact with such respected and revered predecessors.

I suggest that we should understand Walton's (and Barthes's) claims about photographic realism as intending to convey

something not about the truth or epistemic value of photographs, but rather about their emotional resonance. Walton, like Barthes and others, believes that in photographic images the realism is greater because the person is *manifested*. I borrow this term from Patrick Maynard's book *The Engine of Visualization: Thinking through Photography*. There Maynard distinguishes between two important and separate functions of images: a 'depictive' or representational function and a 'manifestation' function.[6] He traces these functions of photographs back to sources within two distinct traditions of image-making in Europe. In the West, art associated mainly with Catholicism developed forms of ever more naturalistic, illusionistic depiction. On the other hand, in Eastern Orthodox realms, emphasis was instead placed upon icons as hieratic images revealing some holy person's manifestation.[7] Such manifestation has less to do with effecting a realistic likeness than with supplying the viewer with a sense of contact with the represented subject.

Insofar as a photographic image functions today to supply a similar sense of contact or manifestation, Maynard says, it 'resembles an earlier and prolific, important sort of image, an icon: "an image whose *function* is largely that of manifesting what it depicts and thereby providing realism through the sense of presence." '[8] Maynard comments that 'testimonies about "nearness," "contact," "emanation," "vestige," "trace," "co-substantiality," and so on, register a sense that photographs of things can combine with these (depictive) characteristics a strong manifestation function as well'.[9] Susan Sontag confirms this linkage when she remarks that having a photograph of Shakespeare would be like having a splinter from the True Cross.

This point holds true of the other sorts of images I have just mentioned; they too, along with photographs, contain a special

kind of power, the power of *contact*. Reinforcing Maynard's account of the two widely divergent functions of images in East and West is the German art historian Hans Belting, who goes so far as to deny that icons are works of art in anything like the usual sense. He calls icons 'images before the era of art' in his monumental book *Likeness and Presence: A History of the Image before the Era of Art* (1994).[10] Like a photo at a funeral service, the icon provides an important kind of contact with its referent, the person or figure shown therein.[11] It is time now to consider the implications for portraits of these two quite distinct traditions of image-making in the West.

Of course portraits in general fulfill a variety of roles. But from the more obvious ones, we can distinguish some as having more to do with providing information (i.e. with the depictive function), and some instead with sustaining contact (the manifestation function). I will offer a fuller definition of portraits in a later chapter. Initially, we can say that portraits are images of persons that fulfill one or more of the following features. They are:

1. Likenesses
2. Psychological characterizations
3. Proofs of presence or 'contact'
4. Manifestations of a person's 'essence' or 'air'.

Insofar as portraits deliver to viewers a realistic likeness of someone or a psychological characterization,[12] they are depictions and could be counted as artworks (perhaps depending upon their quality, among other things). But insofar as portraits are treated primarily as providing a sense of contact with someone or revealing their inner essence, they bear more resemblance to traditional icons. In Chapters 3 and 4 below I will move on to consider the depictive functions of portraits. Here, in order to explain and analyze the third and fourth features of portraits, it will be helpful to look more

closely into the nature of traditional icons so as to understand why they are distinctive and unlike artworks in our sense.

Icons and Contact

The word 'icon' in English derives from the Greek term *eikon*, designating a likeness or image. Despite this etymology, the sorts of icons that proliferated in the Byzantine period and afterward were not realistic or naturalistic likenesses, 'copies' of reality in the sense of mirror images. They were, rather, standardized depictions of holy figures such as Jesus, Mary, and various saints. Here, for example, is a statement from an Eastern Orthodox source about Byzantine icons:

> It is important to understand that an icon does not represent, it expresses. It depicts the spiritual, not the physical. Physical characteristics are not of primary concern; it is the spiritual qualities that are the main focus in an icon. The entire icon is a symbol, not a decoration. They have never been worshipped as pieces of art. Rather, they are venerated for the divine and supernatural forces which they express.[13]

Icon painters or 'drawers' did not usually have any freedom of expression in what they did. Typically they were monks who had to pray before painting to achieve an attitude of appropriate submissiveness to the task. They were required to employ certain approved schemata and to use only certain materials and colors in their work. In the tradition of the East, icons do not have naturalistic coloring; the space in icons is flat and the sky is rendered with gold to symbolize the heavenly realm. Body postures are stiff and generally people are shown in a full-frontal

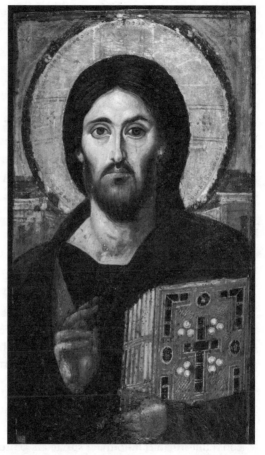

Fig. 2.2 *Bust of Christ Pantokrator* (84 × 45.5 cm), illustrating the direct gaze of many medieval icons. Encaustic icon, first half of the 6th century.

mode, and typically attenuated, putting emphasis on faces which stare out at us with large intense eyes. These eyes crucially assist in promoting the sense of direct contact with the depicted person. The precious materials of icons such as lapis lazuli and gold added to their status and in some cases were held to impart to them certain magical powers.[14]

Authorities on icons defended the use of such images within the Christian Church, amid controversy arising from the Mosaic prohibition of graven images or 'idols', by arguing that icons are special kinds of images whose power derives from a unique relationship to their alleged source. That is, the justification of such holy images was and still is made 'not through their usefulness to, or meaning for, the beholder, but through their inner relationship to their prototypes'.[15] Believers assert that, 'An icon ... does not exist simply to direct our imagination during our prayers. It is a material center in which there reposes ... a divine force, which unites itself to human art.'[16] In this sense, icons function much like relics, as virtual (or in many cases literal) pieces of a lost saint or holy figure.

As noted above, Maynard contrasts the devotional Eastern uses of icons with the cooler or more depictive functions of Western painting. He too sees these images as an important source for photography—at least in terms of some of their common functioning. Like ancient funerary portraits, photographs facilitate a sense of ongoing contact. In this way they also resemble icons, as described by the art historian Charles Barber:

> The image is not to be read in isolation; rather, it is to be interpreted with respect to the viewer's relationship with the image ... [T]he icon, rather than transforming spectators or acting as the site of their transformation, is not a site of identification through representation ... but a site of desire.[17]

We need to understand more about what accounts for this unusual relationship of icons with our human desires, as this will enable us to have a better sense of why portraits matter to us, and how they reveal persons.

Key Features of Icons

A first key feature of icons is that the image on the icon is taken by believers to be an *appearance* of the holy person. It has authenticity (just as Barthes maintained that the Winter Garden photograph of his mother did).[18] Second, icons are objects of veneration. As an approved and veracious image, the icon takes on the qualities of the person depicted. The icon is treated like the saintly person him- or herself and accorded worshipful respect, since the holy person is *manifested* in the icon. People kiss the icon, bow down to it, light incense and candles before it, etc. Again, this point can be made about photographs. The contemporary painter Gerhard Richter, who often works by turning photographs into paintings, has commented that, 'Snapshots are like little devotional pieces that people have in their environment and look at.'[19] Believers make requests of the icon and have faith that it can conduct miracles.[20] A correlate of this second feature is that icons are often regarded as having strong powers. They are paraded about the city they protect or reside in on certain special days. Icons also are said to manifest peculiar and special behaviors that are human-like, such as weeping or bleeding on specific occasions.[21]

Third, icons also are often alleged to have special causal origins. Even if painted by a human artist, icons often were held to be directly caused by the holy person who wished to have a likeness made. Because of the emphasis on the causal role of the depicted person in the icon, there was a corresponding de-emphasis on the artistic source of the human icon painter. This was true, for example, in the case of some famous icons of Mary which were said to have been painted originally by St Luke. It was commonly held in the medieval period, up until relatively late times (the fourteenth century), that various

icons were authentic because they had been painted 'from life' by St Luke who was allegedly present at the Nativity. One of the very first icons, the icon of Mary in Venice (originally from Byzantium), was supposedly posed for and approved by Mary herself. Belting explains:

> This 'authentic' portrait was naturally preferred by the Virgin, as it showed her 'correctly' and had been made with her cooperation; special grace thus accrued to this one painting … The intervention of a painter in such a case was deemed something of an intrusion; a painter could not be expected to reproduce the model authentically. Only if one was sure that the painter had recorded the actual living model with the accuracy we today tend to attribute to a photograph, as in the case of St Luke or the painter whom the Three Kings brought with them to Bethlehem to portray the Mother and Child, could one verify the authenticity of the results.[22]

At times a miraculous or divine force was supposed to have caused an icon to come into existence on its own, using no human agency at all. Belting explains that these kinds of icons tend to be found within various cultures with traditions of sacred images said to have fallen from the sky, etc.[23] Such cult images (and after them, icons) were described as *acheiropoeitic*, i.e. not made by an artist's hand. They were simply 'found' as miracles of representation or of presence, as it were.[24] Acheiropoeitic images were provided by God and hence were exceptions to the ban on images in the Second Commandment.

We can all no doubt think of other examples of images with a similar acheiropoeitic origin, such as the Turin Shroud or the famous Mandylion of Christ. Another example is the image of the Virgin of Guadalupe now venerated at a shrine in Mexico City. News coverage of the Pope's visit to Latin America in July

2002 prompted considerable discussion of the newly canonized Indian saint Juan Diego's miraculous encounters with the Virgin of Guadalupe in 1531—an encounter he proved to the Church bishop by revealing the image she miraculously imprinted upon his *tilma* or cape.[25] Interestingly, numerous Baroque Spanish paintings in Mexico represented this event by showing God as a painter illustrating the Virgin with a brush on cloth while Jesus sits and watches approvingly.[26] Other examples of acheiropoeitic images are more mundane and controversial but still frequent, such as the image of Jesus on a tortilla or in driveway oil stains, or, as happened recently in Houston, on a metal cookie sheet in a high school cafeteria.[27]

The fourth primary feature of icons seems paradoxical, given the beliefs summarized just above about an icon's special causal origin, but icons have also often been held to be *reproducible* in ways that transmit their authenticity and miraculous powers. In one example from 1569, numerous copies were made of an icon of the Virgin and sent all over to castles and monasteries; novices were required to pray before the copy.[28] Such reproduction is often mechanical. Thus, images were authentically reproduced by making impressions of them. And indeed, some of the images were attributed with this power themselves; i.e. they were held to have the ability to transmit copies of themselves onto fabric.[29] Maynard comments, 'there are legends of spontaneous occult editions of *acheiropoeitai*, and a history of mechanical, contact editions, by means which Kitzinger calls "curiously prophetic of methods used in photography." '[30] Even if artists were hired and employed to make the copies, the power to transmit the approved image and its miraculous abilities was attributed to the image itself (or to its prototype figure), not to the artist, who prayed to allow higher forces to operate through him.

To sum up, an icon as an image or likeness is unique because of (a) its subject matter, (b) the beliefs and attitudes it inspires in viewers, (c) its causal origin, and, finally, (d) its reproducibility. First, the icon is a likeness in the sense not of resembling but of being a manifestation or appearance of its prototype. I call this the icon's 'authentic manifestation' aspect. Second, the icon reminds viewers of its prototype, eliciting feelings appropriate to that prototype. This is the icon's 'special treatment' aspect. It serves as an aid to contemplation and a link to a higher, transcendent reality. Third, the icon has been caused to come into existence through the intentions or agency of its prototype. I call this its 'causal history' aspect. Fourth and finally, the image in the icon is reproducible: its copies transmit its other powers and similarly manifest the prototype.

Portraits as Icons

My survey of icons will help us understand certain aspects of portraits and their relationship to persons. Some portraits, like icons, seem special because they are 'authentic'. They directly show us a person or provide contact with that person. The person does not need to be holy or divine, although traditionally portraits were often made only of the very powerful, wealthy, or famous. For us, it is enough that it is someone who matters to us—like my grandmother to me and Barthes's mother to him. In the case of those special portraits or photographs that reveal someone's 'air', this conviction has to do with the similarity of function between the portrait and the traditional icon.

Consider for example the image of Abraham Lincoln that Walton discusses with the claim that in it we can 'see' Lincoln

directly. Lincoln's photograph appears to fulfill the same four conditions that I have just described as applying to icons. First, the image seems to *manifest* Lincoln or make him present. Numerous testimonies from early viewers of photography reveal how these images were taken to guarantee authenticity and reveal presence. Elizabeth Barrett put the point in this way:

> It is not merely the likeness which is precious in such cases—but the association, and the sense of nearness involved in the thing... the fact of the *very shadow of the person* lying there fixed forever! It is the very sanctification of portraits I think—and...I would rather have such a memorial of one I dearly loved, than the noblest Artist's work ever produced.[31]

Second, the image of Lincoln, like the portraits Barrett describes, evokes special feelings and behavior in viewers. They command a kind of respect and awe. Walton expresses this point in a more recent article that revisits his transparency thesis:

> We value the experience of seeing the loved one (even indirectly), the experience of being in perceptual contact with him or her, for its own sake, not just as a means of adding to our knowledge.[32]

The Winter Garden photograph that captured the 'air' of Barthes's mother satisfies a great longing he had to find her after her death.

Third, photographs are often taken to be 'acheiropoeitic' in some sense typically explained by their mechanical causation. Walton writes, for example, that 'Lincoln...caused his photograph, and thus the visual experiences of those who view it.'[33] Sometimes this point is expressed by comments on the apparent 'magical' nature of photographs. The fourth condition, multiple reproducibility, also applies in the case of photographs. Indeed,

it is more than likely that what Walton is looking at when he speaks of looking at a photograph of Lincoln is not an original by, for example, Matthew Brady, but a reproduction of a photograph.

But do these same points hold true, as I wish to maintain, for portraits done in other media besides photography? My answer is that they apply to varying degrees (particularly the fourth condition). But the important point is that the central ideas that explain the function of icons—manifestation, authenticity, special emotional response, and contact—also hold true of portraits. To support this claim I will next survey examples of various kinds of portraits.

Ancient Art

In ancient Greek art there were some sculptures that depicted idealized figures, youths, maidens, gods, etc., but there were also sculptures that purported to represent distinct individuals. Thus we have, for example, busts showing Socrates with some of his characteristic, famous features, looking satyr-like and unhandsome with his protruding eyes and snub nose.[34] Among the realistic sculptures were friezes on graves that commemorated a person's departed spouse or child. The Greek sculptures of gods, obviously, were not portraits but rather idealizations employing particular sorts of insignia (like Athena's helmet or Poseidon's trident) along with characteristic physical traits. Apollo was handsome with a high forehead and curly hair, Aphrodite was the one female typically shown with bare breasts and a lovely womanly figure, Artemis often had a deer, and Psyche (Cupid) was a young boy with a bow and arrow.

Fig. 2.3 *Young Woman*, unknown date (AD 41–54), showing the increasing naturalism of Roman sculpture.

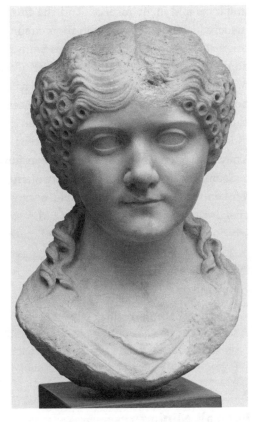

Roman sculpture became more realistic but even so it still 'sought for the general within the particular'.[35] Because of its greater naturalism, we can learn now from ancient images of Roman women[36] facts about how they dressed or trends in hairstyle, for example.[37] Portraits often, then as now, marked a significant transitional stage in life, such as marriage or death.[38] Roman sculptures of emperors and dignitaries were often displayed in public locations where the image could inspire

imitation and incur respect. And the images of emperors were made widely familiar through their circulation in the coinage of the realm. But in Rome, sculptures were also quite important in domestic settings. 'Family life was literally lived in the presence of ancestors, whose images were displayed in those parts of the house most frequented by guests and others dependent upon the patronage of the head of the household.'[39] Like photographs today, the images of ancestors preserved contact with the past. They also often served a special role at funerals.

Sculptural images of the dead were often treated in special ways. We can read accounts, for example, of how the Romans carried a gilded image of Faustina into the theatre to be placed in the location where she used to sit. Sometimes the portraits were also petitioned as if they were still living beings. Again this is a function that renders them very much like icons in later times. West comments,

> Ironically, because of their apparent vivification of the represented person, portraits had an inexorable relationship with death. A portrait could bring the dead back to life and appear to provide both a trace of a body and a stimulus to memory.[40]

Portrait Miniatures

In addition to the sorts of marble and stone portrait busts or coins that many of us are familiar with from the ancient Romans, many kinds of portraits were also carved in gemstones and mounted in brooches or rings.[41] These cameo portraits involved advanced and complicated forms of intaglio done on an amazingly small scale. They had the advantage of portability as well as beauty and, accordingly, served as adornments worn in jewelry

or on clothing and were given as gifts. Cameos date back to Alexandria in the fifth century BC and included scenes from mythology as well as portraits. The stones themselves—amethyst, citrine, sardonyx, agate, shell—were also often regarded as having magical powers, which would presumably enhance the connections with the depicted person.[42]

It is not a great leap to connect such intaglio portraits to the sorts of portrait miniatures that became popular in the early modern period. These originated in the French and English courts of François I and Henry VIII in the mid-1520s.[43] As with cameos, miniatures were often mounted in lockets that were treasured gifts and meant to be worn on the body. A royal personage might distribute such items to his or her loyal followers. Scholars explain their derivation as stemming from varied pictorial traditions, including manuscript illustrations and commemorative medals.

One of the most famous and successful painters of miniature portraits was Nicholas Hilliard in England, who was trained a goldsmith. He claimed to have studied with Holbein, though this claim is considered doubtful. Portrait miniatures were done on and in various materials and mediums. Many such portraits were done on vellum, while some others were in watercolor on ivory. Hilliard tended to idealization in his images, but other artists such as Samuel Cooper were known for a greater realism. He was said to have done a miniature portrait of Cromwell with 'warts pimples and everything'.

The practice of wearing miniatures on the body continued throughout the seventeenth century, with particular popularity in Britain after 1760. In this period one of the successful artists was Richard Cosway, who specialized in the romantic miniatures that lovers gave one another. Such portraits became

'immensely fashionable'.[44] Cosway worked closely with jewelers and goldsmiths; his miniatures were often framed in gold and could include plaits of hair and be surrounded by diamonds or pearls. It is easy to understand how such precious objects, worn constantly about the body, would sustain claims of contact by guaranteeing authenticity and inspiring veneration.

Like ancient portraits in Greece and Rome, the portrait miniature also functioned within rituals of grief and mourning. These images might, for example, show a woman grieving near a broken obelisk. An example of a mourning portrait made in South Carolina showed a young woman, aged 17, named Harriet Mackie, as a 'Dead Bride'. Like many other similar portraits, it was preserved in a locket that also included hair from the deceased.[45]

A vastly popular and proliferating medium, the portrait miniature met a sudden eclipse when new processes of portraying persons came along. After the daguerreotype and other versions came to dominate the global market, 'The three-hundred-year-old tradition of the painted portrait miniature went into a terminal decline almost immediately.'[46]

Silhouettes

Silhouettes were another popular form of portraiture during the late 1700s and early 1800s. Initially these 'shade portraits' were done by hand and were cut out from black paper, then mounted on a white background. Realism was highly sought after, and the method to achieve it was the straightforward technique of tracing the shadow cast upon a wall by a person's face bathed in lamplight. We can see why such an image might appear

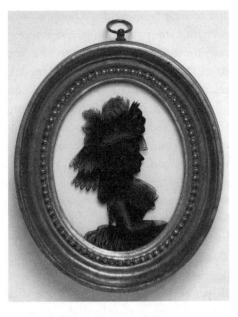

Fig. 2.4 *Portrait of an Unknown Woman* (*c*.1793–4), illustrating a silhouette in miniature format.

acheiropoeitic given that the hand only transcribes a reality that is already 'given'.

In an article about this fad, Wendy Bellion describes the growth of the silhouette as deriving in part from the invention of a new mechanical device, the 'physiognotrace', which was capable of recording a person's profile very quickly and cheaply.[47] She comments, 'The popularity of this method cannot be overemphasized: the proprietor of one physiognotrace capitalized on what he called the "rage for profiles" by making over 8,000 silhouettes in just one year.' The device, which had been invented in France in 1783–4 by Gilles-Louis Chrétien, appeared in the USA by the 1790s. By using it, an artist or even an amateur who was trained in the technique could create a realistic likeness

and from it print engraved copies which were quite affordable. As with earlier silhouettes, the resulting images were white cut-outs mounted on black paper—the paper then showed through to create the outline of the profile. Bellion comments that, 'The resulting images illusionistically appeared solid: these flat, hollow heads seem to project forward into the viewer's space, like shadows emerging from vacuous, white fields.' A profile done in this way would cost something like a mere 6 cents in comparison to the $50 required for an oil painting.

Another important reason for the popularity of silhouettes was wide acceptance of the theory of physiognomy proposed by the Swiss scientist/minister Johan Casper Lavater. I will have much more to say about Lavater's theory in Chapter 4 below. To summarize briefly, it was an account of human beings' individual natures that supposedly could be explained in terms of the shapes of their skulls. Not surprisingly, Lavater felt that mechanical approach to recording head shapes was preferable since it provided images that were more accurate and realistic than anything that a painter could create. His best-selling book *Essays on Physiognomy* (1794) included numerous illustrations, many of which were silhouettes. In support of this he made the following comment:

'Shades,' he argued, offered 'the truest representation that can be given of man' and the most 'immediate expression of nature, such as not the ablest painter is capable of drawing by hand. What can be less the image of a living man than a shade? Yet how full of speech! Little gold, but the purest.'[48]

The practitioners of silhouette portraiture also argued that they produced more veristic images than painters. One of them, Edmé Quenedey, was very outspoken about this and claimed the following:

> The two minutes, at the most, that I employ for drawing the overall shape is not enough time for the model's physiognomy to change. From this comes the great truthfulness that one sees in all the portraits made with the *Physionotrace* and which astonishes the most skillful artists. They compare these portraits to those which have been cast from life.[49]

Other practitioners used similar terms, referring to their silhouettes in phrases that clearly indicated belief in their superior realism, such as 'index' and 'stamp'. This sort of approach also accorded nicely with contemporary aesthetic theories like those of Winckelmann that favored the role of line in art over color.

Although silhouettes could be framed and displayed on the wall or over the mantel in a private home, they were also often mounted in portable forms and exchanged, perhaps to be added to the collections of *cartes de visites* of one's friends or relatives. The engraved images resembled in size and scale portrait miniatures and were presented in similar formats such as in lockets, brooches, or snuff boxes, where such items were often mounted with valuable gems such as pearls or in settings that included locks of hair.[50]

Daguerreotypes

In the form in which they first became well known, photographic images were daguerreotypes—images made using cameras and photographic processes, but with results chemically fixed upon metal plates rather than on coated papers. Daguerreotype results in a unique image that is not susceptible to multiple reproduction (which is partly why it came to be replaced).

Such images combine aspects of both positive and negative in one, since they must be tilted and held to the light 'just so' in order for the image to appear. These tidy portable objects were typically framed in a gold-toned metal setting, padded with red velvet, and enclosed in protective leather cases. Treasured as precious items evocative of loved ones or lost family members, they achieved widespread popularity in the United States at around the time of the Civil War. It was the first historical cataclysm to be recorded in this new medium. Soldiers visited artists' studios where their likenesses were solemnly recorded and sent home to loved ones to treasure during an absence. And in turn, the soldiers' specially preserved images of wives, fiancées, or mothers were cherished, sometimes only to be found with their belongings after death. (My family history includes one such example, a tintype sent by my great-great-grandfather William Mallonee to his sweetheart, whom he later married.) Such poignant revelations are a common trope of the war literature and film genres. A fictional example of photographs exchanged between young lovers grounds the entire story of the best-seller *Cold Mountain*, sustaining the two main characters throughout their respective tribulations.

To understand the seemingly irrational behavior of someone like the hero soldier of *Cold Mountain*, talking to the daguerreotyped image of his beloved while mired in the muck of Mississippi swamps, it is important to grasp how magical such objects seemed. Alan Trachtenberg has written about daguerreotypes,

> No one who has not felt himself or herself spellbound by a daguerreotype portrait, drawn magnetically to the image and beyond, as if it were less an image or likeness than the thing itself,

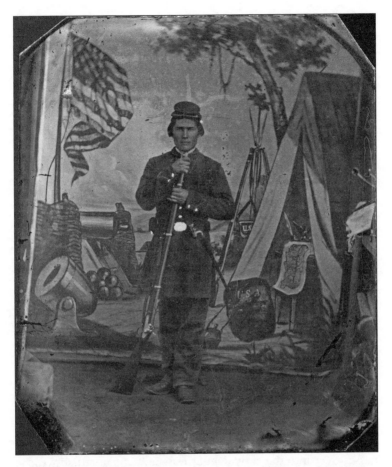

Fig. 2.5 William Mallonee, the author's great-great grandfather in a tintype sent to his sweetheart while he served in the Union Army during the US Civil War.

the very identity of the sitter miniaturised and suspended in an ambiguously monochromatic float or medium, can speak knowingly about this mode of photography. Only those who know by experience the sensation of succumbing to the charm of these

objects can begin to understand what these objectified likenesses might have meant to their makers and possessors in the past, or the functions they performed within households and between persons, or their hold on the emotions and their influence on consciousness.[51]

Similarly, Anthony Minghella, director of the film version of *Cold Mountain*, has explained his thoughts on the use of these images as a key device:

One of the things about the daguerreotype and the tintype is that they are distorted in the sense that the image does not absolutely capture reality—it's mediated by the chemistry of those photographs, and so it inflects the image in a very particular way. Eyes become incandescent, and the high contrast of the pictures, together with the fact that their focus and exposure is so imprecise, means that they contain the signature of the photographer in a much clearer way than modern photographs indicate. There's a more transparent indication of a mediated moment in those images than there is in modern photography, and there's also access to the look of that war, which was the first visually documented conflict.[52]

Of course, daguerreotypes were readily suited to widespread public use since they resembled other familiar forms of portraiture. John Tagg[53] tells us, 'The aura of the precious miniature passes over into the early daguerreotype.'[54] As noted above, the new processes made such imagery more affordable and more broadly available to the general public. Photography caught on very quickly, enabling many more people to acquire depictions of themselves than had ever before been possible. Tagg describes as an example the shift in Marseilles from around 1850, when four or five miniaturists worked in the city, to later when there

were 40–50 photographers working there, 'each producing an average 1,200 plates a year ... By 1853, three million daguerreotypes were being made annually and there were eighty-six portrait galleries in New York City alone ... '[55]

Portraiture of Death

The phrase 'depictions of the dead' is ambiguous. It might allude to images of people, taken when they were still alive, but who are now dead—like the images I described above of my grandmother or of Barthes's mother. We are all familiar with such images now. There are many very striking daguerreotypes on gravestones of children. This practice continues even now with the use of photographs or photo-etching processes.[56] Typically such images preserve the look of the dead person in his or her prime, although sometimes more than one portrait is included, as if to indicate several stages of the deceased person's life. In many cases couples are shown (even if only one is dead), as if to herald their future reunion in the afterlife.

An ongoing relationship might also be signaled by the common practice of leaving offerings at the tomb site including not only flowers but small notes, *ex votos*, etc. In the annual Mexican *Dia de los Muertos* remembrances, photographs of the dead are taken to cemeteries where they are surrounded by candles, flowers, food, and other favorite items of the deceased.

The second sense in which we can speak of 'images of the dead' alludes to images that depict people who are actually dead. Such representations are likely to strike modern readers as macabre, but they were quite common in the nineteenth century.

In her anthology *Looking at Death*, Barbara P. Norfleet has collected many examples from both Europe and the United States. An explanation of sorts is offered by George Santayana in 'The Photograph and the Mental Image':

> Photography was first employed in portraiture; that is, it was employed to preserve those mental images which we most dislike to lose, the images of familiar faces...photography came as a welcome salve to keep those precious, if slightly ridiculous, things a little longer in the world. It consoled both our sorrows and our vanity, and we collected photographs like little relics and mementoes of the surfaces of our past life.[57]

Norfleet tells us that it was actually a very common early use of the daguerreotype to mark and in some sense 'preserve' the dead body of a lost child or loved one. Sometimes the children were posed as if asleep, but at other times, as if still alive.[58] This was less strange then than now in part because the use of such imagery was relatively rare. Today we are inundated with imagery and friends proudly show off their baby's first picture in the form of an ultrasound. Every day after that gets somehow visually recorded. But this was not true in the 1800s, nor even up until the Second World War, Norfleet remarks. Photographs regularly showed bodies that were dead from illness, accidents, and murders, often quite ghoulishly, riddled with bullets or disfigured by disease. There were photographs of skeletons, mummies, beheaded criminals, and massacre victims. But the most moving from among these images are the ones that were the most intimate because they represented a person who was loved and mourned. These images might be reproduced and circulated on the popular *cartes de visites* of the time. In particular, dead babies or young children were depicted, sometimes

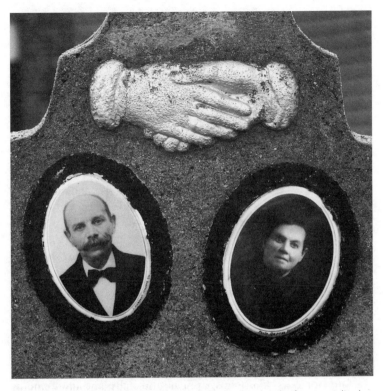

Fig. 2.6 *Tomb in a cemetery in Wallonia, Belgium; husband and wife memorialized on their gravestone.*

posed as though still alive and only sleeping, sometimes even cradled in their mother's arms.

From a surprisingly early date, also, processes were developed to enable photographs to be recorded more or less permanently encased on tombstone. John Matturri reports,

As early as 1851, Solomon Tomkins of West Cambridge, Massa-chusetts had obtained a patent for 'securing daguerreotypes to monumental stones' and in 1855, the Scoville Manufacturing

Company of New York, which three years earlier had offered a daguerreotype case specifically designed for memorial pieces was distributing a catalog for 'Monumental Daguerreotype Cases'.[59]

Technology advances, and to keep up with its advances we have ever-newer ways of preserving our lost loved ones and maintaining a sense of contact with them. It is even possible to find special arrangements in cemeteries to preserve and replay memories of a lost one's life through DVDs.

Summary and Conclusion

In this chapter I have distinguished two primary functions of portraits: a depictive or representational function and a manifestation function. My focus has been on the former function. As was true for Barthes in treasuring the Winter Garden photograph of his mother, and for my own family in viewing photos of my grandmother, images of people are valued because of their power to provide continuing proofs of presence, a quasi-immortality. Certain portraits, like icons, appear unusually authentic and as such they are treated in special ways. In some periods and cultures they are venerated at ceremonies honoring ancestors, and in other times they are carried about on someone's body as a form of precious personal ornamentation. Such images, again like icons, can seem to possess magical properties, appearing to coalesce almost of themselves, perhaps by a divine intervention or perhaps by direct contact with a person through the use of masks, shadows, or chemical and mechanical operations. The most important point is that since antiquity, portraits have been valued because they facilitate contact with important persons

who are lost to us. In the next two chapters I will explore the other primary function of portraits, depiction. The subject will shift, focusing less on the psychological value of portraits than their informational value. This examination begins in Chapter 3, where I will discuss how portrait artists have managed to capture aspects of the external appearance of the persons they depicted. Then in Chapter 4 I will look at developments in artists' efforts to provide more expressive indicators of the psychological characteristics and emotional qualities of their living subjects.

Individuality

Introduction

In the previous chapters I have listed three key things needed for portraits: (1) a recognizable physical body along with (2) an inner life (i.e. some sort of character and/or psychological or mental states), and (3) the ability to pose or to present oneself to be depicted in a representation. I have also argued that portraits can fulfill four important functions. They provide likenesses, psychological characterizations, proofs of presence or 'contact', and manifestations of a person's 'essence' or 'air'. I borrowed this last idea of a person's unique individuality or their 'air' from Roland Barthes, who described it as 'the expression, the look', 'that exorbitant thing which induces from body to soul'.

My account of what a portrait is and can do might not have been accepted during previous periods of history. In earlier times, the nature of the individuals shown in portraits was often subordinated to their role and place in life. For example, the lords and ladies or kings and queens of Elizabethan portraits appear unnatural and stiff. There is little emphasis on

psychological characterization in such images, nor do we find many revealing indications of personality or 'air'. Yet one hesitates to say that the people themselves were truly that different in the past—that they lacked personality or psychological traits. Obviously, it is standards and expectations of portraiture that have changed.

Consider two portraits of queens that illustrate my point about the pre-eminence of the role over the individual person in early portraiture: the *Armada Portrait* of Queen Elizabeth I of England (*c.*1588), perhaps by George Gower (see Plate 3), and the *Portrait of the Xiaosheng Empress Dowager* (1751), by anonymous court artists in China (see Plate 4). Despite noteworthy differences in style, culture, time period, and medium (the Empress's portrait is done on a silk scroll), the portraits manifest surprising similarities. Each depicts the imperial woman as wealthy and powerful, with a stately bearing that holds up even to requirements of an unnaturally stiff pose. In each portrait, the artist has devoted lavish attention to details of their beautiful dress, headpieces, and setting.[1] Each woman is bedecked with large, expensive pearls. But their faces are still and expressionless, marionette-like. Queen Elizabeth looks slightly off to the left as if preoccupied with matters of international importance, an interpretation supported by the inclusion of two background maritime scenes with ships (one at the left sunny, the other stormy, reminding viewers of the recent success of the English navy against the Spanish invaders). She has one hand on a globe, indicating her command of a large region of Europe, while at her other side sits her crown. By comparison, the Empress's hands and feet are not shown, but decorously covered in her long robes, and the background is empty, as if it transcends normal time and space. Although the portrait of

Elizabeth is centuries earlier, it employs a few more naturalistic techniques, such as the shadow of the Queen's right hand over the globe.

Richard Brilliant comments in his book *Portraiture* that paintings like these were not meant as depictions of any internal nature or personality. 'For Queen Elizabeth, the masque (or mask) is all. No other access to her exists ... Recognition of her comes through externals, while her face, almost insignificant in the visual field, appears as a reductive, nearly impersonal sign ... '[2] In each case, instead, the artist employs key symbolic associations that would have been understood by the intended audience. The Chinese empress wears the yellow robes decorated with five-clawed dragons, a color and design detail reserved for royalty.

Portraiture evolved significantly in the period from the late Renaissance to early modern times, acquiring an increased emphasis on realism together with greater interest in rendering the sitter's inner psychological states. Two of the earliest, most brilliant and profoundly influential artists of portrait painting, who contributed to this shift, were Hans Holbein (1497–1543), court painter to Henry VIII in England, and Titian (Tiziano Vecellio), court painter to Philip II of Spain. They helped provide the art form of portraiture with an impetus toward insightful study of persons and their inner lives. In their works we can notice a very strong sense of the artist's attention to the individual character of the person being depicted.

Ernst Gombrich writes, for example, about Holbein's portrait of Sir Richard Southwell (1536),

> In his earlier portraits he had still sought to display his wonderful skill in the rendering of details, to characterize a sitter through his

setting, through the things among which he spent his life. The older he grew and the more mature his art became, the less did he seem in need of any such tricks. He did not want to obtrude himself and to divert attention from the sitter. And it is precisely for this masterly restraint that we admire him most.[3]

Or again, in Holbein's portraits of Erasmus we can see evidence of the man's scholarly nature and devotion to the life of ideas. The artist had first met Erasmus in Basel and did numerous portraits of him; Erasmus was crucial in introducing him to England where Holbein spent most of his career after 1532 and acquired many important commissions. His paintings of Henry VIII and several of his wives—Anne of Cleves (1539) and Jane Seymour (1537), and of the young heir Edward VI as a child (1538) are more formal and stiff, less psychologically revealing than the pictures of his friend Erasmus. Erasmus is shown in several of the paintings in profile or three-quarters profile. His face is very detailed, so that we can inspect his features: a rather large nose, cleft chin with gray stubble, and locks of gray hair emerging from under his black cap. His clothes are rich, with a fur collar and velvet sleeves, but simple and undecorated. One frontal image shows his piercing but not unkind dark eyes; in another, he looks down to the pages of a book where he is writing something. His graceful hands are adorned with some simple rings. Erasmus looks like a serious, thoughtful, and kind individual in these images, someone who readily corresponds to our mental image of the great humanist author he was.

There are similar psychological insights in the many portraits done by Titian. In his painting of the Doge Andrea Gritti (1544–5), for example, the sitter looks stern and strong, with a lean elegant face and the white beard of a venerable elder. He glances

to the side as if about to address some important matter, eyes focused intently, his right hand drawing his cape up to him, jaw held firmly though not stubbornly. By comparison, Titian's Frederico II Gonzaga, Duke of Mantua, exhibits greater gentleness combined with an inner strength. Frederico gazes directly out at us with his right hand spread to caress the curls of a small spaniel which extends a paw, seeking his master's attention.

These artists' paintings, like the earlier but stiffer portraits of Queen Elizabeth and the Chinese Dowager Empress, depict people who were prominent rulers or aristocrats and who were clearly posing for an official record of themselves, wearing their most elegant clothes. The painters were well paid and the commissions to do such portraits would have been very significant, as indicated by the fact that many of the paintings are quite large—a number are full- or half-length. Despite such similarities, however, these artists clearly break new ground. Holbein and Titian succeed in differentiating individuals and conveying aspects of their characters.

Obviously something significant was happening in the early Renaissance when artists in both southern and northern Europe began to paint portraits of individuals with a new emphasis on realism and psychological characterization. The art of portraiture evolved along with social and economic structures permitting more people to become able to commission portraits. Such works also underwent changes in social uses as there was increased demand for depictions of people as members of groups and guilds, for marriage and family portraits, etc. This sequence of changes involved several major transitions from medieval and late Gothic depictions of individuals which had primarily featured saints, biblical characters, or figures from classical mythology. Portraits of individuals first emerged as a genre in their

own right with donor portraits, which initially were included as less significant parts of religious paintings. The donors were often positioned to one side or on exterior panels, sometimes shown in a smaller scale or not in full color. Donor portraits began to figure prominently in works by van der Weyden in the north (for example, he showed Saint John the Baptist with the donor Heinrich von Werl in the left wing of a triptych, the *Werl Altarpiece*, *c*.1434–8), and also by Hans Memling. In Italy, such works included paintings by Andrea Mantegna, as with his *Gonzaga Family*, 1474. The *Procession of the Magi* by Benozzo Gozzoli (1459–61) included numerous portraits of members of the de Medici family. These sorts of images gradually grew in both size and significance until they acquired independence.

The period of Baroque Art following the early Renaissance, beginning around 1600, saw even more contributions by great portrait artists such as Caravaggio, Bernini, the Carracci, Rubens, Rembrandt, Vermeer, and Velázquez. Erwin Panofsky, in his 1934 essay, 'What Is Baroque?', wrote about the psychology of the more modern individuals of the Baroque period as follows:

> They not only feel, but are also aware of their own feelings. While their hearts are quivering with emotion, their consciousness stands aloof and 'knows'...The experience of so many conflicts and dualisms between emotion and reflection, lust and pain, devoutness and voluptuousness has led to a kind of awakening and thus endowed the European mind with a new consciousness.[4]

In this chapter I will examine the rise of portraiture as a distinct art form, with the goal of considering how this genre evolved in tandem with changing views of the person and the self.

What is a Person?

Since my chief concern in this book is with how portraits can depict the nature of persons, I want to focus here on what differing kinds of portraits indicate about the self and the nature of a person. As I suggested just above, it seems implausible to think that people and human nature have themselves changed significantly over time in the few centuries since the Renaissance. The sort of scientifically grounded approach I favor is based on a biological analysis of human nature which would imply skepticism about any broad relativist claims that persons *themselves* have changed in just a few centuries' time. From the standpoint of evolutionary psychology, human nature has not changed much in millennia and can be regarded as, in effect, staying constant across cultures and time periods, despite the fact that humans' own *ideas* about what it is to be a person may vary from culture to culture or over the centuries. Some of the key issues that I want to explore concern not so much these big debates between relativists and universalists, however, but rather the question of how visual works can reveal things about persons, including aspects of their inner lives and even about a person's true inner self or 'air'. Portraits do reflect the many changes in religion, science, and, not coincidentally, in philosophical thought about what is it to be a person.

Of course philosophers, like psychologists and specialists in many other academic disciplines, have had much to say about the self, both in particular and in abstraction. Recent years have seen a surprising proliferation of big philosophical books about the self, many tending toward a historicizing outlook. That is, their authors lean toward a relativist stance by assuming that conceptions of the self have changed fairly dramatically over

time in response to multiple circumstances—political, social, religious, and economic. Among these recent books are Jerrold Seigel's *The Idea of the Self* (2005); Richard Sorabji's *Self: Ancient and Modern Insights about Individuality, Life, and Death* (2006); Charles Taylor's *Sources of the Self: The Making of Modern Identity* (1989); and Raymond Martin and John Barresi's *The Rise and Fall of Soul and Self* (2006).[5] If we include books with a greater focus on the self in relation to ethical issues, we might also cite Marya Schechtman's *The Constitution of Selves* (1996) and David Velleman's *Self to Self* (2006).[6]

Unfortunately, few of these works pay attention to visual art as providing any sort of source material for their theorizing, something I find rather odd in light of the fact that they often do cite literary texts. Why should novelists or poets and not visual artists be regarded as contributing insights into the nature of the person? In this section I want to develop a framework derived from these various books that will enable us to begin exploring connections between accounts of the self and developments in portraiture in art, especially in the modern period. Some of the main points to consider are the new emphasis on self-reflection and self-consciousness; the emerging focus on the nature of the mind in its relationship to a newly conceptualized body; and a growing interest in how the individual self is shaped in interactions and relations with others. Here I am roughly following the schema suggested by Jerrold Seigel in his book *The Idea of the Self*. Seigel argues that there are three main dimensions in thought about the self in modern Europe: the *bodily* or *material*, the *reflective*, and the *relational*.[7] The *bodily* nature of the self involves its existence as a physical entity with particular sorts of needs and vulnerabilities, and a specific external appearance. The *reflective* aspect of the self involves its nature

as a being endowed with consciousness, capable of assessing and forming itself, shaping actions, etc. The *relational* aspect of the self involves truths about the person's membership in groups that impart values and roles. In sections of this chapter below I will be taking up each of these three aspects of the self in turn.

Seigel neglects one further important dimension of philosophical thought about the self in the modern period—the strand that focuses on the self as a center of moral agency. Perhaps it is more accurate to say that he subsumes it under his notion of the reflective self, whereas I prefer to address it separately. This important strand in modern thought about the self has been given more emphasis by Charles Taylor, as well as in the books I mentioned by Schechtman and Velleman. I will take up this topic, the moral self, toward the conclusion of this chapter, treating it as a fourth aspect of thought about the person.

In all of these dimensions, conceptions of persons and the self changed in relation to developments occurring in religion and science. Such developments, rather obviously, had an impact on general intellectual views about the nature of a person's inner life (mind or soul), as well as upon considerations of human bodily existence and the nature of a person's external or physical self. The developments in science and religion were equally significant in influencing thoughts about the person as a moral entity. Determinist or atheistic cosmologies, for example, challenged traditional religious conceptions of a person's moral freedom and responsibility for choices. To discuss the moral self will lead us into other newly developing fields such as sociology, psychology, ethnography, and medicine. Many such fields contributed to new scientific (or quasi-scientific) modes of classifying persons. Often these involved taxonomies of physical appearance that allegedly reflected aspects of normalcy, criminality, or disease. Such factors

were typically associated with aspects of race, ethnicity, gender, and social class. Portraiture, not surprisingly, reflected these developments in ways that I shall have more to say about below.

Philosophical debates and theories about the nature of the self are relevant to portraiture because we can see signs of their influence in the visual evidence of how painters depicted persons. And of course, various notions about how to understand the self affected not only intellectual opinions of artists, but also of influential people who were able to afford to pay those artists to create their portraits. In other words, contemporary views about the person, virtue, personality traits, and so on, would surely have an effect on how people who commissioned portraits thought about what was needed in order to pose and create a successful presentation of themselves to others.

It is easy to see that the external or bodily aspects of persons were significant and had to be addressed by painters who sought to achieve a kind of likeness in rendering the body, face, and general comportment of their subjects. But rendering the reflective, relational, and moral aspects of subjects has always been more of a challenge. Though I shall have something to say about these latter dimensions of the self here, issues concerning reflection and relationship will continue to be topics in my next three chapters. Chapter 4 will examine the views formulated by philosophers, painters, anatomists, and others about the nature of emotional expression and how it ought to be captured in art. Chapter 5 will look at self-portraits as a way of examining how artists sought to convey aspects of *their own* inner lives and psychological identity over time. And in Chapter 6 I will probe the relational aspects of persons by studying artists' portrayals of the people with whom they were the most intimate: lovers, spouses, parents, and children.

In this chapter, I will lay the groundwork for these later studies, by providing a broad introduction to the four fundamental dimensions of personhood identified above—bodily, reflective, relational, and moral. In the course of surveying evolving views of the self in modern thought, I will discuss examples of portraits that show things about each of these four dimensions of the self.

The Bodily Self: External Appearances

One very important development in thought about the nature of the person in the early modern period stemmed from the rise of modern science and developments in physical theory, such as atomism and corpuscularian theories of matter. New physical theories challenged not only traditional religious views on how the soul or mind was related to the body but also conceptions of the nature of the body itself. No longer was it something sacred created by a divine being, but something mechanical with working parts that could be dissected, explained, and understood. Despite his adherence to a Christian view about the immortal soul and its distinct essence as thinking substance, Descartes paved the way for mechanistic views of the body in his own account of how mind and body interact through the very fine particles he called 'animal spirits' in the pineal gland at the base of the brain.

Because of advances in the scientific picture of human and animal bodies, new philosophical problems arose about the self and the person. Questions needed to be resolved about the unity of the multiple parts of a single body as well as about a body's temporal continuity over extended periods of a person's

life. The latter was an issue given that a person's atomic bits enter and leave in constant succession and might all be replaced as that person grew and aged. These topics were of the greatest importance to John Locke, who is generally held to have offered the first account of the nature of personal identity in his *Essay on Human Understanding* (1690). In fact, Locke discussed this issue in his chapter titled 'On Identity and Diversity' (2.27), which was a chapter added to the second edition of the book in 1694.

Two important problems concerned Locke in particular: whether the soul might be material or had to be considered immaterial, and the nature of personal identity over time. Locke argued for our mind's dependence upon the senses for knowledge of the external world, which provided the origins of most of our ideas. He also held that the mind itself was atomistic in the sense that our human consciousness comprises discrete moments occurring in succession (what Charles Taylor labels the 'punctual' self). The problem Locke faced was how to explain the persistence of a person through time despite numerous changes in that person's bodily constitution and consciousness. Locke could not fall back on the unity of a Cartesian soul given that he saw the conscious self as something also extended in time with numerous changes in its own occurrent, evanescent experiences. He was among the first to imagine thought-experiments about the possible transfer of one person's mind into another person's body, wondering what the resulting metaphysical analysis ought to say about that person's identity. Such thought experiments continue to occupy philosophers today as they speculate about the identity of, say, Hilary Putnam's famous 'brain in a vat', or about science-fiction-like but still not altogether fanciful possibilities of brain transplantation, human cloning, etc. In cases like

these, just as in Locke's intellectual milieu, scientific advances drive the need for philosophical reflection.[8]

Locke's answer to questions about personal identity was to maintain that human consciousness, in particular a person's memory of the past, links moments of a human being's experience together across time so as to constitute the unity of a self. Since the self is unified through consciousness; what a self is or amounts to is just what a person calls himself.[9] Locke differentiates the terms 'self' and 'person'. He writes, 'As far as this consciousness can be extended backward to any past action or thought, so far reaches the identity of that *person*: it is the same *self* now as it was then'.[10] Memory of the past is complemented by concern for the future—of the soul and also of the body and its parts, as Locke explains in sections 2.27.26 and 2.27.17–18 of his *Essay*. Locke's terminology allows that, for example, a *person* with a damaged memory through illness or traumatic injury might remain the same, i.e. a woman might remain the same physical person without being the same *self*, if all of her awareness and memory of past experiences has disappeared.

Shearer West in her book *Portraiture* acknowledges the importance of seventeenth-century thinkers like Locke in developing our modern conception of identity. She compares this modern notion to an earlier one that was more purely physical: 'Previously identity was seen to be rooted in those external attributes, conveyed through the body, face, and deportment, that distinguished one individual from another.' West notes, even so, that notions of what constitutes a believable or lifelike rendering of a person can vary. As she puts it, 'likeness is not a stable concept. What might be considered a "faithful" reproduction of features relates to aesthetic conventions and social expectations of a particular time and place.'[11]

To demonstrate this point, West compares two portraits of the same man, the donor Chancellor Rolin, by Jan Van Eyck (1433) and Rogier van der Weyden (1445–50). Although these northern Renaissance artists strove for realism and both images present a man of similar appearance, he seems to manifest different expressions and character in the two paintings. In one artist's picture Chancellor Rolin looks more arrogant, in the other, more humble. These shifts might be due partly to the man's greater age in one picture, or to differences of style between the two artists. But West suggests another reason for the difference: 'It is more likely that the different decisions made by these artists could have been inspired by the diverse purposes for which these portraits were produced.'[12] Thus the more self-important rendering in the former was done for the man's son, who was a Bishop, whereas the latter, more humble visage, was appropriate for a portrait that was part of a multi-paneled altarpiece.

West's points would not be surprising to someone familiar with Locke's theoretical account, which places memory at the center of a self's unity over time. Prior to this period, West argues, when sixteenth century images sought to convey something of personality they often did so more through symbols and hints rather than through intimations of some sort of internal emotional life. Among such symbols were elements of the background, props, dress, and pose. West emphasizes that knowledge of deportment was particularly crucial for portrait painters, since aspects of pose and manners were important external signs indicating a sitter's social status and background.[13]

As an example, we can consider Velázquez's portrait *Prince Baltasar Carlos on Horseback* (1634/35) (see Plate 5). Velázquez, who had been appointed Court painter to Philip IV of Spain in

1623, executed numerous paintings of both the King himself and other members of the royal family and household, including of course his later well-known portrayal of the Infanta Margarita in *Las Meninas* (1656). In this painting of Philip's young heir Baltasar Carlos (son of Philip's first wife Isabella), we might see at first only a rather typical treatment of a royal figure by an artist commissioned to create a portrait.[14] The little boy sits atop a rearing horse, looking calm and in control. He is unmistakably the son of his parents, possessing the same long face as his father along with his lantern jaw and pursed red lips. (This family resemblance is equally clear in the artist's paintings of the King's brothers, Don Carlos and Don Fernando.) The image shows the young prince as regal with a stately bearing and wisdom that extends well beyond his actual age, which was probably only around 6 years old at this time.[15] He had been shown in an equally regal pose at an even earlier age in *Prince Baltasar Carlos and a Dwarf* (1631), where he holds the baton of command in his right hand, with his left hand on the hilt of a sword.

Some of what West has in mind by the term 'deportment' can be seen at work here. We should begin by noting the fact that this is a particular kind of painting, an equestrian portrait, reserved for certain individuals with high status and skills acquired through extensive (and expensive) training. The young prince is shown in full control of a rather powerful-looking horse. We can marvel at its girth—scholars tell us the painting was meant to be seen from below, positioned above a doorway in the Hall of the Realms where larger equestrian portraits of his parents would appear on either side.[16] Moreover, the little boy has even coached his mount into the difficult *levade* position, holding up its front feet while crouched on its rear legs.

This pose is discussed in Chapter 1 above; it indicates an exceptional amount of skill and control in both horse and rider. This position was reserved in portraiture of the time only for royalty or very high officials. We might suspect that the artist's depiction of the very young Baltasar Carlos executing such a difficult feat was a fabrication created simply to enhance the image of the future King's dominance and power (a prediction that remained unrealized, since he died at age 17). But in fact it seems that the boy was a quite adept young student in the royal riding school.[17] Harris explains that the young Prince enthusiastically devoted himself to training in mounted sports such as running with a lance at the ring or tilting.

New philosophical reflections on identity can take time to show up more broadly in the artistic and literary works of a culture. Thus the fine distinctions between the unity of the (external or bodily) person and the (internal) or conscious self whose identity is supplied by memory did not show up in any obvious way in visual art in Locke's time. (Rembrandt is the obvious exception of someone who was a very early explorer of the changes and even degradations of the physical self, along with the emotional toll of a person's life, in his own remarkable series of paintings of his own face; I will discuss his self-portraiture in Chapter 5 below.) Of course, the problem of physical continuity over time would not be likely to confront a portrait artist as a significant issue, since portraits depict a person at one particular time of life. This became more of an issue when artists began recording successive versions of their subjects—quite often, of themselves—a topic to which I shall return in Chapter 5 below. A typical response to the ageing of a portrait subject in this time period might be like that of Velázquez, who softened the signs of ageing in his later portraits of King Philip, disguising

his double chin behind a clever collar, for example. In contrast to this, a century later in England Hogarth, writing in his *Analysis of Beauty* (1753), criticized the over-aestheticizing of typical portraits. For him, 'the character of a given individual could be reflected on his or her face, and the changes over time in the human face were not to be discounted'.[18]

This quotation from Hogarth suggests that artists needed time to grapple with the challenge of depicting the role of memory in a person's self-understanding and self-constitution. This is something that a twentieth-century artist like Frida Kahlo would make central in her own multiple works of self-portraiture. But even so, Locke's investigations into the nature of self and the person, raising questions about identity over time, were important. Perhaps the new scientific reflections on the unstable nature of a body's physical identity might have led to worries about capturing a person before he or she could slip away. Along with developments in scientific studies of anatomy and physiology, this might have contributed to an interest in generating more naturalistic depictions, like those Hogarth recommended, of a person's external appearance at a particular time.

To sum up this discussion of physical identity and its role in defining a person, we should remember that conceptions of realism and of physical likenesses vary a good deal, not only according to the norms and expectations of a given period, but also according to artists' abilities and concerns. Portraits adhere to differing standards of naturalism, even in small matters such as whether they include the depiction of shadows or backgrounds. Portraits also differ in their relative degree of emphasis on purely pictorial concerns such as the use of flat decorative patterns or the pursuit of expressive aims. Examples like West's two versions of portraits of Chancellor Rolin might seem to support

skepticism about what constitutes the best or 'truest' rendering of a person's external appearance. However, in her example the primary difference was not in *appearance* but rather in depiction of *character*. The generally operative standards of resemblance during much of the early modern period would only begin to collapse in the twentieth century when standards of realism evolved quite quickly to encompass the divergent goals of the many 'isms' of the century—Impressionism, Cubism, Expressionism, etc.—to the point where images were created that conveyed elements of the sitter's personality without really 'looking like' that person—as, with Picasso's famous portrait of Gertrude Stein.[19] If the 'outside' of a person is up for grabs, then there would obviously be even greater challenges involved in developing methods for portraying a person's internal or conscious life. I turn to that topic next.

The Reflective Self: Meditation and Inner Life

In the early modern period, changes in religious conceptions of the nature of soul and its relation to the body gave rise to new attention to the mind and inner life.[20] Historical accounts typically compare the concept of *self* to older notions of the *soul* deriving from a more purely religious perspective. The early modern period is often thought to be distinguished by its increased emphasis on autonomous reflection or self-awareness, something usually attributed to Descartes and epitomized by his famous *Cogito ergo sum* argument in the *Meditations* (1641). But scholars like Richard Sorabji point out that Descartes's emphasis on self-reflection is not altogether original, since it owes much to the Augustinian Christian tradition of theorizing the soul.[21]

Augustine also emphasized inner reflection, which subsequently became an important part of Christian thinking and, through this, Christian art. Charles Taylor seconds Sorabji's point: 'It is hardly an exaggeration to say that it was Augustine who introduced the inwardness of radical reflexivity and bequeathed it to the Western tradition of thought.'[22] Augustine sought the certainty of God within himself, says Taylor, rather than through logical arguments or proofs (as Aquinas would later, for example). Unfortunately, Taylor says nothing about how this might link to evolving traditions in Christian art.

Another example of this newly concentrated self-awareness in early modern times is Michel de Montaigne, who prefaced his *Essais* (1580–8) by saying, 'I study myself more than any other subject. That is my metaphysics; that is my physics.'[23] Montaigne is sometimes held to have written the first autobiography. Interestingly, he maintained that his aim in that work was to create a *portrait* of himself.[24] Taylor emphasizes Montaigne's importance in theorizing about a new self that differed from the ancient self, which was thought to have a stable and unchanging nature or universal human essence (as held by philosophers like Aristotle).[25] Instead, Montaigne emphasized impermanence and change: 'Montaigne therefore inaugurates a new kind of reflection which is intensely individual, a self-explanation, the aim of which is to reach self-knowledge by coming to see through the screens of self-delusion which passion or spiritual pride have erected.'[26] Taylor sees this viewpoint as representing a strong contrast with that of Descartes, who still adhered to belief in some universal essence. Instead of coming to *know* the self in its inner nature, Montaigne endeavored to *discover* the self as it evolved in actual life, or as it was unfolding. As Taylor puts it, 'Montaigne is an originator of the search for each person's

originality; and this is not just a different quest but in a sense antithetical to the Cartesian.'[27] But Taylor cautions us not to leap from this to an anachronistic reading which forces onto Montaigne developments that would occur only later, after the rise of Romanticism.

A visual equivalent of the reflective searching self of Montaigne might be found in works of some of his contemporary artists like Holbein, Titian, and Dürer. I have already discussed Holbein's numerous portraits of Erasmus in the 1530s.[28] Clearly these follow in the tradition of late medieval depictions of scholar-monks, like some of the paintings of van der Weyden in the 1450s. Dürer's paintings are often said to have inaugurated the genre of self-portraiture as an independent one in art history, and among these his monumental, frontal self-portrait of 1500 would be especially significant. It relies far less on aspects of background and clothing than his previous self-portraits, and prompts greater attention to the artist as a unique individual who is reflecting on his very human essence, even comparing it to that of Christ. On the surface, all of Dürer's self-portraits evince such a superb self-confidence that they appear quite dissimilar in tone to the inquiring, skeptical, and sometimes playful writings of Montaigne. And yet as interpreted by scholars, Dürer's paintings, and especially his 1500 self-portrait, are complex representations of his own humanist self-exploration.[29] He depicted himself in the guise of the Man of Sorrows in order to display not *hubris* but rather, Christian humility; I shall say more about this work below in Chapter 5.

Taylor thinks that our contemporary notions of a highly self-conscious self derive from developments during Romanticism which led to an attitude he calls 'Expressive Individualism'. A new emphasis on the individual's personality and individuality

arose in the Romantic period prompted by thinkers in the tradition following Rousseau. The self is now understood to be defined not simply through self-awareness but through emotional self-searching, as it seeks a life of complete 'self-expression'. Taylor regards the Romantic idea as the first appearance of a picture of the self according to which each person has his or her own original way of being. Johann Gottfried Herder wrote: 'Each human being has his own measure, as it were an accord peculiar to him of all his feelings to each other.'[30] West concurs with Taylor's account; she comments that the idea of conveying something 'about the sitter's psychological state or personality is a concept that evolved gradually and became common only after nineteenth-century Romanticism fuelled the idea of a personality cult'.[31]

Taylor is the one writer from among the recent authors of philosophical works on the self who offers occasional comments about visual art and artists, although they come in only fairly late in his chronology. Thus he discusses the post-impressionists like Cézanne, Gauguin, and Van Gogh, and remarks:

> With the expressionists, for instance, there is no pretence that the figures in the painting could ever look like that in life, however much perception has been shaped by art. There is a self-conscious awareness that what is appearing here isn't to be found reflected through the surface of ordinary things. The epiphany is of something only indirectly available, something the visible object can't say itself but only nudges us towards.[32]

As an example of this highly self-conscious and almost theatrical presentation of the self, we can consider John Singer Sargent's *Portrait of Madame X* (*Madame Pierre Gautreau*, 1883–4) (see Plate 6).[33] Sargent, like Madame Gautreau herself, occupied a

somewhat ambiguous position in French society. Both were Americans who had been accepted in lofty cultural and social circles due to their talents and sensitivities. The woman depicted in Sargent's painting, who was born in New Orleans and married a French banker, was a 'professional beauty', a term designating a woman whose reputation resided not only in her beauty but in her cultivation of it, her daring sense of fashion, and her charm. Madame Gautreau tinted her ears rose-pink and wore lavender powder to emphasize her paleness. She was renowned for her alabaster skin, something that evidently fascinated the artist, who exercised considerable influence through friends to become able to paint her. Her white skin was exaggerated in this painting by contrast with her black satin dress. One specific aspect of the painting that provoked outrage at the time, prompting the painter to withdraw it from the Salon exhibition, was the exceptionally revealing dress. In the original version one of the jeweled shoulder straps had slipped down over her right shoulder, in a quite risqué attitude.[34] But the negative reactions of critics were also occasioned by the deliberately assumed arrogance of Madame Gautreau's pose. She turned her face away from the viewer in a show of indifference while at the same time angling her body to provide for the best full frontal view.

Sargent was a highly successful portrait painter trained in France, who advanced beyond Academic style but was still traditional enough to win many important commissions. After fleeing France in the wake of the scandal over the Madame X portrait, he nevertheless did very well for himself and flourished in England. His portraits were sometimes seen as rather eccentric in his choice of point of view and fondness for vivid colors. His paintings were sumptuous and grand, as he followed deliberately in the traditions of van Dyck and Gainsborough creating

full-size, large portraits of prominent men and beautiful, socially important women (this portrait, for example, is nearly seven feet tall and might thus seem to dwarf or intimidate the viewer).

Although Madame X might appear to be as remote and distant as some of the stiff figures in Elizabethan portraits, we can glean quite a lot more about her from Sargent's portrait than was possible for those early images. She flaunts her beauty with a form-fitting, low-cut dress, placing her exquisite nose in perfect profile. Her slender white arms are also given prominence in the pose, with one twisted behind her to support her and the other holding a fan and slightly ruffling up the hem of her dress. The dark satin shines, her skin looks pale but edible, and the whole effect is heightened by the warm golden brown tones of the background. This is clearly a case in which the artist and his sitter collaborated in creating what both anticipated would be seen as a masterpiece enhancing the status of each of them in French society.

In more recent times perhaps the best kind of comparison with a status-conscious portrait painter like Sargent would be a celebrity photographer like Richard Avedon (1923–2004). In most of his best known images done for glossy magazines like *Vogue* and *Harper's Bazaar*, Avedon enhanced the beauty and luminousness of his subjects, ranging from Jackie Kennedy to various movie stars, literary figures, politicians, and fashion icons. His photographs of film sirens like Anna Magnani and Catherine Deneuve showcased not only their beauty but their engaging personalities. In an image that bears particular comparison to Sargent's painting of Madame X, Avedon photographed the young Audrey Hepburn (1953) in three-quarters profile highlighting her elegant swan neck. The image brings out her striking black hair and brows through its use of a highly contrastive black and white tonal range. Similarly, in his portrait of Sophia

Loren (1970), Avedon showcased the Italian star's long neck, bare shoulders, and profile, with lighting that emphasized her jawline and bone structure. Loren's tousled black hair forms a background against which her pale skin and beautiful nose are silhouetted in a manner reminiscent of Mme Gautreau's sharp little nose.

Perhaps in response to the attitudes of some critics who regarded fashion or celebrity portraiture as superficial, Avedon insisted rather bluntly, 'My photographs don't go below the surface. They don't go below anything. They're readings of the surface. I have great faith in surfaces. A good one is full of clues.'[35] Avedon also reacted against the sort of beautification of his commercial portrait work by creating other bodies of images that went to the opposite extreme. These included the heartbreaking series of harshly lit and frank portraits he did of his father, Jacob Israel Avedon, in the last seven years of his life, tracing his slow progress of succumbing to cancer (1969–76). Then there were also the carneys, waitresses, drifters, oil field workers, cowhands, beekeepers, sullen teens, and other hard-boiled types who populated the still-alive frontier of the West (of Avedon's imagination at least) in his project and book *In The American West* (1979–84). Avedon said he rejected beautiful lighting and backgrounds, along with any narrative element, and used only plain white backdrops, so that the setting was reduced to essentials: 'I have the person I'm interested in and the thing that happens between us.'[36]

The Relational Self

The third kind of self that I want to discuss is the relational self—the self in its various social relations and public roles. Seigel explains that there are numerous modifications possible along

these dimensions. Aspects of the political experience of people and of their religious lives would be likely to affect their sense of what it is to be or have a self. He says that, for example, for British thinkers the reflective had benign relations, whereas in France outside powers were perceived as more potentially harmful and untrustworthy, a result of tensions leading up to the Revolution. At the same time, Germany has a strong tradition of inwardness fostered by Protestant piety, along with the feeling that the self had a similar structure to that of society.[37]

To say that the self is constituted by various relationships may seem rather obvious, but specifying how such a view can be artistically rendered is harder. One option is for the portrait creator to depict an individual person while indicating through various means that person's social role or importance in politics, religion, science, etc. One way to accomplish this involves depictions of people shown as belonging to specific groups. In some cases this could mean simply the pair portrait, which typified married couples, or the mother–infant portrait (a format that was not surprisingly inflected by the wealth of prior religious images of the Madonna with baby Jesus). But a person could be shown as part of a larger family group, or as a member of a particular guild or other professional or social group. Everyone is familiar today with many of these sorts of images, such as those shown in school photos, pictures of sports teams, soldiers, corporate leaders, scientists, government advisers, travel companions, and so on.

We have already seen a number of examples of portraits of kings and queens that implicitly addressed their political roles by showcasing their wealth, power, and superior bearing. Such portraits promoted the monarch's visibility and were often duplicated and distributed as gifts, sometimes in

miniature versions. Brilliant explains, 'For kings and queens, identity was tied to their work, and artists portrayed them in their roles as personifications of the ruling power, and only incidentally as persons of flesh and blood.'[38] Similarly, the emerging genre of the group or guild portrait, which flourished in the Netherlands, highlighted the social role of members of specific groups while still devoting some attention to the individuals by indicating the hierarchies and relationships within the group. These included numerous images by artists like Franz Hals and, of course, Rembrandt.[39] In his famous study of this genre, *Group Portraits*, published in 1902, Alois Riegl described it as consisting 'of completely autonomous individuals who associated themselves with a corporation solely for a specific, shared, practical, and public spirited purpose, but who otherwise wished to maintain their independence'.[40] Riegl interpreted group portraiture as indicative of the democratic spirit of Dutch society, where 'individual fulfillment was socially constituted by the group'.[41]

Family and marriage portraits were particularly popular in the northern countries, with an early example being the well-known *Wedding Portrait of Giovanni Arnolfini and His Wife* (1434) by Jan Van Eyck. Often such images took the form of the pair portrait, involving two separate paintings meant to be hung in a room side by side. Conventionally, the husband was portrayed so as to indicate his success and sobriety, while the wife held items symbolizing more emotional qualities of affection or devotion, such as a fan or a glove; often she would turn her eyes toward her mate.[42] The marriage portrait tradition was carried over through van Dyck into England and remained popular in the work of Gainsborough and Reynolds. In this later period, however, such portraits more typically showed both partners together and

placed them in a landscape or other setting that indicated both their possession of property and their cultivation of it. I shall have more to say about artists' rendering of people closest to them, including portrayals of spouses and of mothers with children, below in Chapter 6.

Interlude: The Relational Self and the 'Real' Self

The idea just discussed about the importance of a person's presentation of himself to an outside world is also treated in Richard Brilliant's book *Portraiture* (1991). Brilliant comments that portraits work in aid of larger processes that serve in the 'fabrications' of people's identities. By this perhaps misleading term he does not really mean to claim that people deliberately create false identities, but rather that identity itself is a fundamentally social phenomenon constituted by people's interactions with one another. He puts the point by saying, 'Apparently, people impersonate as a normal condition of their social existence.'[43] Such impersonations are other-directed and only to some extent artificial. The task of portraiture is made more complicated by the fact that in rendering a person, that artist has to interpret not only the person's actual appearance but also the person's impersonation of a self.

There is a further order of complexity in the fact that the *audience* adds an additional layer of interpretation to the artist's rendering of the original subject's presentation of a self. Viewers sometimes respond to a portrait because it corresponds to their prior expectations about a person derived, say, from reading about him. Brilliant offers a nice example of this, a daguerreotype by Southworth and Hawes of Daniel Webster (22 April 1851),

which portrays the statesman as very firm and decisive.[44] Webster himself knew how just how to pose in order to create the impression he wished to convey, and the artists collaborated with him to achieve the desired effect.

Brilliant sometimes puts his point about the fabrication of the self in ways that overemphasize the self's fictitiousness. For example, he writes:

> Portraits partake of the artificial nature of masks because they always impersonate the subject with some degree of conviction. What, if anything, lies behind the mask can only be inferred by the viewer from the clues provided by the mask, which may mislead as well as inform through the use of conventions of representation. Ultimately, the emergence of the subject revealed in the portrait must take into account the fact that self-effacement behind the mask is consistent with the social nature of men and women, of all who (re) present themselves in public.[45]

Here Brilliant seems to be advancing a skeptical account of the person, according to which there are in reality no such things—no inner core at the center of the outward masks. However, this is not his actual view. He means to emphasize the difficulty of the artist's task in presenting someone—under an interpretation, of course—who remains elusive to an audience, but whom we still wish to know and grasp. Because of our curiosity about other persons, we constantly seek the 'reality' of a person in a portrait and wonder about their identity, and we can fall prey to a tendency to look to the referent more than to the artistry of the work in the case of portraiture. Brilliant says that portrait artists respond to three primary questions about persons: *What do I (you, he, she, we, or they) look like?*, *What am I (you, she, he, etc.) like?*, and *Who am I (you, etc.)?* To answer the first question, artists

provide clues to visual recognition. Concerning the second question, Brilliant says that artists depict character according to external factors or personal behavior. And as for the third question, he holds that the most common response is to give social designators, but artists may also seek to convey their perception of some essential characteristic of the sitter.[46] This suggests that there is a chasm between the crafted external self and some inner core or essence.

I would prefer to put Brilliant's points using different terminology, by saying that people present a self to the outside world as part of *who they are*, in and of themselves. The self is inevitably social. This point is confirmed by researchers in evolutionary psychology like Michael Tomasello, who pinpoints the development of a child's sense of self to the very first year of human existence. As social creatures by nature, we humans, like apes, are capable of complex interactions with others. In our case this complexity involves the mutual recognition of the consciousness of others. As a child reaches the first year, Tomasello says, this human capacity takes shape, so that the infant now knows 'she is interacting with an intentional agent who perceives her and intends things toward her'.[47] He adds,

[W]hat happens at the first birthday is not the sudden emergence of a full-blown self-concept, but just the opening up of a possibility. That is, what infants' new-found social-cognitive skills do is to open up the possibility that they may now learn about the world from the point of view of others, and one of the things they may learn about in this way is themselves. . . . This categorical component is an important dimension of the self-concept as well, especially during the preschool period as children understand themselves in terms of concrete categories such as child, male, good at tree climbing, bad at bike riding, and so forth.[48]

From a quite different conceptual base, the philosopher David Velleman reaches a similar analysis in his book *Self to Self*. In his very interesting account of 'The Genesis of Shame', Velleman uses the biblical story of Adam and Eve as a framing device to answer the question of why we humans are capable of feeling shame. His answer, in a nutshell, is that at times our private self is exposed to public scrutiny when we feel it should not be. The notion of a public self might seem to designate a sort of mask or disguise, as it sounds like it does for Brilliant, but Velleman disagrees. In his view, the public self simply *is* the self, something each person develops as a part of configuring who he or she really is. Velleman explains,

> Putting an outward face on our behavior sounds like an essentially social enterprise, but I think that this enterprise is inherent in the structure of the individual will.... In order to make sense and keep track of his life, Robinson Crusoe had to engage in a solitary form of self-presentation—displaying, if only to himself, behavior that was predictable and intelligible as manifesting a stable and coherent set of motives. Self-presentation serves a similar function in the social realm, since others cannot engage you in social interaction unless they find your behavior predictable and intelligible. Insofar as you want to be eligible for social intercourse, you must offer a coherent public image.[49]

Velleman makes the same point here as Tomasello, and the same one that I have been articulating about Brilliant's position in his *Portraits* book, namely, that 'self-presentation is not a dishonest activity, since your public image purports to be exactly what it is: the socially visible face of a being who is presenting it as a target for social interaction.'[50] This fact of self-presentation is the key to what I have described in Chapter 1 above as a crucial

requirement of portraits: the possibility of *posing*. Humans have a self that is relational and that by its very nature involves self-presentation to others, with an awareness and concern about how one is seen, and this is part of what is rendered when an artist creates a portrait.

The Moral Self/Types and Classifications

My discussion about honest vs. misleading presentations of the self provides a good entryway into the next topic I wish to consider in this chapter, the self as it is involved in moral relationships. Intellectual reflection about the self in the Enlightenment addressed not only the person's internal life and metaphysical identity but also autonomy and decision-making powers. Thus for Locke, as for his successors such as David Hume and Immanuel Kant, the fact that a human being had powers of reasoning, memory, and identity through time grounded the possibility of being regarded as a moral agent. Rationality enabled the person to comprehend right and wrong, and memory and identity through time were essential to making moral rewards and punishments effective and justifiable. (It would be neither fair nor productive to punish a person for a crime that person had no ability to recognize or remember.) The transition from earlier, more religiously based conceptions of the self into new ones emphasizing autonomy depended upon, and in turn reinforced, new conceptions of moral authority derived from reason rather than from divine commandment.

Again, as with my previous examples of the self as understood along outer, inner, or relational dimensions, the moral self has such importance in early modern thought that it will inevitably make some sort of an appearance in art. There are hints about

specific moral attributes of some persons in various of the depictions I have already mentioned. Thus the queen or king is not merely a regal and imperious being but a person with divinely sanctioned moral authority to lead and direct the state, as indicated in portraits discussed above of Elizabeth I or of young Baltasar Carlos. Similarly, in various family and marriage portraits, there is usually a particular dominant figure who assumes the moral authority of leading the group or guiding the family.[51] Changes in moral and social views were reflected in changes in portrait practice. So for example, at least as Riegl saw them, Netherlandish group portraits depicted societies of equals. As views about the appropriate relationships among family members evolved, so also did depictions of these relationships in portraits. The depictions of partners in marriage portraits began to show greater equality and mutual affection. Rather than appearing in a hierarchical relationship, the patriarchs in families might be depicted as loving and attentive fathers.[52] Similarly, more sentimental views of motherhood led to changes in the depiction of women and their children.[53]

Members of the lower classes, if they appeared at all in early period portraiture, were likely to be depicted as servants tending to animals, cooking, sewing, and so on. Or, if perhaps they were going astray, this was depicted in order to enable the artist to make a moral point for the picture's audience. Artists like Gainsborough began to depict some of the poor, especially appealing young children, in a period when a more sentimental attitude became popular among the landed classes, revealing their sense both of their own social superiority and their generosity or pity.[54] There were also, of course, works in subsequent centuries by more politically oriented artists concerned with

inequality and mistreatment of various classes of people, from the peasants of eighteenth-century France to the Dust Bowl victims featured in the photographs of Walker Evans, to the homeless people or war victims of today's documentary photographers.

In portraiture of various sorts of social groups, the relevant categories or types of persons depicted were often assumed to be indicative of some specific moral status. Such typologies emerged and fluctuated in connection with evolving theories of the social and genetic origins of moral responsibility, indicating new views about disease and criminality. Upstanding moral types might be represented in pictures that showed members of a group that was, say, dedicated to guarding and protecting the city, as with Rembrandt's *Night Watch*. Or, moral criticism was conveyed in images depicting unsavory types like the anonymous soldiers of the firing squad in Goya's *The Third of May, 1808: The Execution of the Defenders of Madrid* (1814). By the nineteenth century more artists were employing indications of group membership, shown either explicitly or by implication, to depict a broad sample of the socio-economic spectrum. It became more common for artists to do portraits of the lowliest members of society, sometimes with sympathy or admiration, but more often to illustrate stereotypical associations of ethnicity or poverty with disease, drug use, criminality, mental illness, etc.

Among the most common 'type' shown in portraiture is the mad person, who began to be seen as mentally ill and treated in a hospital, rather than as illustrating one of the four classical humors, as shown by Michelangelo, Dürer, and others.[55] An example of the newer approach is the portrait *Insane Woman (Monomania of Envy*, 1822–3) by Théodore Géricault

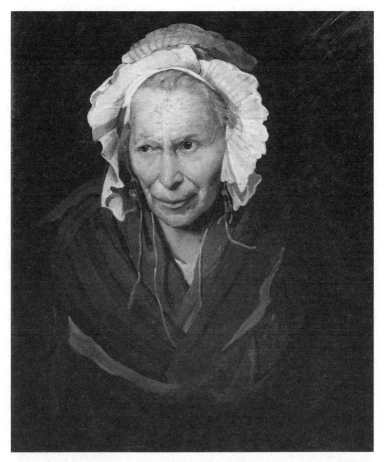

Fig. 3.1 *Insane Woman* (1822–3), Theodore Géricault. One of Géricault's depictions of the patients at the Salpêtrière in Paris.

(1791–1824). The painter depicted the patients of his friend, Dr Étienne-Jean Georget at the Salpêtrière in Paris, the hospital that would later become famous as the setting for Charcot's early studies of hysteria, which inspired Sigmund

Freud in his development of psychoanalysis. Other examples from this same series are Géricault's *Portrait of a Kleptomaniac, Woman with a Gambling Mania,* and *Mania of Military Command.* These portraits, meant to serve diagnostic purposes, would later influence Charcot in his own studies and publications of art depicting the insane in the 1880s. In Chapter 4 below on 'Expression', I will discuss parallel works by the Scottish anatomist Charles Bell which influenced and were used by Charles Darwin.

Like van Gogh after him, Géricault was himself a patient at the hospital housing the mentally ill people he painted. There is considerable room for interpretation in each man's work of how he saw his fellows. Some commentators think that the people in Géricault portraits of the mentally ill 'look' crazy. Louise Gardner speaks of the woman in *Monomania of Envy* as 'leering' with 'red-rimmed eyes' and 'paranoid hatred'.[56] However, there is also considerable humanity in their depiction. His insane people appear more to be sad rather than stereotypically deranged and dangerous. Géricault was an artist with a strong political orientation who also did work criticizing the slave trade and, in his famous *The Raft of the Medusa* (1819), protesting the corruption of a ship's captain who left his crew and passengers to die during a horrific storm at sea.

By the late nineteenth century photography had become the medium used by doctors and scientists, such as emerging experts in criminology and disease, to depict mentally ill people as well as members of other socially, economically, or ethnically charged groups. The new medium, if nothing else, facilitated more ambitious attempts to create comprehensive archives encompassing large numbers of people.[57] Many such projects could be discussed here, but among the earliest and most interesting enterprises

along these lines was August Sander's (1876–1964) massive effort to depict 'Man of the Twentieth Century'. West explains Sander's aims as follows:

Sander intended that his photographs should represent types of people in contemporary Germany, and he divided his subjects into social categories such as farmers, craftsmen, and professions. Because Sander's project was concerned with types rather than individuals, he did not identify most of his sitters by name ... Sander's works are portraits of individuals, but these portraits were conceived as representing qualities of class and profession.[58]

Sander's project was enormously ambitious. His portraits showed peasants, circus artists, musicians, boxers, intellectuals, bricklayers, blind students reading Braille, Gypsy children, architects, pastry cooks, policemen, missionaries, soldiers, brides, secretaries, and on and on, as he amassed a collection of more than 30,000 images in his lifetime. His work spanned all social classes. In each case the style of his portraiture was neutral, straightforward, well-lit and realistic, resulting in a posed, studied, full-length image. The artist himself explained, '[W]e know that people are formed by the light and air, by their inherited traits, and their actions. We can tell from appearance the work someone does or does not do; we can read in his face whether he is happy or troubled.'[59] Bits of setting would occasionally add to Sander's depiction of the person, but he relied primarily on the visual evidence of their clothing, stance, and physical appearance. Part of this work, including sixty portraits, was published in 1929 with the title *Face of our Time*. Sander's work was censored and some of his plates destroyed by the Nazis, who felt his images did not depict the German ideal, and unfortunately,

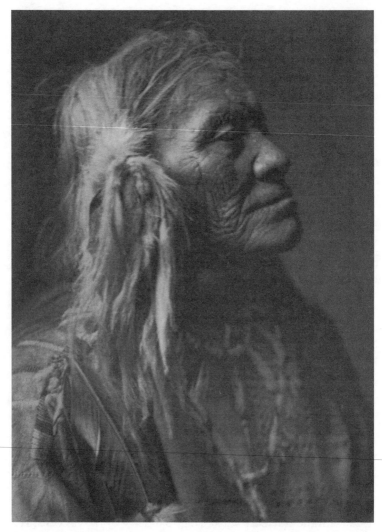

Fig. 3.2 Edward S. Curtis, Photogravure, *Luqaiot—Kittitas*. One of Curtis's thousands of photographs of 'noble' native Americans.

many of his works were lost during Allied bombing of Cologne during the War.

A project on something like the same grand scale as Sander's was also done in the United States. This involved not capturing the range of so-called 'ordinary' Americans but rather making a record of the fast-disappearing indigenous Americans, or Indians. Edward S. Curtis (1868–1952) was a young photographer in Washington in the western USA when he was invited to join scientific expeditions studying Indians in Montana and Alaska. Over subsequent years Curtis took over 40,000 photographic images from over 80 tribes. His work was published in the massive *The North American Indian* (volumes i–xx, 1907–30).

Curtis's images are controversial. Despite his dedication to providing a record of what he saw, he is now known to have introduced alterations into the depictions he made so as to further the particular vision he had of the Native Americans as certain sorts of 'noble savages'. His images involve inaccuracies, such as inclusion of the wrong sorts of baskets in some images of products of a particular culture, or depiction of an individual with braids in a group that would not have adopted such a hairstyle.[60] To preserve his own ideas of purity he removed signs that there were also Caucasians in the presence of the Indians, watching ceremonies, for example, and he posed people doing everyday tasks wearing their finest ceremonial clothing.[61] It has also been pointed out that Curtis often presented the people whose portraits he made as representatives of a type rather than as individuals with their own names. On the occasion of an exhibition of the images held in the collection of San Diego's library, scholar Ross Frank said,

> Curtis named noteworthy individuals he photographed, like Ger-
> onimo, but he left most of his subjects suspended in anonymity,

their individuality obliterated by their race. A Diegueño woman is simply 'Southern Diegueño Woman,' and a Qahátíka Girl is 'A Type of Desert Indian.'[62]

Portraiture that aims to show some sort of collective truth about types of individual persons still exists. One example is the video and photographic installation works by Fiona Tan. The Indonesian-born artist, who is of mixed Chinese-Indonesian-Australian heritage, now lives and works in Amsterdam. Tan was one of many artists participating in the large-scale project *Be(coming) Dutch* which addressed issues of national identity and its meaning in the twenty-first century. She was inspired by Sander's German documentation project in her 2002 project *Countenance*, in which she did a new version of his project in Berlin. It included 200 full-length black-and-white film portraits revisiting some of the same 'types' shown by Sander, such as the baker, artist, etc. Tan explained, 'I am curious to find out how much society has changed since Sander's time. At the same time, I call into question this very practice of general characterisation the way we form notions of society as a whole.'[63] In a video shown at the exhibit she asked, 'Do I look better at someone's face in a foreign city?' and said, 'Almost automatically I try to guess someone's background and origin...all my attempts at systematic order must be arbitrary, idiosyncratic.'[64]

Tan's project *Vox Populi* (2004) involved visits to Norway, Japan, and Australia, where she created a kind of ethnography of each country. She sought and then edited family photographs covering several generations, for example, from over 100 families in Norway. Tan mounted the individually framed images in groups organized into categories of Home, Nature, and Portrait. The resulting collage of small-scale photographs read like a

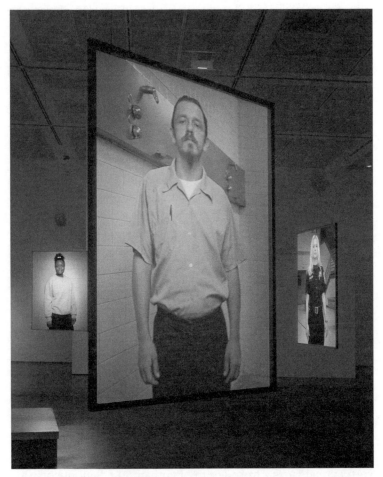

Fig. 3.3 *Correction*, Installation View, Fiona Tan (2004). A view of Tan's exhibition examining the US prison system.

gigantic collective family album that could both reinforce and challenge stereotypes about the identity of inhabitants of each country.

Tan's portrait medium is unusual, as is her installation practice. She creates and shows video clips that depict a person who remains still, so that the video image appears like a barely moving photograph. Her installations use screens of varied sizes that surround viewers and provide multiple viewing opportunities. In her more recent exhibition and book *Correction* (2004), Tan created portraits of people affiliated with prisons in the USA, both prisoners and guards. The people she filmed agreed to stand still for 50 seconds at a time. The work consists of 300 videos shot at four prisons in Illinois and California, with videos shown on both sides of various hanging screens.

Critic Joel Snyder describes the specifics of Tan's visual installation as it was shown in Chicago. It had 'six screens, each measuring 3.6 feet by 4.9 feet, . . . suspended from the ceiling, their bottom edges hanging 3.9 feet above the floor, at intervals of roughly 17 feet, providing six points of a circle with a diameter of 40 feet and a circumference of 125 feet.'[65] Tan points out that the USA has the highest population of prisoners in the world, indeed, 'a quarter of all prisoners worldwide'. *Correction* also includes sound, but nothing decipherable, just distantly heard human voices. The circular structure of the installation is a reference to the classic idea of a central observation post in a correctional facility from Jeremy Bentham, the Panopticon.[66]

The exhibition *Correction* brings to mind various kinds of thoughts and associations. In seeing it, one might ask whether it is possible to detect the 'criminality' of the individuals who are shown. (What sorts of criminals are they—axe murderers? Pederasts?) Their enforced stillness makes the individuals seem

uncomfortable and calls attention to their confinement, and we can notice that the problem is the same for the guards as for the prisoners—they too are 'confined' by the correctional institution. The distantly heard voices remind us of the prisoners' lack of privacy. And as with Tan's other exhibitions, the use of video is both intimate and distancing. Since the screens are large, we can see many details, and sometimes the images flicker across bodies of people visiting the exhibition. But the images are strangely still and mute, inviting an inspection that makes both the subjects and, potentially the viewers, uncomfortable about the circumstances of watching and being watched. Unlike Curtis's and Sander's projects, Tan's explicitly seeks to create doubt about the possibility of accomplishing the goal or conveying personality through an archival enterprise that accumulates people while sorting them into the 'correct' types they allegedly instantiate.

Interlude 2: The 'Air'

In Interlude 1 above, I argued that the true self actually is, and includes, the social self. The person an artist depicts *is* the person as he or she has chosen to pose or appear. This, however, seems at odds with the idea of there being some inner core that a portrait artist strives to get at. Similarly, the sorts of portraits done by Sander, Curtis, and Tan might also lead us to question the possibility of accessing such an inner core. There are many stories about a contest of wills between the person being depicted in a portrait who wants to be seen in a certain way and artists who strive to present their own unique vision and insight, penetrating the façade shown them. What happens in

these processes to that mysterious notion of the 'air' that Roland Barthes wrote about so eloquently? Is there such a thing?

This brings us to the fundamental question of what a self is apart from all of its episodes, experiences, social displays, transitions, and relationships. Is there a true self, hiding somewhere within, an essence of some sort? Marya Schechtman has said that this would be 'the core and defining traits and features of such a subject—about who that person *truly* is'.[67] But does such a core really exist? My answer to this question is prompted by remembering something quite particular that Barthes said when speaking about his notion of the 'air'. He wondered, 'Perhaps the air is ultimately something moral, mysteriously contributing to the face the reflection of a life value?'[68] I am intrigued by Barthes's idea that the true self or inner core involves a fundamental moral attitude. The moral outlook is a sort of summary of a person's character. In the case of Barthes's own mother, the core involved a fundamental goodness which he described as paradoxically assertive innocence.

This kind of moral outlook is, I think, often what we recognize and respond to in the finest examples of portraiture. They show 'who someone is' in the sense of describing for us what kind of person they are, rather than simply showing that the person is a queen, mother, horseman, astronomer, general, landowner, burgher, milkmaid, movie star, baker, or whatever. It goes beyond saying that someone is beautiful, rich, successful, or anything in the opposite range. And for Barthes it was significant that the air shows in the face as a 'reflection of a life value'. This means that the inner core is not inaccessible or hidden. As Brilliant, Tomasello, or Velleman have told us, it too is manifested in a form of self-presentation to the world.

Consider what we could say about the true selves or cores of some of the people whose portraits we can study today. The 'air'

we discern in Velázquez's Pope Innocent X involves the fact that he is arrogant and cruel; Goya's Charles IV and his family are vapid and vulgar; Freud's Queen Elizabeth II is determined and gritty; Sargent's Madame Gautreau is vain and showy; and so on. When we feel we can see the true self of someone in a portrait, I think Barthes is quite right, that this often has something to do with their manifestation of a very fundamental moral attitude, a core set of inner values and attitudes toward life. Obviously this view runs the risk of oversimplification, both in viewing artworks and in our relationships to other people in real life. And perhaps the artists' renderings are not to be trusted. But still, this is a central reason why we admire the greatest portrait artists, for an ability to render not only a person's exterior or physical self but also to discern and convey the moral dimensions of a person's core self or character manifested in their social self-presentation.

The Disappearing Self

One of the books I mentioned at the start of this chapter among the many recent studies of the self is Raymond Martin and John Barresi's *The Rise and Fall of Soul and Self*. This title is arresting since it prompts us to wonder what is meant in saying that the soul and self have 'fallen'. The authors' report of this 'fall' seems to locate it in rather recent times, though it is hard to pinpoint exactly when. During the rise of existential thought in the mid-twentieth century, the idea of the self began to be regarded with more skepticism and suspicion. In this era some philosophers and writers came to feel that to seek to develop or have a self was to adhere to a bourgeois notion of consistency. For these

thinkers, existential freedom required more openness and ongoing self-creation. Sociologists began suggesting that all a person amounted to was a series of masks and roles, an onion that could be peeled away leaving no inner core.

I have addressed these sorts of skeptical opinions above in Interlude 1 on the relational vs. the 'real' self. As I stated there, I do not find them plausible; there is no reason to hold that even strong notions of a person's identity or of an inner moral core must exclude human freedom and choices in self-formulation. But I do plan to consider how these more skeptical views of the self have influenced artists in the twentieth century and beyond. I will address such concerns and consider various examples of postmodern portraiture in my final chapter, Chapter 7, titled 'The Fallen Self', looking at various artists who seem to illustrate the skeptical position of the disappearing self. Cindy Sherman, for example, has created a variety of series of photographs in each of which she is herself the model and assumes a number of guises, but her works are generally not regarded as self-portraits because they withhold revelations about who she really is as a person. As a preview, in that chapter I will argue that these kinds of works are interesting for what they show about recent developments in views of the person and difficulties in identifying the self, but that they do not, and really could not, indicate that selves have actually disappeared. Selves, like persons, are with us to stay.

Expression

Introduction

Artists who create portraits have often tried to convey aspects of their sitters' moral character, emotional life, and personality in their depictions. All of these are aspects of what was called the 'reflective' or interior aspects of personhood in the previous chapter. What artists have aimed to reveal, scientists and philosophers have sought to systematize. Ever since Aristotle and Theophrastus launched physiognomy by linking various bodily characteristics with personality traits, it has been thought that 'inside' and 'outside' of persons must inevitably be connected.[1] In fact, in a later era (1831), Theophrastus' *Characters* was published in an edition by Frances Howells that realized this idea by showing each character trait as accompanied by 'physionomical sketches'.

Renaissance scholars and artists like Lomazzo, Leonardo, and Alberti 'believed that the passions of the soul as conveyed in bodily gestures and facial expressions were the essence of art'.[2] Leonardo said 'the [pictorial] figure is most praiseworthy which by its actions best expresses the passion of its mind'.[3] He made

important sketches of both the skull and the brain and worked out ideal proportions for the skull and head.[4] He also advised artists to sketch people in their natural actions so as to learn their movements and expressions.[5] Certainly Leonardo was adept at the depiction of figures in gentle or extreme emotional states, perhaps aided by both observation and detailed anatomical studies and dissections. However, his actual theories of the mind and emotions were primarily influenced by the thoughts of the ancients which were still dominant in his time.

The Seventeenth Century: Descartes and Le Brun

In the modern period, the study of human emotions or passions was shaped by Descartes's important book *The Passions of the Soul*. From Descartes (1596–1650) on to the work of contemporary scientists of emotional expressions, experts have attempted to identify basic emotions and to connect them to outer and visible signs. Such signs include expressive responses like smiling or frowning, laughing or crying. Emotions have been studied and analyzed in terms of movements of facial parts as well as of the unseen nerves and muscles involved in the drawing back of lips, widening of eyes, contraction of eyebrows, or furrowing of the forehead. Given that both artists and scientists have aimed at roughly the same thing, a clearer grasp of the presumed links between inner states and their outer expression, it should be no surprise that artists' manuals have repeatedly interacted with scientific accounts of the human face, emotions, and character, in intriguing and complex ways.

Our study of these interactions can begin by discussing the influence of Descartes's treatise on *Passions of the Soul* (1649)

upon what was to become the standard manual for painters for over 100 years, a posthumously published lecture by King Louis XIV's official painter and founding professor at the new Academy, Charles Le Brun.[6] Descartes's book was the first major innovation that involved rejecting the long-popular account of diverse human temperaments in terms of the four humors. In this text, written late in his life, Descartes sought to account for mind–body interaction primarily by means of the somewhat mysterious notion of animal spirits, which were corporeal but very fine and in constant movement like the particles of a flame. These were located primarily in the pineal gland (Article XXXI) at the back of the brain. More correctly, this gland was suspended in a cavity which was said to contain the animal spirits (XXXIV). Passions play the key role in humans of preparing our bodies for action, typically, fight or flight (XXXVI). Descartes identified six primitive passions: wonder, love, hatred, desire, joy, and sadness. He held that other emotions were compounds or formed from these (they include examples like disdain, and jealousy) (LXIX). For example, here is his definition of desire: 'The passion of desire is an agitation of the soul caused by the spirits which dispose it to wish for the future the things which it represents to itself as agreeable' (LXXXVI). Passions have external signs which show up especially in the eyes, but also in other parts of the face such as the forehead and lips, and in behaviors such as laughing or weeping. In this brief treatise Descartes does not present a full ethical theory, but he does make it clear that wisdom and self-control are essential ways to deal with the passions so as to make life bearable (CCXII).

Le Brun's *A Method to Learn to Design the Passions* (1667) emulated Descartes by attempting to provide a systematic account of the passions based upon first principles. Instead of

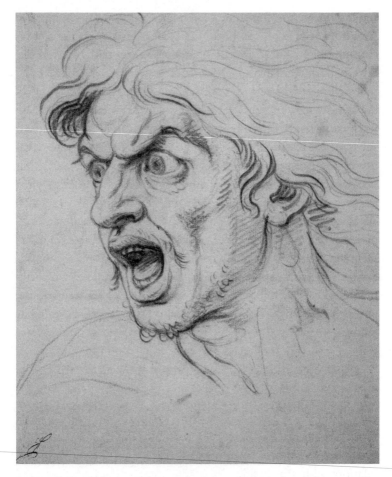

Fig. 4.1 *The head of a man screaming in terror*, a study for the figure of Darius in 'The Battle of Arbela' (charcoal on paper), Charles Le Brun (1619–90).

relying on observations, Le Brun tried to derive all conceivable variations a priori, as it were, based upon possible geometrical combinations of the relevant signifiers (eyebrows, eyes, mouth). He adopted Descartes's six basic emotions but added more, since there were other passions that would also be useful for artists to know how to depict. Following Descartes's own attempt to link what in fact could really not interact, spiritual and extended substance, Le Brun stated that the pineal gland was the locus of soul–body interactions. He wrote, 'But if it is true that there is one interior part where the soul exercises its functions most immediately, and that this part is in the brain, then we may also say that the face is the part where it makes its feelings most apparent.' And from this, Le Brun concluded, somewhat surprisingly, that it is *eyebrows* which are of the foremost importance in discriminating emotions. This was because the muscles manipulating them are an indication of the direction of the pineal gland.

> And as we have said that the gland which is in the middle of the brain is the place where the soul receives the images of the passions, so the eyebrow is the part of the face where the passions are best distinguished, although many have thought that it was the eyes.

More specifically, both the corners of the mouth and the eyebrows tended to curve downward toward the heart in correlation with the 'wildest and cruelest passions' and upward toward higher things (presumably God and heaven) in expressing 'all the gentlest and mildest passions'.[7]

Le Brun's system was rather direct and crude. Jennifer Montagu, who has translated and written a commentary on Le Brun's text, explains that, 'The eyebrows worked like the hand

of a speedometer to reflect the conditions of the soul.'[8] This work was actually supposed to be accompanied by another work on physiognomy. As Montagu describes it, the accompanying work would have incorporated three studies: heads of ancient philosophers and rulers, comparisons of heads of men and animals, and a study of the eyes of men and animals.[9] Although Le Brun's work always had critics, Montagu testifies that 'it was widely used throughout Europe at least until the rise of neo-classicism in the later years of the eighteenth century'.[10] It began to be eclipsed when neoclassical taste was spread by later theorists like Winckelmann and artists like David. Montagu notes that other changes included the development of new modes of expressiveness in painting through other means such as color.[11]

Le Brun's text became the guide for an entire generation of painters and encompassed the depiction of animal as well as human emotions.[12] But Le Brun did not simply adopt Descartes's views; he made important revisions, indicating that artists themselves contributed significantly to the conceptualizations of emerging psychological science:

> LeBrun's borrowings are erratic, idiosyncratic, and placed in quite a different context from the originals; often there is less similarity than meets the eye. Descartes' work on the passions addresses topics such as physiology, the bodily effects-cum-signs of the passions, and the discipline of virtue in order to show the various dimensions of the mind–body union. LeBrun's *Conférence*, on the other hand, formulates a system for representing the passions of characters in a history by way of their facial expressions. To this end, it establishes basic units (eyebrows, mouth, etc.) which function like gauges correlated by their departure from a neutral state to the character and intensity of particular passions.[13]

The Eighteenth Century: Phrenology and Physiognomy

In the eighteenth century two new alleged sciences of the head arose to become dominant, although neither was without its critics: phrenology and physiognomy.[14] Phrenology's champion was Franz Joseph Gall (1758–1828). He published *The Anatomy and Physiology of the Nervous System in General, and of the Brain in Particular* in 1810. Gall held that various structures and bumps on the head encoded information about a person's inner character. Such bumps could be read as guides to qualities like intelligence as well as to moral virtue or vice. 'Gall suggested that the brain was divided into 27 separate "organs".[15] Each organ supposedly corresponded to a discrete human faculty, though Gall identified 19 of these faculties as being shared with other animal species.' The common qualities included emotions such as affection, guile, vanity, and pride. Properties unique to people included kindness, religious capacity, and firmness of purpose. An important collaborator of Gall was Johann Spurzheim (1776–1832), who successfully disseminated phrenology in the United Kingdom and the United States. It was Spurzheim who popularized the term *phrenology*. Although phrenology became popular to the point of prompting numerous studios where people flocked to receive 'readings' of their facial bumps, it was never as influential upon visual arts practice as the second major science of the period, physiognomy.

The initial text on physiognomy was by the Swiss scientist and minister Johann Caspar Lavater (1741–1801). His work *Essays on Physiognomy: Designed to Promote the Knowledge and the Love of Mankind* was published from 1775 to 1778 in a number of expensive and lavishly illustrated volumes that went through

multiple editions and became best-sellers of their day. Physiognomy held that there are various types of facial features associated with moral types or personality characteristics. In Lavater's case, the system reflected a peculiar combination of two influences: first, a Christian outlook (he was himself a minister); and second, a belief in the philosophy of Leibniz, and in particular in Leibniz's theory of individuality. According to Leibniz, each created entity or monad had an individual essence that uniquely differentiated it from every other. Lavater interpreted this to indicate that each human face comprised a particular kind of semiotic code with a message that would take an almost infinite analysis to unfold.[16]

Lavater was a great friend and collaborator with Goethe. Both men believed that drawing was an essential skill for a physiognomist and that it aided the requisite observations. Lavater's books were illustrated by engravings and artwork by all of the top artists of the day.[17] 'Both his original (1775–8) and revised text [Lavater's] contain many illustrations that borrow from Dutch, Flemish and Italian drawing manuals of the seventeenth and early eighteenth centuries'.[18] For example, the depiction of Judas included in the book was an engraving based on a painting by Holbein. Also, Lavater included portraits of many famous people and so his books had a sort of 'who's who' appeal. Translated into English in 1789, Lavater's work was later made available in less expensive but still well-illustrated editions.[19] William Blake was one of the artists who helped illustrate the English edition. Lavater's influence was especially strong in England due to the enthusiastic support of his fellow Swiss, Johann Zimmermann, the King's physician.[20]

Lavater's system of physiognomy became popular to the point of becoming a fashion or vogue. One important way in which

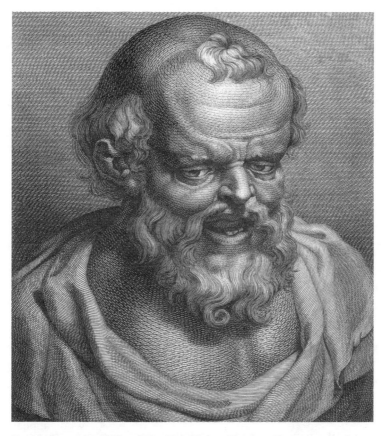

Fig. 4.2 *Democritus*, William Blake; Plate 25 from *Essays on Physiognomy* by John Caspar Lavater (1789).

physiognomy had an impact on art practices was by contributing to the popularity of the outlined profile or silhouette. For Lavater, facial structure was more important than a realistic portrayal of the face as three-dimensional and in full color. Rather, it was the person's profile that was particularly revealing. Thus, well

before the rise of photography in its early form of the daguerre-otype as a portrait medium more accessible to the masses than painting had ever been, a device known as the physiognotrace was invented in France, transferred to America, and made enormously popular there (this was also described above in Chapter 2).[21]

Lavater's work was known to philosophers like Immanuel Kant and clearly influenced Kant's early essay 'On the Beautiful and Sublime'. We might say it had a pernicious influence on Kant in particular through its confirmation of racial and ethnic stereotypes which he perpetuated in that early work where he compared various races of the world with people of European nations.[22] Arthur Schopenhauer also wrote on physiognomy, and for him (not surprisingly) it reinforced a natural pessimism about human nature.[23] He wrote,

> How poor most faces are! With the exception of those that are beautiful, good-natured, or intellectual, that is to say, the very few and the far between, I believe a person of any fine feeling scarcely ever sees a new face without a sensation akin to a shock, for the reason that it presents a new and surprising combination of unedifying elements.... There are faces, indeed, the very sight of which produces a feeling of pollution.

Lavater's work had a tremendous impact on portraiture across both Europe and the New World. It was influential on numerous artists' manuals of the time. Among those affected by it were some of the most important painters of the new American nation, men who portrayed the country's statesmen and heroes, including Gilbert Stuart and Rembrandt Peale. Its influence continued to be felt into the modern period in artists like Degas and Manet.[24] Strangely, Lavater's popularity, as well as

Fig. 4.3 *Elizabeth Patterson Bonaparte* (1804), Gilbert Stuart. An illustration from the follower of physiognomy showing this woman's beautiful features from three angles.

that of physiognomy, seemed to fade about a century after it had arisen, around the late 1870s. His supporters withdrew, and his views were viciously criticized by the German physicist Georg Christoph Lichtenberg. 'Indeed, the entire field seemed to go up in smoke,' comments one scholar.[25]

Bell, Darwin, and the Nineteenth Century

After the period in which physiognomy was the dominant influence, new theories of the emotions began to be developed as the science of psychology took its early form in works by figures like William James and John Stuart Mill. An empirical and associationist psychology was advocated by Mill: 'In his *Logic*, Mill calls for a science of character, to be called "Ethology". Its laws are to be derived from the "Laws of Mind" as investigated by the associationists. Mill did not attempt to spell out the details of such a science.'[26]

The nineteenth century also included several scientists who advanced our knowledge of the anatomy of facial expressions by using new techniques of surgery and dissection as well as new methods of rendering and representing their findings. The first of these scientists who still is credited as a major influence in the development of medical science (his work influenced Darwin in his own book on emotional expression) was the Scottish anatomy expert and surgeon Sir Charles Bell, who published *Essay on the Anatomy of Expression in Painting* in 1806. Bell was himself trained in the arts and illustrated his own books with accurate and beautiful drawings.

Before leaving Edinburgh, Bell had written his work on the *Anatomy of Expression*, which was published in London soon after his

arrival and at once attracted attention. His practical knowledge of anatomy and his skill as an artist qualified him in an exceptional manner for such a work. The object of this treatise was to describe the arrangements by which the influence of the mind is propagated to the muscular frame, and to give a rational explanation of the muscular movements which usually accompany the various emotions and passions. One special feature was the importance attributed to the respiratory arrangements as a source of expression, and it was shown how the physician and surgeon might derive information regarding the nature and extent of important diseases by observing the expression of bodily suffering.[27]

Bell's work was well known and widely influential. 'The theory of expression which Bell presented actually became something of a classic in its time, in particular amongst the artistic and literary communities . . . *The Anatomy of Expression* . . . was a well-known and widely used textbook for artists, anatomists, and writers alike throughout the nineteenth century.'[28] Among others, it influenced were the Pre-Raphaelites.

The second of these new scientists was Guillaume Duchenne de Boulogne (1806–75), who published his *Mécanismes de la physiognomie humaine* in 1862. Working in the Salpetrière mental hospital in Paris (the same hospital where the painter Géricault had painted a series of mental patients in 1822–3), Duchenne employed the new technique of Galvanism (electric shock) in experiments from 1852 to 1856. He was able to stimulate various facial muscles in order to demonstrate diverse emotional conditions and disorders. Instead of drawings, he employed Adrien Tournachon (the brother of the eminent early French portrait photographer known as Nadar) as his photographer. But photography's abilities and usefulness suffered from the severe technical limitations at this time:

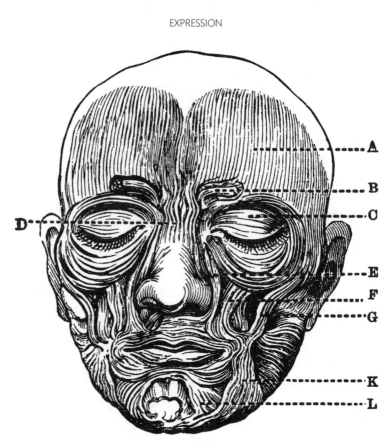

Fig. 4.4 *Diagram of the muscles of the face*, from Sir Charles Bell, *Anatomy of Expression as Connected with the Fine Arts* (1806).

One problem was that his films lacked light sensitivity, so that he was often forced to take pictures in front of windows with people staring into the sunlight. A second problem was that the subject's eyes and nose could not be put into simultaneous focus with the lenses available between 1855 and 1857. Although the depth of field problem was solved by 1862, Duchenne wanted to include

his original photographs in his books because he considered some of this material unique.[29]

The work of Duchenne and Bell was clearly important for Charles Darwin (1809–82), who also used photographs to illustrate his important book *The Expression of the Emotions in Man and Animals* (1872). Darwin worked, among others, with the Swedish art photographer Oscar Rejlander. Darwin's book was the first scientific text to make use of photographs and it must be counted as a major signpost in development of an understanding of photographs as evidence. Finding photographs that would successfully record the range of facial movements Darwin considered relevant to each emotion proved difficult, primarily because at the time photography still required long exposure times. Duchenne had only succeeded at the task because he used a patient with an 'anaesthetic' facial condition, for whom the use of galvanic action allowed the muscle movement to be sustained long enough to be recorded by the camera.

As Phillip Prodger explains in an Appendix to the most recent edition of *Expression,* there is some irony in the choice of Rejlander to do this work, since he was a prominent early champion of photography as art. Furthermore, although Darwin claimed the photographs were evidence as to the true nature of various sorts of emotional expression, the fact was that Rejlander had to stage many of them, and this is why he posed himself. Rejlander explained to Darwin, 'It is very difficult to get, at will—those expressions you wish—Few have the command or imagination to appear real. In time I might catch some—So I have tried *in propria persona*—even cut my moustache shorter to try to please you'.[30] Rejlander also used his wife as a model and she is the person seen in the plate illustrating the emotion of contempt: she

133

Fig. 4.5 (a) *Indignant man with clinched fist* and (b) *Man shrugging his shoulders*, Oscar Rejlander (artist and model).

had an unusual capacity to sneer while displaying the canine tooth to one side, a point Darwin was quite interested in.[31]

Darwin proposed a system of explaining emotional expression that used certain fundamental principles: 'serviceable associated habits, antithesis, and the direct action of the nervous system'.[32] Based on the first principle he claimed emotions emerged through habit, but the other two worked differently. Although he credited Bell as one of his primary influences he also disagreed with Bell's theological account of the purpose of emotions. 'Bell claimed expressions had a transcendental purpose in that their

origin was in instinctive actions intended to convey a theological framework: 'grimaces and smiles, frowns and blushes had been inscribed in human physiognomy', Robert Richards writes, 'as a kind of natural language which allowed immediate communication of one soul with another.'[33]

The Twentieth Century and Today

Emotion research has, of course, gone through many stages in the century and a half since Darwin published his book. Not only did psychoanalysis come along with its theory of unconscious desires and repressed emotions, but also, enormous strides were made in the fields of anatomy, neurophysiology, brain science, and comparative anthropology. Philosophers too have developed far more sophisticated approaches to the emotions. Emotion processing has been linked to the development of cognitive processes and has been found to be localized in a particular part of the brain, the amygdala.[34] Processing of information about facial identity involves a different part of the brain, the fusiform gyrus in the inferior temporal lobe.[35]

To bring things up to the moment, the key figure to consider is the contemporary psychologist of the face, Paul Ekman. The author of numerous books including *Emotions Revealed: Recognizing Faces and Feelings to Improve Communication and Emotional Life* (2003), Ekman is widely recognized as *the* modern expert on the facial expression of emotions. In the tradition of Duchenne, Bell, and Darwin, Ekman emphasizes the role of underlying facial nerves and muscles in the repertoire of human facial expressions. He also relies on evidence from animal studies and evolutionary biology. Ekman counts Darwin as his one true predecessor, writing,

Fig. 4.6 *Disgust, Anger, and Fear,* emotions illustrated through facial expressions.

The scientific study of the facial expression of emotion began with Charles Darwin's *The Expression of Emotions in Man and Animals*...Among his many extraordinary contributions Darwin gathered evidence that some emotions have a universal facial expression, cited examples, and published pictures suggesting that emotions are evident in other animals, and proposed principles explaining why particular expressions occur for particular emotions...[36]

The one thing Darwin did not do that Ekman considers paramount was to study deception, or how humans are able to convey misleading information with their voluntary behavior.

There is now considerable evidence about the reasons why higher primates developed facial expressions and the ability to recognize their meaning.[37] It is thought that there are two evolutionary pathways for distinct parts of the emotional processing system, one far older and part of the reptilian brain, the other later and involving voluntary muscles associated with the mouth and speaking. 'The resulting fine-tuned control of the lower face not only benefited the repertoire of speech sounds but also supported voluntary facial actions that could be used for visual rather than vocal communication.'[38] Just as there are these diverse routes to facial expression, so are there diverse neural routes to processing facial information. Information about angry faces in particular is processed non-consciously through subcortical routes. 'This system is an evolutionarily ancient one ... and the perceptual analysis it can accomplish is necessarily crude.'[39] Experiments have also shown that 'Eyebrows had the most profound effect on emotional impression, followed in order by mouth and eyes.'[40]

For example, in *About Face* Jonathan Cole argues that these exterior expressions were probably developed alongside the

inner states they accompanied: 'Indeed, a mobile expressive face may have been crucial for this intellectual development. One reason for the success of primates has been their development of complex social groups. These require regulation, based on mutual regard and hierarchy, and I suggest that facial display has a role in this.'[41] Studies of the localization of various abilities within the brain have shown that there is a particular region devoted to face recognition and that when this is damaged, people cannot identify even familiar faces any longer—although, surprisingly, they still can identify and discriminate facial emotions.[42] 'Facial expressions are perceived categorically, not by individual features or a configuration of physical properties. Thus, while specific features and spatial orientations contribute importantly to the accuracy of facial expression recognition, this ability is not dependent on constructed bottom-up processing.'[43]

Ekman, along with other researchers such as Friesen and Izard, has followed in Darwin's steps by studying the nature of facial expression. He also had developed a 'neurocultural' theory of the nature of emotions in general and a typology of the six most fundamental or basic emotions: anger, happiness, fear, disgust, sadness, and surprise.[44] Further, like Darwin, Ekman advances claims that human emotional expression is fundamentally universal, and that it bears clear evolutionary links to expression of similar emotions in other animals. Finally, Ekman also uses photographs as illustrations. He has explained in one interview that he was adept with a camera at age 12, which was partly why he used this tool for his work.

Ekman's research to establish the universality of expressions associated with emotions was grounded in Papua New Guinea, where he used photographs as part of his study. For example, he asked people to show how someone would look who had lost a

child, and took their photo; or he showed photos and asked people to identify the relevant emotions being depicted. In addition to still photography, he has recorded people's emotional reactions on video. To gather information about deceptive emotions he showed certain sorts of grisly films to nursing students and asked them to mask their feelings. Thus a variety of media—photography, film, and video—have been crucial to Ekman's research as well as to the presentation of his findings.

Some of Ekman's recent books are promoted, in effect, as manuals for learning to detect and differentiate various emotions. For these, he has taken photographs of facial expression using human models. He explains that it was important to have the same person in the same lighting conditions display the variety of expressions to enable viewers to learn to make differentiations. Interestingly, the researchers proceeded not by asking their models to feel various emotions (as method actors might, or perhaps as Rejlander did in posing for the Darwin images); but rather, they

> were given instructions such as 'lower your brow so that it looks like this' or 'raise the outer corner of your upper lip,' or 'tighten your lower eyelid.' The models recreated the faces we had seen and studied when people were really experiencing emotions. We were in a sense drawing with a camera—not relying on imagination, as an artist might, or on the models' possible dramatic skill in trying to feel an emotion, but tracing photographically the muscular movements shown in the Facial Atlas.[45]

As mentioned above, Ekman and Friesen focus on six primary emotions in their book *Unmasking the Face* (2003): happiness, sadness, surprise, fear, anger, and disgust. There are other emotions that may be shown in the face, including shame and

excitement, but they comment that these are not as universally recognized by emotion researchers.[46] Similarly, the authors comment that feelings sometimes taken to be emotions, such as love, are not really emotions but something more complex and longer-lasting (and so are moods). Ekman and Friesen also distinguish static, slow, and rapid facial signals.[47] Obviously a key point to be noted is that in our everyday observations of facial emotions, the triggers are living and dynamic, not like the faces in classical portraits or in the photographed studies that they use in their book. Besides, we generally have access to a person's voice as well as to other aspects of their physical demeanor (i.e. body language). These clues are all taken together to help us interpret the emotional expressions of other human beings.

Analysis (1): The Scientific/Philosophical Tradition

The scientific and theoretical or philosophical explorations of the face and facial expression have had varied purposes. For a philosopher like Descartes, the aim is to describe human emotions in a way that is consistent with his general theory of the immaterial soul. Obviously, soul–body interactions are a problem given his separate and distinct accounts of extended and thinking (immaterial) substance. Descartes has to account for both bodily motion of a voluntary sort and for the range of other bodily phenomena that seem closely tied to mental or spiritual experiences—e.g. the passions. In Descartes's work questions of theology and morality are always lurking not too far beneath the surface. Just as for Theophrastus the descriptions of character inevitably linked character both with the humors and with personality types prone to various sorts of virtue or vice, so also

with Descartes. Descartes was prompted to do his work by challenges from his correspondent Princess Elizabeth concerning how mind and body could interact given his accounts of them. He also argued for a sort of stoic approach to the passions according to which these bodily eruptions could be felt, as they inevitably would be, without disturbing a person's equanimity.

Le Brun was attempting to create a science of the passions that would fit the ideal of science of his time. Of course, he also aimed to support the genre of painting that was considered highest, namely, history painting. Beyond this, clearly his *Conférence* had a good deal to do with broader aims of standardizing and setting standards in the art of painting in accordance with the aims of the brand new French academy.

As noted above, physiognomy for Lavater had much to do with both Christianity and his Leibnizian metaphysics of individuality. Hence it is not surprising that physiognomy became closely associated with studies of a person's inherent moral character. Although Lavater, as both a Christian and Leibnizian, could not hold that individual faces were in some way 'bad' or determinative of a grim moral fate, nonetheless his system enabled this to be read from physical traits (as was the case for someone like Judas, illustrated in his book). Thus painters could employ some of the key tenets of physiognomy to enhance or downplay aspects of a sitter's face in order to highlight either negative or positive qualities like a lofty brow or expansive, far-seeing eyes.

For medical scientists like Bell and Duchenne, the issues concerning facial expression of emotion had to do mainly with the mechanics or detailed causal explanations of facial phenomena visibly associated with emotional expression. At the same time, these men were also quite interested in general

issues about morality. Such concerns were now expanded, however, so as to include what we would term 'mental health' in a period that developed new accounts of mental diseases. These illnesses, whether associated with brain problems or with ill-favored cranial bumps and proportions, which were allegedly explicable in scientific terms were also supposed to be made visible through scientific study and typology or systematization. Classifications of persons by type arose in connection with new sciences such as sociology and criminology and were also associated with new methods of tracking individuals for purposes of health care, criminal detection, and so on.[48] Later studies of urban vs. rural 'types' perpetrated and popularized the idea of various physical types which evinced typical forms of behavior.[49]

The main new factor contributed by Darwin was the idea that emotions could be explained by the same processes of evolution as various physical traits, and that the expressions of emotions were often common among men and animals. This view was not shared by Darwin's medical predecessors (though it did show up in Le Brun), and indeed it was strongly disputed by some of them, including Bell. Bell even complained that artists like Rubens had misrepresented their animals by making their expressions too human-like.

By the nineteenth century, ideals of objectivity also contributed to the determination of how a scientific volume, whether on emotions and psychology or on physiology, nerves, and anatomy, ought to be illustrated. We have seen that a general transition occurred from the use of paintings or engravings copied after paintings by great masters to the outline drawing or silhouette, and then ultimately the anatomical drawing and the photograph or photo-mechanical engraving, ultimately being

supplemented by film and video images. These developments accompanied broader shifts in ideas about whether objectivity alone sufficed in the discovery and identification of emotions as external signs of a mysterious, hidden inner phenomenon. Although all the people I have described would have said that there is a natural semiotics of the face, they would not all agree on how it should be studied or portrayed in order to convey its vocabulary or syntax. For some of these thinkers, emotions were classifiable into clear systems. For others, emotions were extremely individualized and context dependent. Some emphasized the goal of capturing a fleeting emotion, and others aimed more at the display of structure.

Objectivity itself is a notion constructed out of considerable complex concerns.[50] The objectivity of the photographic images used by Darwin is, we have seen, quite questionable given his method and the techniques used by Rejlander, with models enacting emotions and then posing. Duchenne's experiments might seem more 'objective', but the images that showed a man's face manipulated by electric shocks were deemed too disturbing by Darwin and altered in his own book so as to remove the hands and wires. Of course, any scientist observing emotions in a laboratory setting is involved in a separation of the emotions from their real-life roles.

Some painters held that observation alone sufficed to enable them to render emotions; others thought this process required a systematic coding system (triangles drawn out of eyebrows, nose, and eyes). Yet others felt that intuition alone, or intuition and empathy coupled with artistic genius, was what was required. In the heyday of physiognomy artists were urged to go to the theater to study great actors to learn more about the expression of emotions.

Ekman's research began in a context of studies from anthropology and ethology by key figures like Gregory Bateson and Margaret Mead, who had argued for a form of cultural relativism. Thus Bateson believed that emotional expression was a form of communication and not something biologically grounded or innate. Ekman says he began his research assuming the truth of such a view, but that his findings began to convince him otherwise, i.e. of the universality of emotional expression, and hence of the truth of Darwin's position. The context made his assumption of this view controversial because by this time that view had become associated with forms of eugenics that argued for the cultural superiority of certain groups over others.

Ekman is another scientist whose work on descriptive differentiation is closely linked, in not even veiled ways, to moral analysis. Thus he purports to be able to use his 'facial action coding system' to be able to differentiate 'true' from 'false' (concealed or faked) emotions. His books bear subtitles like how to tell if people are lying. It is not surprising that he is consulted now by agencies like the FBI, Transportation Security Administration, and Secret Service, or consulted by corporations and experts in criminology and anti-terrorism research. Everyone learns how to 'manage' facial expressions, to use his term; sometimes we must qualify or moderate emotions in accordance with our culture's 'display rules'. Still, people make errors or simply cannot succeed at duplicating purely autonomic aspects of real facial expression, and Ekman provides pictures and self-tests to help one improve in detecting false facial displays. He also comments that some people are professionals and are too good at faking emotions for us to detect—here he mentions actors, trial attorneys, and salesmen.[51] But non-experts give what he describes as 'leakage' and 'deception clues'.

Ekman also presents his work in a self-help mode (witness the subtitles to his books and the inclusion of self-test appendices of photographs in the ends of several of them). He advises readers that 'we can change what we become emotional about' and that we can also aim to 'reduce destructive emotional episodes and enhance constructive emotional episodes'.[52] Ekman has recently participated in discussions with the Dalai Lama (who has helped fund his research) and he claims that his own views on handling emotion are surprisingly similar to those of the Buddhist tradition.[53] He also has turned to place more attention on a multitude of (over a dozen) enjoyable emotions, realizing that up until now he has mostly focused, like many other scientists, on negative or upsetting emotions.[54] The more positive emotions now discussed include feelings like wonder, excitement, gratitude, and bliss. It is somewhat unclear what facial expressions these emotions would be associated with; perhaps Ekman needs to look back into the history of religious art—paintings by Zurbaran, for example—to find appropriate illustrations!

Analysis (2): The Artistic Tradition

The study of facial expression as it played a role in art takes us into larger issues about changing conceptions of art's purpose. In portraiture, greater emphasis on individuality is generally recognized as a development of the modern period. Renaissance portrait artists typically were expected to emphasize their sitter's status and worldly position by the depiction of settings, costume, artefacts, and pose, as we saw in Chapter 3. Early in the modern period, emphasis shifted to the depiction of the subject's moral character (and this had always been more true of women

subjects as well). There was also a new interest in the unique psychology of each individual. It is fairly obvious how the facial coding systems of phrenology and physiognomy would play into such an interest. Similarly, the depiction of expression could help convey certain aspects of the sitter's unique personality. One of the issues Le Brun was involved in concerned whether a depicted person should represent a universal or individual.[55]

A second issue in art theory concerns the larger role of the academic training system, and in conjunction with that, of the history painting. It is no accident that Le Brun was the founder of the painting school of the French Academy, nor that a requirement in artists' training there was the production of an expressive head. For painters at this time the highest art form was the history painting, and expression was deemed crucial to the success of such a genre. In other words, within a large-scale depiction of a battle or a biblical event, the artist sought to include an array of characters whose parts in the historical drama could be readily grasped through reading their facial expression (aided, of course, by other aspects such as pose, position, and costume). Here Le Brun was the true follower of his mentor and idol Poussin, as well as the instructor of his successor as court history painter, Rubens.

A third issue in art theory concerns standards of beauty for the human figure in particular, and for the painting in general. Bell's work as an anatomist was based on a relatively new conception of beauty that insisted that form follows function. Bell was a great admirer of classical sculpture. His notion of beauty included the idea that expressive faces ought to be somewhat exaggerated to bring out the form–function relationship. In this he was very influential and contributed to a larger attack that led to the breakdown of the more detached idealized conception of

beauty advocated by scholars like Winckelmann and Lessing. Cummings explains, 'Winckelmann and Lessing at the same time insisted that expression was inimical to beauty, that beauty of form was everything.'[56]

Bell is an especially interesting example to consider, since he not only participated in a changing aesthetic discourse about beauty, and was hence very influential upon the artists of his time, but also held that artists themselves must acquire scientific knowledge and adopt a scientific approach to their subject matter. Along with the shift from an idealized conception of beauty to a more naturalistic one, he held that artists needed to study how nature is actually set up:

> Indeed, according to Bell, the artist must become a scientist, because his capacity to look for the right thing and his power to achieve visual effects derive from his comprehension of the structure of which the visible is composed. The artist had to dissect in order to know how structure constitutes form.[57]

Bell's insistence on scientific background regarding the physiology of emotion is analogous to Alberti's positing of a scientific basis for the art of painting in geometry and perspective. It was done for the same purpose: to raise the artist above a mere mechanic copying what he sees to the level of a poet who, as a result of his knowledge or science, grasps the exterior world almost intuitively and transforms it by means of his art.[58] This contributed in general to a de-emphasis on the history painting as the pre-eminent genre of art.[59]

Interestingly, as I have noted, Ekman's studies employ video, and he often uses actors who are asked to model various emotions (just as Darwin or Rejlander did). This makes it especially apt to compare some of Ekman's imagery to the large-scale,

slow-motion imagery in the recent major video installation exhibit *The Passions* (2003) by contemporary artist Bill Viola (b. 1951). *The Passions*, which was launched at the Getty Museum in Los Angeles, has since been exhibited at the National Gallery of London, Metropolitan Museum in New York, and the National Gallery of Australia in Canberra. Viola's exhibit comprises a number of separate video pieces of various sizes and compositions. Some are very large and some relatively small; some involve use of one screen and some involve up to as many as six display panels mounted together. One piece in the exhibit takes the form of a diptych mounted in an upright formation resembling the open leaves of a large book. Viola's works are all shown on state-of-the-art high-resolution plasma screens with remarkable sharpness and vivid colors. They employ works originally created in film that are subsequently screened at extreme slow motion in the medium of video.

One sample work is titled, *Six Heads* (2000). It is described by the catalog as 'Color video on plasma display mounted on wall.' In addition, the catalog tells us,

> Viola used video to shoot an actor gradually entering and leaving various emotional states, sometimes looking ecstatically out of the frame, and made a montage of six different takes on a single plasma monitor—a kind of living, breathing, baroque study of inner drama.[60]

Viola has been at the forefront of video art since its beginning. His work on *The Passions* was stimulated by a year in residence at the Getty Institute as part of a fellowship group studying passions and emotions. Viola was particularly influenced by the depiction of emotions in northern Renaissance Christian art and, as with the *Six Heads* just described, he cites various

Fig. 4.7 *Six Heads* (2000), Bill Viola, colour video on plasma display, video still.

examples of works from that period as his inspiration, for example, Mantegna's *Adoration of the Magi*. Viola was also inspired by images of saints having visions in which the focus was on views of the saint's face with the actual content of the vision left off-screen as it were—left up to our imagination. Viola employed this technique in his work *For the Millennium* by showing a line of people advancing to view something apparently horrendous and reacting to it; we the viewers see only their faces, not what they see.

The effect of some of these works is mesmerizing. It depends partly upon the voyeuristic pleasure of being able to observe someone minutely as the almost infinitely slow motion of the screen shows tiny changes in their mouth, face, and eyes. But beyond this the images—at least some of them—are emotionally contagious. Viola seeks this effect, commenting about his work *Silent Mountain* (2001),

> Emotions from another transmit right into our bodies, not just to our eyes. When you see someone in distress, your response is to want to help them. Like an antenna, we often feel the feeling that another is experiencing. There's a kind of transmission of the self that's going on here, underneath the words and specific circumstances.[61]

Viola worked with actors in the pieces for *The Passions* (it was actually the first time he had done so). This raises some interesting questions. Recall that Ekman's view is that faked emotions are differently displayed from real ones. But he also acknowledges that some people, including actors, are very good at faking emotions. So one wonders if a person trained in Ekman's facial acting coding system would be able to detect the deceptions involved in emotional displays by some of Viola's actors. For an amateur observer like myself, they appear very convincing.

A further problem, and I think a more serious one, is that Viola sought to study pure emotions out of any ordinary context. He compared this to studying a pure color like red in abstraction. Whether this works is debatable as it seems to negate one of the premises of emotions as they are now understood: complex responses to situations that include a perception, a feeling, and a readiness for action.[62] I found some of the works in *The Passions* a bit gimmicky, while others were profoundly moving and even emotionally upsetting.[63] Other viewers were far more critical, and there were complaints about the catalog's comparisons between Viola and 'real' artists of the face like Rubens.[64] One reviewer targeted 'the woolliness of the ideas behind it, the attempt to dazzle the viewer with technological effects that hide the absolute emptiness of the art.' My assessment is that those among Viola's pieces in this exhibit, the ones that involve a more theatrical or narrative premise prove to be more successful and effective. This is easy to explain, because human emotions, given more of a situational context, become more realistic— easier both to express and to comprehend visually by looking at the face of another person.

Conclusion

My broadest aim in this chapter has been to sketch how art and science have interacted in benchmark periods in the development of portraiture since the seventeenth century. Both fields, art and science, have contributed to evolving ideals of the scope and meaning of facial expression in representational genres, from painting and drawing to photography, film, and video. Each stage both reflects and shapes broader cultural agreements

about the very nature of human emotion and, in turn, what it is to be human. And these agreements become part of artists' conceptions of what is important to include in their representations of people in portraits.

The end of my historical story of this relationship between artistic representation of emotional expression and the scientific study of the same topic is a complicated one. Of course, portraiture itself has changed drastically in the time period from Le Brun and Rubens to Francis Bacon, Lucian Freud, Picasso, and Matisse (let alone more recent artists like Andy Warhol, Cindy Sherman, Jeff Koons, and John Currin). The shift in art itself from representation to abstraction is a topic that has been dealt with often, typically attributed to the threat to painting from the newly developed medium of photography. Portraiture did not go away, of course, but in the periods of Impressionism, Expressionism, Cubism, and then Abstract Expressionism, not to mention Photorealism, Postmodernism, etc., it underwent numerous changes. We do still find portraits in the work of many modern artists, however, and portraiture has also been central to the practice of some postmodernists like Gerhard Richter and Cindy Sherman. The variety here truly defies description. I shall return with more comments on such work in Chapter 7 below.

A factor less commonly recognized as constituting a threat to the depiction of emotions in art was the rise of the new genre of cinema. Why settle for even the best and most intense rendering of a static facial expression when one could see the entire course of an emotion as it developed, peaked, and faded, depicted in a masterwork like Carl Dreyer's *The Passion of Joan of Arc*? Acting on stage had, of course, always been a potential rival to painting in the contest of rendering emotions, but this new medium of cinema offered something visual that could also be fixed or

preserved. It had the additional appeal of mass exposure (which, of course, had its drawbacks and evoked charges like those Adorno expressed for crass ideologies in the new mass marketed art forms[65]). The incorporation of narrative adds a crucial dimension to cinema that is less readily adapted to forms of still visual art but that enhances the naturalism of emotional expression. This probably explains why today almost all scientists who study emotions use film and video as their primary medium— both for stimulus objects and for recording and discriminating among records of the emotional experience (that is, all except for the neuroscientists, who use another form of visual rendering, the fMRI or PET scan).

Portraiture in the still mediums of painting, sculpture, and photography has become more expressive and naturalistic while yet still aiming to present a glimpse into a person's life that is somehow revealing. If we think back to the picture of my grandmother that seemed so particularly vivid to me, the one that captured her 'air', I suggested that it did so because it showed a characteristic expression she had that seemed to reveal basic features of her character. In my last chapter we saw that the earliest sort of portraiture, like that of the queens and kings of England, showed people who looked almost unnaturally cool and impersonal. Their stiff demeanor was held appropriate and reflected their status. Today a portrait artist like Lucian Freud, even when tackling such an eminent portrait subject as Her Majesty Queen Elizabeth II, tries to convey her inner character as revealed in her facial features—such as the strength tending toward stubbornness typified by a certain clenching of the jaw. Artists are no longer required to flatter their royal subjects. And in fact, even an artist like Goya managed in his time to show aspects of character when he painted the royal family of Spain.

The fascination of portraits has for many centuries now included curiosity about the inner lives of those shown in art, as well as in their external appearances. As humans we are all attuned to the vivacity and variety of other humans' emotional expressions, and we are also experienced in discerning aspects of interior life shown in a person's outward behavior, most especially in that favorite subject of portrait artists, the face.

Self-Knowledge

Introduction

In this chapter I will delve more deeply into the question of what portraiture can tell us about the self. Not surprisingly, I believe that portraits in general, and more especially self-portraits, do inform us about selves. But they do so in ways that either undermine or supplement one of the most popular current philosophical accounts of the self, the so-called narrative view. According to this view, the self is or involves an ongoing and coherent story linking past with future into a meaningful whole. In my next section I will give more details about recent narrative accounts of the self, arguing that they are flawed in part because they fail to consider some important issues about the very nature of narrative.

Then I will move on to examine portraits, focusing on several important examples of artists' self-portraits. Self-portraiture will be helpful to focus on in assessing the ways in which portraits can tell us about persons, because this genre enables us to bypass the complex negotiations of identity between the artist and sitter when the two are distinct. Even in the best circumstances with a

very cooperative subject, it is still often true that this interaction involves a kind of psychological struggle. The artist seeks to show a unique perception of the subject, while that subject at the same time attempts to project a particular self-image.[1] Thus Matisse wrote, 'The art of portraiture . . . demands especial gifts of the artist, and the possibility of an almost total identification of the painter with his model.' 'I believe, however, that the essential expression of a work depends almost entirely on the projection of the feeling of the artist in relation to his model rather than in organic accuracy.'[2] We can limit these complications by zeroing in on self-portraits, where, presumably, artists have more freedom to capture both what they see and what they want to project about an inner self.

My survey of self-portraits in art begins with a brief overview of two early Renaissance artists, Albrecht Dürer and Sofonisba Anguissola, who were among the very first artists to create independent self-portraits. After that I will focus on three artists who are especially well known for their interest in self-portraits. All three created such works repeatedly over the length of their careers: Rembrandt van Rijn, Paul Cézanne, and Frida Kahlo. Their production amounts to a kind of 'serial self-portraiture'. Art historians have advanced readings of these painters' multiple self-portraits as constituting narratives of various sorts—autobiographies, life stories, or even films. But I plan to show that their works do not actually support narrative accounts of the self.

The key problem with narrative accounts, and an important way in which they fail to account for artists' self-portraits, is precisely that the basic notion of 'narrative' is derived from literary or textual rather than visual sources. At its root, the notion of narrative requires some conception of action—of human aims and agency. Of course we can also speak about

visual narratives, but the things that we see and process through direct visual perception affect us in ways that are different from the information we glean from narratives. Because of our evolution, such perceptions are directly intentional: subject and object are co-present. In other words, when we see the bodies, faces, gestures, or in short the material realizations of other persons, whether in real life or in a portrait medium, we can directly experience the real existence of other people with minds. People's bodies and especially their faces offer us an entryway into their ongoing internal lives. This sort of entry can also be supplied by narratives, but in such cases it must be inferred from them more abstractly and is not 'given' in the same direct, evidential way.[3] This is partly why I have spent time on the topic of expression in my Chapter 4, so as to highlight the fundamental ability that humans have both to recognize faces and to differentiate and understand facial expressions.

Below I will say more about some important features of persons that artists bring to the fore in their portraits. The intense self-scrutiny of great artists, particularly those who produced many works in this genre over a period of time, can reveal important things about persons in their (or our own) physical realizations. Such images make visible an inhabited body for us all to ponder. The artist presents his or her embodied self to the world in a way that is simply *not narrative*. This body is physical and as such vulnerable, an object available for viewers to gaze upon. Yet it is somehow assertively defended as worthwhile and interesting, even as it disappoints, suffers, and ages. This is true even for an artist like Cézanne who is often taken to be less interested in subject matter than in form or style. He paints with a focus on the representation of volume and space, appearing to treat bodies, heads, and faces—even those of his wife and

himself—as mere physical objects that are interjected amidst the inert items of an interior or landscape. Though this concern certainly did occupy Cézanne, there is much more at stake in his portraiture, including very personal concerns, as we shall see.

The case for portraiture as revelatory of the person is much easier to make for an artist like Rembrandt, one of the most prolific self-portrayers in all of art history. Like many other viewers, I find his portraits and self-portraits enormously engaging and thoughtful. Here is what one scholar has had to say about one of his late self-portraits:

> In his last decade, Rembrandt ceased to do self-portrait etchings but did a greater number of self-portrait paintings than before. He made several in 1659, and one of them, now owned by the National Gallery of Art in Washington, D.C., is surely one of the most profound explorations of a human being in art.[4]

This idea that a painting can constitute 'a profound exploration of a human being' is precisely what I aim to explore further as I proceed.

Narrative Theories of the Self

Recent exponents of narrative accounts of the self include the philosophers Alasdair MacIntyre and Charles Taylor, as well as psychologists such as Jerome Bruner and Oliver Sacks.[5] For example, Alasdair MacIntyre writes,

> The unity of a human life...is the unity of a narrative quest... [and] the only criteria for success or failure in a human life as a whole are the criteria for success or failure in a narrated or to-be-narrated quest....A quest for what?...a quest for the

good...the good life for man is the life spent in seeking for the good life for man.[6]

Daniel Dennett agrees, with the proviso that there is no conscious narrator for the story that constitutes a self, which he also describes as the subject of a fictional autobiography. Dennett writes,

> We are all virtuoso novelists.... We try to make all of our material cohere into a single good story. And that story is our autobiography. The chief fictional character...of that autobiography is one's self.[7]

Another defender of the narrative self-constitution view is David Velleman, who says,

> My only disagreement with Dennett will be that, whereas he regards an autobiography as fictive and consequently false in characterizing its protagonist, I regard it as both fictive and true. We invent ourselves, I shall argue, but we really are the characters whom we invent.[8]

Unlike Dennett, Velleman emphasizes the two-way interactions between the self as narrator and self as agent. He explains, 'Yet if a self-narrator works in both directions, then the self he invents is not just an idle fiction, a useful abstraction for interpreting his behavior. It—or, more precisely, his representation of it—is a determinant of the very behavior that it's useful for interpreting.'[9]

The most extended development of the narrative account of the self is in Marya Schechtman's book *The Constitution of Selves*. As she puts it, 'Roughly, then, the narrative self-constitution view requires that a person have a self-conception that coheres to produce a well-defined character.' Or again, 'A person creates his identity by forming an autobiographical narrative of his life.'[10] Our distinctive form of existence as temporally extended

individuals means that we are beings for whom the past and present are particularly significant—and in this way unlike most animals. Schechtman explains, 'Individuals constitute themselves as persons by coming to think of themselves as persisting subjects who have had experience in the past and will continue to have experience in the future.'[11]

Sensibly, Schechtman notes that not just *any* sort of narrative will work to constitute a self. Otherwise we might be surrounded by selves with grandiose delusions (or worse). She describes two main constraints on such narratives. The first of these is the *articulation constraint*. 'The narrative self-constitution view does not allow a person's self-narrative to remain entirely subterranean. A further requirement is that an identity-constituting narrative be capable of local articulation.'[12] The second constraint is the *reality constraint*. This is the requirement of truthfulness to the facts. Here Schechtman comments, 'To be a person in the sense at issue here is to be able to engage in certain kinds of activities and interactions with others, and living the life of a person requires living in the same world as other persons.'[13]

The reality constraint is the route through which Schechtman acknowledges what might otherwise seem to be neglected by a narrative view, the important role of *bodies* in accounting for what a person is. She explains, 'Because the reidentification of human bodies plays such an important role in our social interactions, the narrative self-constitution view demands that it play a central role in the constitution of persons and personal identity, even though this view does not simply identify persons with human beings.'[14]

Although she does not explicitly add this as another constraint to her account of how narratives constitute selves, Schechtman also has in mind by the self-narrative of a life that it be or take the form of a certain standard sort of narrative. As any educated

reader will know, however, in the twentieth and twenty-first centuries both literature and drama (not to mention film) have expanded to include a dizzying variety of experimental narrative forms: non-linear, retrogressive, non-closed, etc. We can think of authors like Joyce, Pinter, Beckett, Faulkner, Robbe-Grillet, and others, and of a wide variety of avant-garde film techniques, many of which have by now filtered over into more mainstream use. Recognizing the existence of non-standard narratives, Schechtman at first seems open to such experimental forms as modes of self-constitution, remarking that, 'All of the stretching and redefining of narrative that is possible in literature, it seems, might occur in an individual's self-conception, and so many alternative narrative forms are possible.'[15] This suggests that persons might adopt forms of narrative self-constitution as diverse as those of various experimental authors or film-makers. However, in fact, Schechtman's expectation for narrative is much narrower. She writes that, 'A self-narrative that deviates sufficiently from the form of a conventional story does not constitute a person or create a personal identity.'[16] We might want to call such persons postmodern people rather than ordinary people.

Despite its many adherents, the narrative view of the self has met with some philosophical criticism.[17] To explain my own doubts about such a view, next I will I describe three broad problems about this sort of an approach.

Three Problems about Narrative Theories of Self

Narrative has been much studied and discussed, of course; and yet strangely, the philosophical and methodological explorations of the nature of narrative seem to transpire in a separate intellectual

sphere from ongoing discussions of narrative self-constitution.[18] This is a problem, which might be what prompted Peter Lamarque to write his article 'On Not Expecting Too Much from Narrative' (2004). Lamarque voices numerous doubts about the narrative self-constitution view, arguing that it invokes too many similarities between fiction and autobiography. He also claims that defenders of the view tend to conflate the distinction between the *narrator* and the *product* (the self as storyteller vs. story); that most of our stories about ourselves are quite fragmented, banal, and uninteresting, lacking the drama or unity that is presumed by figures like MacIntyre; that subjects *do* exist even without narrating themselves; that 'life-narratives rarely attain completeness, closure or unity'; and that their 'explanatory value is true, but not profound'. I will pursue several of these points here, grouping them into concerns about narrative *connection*, narrative *closure*, and narrative *explanation*.

Noël Carroll has proposed the leading account of narrative *connection*.[19] He describes five necessary conditions for narrative connection that are jointly sufficient, with the fifth being the most significant:

(1) the discourse represents at least two events and/or states of affairs (2) in a globally forward-looking manner (3) concerning the career of at least one unified subject (4) where the temporal relations between the events and/or states of affairs are perspicuously [retrievably and clearly] ordered, and (5) where the earlier events in the sequence are at least causally necessary conditions for the causation of later events and/or states of affairs (or are contributions thereto).[20]

Carroll offers further specification of the sort of causal linkage he believes is relevant here.

Concerning a life-narrative that is self-constituting, it appears that many of Carroll's conditions might be met without much difficulty, except for the fifth one—but this is the one he considers the most significant. Looking back as far as Aristotle, most writers accept the idea that narratives have a temporal structure. But what about our lives' beginnings and endings—we can't really narrate those, can we? Lamarque cites this point in his argument for the implausibility of the narrative view of the self: in fact we are unable to have coherent narratives of our own beginnings and endings. More importantly, the chains or sequences in a person's life generally involve a high degree of contingency or randomness. No one can be perfectly in control of the events that occur in life, which is full of accidents, illnesses, odd conjunctions, and surprises. If things happen in life in such a purely random way then it appears impossible to seek or to provide even the somewhat minimal yet requisite sorts of causal connections needed for a narrative connection.

The second main issue to consider about the nature of narrative concerns narrative *closure*. This is a topic Carroll has also addressed.[21] First he points out that not all narratives do have such closure—nor are they all expected to: soap operas, for example. There might be interim types of closure in a soap opera, but as a whole the narrative is expected to be ongoing. Carroll thinks that narratives fundamentally raise certain sorts of questions such as 'Why?' or 'What next?' Closure involves answering these questions. He calls it 'the feeling of finality when all the questions raised by a narrative are answered'. Narratives can have both macro- and micro-closure. Episodes within a narrative might have their own sets of questions and answers, and so does the larger structure within which these episodes fit.

Again, however, in relation to a life story, this notion of narrative closure is difficult to apply. Our lives seem more like soap operas: they might have intermittent episodes with closure, but there is generally no larger kind of closure. If there is, it is probably fake or artificially imposed. An autobiography in progress can never possess closure, yet after someone is dead (or, alas, advanced into senile dementia), it is no longer possible for them to finish their story. Accidents or various kinds of inadequacies can interrupt trains of planned events, preventing achievement of the aims that would bring closure to the sequence that constitutes a life. And in some ways, the very notion of bringing 'closure' to one's life-events sounds odd. What would constitute closure of such landmark events as graduations and marriages, prom dates, births, or the purchase of a new house?

Finally, I turn to a third problem about narrative, the nature of narrative *explanation*. Focusing on this topic, Ismay Barwell has argued that Carroll's account of narrative connections must be supplemented.[22] In her view, developed with various examples, a narrative can be constituted *either* by the presence of the right sorts of causal connections *and/or* by the presence of an evaluative dimension that links earlier events in a series to its later or final events. In the latter sort of case, we can evaluate the end of the story in light of its various component factors so as to pronounce it satisfying and fitting, or not. This proposal makes some accidental sorts of narratives (those lacking any coherent causal explanatory connections) 'work'. One of Barwell's examples is the famous ancient story of Mitys' statue, which accidentally fell on and killed the man who had murdered Mitys. Though no causal connection was at work here, the narrative seems like a good one to us—it seems to actually *be* a narrative—because it involves the notion of poetic justice. The concluding event of the

murderer being killed seems right or fitting in relation to earlier events including the murder itself. This is the sort of thing that someone could have planned. Even if the fall of the statue was purely accidental, it makes for a good story or satisfying narrative.

As with the first two issues, this broad question about narrative explanation is relevant to discussions of how narratives could be self-constituting narratives. At first, Barwell's idea of adding in an evaluative element so as to expand the sorts of connections that constitute a narrative seems attractive. It appears to answer my concerns about the lack of fit between Carroll's conception of narrative connection and our actual, often random and chance-filled, life stories. However, closer examination shows a problem. The idea of evaluation, or of somehow assessing whether in light of an end, the earlier parts of the narrative 'fit' appropriately, suggests that we are importing a human dimension or a purely subjective valuation into our assessment of what was thought, at least initially, to be a sort of metaphysical connection. Things make for a good story if they 'make sense' to us in terms of human aims, motives, and ends rather than if they are *in fact* really connected.

Along similar lines, and explicitly endorsing such subjectivism (if we can call it that), Susan Feagin has also recommended supplementing Carroll's notion of narrative closure. Feagin notes that historical narratives tend to emphasize the importance of human agency. Such narratives include mention of human psychological factors such as motives, aims, and plans. This suggests that a narrative acquires its intelligibility by alluding to the activities of a conscious, rational self—a being with a continuous past, present, and future.[23] Our human lives are forward-looking and depend upon ourselves as persons being temporally extended and looking in our aims toward the future.

Ironically, what this means is that a correct and plausible philosophical account of narrative, at least according to Feagin, must ultimately invoke certain facts about human nature. On this proposal we should explain narrative in terms of selves—a proposal that must sound rather startling to those who seek instead to explain the self in terms of narrative.[24] *Something* has to be fundamental here—either the story or the person. In my opinion, it is the person and not the story. We need something different to help explain what a person is, and this something different should not itself be a narrative. Next I will proceed to add more, both to my doubts about narrative theories of the self and to the alternative options, through an examination of self-portraits in visual art.

Pictorial Narratives

Art historians tend to draw a broad distinction between portraits and narrative pictures. The latter term is used to describe scenes with narrative content, deriving typically from biblical or ancient history or mythology. Narrative pictures are considered to fall into two broad categories, history paintings and genre paintings.

Portraits are paradigms of non-narrative art. Historically, portraits were considered less inventive and lower in status than history paintings.[25] This hierarchy, which already existed in the Italian Renaissance, became formalized by André Félibien in the French Academy in 1667. The reason for their lower status was that portraits were thought to involve less imagination or 'invention' than narrative pictures. A portrait aimed at being a faithful likeness, and experts regarded this as implying that the painter was restricted to slavish copying of appearances.

In contrast, the narrative artist was superior because he had to use imagination or *inventio* to construct complex scenes of people interacting in a grand and important situation. The work on composition alone in such paintings was considered far more challenging and glorious. Rubens's painting of the crocodile and hippopotamus hunt, discussed in Chapter 1 above, would be a good example. It depicts the moment of a ferocious, elemental struggle when things are at their peak and some men (or creatures) are surely about to die.

Examples of history paintings include famous Roman scenes re-created by David, or depictions of victorious generals in battle, such as *Washington Crossing the Delaware* by Emanuel Leutze, 1851. Examples of genre scenes include works by Bruegel, Vermeer, Greuze, and Hogarth, for example, Vermeer's *Woman Holding a Balance* (1664).

But in fact, matters are more complicated than the simple theoretical dichotomy between narrative paintings and portraits would suggest. Various types of portraits have often included symbolic elements that push them in the direction of narrative. There are many examples of this, but I can mention one type for now: the wedding portrait. Wedding portraits were often done as pair paintings, i.e. as pairs of separate pictures meant to be hung together in a room—say, over the fireplace. There were conventions concerning pose and attributes in these paired pictures, so that, for example, a woman's holding a fan or gloves in particular ways could indicate certain things about her and about her relationship to her husband. In the pair portrait as it developed in eighteenth-century England, the newly wedded couple was often portrayed in front of a landscape, indicating both ownership of property and plans for its future improvement. At times the husband was depicted in discourse, so as to improve

the character of his wife.[26] Another kind of narrative pair portrait that became very popular in this time period was the so-called 'promenade' portrait, in which the couple put itself on display by walking along a path, which might in fact be an actual and recognizable public path meant for the mutual display and recognition of their status, finery, wealth, etc.[27]

A nice example of the overlap between genres of portrait and narrative picture is the lovely painting Gainsborough did of his two daughters. While this might strike us, reasonably, as a double portrait of these cute little girls, it too can be interpreted as having important narrative elements. The older daughter, at the right, restrains the younger one, at the left, from her impulsive pursuit of a butterfly, helping to teach her the value of self-restraint. This lesson is reinforced by the fact that the older girl is heading straight ahead on the path while her sister threatens to veer off it in pursuit of bright but transient pleasures. Reinforcing the message, there are thistles at the left side whose thorns menace the younger girl's fingers should she really try to grasp the elusive butterfly. Thus, her elder sister is protecting her from physical harm as well.

Early Self-Portraiture: Dürer and Anguissola

Albrecht Dürer painted what are often described as the earliest autonomous self-portraits in western art. These began to appear by the late 1400s and early 1500s. Of his three self-portraits in oil, the first two are known respectively as the *Louvre Self-Portrait* (1493), and the *Prado Self-Portrait* (1498).

Looking at these pictures, we can conclude various things: that Dürer was a handsome, blond-ish man, with a taste for

Fig. 5.1 *Self Portrait* (1500), Albrecht Dürer. The artist's Christ-like representation of himself.

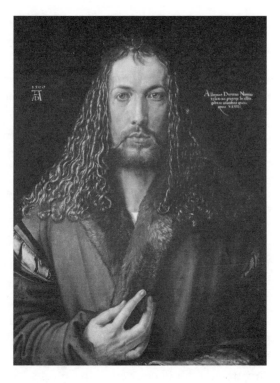

Fig. 5.1 *Self Portrait* (1500), Albrecht Dürer. The artist's Christ-like representation of himself.

elegant clothing and fancy hats. Art historians tell us much more; for example, that the *Louvre Self-Portrait* was a wedding gift for his bride-to-be and that the flower in his hands is a symbol of virility or performance enhancement. As for the *Prado Self-Portrait*, the inclusion of a landscape scene indicates Dürer's pride that he has been over the Alps to Italy. His gloves are made in Nuremberg, his home city. He exhibits pride in his appearance and asserts his status as a fine gentleman, in an era when artists were typically regarded more as workmen and inferiors. Notice the visual similarity in the two poses, half-length, three-quarters

turned, hands together at the lower right of the picture plane. Art historians also remind us that in this time period there were no large mirrors, as technology did not yet permit them. The self-portrait is all the more impressive if we keep in mind that Dürer had to have worked from a fairly small-sized, hand-held mirror in scanning and portraying himself.

These images scarcely prepare us for the majestic—even messianic—self-portrait of 1500, the *Munich Self-Portrait*. Art historian Joseph Leo Koerner comments, 'Dürer's panel will always convince us that it was made to stand as frontispiece for surveys of northern Renaissance art.' Clearly this is a person who has a strong sense of mission and importance. The pose has shifted to a full-frontal position. Dürer is still dressed elegantly, this time with a fur collar to which his delicate hand draws attention. He does not wear an elegant hat this time but his hair is beautifully curled with every strand included in the frame. Koerner notes that, unlike the earlier two paintings, in this one Dürer's actual right hand (mirrored here as his left) is missing, cut off at the bottom of the panel, as if to indicate the active artistry at work in creation of this image.

Of course the most noteworthy aspect of the *Munich Self-Portrait* is the Christ reference. While this might appear delusional, Koerner argues that Dürer was deeply religious and was illustrating aspects of his own faith. Koerner explains it this way: the Munich self-portrait 'thematizes the unbridgeable rift between himself, in all his vanity, narcissism, and specificity, and the higher role to which he aspires. Dürer presents himself *as* Christ but reveals himself to be mere man.'[28] Besides comparing himself to Christ, Dürer is also comparing himself as artist to the creative artist of the universe, God himself. Again, although this might appear to betray sinful hubris, Koerner explains that Dürer

wants to emphasize the seriousness of the artist's vocation and express his devotion to the task of creation.

These self-portraits by Dürer lead to various observations. Not surprisingly, a major concern they express is the nature of art and the artist's status in society. Dürer is asserting not only his skill but his gentlemanly status through the depictions of his clothing, gloves, and the general refinement of his appearance—the carefully coiffed hair and delicate hands, for example. These features also express aspects of his religious beliefs which would have been clearer to his contemporaries who were familiar with the kind of Christ depictions he was alluding to in the *Munich Self-Portrait.* Beyond all this there is always an element of self-conscious reflection upon art and the role of the artist. Here the issue is not so much the artist's social status as his 'ontological' status, as it were—his being a creator of original works and as such an imitator of the divine artist.

Another of the very earliest artists of self-portraits is Sofonisba Anguissola. Her self-portraits emphasized her virtue, elegance, talents, and simplicity.[29] It was not until the 1550s that artists posed themselves with tools of their trade. One of the more fascinating examples of her work is one she did which shows herself in a portrait that is being painted by an artist who was quite possibly her teacher and mentor. '[It is] at once a homage to her master, and an affirmation of her own emancipation from apprenticeship,' writes Joanna Woods-Marsden. In another self-portrait that survives only in an engraved copy, Anguissola features her rich clothing at court in Madrid. She fingers a heavy gold chain—a significant gift from Philip II, who gave the same rare mark of distinction to Titian.

Lessons about this genre that can be discerned from Anguissola's case are that in the sixteenth century, female artists were

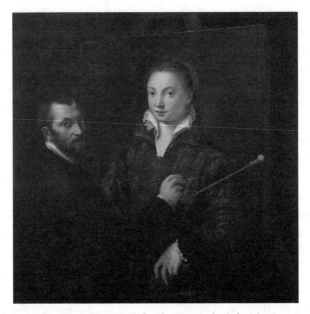

Fig. 5.2 *Bernardino Campi Painting Sofonisba Anguissola,* Sofonisba Anguissola (1557–79). Anguissola painted this image of herself being painted by her mentor.

possible in Europe, but only if they were from among the aristocracy. (It was another 100 years before Artemisia Gentileschi, daughter of a famous painter, could acquire enough fame to secure her own commissions and financial independence.) In fact, Anguissola was never herself paid for her art. Instead, she was employed as a lady-in-waiting to the wife of Philip II of Spain. Her salary was paid to her father and she received rich gifts such as dresses and jewelry. Scholars comment that various weaknesses in her compositions reveal her lack of training. It was also possible that she was able to succeed to the extent she did as an artist because in this period portraiture was considered an inferior

art aiming at mere imitation and lacking 'invention'. Despite this restriction, some of her images were praised for having some narrative significance and thus including an element of '*inventio*'. A noted case of this is the depiction of a chess game she did including her three younger sisters. Finally, as with Dürer, Anguissola's self-portraits reveal pride in her social status and artistic accomplishments.

Dürer and Anguissola images both involved a kind of self-promotion. Whereas in Dürer's earlier two self-portraits he was already a successful artist and aimed primarily at reinforcing his status as a gentleman, Anguissola's enterprise went in the reverse direction: she was an aristocrat who wanted to make the case (or her father did on her behalf) that she was a good artist. In both cases there is little emphasis on some aspects of representing a person that we might now expect to see, such as further exploration of facial expressions or of emotions (as, say, with Lucian Freud's portrait of Queen Elizabeth II). Of course each artist succeeds in conveying that they are someone with presence and with a kind of gravity and seriousness. Probably the most interesting from all of these examples of images is the Christ-like self-representation of Dürer's monumental 1500 *Munich Self-Portrait*.

One problem with tying these early examples of self-portraiture to the theme about narrative and the self is that there is relatively little material to consider. If we have only a few pictures then it is hard to draw much of a conclusion about connections among diverse temporal stages of a person's life. We do have one image Anguissola did when she was much older, but I have not been able to learn much about it. It is interesting to observe, at least, how very similar this portrait is to some of the earlier ones in pose, dress, and overall 'look' of the person. She is recognizably the same woman, still graceful but somewhat reserved and even

inscrutable. The next three artists I will consider as my case studies provide us with a far greater wealth of information on which to proceed in evaluating the narrative view of the self.

Case Study 1: Rembrandt

Rembrandt was a particularly prolific self-portrait artist. Susan Fegley Osmond informs us that,

> he depicted himself in approximately forty to fifty extant paintings, about thirty-two etchings, and seven drawings. It is an output unique in history; most artists produce only a handful of self-portraits, if that. And why Rembrandt did this is one of the great mysteries of art history.[30]

There are numerous speculations about Rembrandt's preoccupation with self-portraiture. 'From youth to old age, Rembrandt scrutinized himself before the mirror, painting, etching, and drawing his changing physique and physiognomy as well as the varying psychological states that reflected the fluctuating fortunes of his life.'[31]

A first concern that seems evident in these works, as with the previous artists I discussed, is Rembrandt's social status and his identity as a gentleman. This concern shows up in his elegant garb, cloaks, hats, armor, and even in the poses in some of the images. Along with this is a concern with his artistic status and success.

Another conjecture about at least some of the images is that they are studies for paintings. Rembrandt used himself because he was a cheap, readily available model when he was planning certain sorts of composite history paintings or biblical portraits. This might account for the self-portraits showing extreme facial

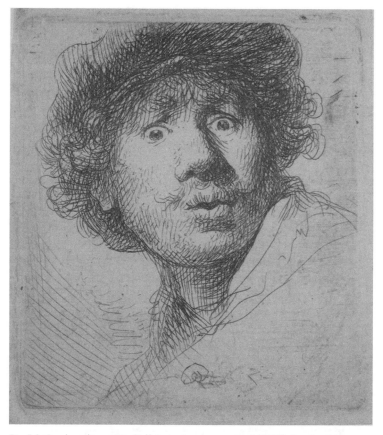

Fig. 5.3 *Rembrandt van Rijn 'Self-Portrait, open mouthed'* (1630). Rembrandt exploring some of his own moods.

expressions, ones for instance where he is laughing or fearful. But these may also have been examples of a genre called 'tronies' which were popular at the time and had a good market.

At a deeper level, we can sense that Rembrandt is seeking to formulate and reveal a conception of his own psychological

identity, the unique person that he was. This fits with the view expressed by Arthur Wheelock Jr., who notes:

> [Rembrandt] was a singularly complex individual, who from an early age seems to have fostered the image that he was different from other men, and that neither his talent nor his success depended upon others or upon the good fortune that came his way.

Wheelock later comments,

> Rembrandt's earliest self-portraits are of particular interest because they demonstrate that the myth of Rembrandt as isolated genius did not first emerge in the Romantic era...but was fostered and developed by the artist himself.[32]

Along these lines, art historians compare Rembrandt to more recent artists who have used the self-portrait as a form of experimenting with self-formation by trying on various identities (Rembrandt as the Andy Warhol of the seventeenth century!).

> Like Cézanne more than two centuries later, Rembrandt employed the self-portrait as part of an effort to fashion the self, a self that took on multiple forms as the Dutch master progressed from youth to old age.

> Apparently, the identity of the artist-patriot seemed most agreeable to the youthful Rembrandt. As he matured, however, armor, patriotism, and all of the glamorous associations of war would lose their general appeal, and other identities would more powerfully attract his unsettled self.

> Beginning in 1629, Rembrandt embarked on a new trajectory and began to fashion different identities in independent self-portraits. It was as if he was searching for a fit—a persona that would best align with his propensities at the time.

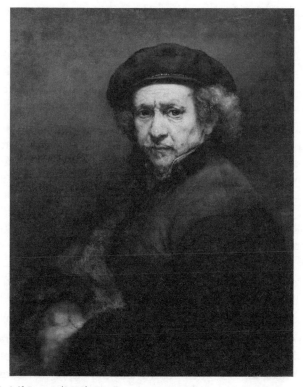

Fig. 5.4 *Self-Portrait* (1659), Rembrandt van Rijn. The artist's painfully honest self-examination.

His appeal is perhaps to be found in his ability to paint 'between the lines' to give the viewer the tools to see through the very self-images he constructs. Thus when he poses one senses the artifice, and when he reveals one is smitten with the sincerity of the disclosure . . . [33]

A fourth and final hypothesis that may apply to some if not all of the self-portraits is that they represent a psychological journey in which Rembrandt shows increasing concern about mortality

and ageing. Thus his latest portraits appeal in particular, and make a striking contrast with the rather boastful earlier images, because of their apparent honest, even almost brutal, self-scrutiny. Platzman concurs:

> Most noteworthy for the history of the genre was Rembrandt's journey from the narcissistic self-absorption of his youthful portrayals to the vulnerable self-admission of his late confrontations with his person. In fact, Rembrandt's ability to communicate across the centuries is undoubtedly due to the perceived honesty of his self-examination. (p. 13)

To sum up, there are four possibly competing, possibly compatible explanations or analyses of the prolific self-portraiture Rembrandt engaged in throughout his life. First, he was advancing a view of himself as a successful gentleman, at the same time as he was acquiring commissions, forming a successful studio, setting up a vast household in Amsterdam, etc. Second, he was both working on, and at the same time more or less arguing for, his status as a successful artist. Third, he was trying on different versions of himself to see which would fit best. And fourth, he was exploring his countenance as a way of facing and coming to terms with his own ageing and mortality, impelled no doubt by the losses he had faced of both wives and of his beloved young son Titus.

The Rembrandt oeuvre might seem to fit fairly well with the narrative theory of the self, since on several of these hypotheses we could say that his self-portraits, taken as a body, constitute a sort of self-narrative. Thus it is not surprising to find that a position saying something just along these lines has been articulated. Osmond puts it this way:

> No artist has left a loftier or more penetrating personal testament than Rembrandt van Rijn. In more than 90 portraits of himself that

date from the outset of his career in the 1620s to the year of his death in 1669, he created an autobiography in art that is the equal of the finest ever produced in literature even of the intimately analytical *Confessions* of St. Augustine.[34]

Osmond is making the proposal that a series of self-portraits done over a lifetime amounts to an autobiography. Of course, this is qualified since the phrase referring to Rembrandt's 'an autobiography in art' is compared to St Augustine's autobiography in literature. But just what is the difference?[35] Is there one? Surely if Rembrandt had left us with an actual autobiography it would not be likely either to be preferred to or regarded as somehow more authentic or revealing than his sequential self-portraits. In fact the self-narration view does not actually equate the sort of narrative that constitutes a self with an autobiography. I would put the difference by saying that the one (narrative self-constitution) is done prospectively as an ongoing process and the other retrospectively. The self that is constituted by living out a narrative must reflect and assess on a pre-existing whole in order to produce an autobiography.

Case Study 2: Cézanne

Like Rembrandt, Cézanne was also a very prolific self-portrayer. And, again, as with Rembrandt, we have multiple images he painted and drew of himself over a long time period. Steven Platzman, in the definitive text on the Cézanne self-portrait, traces both the personal and artistic developments that transpired over the course of Cézanne's career.[36] For example, one fairly early self-portrait bristles with furious Fauvist colors and energy, appearing to express Cézanne's independence and the rejection

of his father's expectations that he will choose a more traditional career in banking. 'Transforming an innocuous photograph into a vehement declaration of his artistic self, Cézanne purposefully declares his desire to become an artist.'[37]

As Cézanne settled into his artistic career and pursued his own path in exploring the depiction of space, he took on a workmanlike approach to his own self-depiction as well. Hence in one image he shows himself as a laborer and Bohemian, rather unkempt but hard at work (see Plate 7). Platzman comments that here he shows himself as a 'dedicated worker-artist, unsophisticated in his dress and manner'.[38] But in later images, presumably after he had achieved greater artistic success and financial security, he depicts himself as a better-dressed and -groomed bourgeois gentleman. 'By dressing up and grooming himself, Cézanne was once again experimenting with his status as a member of the provincial bourgeoisie.' He also 'poses as a wanderer in search of aesthetic truth'.[39] Thus, a first hypothesis about Cézanne's self-portraiture is similar to what we have seen with the other artists, concern over his social status and success.

Similarly, a second concern is with his artistic status and success. Platzman notes comparisons between Cézanne's self-portrait at the easel and a famous self-portrait by his great French predecessor Poussin, to whom the newer artist appears to wish to compare himself.

> Besides using his self-portraits to investigate his relationship with his family and contemporary society, Cézanne also employed the genre to examine his affiliation with the art-historical past.[40]

But there are deeper psychological issues at stake in this work, again, as we saw with Rembrandt. These concern both the artist's

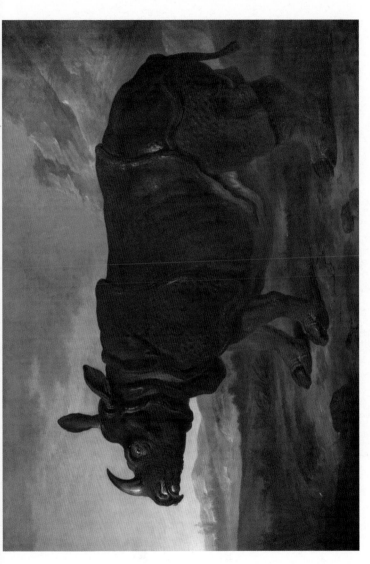

Plate 1. *Rhinoceros* (1749), Jean-Baptiste Oudry's grand portrait of the dignified traveling rhinoceros Clara.

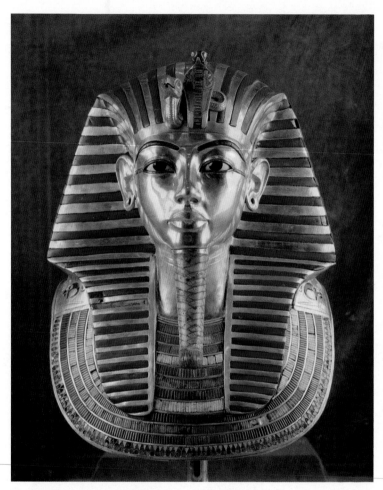

Plate 2. Gold Funerary Mask of King Tutankhamun (14th century BC). Mummies preserved the body of the deceased and portraits preserved their appearance.

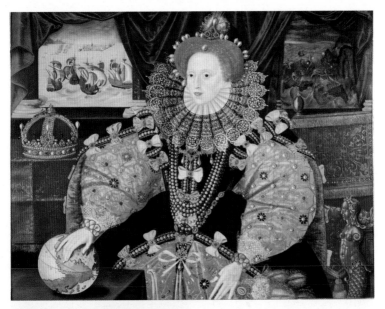

Plate 3. *Queen Elizabeth I of England*, 'Armada Portrait' (*c.*1588), George Gower (?). The queen contemplates worldly affairs with a maritime scene featured in the background.

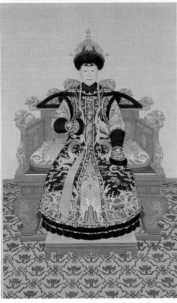

Plate 4. *Portrait of the Xiaosheng Empress Dowager*, Qianlong period, 1751, by anonymous court artists. The Empress is depicted on an imperial throne in formal wear indicating her status.

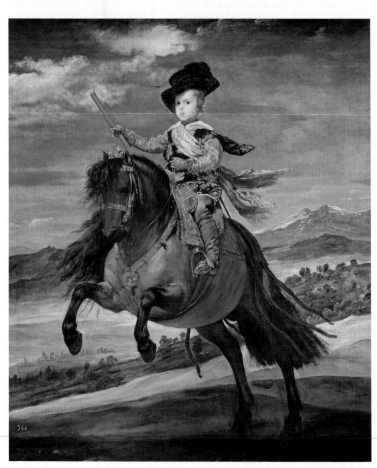

Plate 5. *Prince Baltasar Carlos on Horseback* (1634/5), Diego Velázquez. The artist celebrates the young prince's remarkable skills at horsemanship.

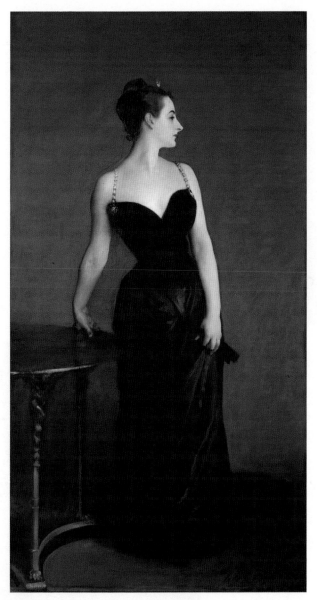

Plate 6. *Madame X* (Madame Pierre Gautreau) (1883–4), John Singer Sargent. Sargent scandalized French society with his depiction of this arrogantly posed 'professional beauty'.

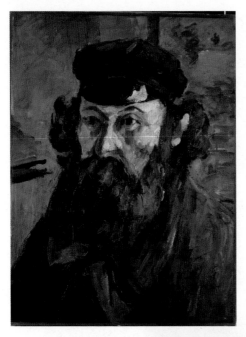

Plate 7. *Self-Portrait in a Cap* (1875), Paul Cézanne. The artist as an honest laborer.

Plate 8. *Self Portrait with Monkey* (1938), Frida Kahlo. One of the many images in which Kahlo emphasized her affiliation with Mexico's native cultures and animals.

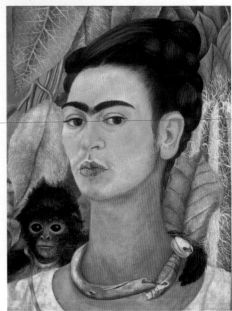

Plate 9. *My Parents* (1977), David Hockney. The artist shows an apparently distant relationship between his parents.

Plate 10. *The Painter's Daughters chasing a Butterfly* (c.1756), Thomas Gainsborough. The painting offers the two little girls lessons about following along life's path.

Plate 11. *Jeune femme portant un enfant nu* (Young Woman Carrying a Nude Baby) (1890), Mary Cassatt. Like many of the artist's other images this highlights the close physical intimacy between mother and child.

Plate 12. *Nude in the Bathtub with Small Dog* (1941–6), Pierre Bonnard (French, 1867–1947). Oil on canvas, 48 x 59½ inches. One of a series of paintings the artist did of his wife in the bathtub, continuing even after her death.

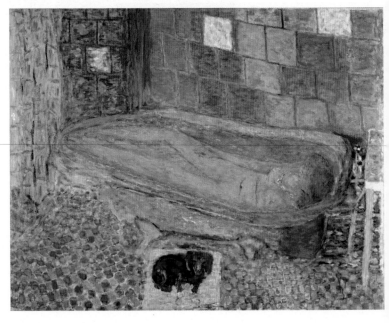

articulation of a view of himself as a person and his confrontations with ageing, mortality, and death. Cézanne, like his friend Gauguin, 'each employed the self-portrait, at least in part, to probe the nature of their respective beings. They used the format as a vehicle for the exploration of the private self as well as for testing the orientation or inflection of the self to the world at large.'[41]

In his later works Cézanne repeatedly painted still lifes that included not just the usual apples and other fruits but also piles of skulls. Platzman comments on how the self-portraits in this later period of the artist's life emphasized his high bald cranium, as though already anticipating its transformation into a skull. 'One of the many roles played by the self-portrait in Cézanne's life and oeuvre was that of providing an arena in which he could explore his ever-present anxiety concerning the threat of death.'[42]

To sum up: Cézanne's self-portraits again concern the social status of the artist. There are explicit addresses to art history and his role in it. In his self-portraits just as in his studies of Mount Sainte-Victoire, the artist was addressing numerous technical issues about style and composition. Despite treating himself as just another three-dimensional object in space, posed in almost identical fashion and wearing little by way of facial expression, he betrays psychological concerns about his true identity as well as fears about death and mortality.[43]

It could be supposed that, as with Rembrandt, the series of Cézanne's self-portraits is implicitly narrative in form. This claim is explicitly made by Platzman:

> Cézanne's self-portraits are the story of both his physical and mental life. Viewed as a sequence, they form a unique narrative. Just as his life unfolds according to the uncertainties of time and the demands of his personality, so too do his self-portraits.[44]

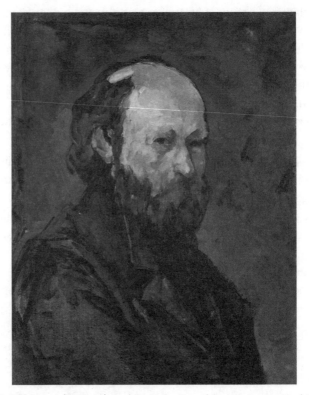

Fig. 5.5 *Self-Portrait* (1878–80), Paul Cézanne. One of the later images in which the artist's bald head begins to appear skull-like.

This is actually a distinct proposal, though it sounds similar to Osmond's suggestion about Rembrandt. Recall that she said that Rembrandt's oeuvre of self-portraiture constituted an artistic autobiography. I questioned whether such an autobiography was really the same as a self-constituting narrative. Platzman is suggesting something stronger, namely, that the Cézanne self-portraits do constitute a narrative. The problem here involves

the question, who is it here who does the constituting of this narrative? Notice the way Platzman puts it, 'Viewed as a sequence, *they form a unique narrative.*'[45] It seems to me that it is we, the viewers, who are creating this narrative by regarding Cézanne's portraits as making a kind of sequence. This is not to deny that for the artist, as well, the portraits formed a sequence, but I do not find them making a life-constituting narrative any more than Rembrandt's do.

Here is another remark from Platzman, also complicating the picture:

> There is no neat linearity to the visual story; it unravels in a disorderly fashion, progressing and regressing, opening and closing. Yet there is always a momentum, forced by the continuous and inevitable movement of time, and despite the disarray surrounding Cézanne's life and personality, it is possible to create some semblance of order.[46]

This second comment reinforces my impression that the *viewer*, not the *painter*, is the one doing the organizing or narration-formation in the case of Cézanne's multiple self-images. Notice how Platzman talks about the 'disorderly' unfolding of the life as compared with our own creation of a 'semblance of order' based on the evidence of the paintings. This is an important contradiction: disordered, random, unpredictable life, vs. an artificially imposed order with teleologically ordained formal unity.

Case Study 3: Kahlo

Frida Kahlo (1907–54) is another artist particularly known for creating an extended series of studies of herself in her art. There

are 55 self-portraits among the total of 143 of her known paintings. We can notice many of the same concerns in her work as those addressed by the previous artists: social status, artistic success, identification of a core self with key psychological traits, and concerns about mortality. There are, however, a few additional factors that arise in Kahlo's work. For one thing, she is notably concerned with issues of national and ethnic identity. Kahlo is also concerned with her status as a woman and with her troubled partnership and marriage with her teacher and fellow artist Diego Rivera. Kahlo's concerns about mortality were intensified by her childhood polio and by the bus accident that left her damaged and in need of multiple operations. Her wounded and suffering body became a persistent theme in Kahlo's work. Ironically, perhaps, the concern with mortality does not seem to be much reflected here by paintings that show the self *ageing*. Frida's face looks remarkably the same across her works (unlike the faces of Rembrandt or Cézanne). She is always recognizable with her coal black hair, uni-brow, and intense dark gaze, even when she pictures herself as an infant suckling at her nurse's breast!

Kahlo's paintings, like those of the previous artists, show an awareness of art history and reflect linkages with predecessors she admired, often those from the Spanish tradition or from distinguished Italian portrait artists. For example, in her *Self-Portrait with a Velvet Dress* (1926), she alludes through both the red dress and the slender elegant fingers both to Botticelli and Bronzino.

Many of Kahlo's works feature the wounded self/damaged body, which is specifically a female body. She is shown dealing with the pain and loss of miscarriage and infertility in *Henry Ford Hospital*, and with pain stemming from both physical and emotional wounds in paintings such as *Broken Column*, and

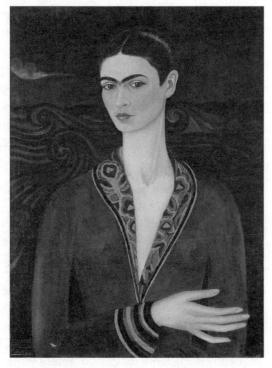

Fig. 5.6 *Self-Portrait in a Velvet Dress* (1926), Frida Kahlo. Kahlo's early self-image pays homage to art historical sources.

Wounded Deer. Despite the female identification Kahlo can also play upon and invoke identification with male saints: with St Sebastian (in *Wounded Deer*), and with Christ (in *Broken Column*).

Kahlo's repeated experiments in the self-portraits with clothing and accessories such as jewelry, native plants, and animals, shows a preoccupation with defining and embracing her ethnic heritage (European German-Jewish, Mexican, Indian). Writing about Kahlo's works, Sharyn R. Udall remarks, 'She is trying on identities, both personal and artistic: from the melancholy aristocrat of her first self-portrait, she seems to be testing an

image that speaks of her mixed Euro-American and Indian heritage.'[47] She is also concerned with political and national issues about the distinctive identity of Mexico as it emerges from colonialism into independence, and in particular with its identity vis-à-vis its northern neighbor, the United States. She resists comparisons that rank the two countries by showing the progressive, industrial, wealthy northern country as superior to its poor and 'primitive' southern neighbor. Her own allegiance is clear.

> Frida's mestiza-self, as embodied Mexican nation, is an active, fertile, female agent with a self-generated subjectivity and self-defined sexuality, which challenges the post-revolutionary constructions of the conquered and raped fatherland.[48]

To sum up, then, for Kahlo as for the previous artists, self-portraiture involves reflection on personal and artistic issues. Her work manifests a greater concern as well with gender, ethnic, political, and social issues. Kahlo, working at the time of the Surrealists, can also employ more vivid visual symbolism, frequently using flags, indigenous symbols like the sun, moon, or hummingbird, animal metaphors, etc.[49]

Claims have been made for Kahlo, as for Rembrandt and Cézanne, about the self-constituting nature of serial self-portraiture. One of the novelties of these claims is that instead of making up a kind of autobiography or life narrative, Kahlo's work amounts to, as it were, a film in which she is the star:

> By starring in her self-portraits (as opposed to a film), Frida very methodically (frame by frame) builds a repertoire of imaged-I's (or Imaged bodies) within which she offers us a small window onto her world, a kind of case-study methodology.[50]

Interestingly, in Kahlo's case her self-portraits are not the sole source from the artist about her life, since she also kept a diary which has been published (both in the original Spanish and in English translation). This returns us to the questions that arose before for Rembrandt and Cézanne. One question is how an artist's diary relates to an autobiography, and how each genre relates in turn to the self-narrative (if such it is indeed) in their work over a lifetime. I believe that a diary is a distinct kind of self-narrative from either an autobiography or a series of self-portraits, and it is doubtful that proponents of the narrative self-constitution view really have in mind that the narrating self is writing something like a diary. Complicating things even more in Kahlo's case is the extensively illustrated nature of the diary, which at times contains sketches for paintings and at times what amount to small well-worked-out paintings in their own right.[51] If there are three competing 'external' narratives of Kahlo's life, then which would be the correct one to refer to in trying to access her own self-narrative? Or is that something altogether different? As stated before, here too I find it implausible to identify the self-constituting narrative (if it exists) with any of these three public ones. I feel the same reluctance in these cases as I would in identifying the artist's own narrative with even the best, most complete and authoritative biography.

Conclusion

In discussing the three central case histories of artists who created serial self-portraits—Rembrandt, Cézanne, and Kahlo— I have tried to sum up the sorts of issues and concerns that are

evinced by their work. These are remarkably similar and include such things as social status, artistic success and identity, personal psychological revelation, and confrontations with ageing, mortality, and death. Kahlo's work prompted me to add in additional concerns about gender, ethnic, and national identity. In each case I mentioned suggestions from scholars who appear to support the idea that these artists' serial self-portraiture amounts to some sort of life-constituting narrative. It was claimed, first, that Rembrandt's self-portraits constitute an *autobiography*; second, that we can identify the *narrative coherence* of Cézanne's work; and third, that Kahlo's self-portraits constitute a kind of *autobiographical film* in which she is the star. I expressed doubts about each of these interpretations. My doubts both reflect and reinforce the worries raised earlier about narrative theories of the self: such theories fail to address key issues about narrative connections, closure, and explanation.

Now, in concluding, I want to mention three added reasons to deny that serial self-portraiture reveals selves in a way that is consistent with narrative self-constitution theories of the self. Things that portraits might show about the self that are *not* narrative include the following.

First, the narrative theory seems either to ignore or to fail to get right facts about the body and the appearance of a person (despite Schechtman's reality constraint). In particular, such facts have a lot to do with the *face*, which is no doubt the reason that faces figure so prominently in the entire history of visual portraiture. Sometimes this emphasis on the body shows up in a self-portrait as a concern about such things as disease, mortality, or ageing, concerns that were obviously significant in the works of Rembrandt, Cézanne, and Kahlo. It can involve the recognition and depiction of gender. It simply is a fact about humans

that we are visual animals with a strong interest in identifying and re-identifying the faces of others. This is so important that a part of our brains is actually hard-wired for the task.[52] And other brain parts are geared toward recognizing the facial expression of emotions.[53] So it should not be surprising that portraits interest us. Even if we do not already know the person pictured in a portrait, their image presents us with a distinct, knowable individual, a face which we can begin to read and derive insights about (depending, of course also, on the artists' skills).

It may seem so obvious as to be silly even to mention this, but portraits are interesting to us precisely *because* they are pictorial and not verbal.[54] If forced to choose between the most elaborate biography or autobiography and a single good portrait of a person we admire from the very distant past, I am not sure which option many of us would choose. (One of my students put this in terms of what one would look for in venturing on a blind date with someone: do you want to see their photo or hear them described in great detail?) One thing that seems plain, at least, is that the two sorts of information, visual and verbal, cannot adequately supplant one another.[55]

A corollary of this first point is that visual art employs distinctive sorts of metaphors and symbolism that simply work differently from the sorts appropriate to literary or other forms of narrative art. It is one thing for Kahlo to complain that she feels like a deer shot full of arrows, and another for her to paint herself with her own distinctive head sitting atop a deer's body wandering wounded in the woods. The power of the image strikes us very directly and is reinforced by aspects of the setting. The deer is isolated, hunted. It is frozen in a clearing in the woods in its attempt to leap over a broken branch. Blood drips from its sides

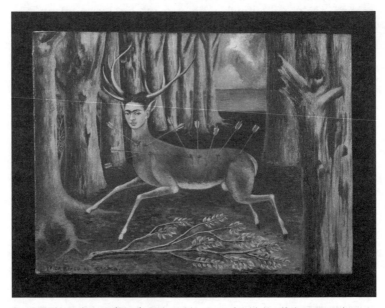

Fig. 5.7 *The Little Deer* (1946), Frida Kahlo. One of Kahlo's self-depictions that highlight wounds and suffering.

pierced by many arrows. Kahlo's head looks out at us, calm but questioning the need for such pain. A path leads to a distant ocean under a stormy sky. Frida's eyes are unusually elongated with heavy lashes, evoking the sensitive eyes of the deer. And 'Little Deer' was in fact Rivera's nickname for her. The constellation of images here creates the message of a resolute victim, a gentle creature who combines strength with vulnerability, grace with suffering. It is a very potent self-representation.

Second, visual portraits are part of very complex, venerable, and familiar traditions of social self-presentation and display. A portrait or self-portrait in effect dramatizes or enacts something important about each of us: that in our lives, we constantly

present ourselves visually to others. This goes beyond, and is distinct from, the project of narrating ourselves first to ourselves and secondarily to others. Even if the narrative self-constituting view is correct, there is something *different* about what we say in constituting ourselves and what we actually do when we go out and *show* ourselves to others in the world.

To be sure, as with metaphor and symbolism, there can be important modes of social self-presentation in narrative art such as literature, drama, and film. Still, visual depictions offer up very direct renderings of how people commonly present themselves to others. Since the people I have been exploring were all painters, it is not surprising that their concerns included some about the nature and status of a person as an artist. Musicians might want themselves depicted in specific ways, say, with an emphasis on hands or mouth. Artists, like various other kinds of people, may show concerns about success and fame in their self-portraits. They also offer up a combination of images about the self and its relation to the viewer and about the art they are producing as an object to become part of a larger social history, the history of art. This means their self-portraits constitute very complicated addresses to the viewer.

This kind of special address to the viewer depends on some fundamental human capacities. As the evolutionary psychologist Michael Tomasello has explained in his book *The Cultural Origins of Human Cognition*, humans are distinct from other primates because of our basic capacity, which emerges in normal infants at around nine months of age, to grasp the intentionality or mental life of others of our kind. This same capacity accounts for our ability to understand products of culture or artefacts that other people produce, from tools to mathematics to visual symbols, as reflecting human purposes.[56] Our perception of the

thing's meaning is related to contexts that help us understand how other people meant this artefact to be used. The point is true also of portraits. These are visual artefacts that are made in order to draw our attention to the depicted person as a subject with his or her own intentionality; the artefact itself thus manifests two distinct sorts of purposes (both intentional), that of the creator and that of the subject. We can appreciate both at once, in a complex grasp of the meaningfulness of other people's actions and awareness.

So far, then, I have expressed two concerns about the narrative theory of self: that it omits key things about bodies, and that it cannot adequately capture important acts of social self-representation or display, and the way in which such acts are recorded and made evident in paintings as human artefacts. It might be worthwhile, before concluding, to compare my reservations to those expressed by a prominent critic of the narrative theory, Galen Strawson. In his paper 'Against Narrativity', Strawson argues that narrativity is neither a correct descriptive view nor a plausible ideal of the self.[57] He suggests that there are deeply non-narrative people and good ways to live that are deeply non-narrative. Indeed, narrative ways of life can be a problem. 'The more you recall, retell, narrate yourself, the further you risk moving away from accurate self-understanding, from the truth of your being.'[58]

Strawson describes two types of people. The 'Diachronic' person naturally figures herself, considered as a self, as something that was there in the (further) past and will be there in the (further) future. But the 'Episodic' person does not figure herself, considered as a self, as something that was there in the (further) past and will be there in the (further) future. What accounts for this difference? It seems to Strawson simply to be a brute fact.

He comments, 'The fundamentals of temporal temperament are genetically determined, and . . . we have here to do with a deep "individual difference variable", to put it in the language of experimental psychology.'[59]

But to this we might add—and I would propose to do so here, as my third and final concern with the narrative self-constitution view—that Strawson's distinction between Diachronics and Episodics is too simple and incomplete. It reflects an odd prioritizing of time over space in the identification of who and what a person is. If we sought instead to classify people according to their spatial orientation, we might wind up with a different set of distinctions, perhaps overlapping or simply supplementing this pair.[60]

For example, people are embodied beings, and as such we exist in physical space and move through it with the sorts of physical selves we are or have. Perhaps the Diachronic/Episodic distinction reflects a temporal orientation that maps onto the verbal plane better than the pictorial. But it might be true that it is alien to some people who are much more fundamentally oriented toward the spatial. Such people might turn out to be oriented either toward the visual or the kinesthetic in their senses of themselves.[61] Barbara Tversky has discussed the problems of forcing spatial experience into the linear form of a narrative. She lists three main types of such narratives: they may take the form of account for a route through the space, of a survey from high above the space, or of a 'gaze', i.e. the viewpoint that takes in the entire space from one vantage point (say, a doorway). Route or travel accounts of space do involve events ('first you go here, then you go there') but the other two sorts of spatializing narratives do not.

Spatial narratives of any of these three types (and Tversky reports that in research studies, they often prove to be mixed)

might supplement more temporally oriented ones. They could also be more natural for some people to use to express both a view of the self and various concerns about that self through non-verbal means. These might include dance or sports, or of course for great artistic geniuses like those I have discussed here, portraiture. Nothing will convince me that a narrative account of the self can either capture the complexity of their endeavors or convey its uniqueness in helping us understand both ourselves and our fellow human beings.

Intimacy

Introduction

My previous chapter examined how self-portraits can convey a sense of artists' own selves or personhood. Now I want to consider artists' depictions of the people closest to them—spouses, lovers, parents, and children. Presumably, like the rest of us, artists have knowledge about and strong feelings for the people with whom they are most intimate. We would expect them to care especially about the goal of conveying subjectivity in their depictions of these people. It should not be surprising, then, that artists' portraits of the individuals closest to them may prove to be the most revelatory and charged of all of their creations.

I will begin by discussing the notion of objectification, now familiar from feminist critiques of the treatment of women as sex objects, especially in pornography. This term refers to the morally problematic reduction of a human being to a mere means rather than an end, showing her as a thing or tool to be used. In a sexual context, the person is on display to be used for purely

erotic or sexual purposes. I will review several feminist definitions of sexual objectification in order to clarify the meaning of the term, before proceeding to suggest how such objectification can be avoided in art, including portraiture. Some forms of objectification involve other (non-sexual) uses of humans as things or tools—slavery, for example. Perhaps not all of these other forms of objectification are as morally problematic as sexual objectification (or slavery), but still, objectification will present an obstacle to portraiture in my sense. Portraits aim to show a person who is a subject—an autonomous individual with inner states, and not a mere object or thing.

After developing an account of visual objectification, I will apply it to the analysis of various examples of artists' intimate portraits of people in their lives, including mothers, children, and lovers. This will afford a way of answering questions about when portraits are objectifying and when not—revealing how, in some cases, portraits manage to 'subjectify' the persons they represent.

Objectification

Critics of objectification have focused on pornography's treatment of women as erotic or sexual objects or things to be used. To clarify their complaint, I will examine some prominent feminist treatments of sexual objectification. Getting clearer about what is required for portraits not to be *sexually* objectifying will also help show how portraits can resist both this and other kinds of objectification.

The critical term objectification is most likely to be used when the subject in the artwork is shown nude in an image with erotic aspects. In the history of art, erotic portraiture has most typically

involved the depiction of naked women by heterosexual male artists, in works primarily aimed at male viewers. Contemporary artist John Currin points to this fact in defending his own paintings, which have often depicted women with exaggerated, balloon-like breasts. Currin explains that, 'Painting has always been essentially about women, about looking at things in the same way that a straight man looks at a woman.'[1] Since depictions of naked females in art have so often aimed at displaying possession or evoking arousal, perhaps art history should be viewed as just another branch of pornography in which women are presented as sexual objects (with a few prominent exceptions like the Madonna and Christian saints). The availability of women for purposes of sexual arousal is emphasized in the common odalisque form of the nude. Naked women in art may be depicted as rape victims who appear to be enjoying the experience, as mere orifices, as members of exoticized harems, or as only minimally active.[2]

The practice of depicting women as sexual objects in art has continued into the modern period. Leo Steinberg describes Picasso, for example, as aiming to possess things, including women, through painting them.[3] Picasso is not alone in using women in his art to celebrate his own subjectivity and virility. Much the same point has been made for many other modern artists, including Renoir, Matisse, Freud, Currin, etc. Carol Duncan has accused de Kooning of a variant form of objectification in his depictions of women as the castrating mother or bitch.[4]

But what is sexual objectification, exactly, and what is wrong with it? One well-known account of the term comes from feminist legal theorist Catharine MacKinnon, who says that 'to be sexually objectified means having a social meaning imposed on your being that defines you to be sexually used, according to your

desired uses, and then using you that way'.[5] What is wrong about objectification is that it promotes the use of human beings, who are subjects (or, as Kant would say, ends-in-themselves) as mere means or tools, as pure sexual objects. For MacKinnon and other radical feminists, sexual objectification applies at the cultural or social level; it goes beyond any one individual's behavior. She explains,

> Pornography makes the world a pornographic place through its making and use, establishing what women are said to exist as, are seen as, are treated as, constructing the social reality of what a woman is and can be in terms of what can be done to her, and what a man is in terms of doing it.[6]

On this view, art history is just one part of the broader social history of sexual objectification. Like pornographic materials, artistic representations are problematic because of their tendency to depict naked women as enticing and available sexual objects. This attitude grounds the activism of feminist art critics and groups like the Guerrilla Girls, who have created a stream of humorous posters and advertisements targeting sexual and racial inequalities in the art world. One of their best-known works appeared as posters and on a billboard. It showed a naked odalisque wearing a gorilla head that asked, 'Do women have to be naked to get into the Met museum?'[7]

An alternative account of objectification has been proposed by philosopher Martha Nussbaum.[8] Disagreeing with the more socially oriented explanatory framework of feminists like MacKinnon, Nussbaum focuses instead on 'personal objectification', that is, on individuals' treatment of other individuals. She lists and systematically examines the moral status of the following seven different types of objectification:

1. Person P uses person Q as an instrument (means);
2. P denies Q's autonomy;
3. P treats Q as inert;
4. P treats Q as interchangeable or fungible;
5. P violates Q's boundaries;
6. P treats Q as something that can be owned;
7. P denies Q's subjectivity.

In examining each of these seven behaviors, Nussbaum considers examples drawn primarily from literature, including well-respected writers along with mass-market pornographers. She does not think they are all necessarily bad. In fact, she concludes that some forms of objectification may be benign, wonderful, and even necessary. Writing on D. H. Lawrence, for example, she interprets him as claiming in *Lady Chatterley's Lover* that, 'objectification is . . . connected with a certain type of reduction of persons to their bodily parts, and the attribution of a certain sort of independent agency to the bodily parts'.[9] Lawrence is pointing out the truth that, 'a certain sort of objectifying attention to bodily parts is an important element in correcting the deformation [of sexual desire by puritanism] and promoting genuine erotic equality'.[10] Similarly, in analyzing Alan Hollinghurst's novel *The Swimming-Pool Library*, Nussbaum suggests that it envisages a realm of free-flowing homoerotic sexual desire open to multiple and interchangeable objects. If such sexual fungibility could be achieved, it might be benign in that it reflects a democratic and egalitarian treatment of persons.

I propose creating a variant of Nussbaum's definition that will provide us with a list of behaviors relevant to 'subjectification'. It seems a natural move to assume that this would involve the

opposite of the seven kinds of behavior Nussbaum lists as constitutive of objectification. Here, then, is my list:

1. Person P treats Q as an end and not a means;
2. P endorses Q's autonomy;
3. P treats Q as active and alive;
4. P treats Q as unique and irreplaceable;
5. P respects Q's boundaries;
6. P treats Q as something that cannot be owned;
7. P endorses Q's subjectivity.

Nussbaum's discussion focused specifically on *sexual* objectification. A person who can achieve some of the (opposite) goals mentioned just above in sexual relationships would thereby reduce or avoid the problematic moral aspects of sexual objectification. But her framework affords the basis for a more general account of non-objectifying behavior in non-sexual contexts— say, in dealing with subordinates at the office, raising children, or creating portraits. Recognizing that another person is a subject, not a mere tool or object, in these other contexts will presumably involve the sorts of things indicated above in my list, such as respecting their boundaries (no sexual harassment), acknowledging that they cannot be owned (necessary for parents of young children), and treating them as unique while acknowledging their subjectivity (as artists aim to do in portraits).

Some defenders of, say, violent pornography have argued that such images need not be morally problematic if they are done without behavior that is violent or coercive, with participants who consent to the processes of producing the images. For MacKinnon, this defense will never succeed because the images themselves promote inequality, regardless of the artist's behaviors or the choices made by models. This is because for

her, 'pornography is not imagery in some relation to a reality elsewhere constructed . . . It is sexual reality.'[11] However, a full discussion of these issues would take me too far away from my present study of portraits. My focus will be on how persons are treated in visual depictions, and not on biographical facts about how artists *behaved* or treated their sitters or models in real life.

It may help to show how portraits or visual images can either be objectifying in a problematic way or the opposite if I sketch some examples. At one end of the spectrum are the nude portraits of Lucian Freud, which Arthur Danto has described as 'glacial' and even 'sadistic'. He says that Freud's nudes manifest

> a complex and essentially sexual transaction between the artist's will and the submission to it of reluctant models . . . his figures look tense, strained, posed, uncomfortable: they look the way we feel when we contemplate these sadistic works. They are about domination . . . [12]

Other reviewers share Danto's response. Jeffrey St Clair coined a nice phrase when he remarked that, 'To be painted by Lucian Freud is to be subjected to a kind of aesthetic autopsy.'[13] Robert Hughes, despite calling Freud 'the greatest living realist painter', says, 'It is unlikely that any painter since Picasso has made his figuring of the naked human body such an intense and unsettling experience for the viewer.'[14] And John Russell remarks, 'Freud carries the experience so far that we sometimes wonder if we have any right to be there.'[15]

Some of Freud's own statements support such assessments. He has commented, for example, that 'I used to leave the face until last. I wanted the expression to be in the body. The head must be just another limb. So I had to play down expression in the nudes.'[16] Few people would want to be depicted with their

heads treated as 'just another limb'. There is something chilling about the very idea—it implies that my face and its precious sensory organs and expressive potentials, along with my personal feelings, are being ignored or disregarded.

Freud's nudes are problematic because they fulfill several of Nussbaum's stated criteria for sexual objectification—in fact they appear to be textbook examples. Danto points out how uncomfortable the models look; their poses are neither relaxed nor natural. The light is harsh and the depictions are extremely unflattering. The people in Freud's pictures are not shown as autonomous or active subjects, but as inert material things subject to his artistic will. Their boundaries are violated, as they lie with legs splayed open and either penises or vulvas awkwardly pushed out for the viewer to inspect.[17]

The problem with Freud's images goes beyond sexual objectification to a broader kind of visual objectification. This point is nicely made by reviewer Richard Dorment in his discussion of Freud's painting *Sleeping by the Lion Carpet*, an image showing what Dorment calls a 'grotesquely fat model'. He comments,

> The model was chosen simply because her body provided Freud with an opportunity to paint rivers, mountains and gullies of flesh. She is a living, breathing, one-woman landscape. So repulsive is her body that Freud's relish in painting it feels chilling and even cruel. Utterly detached from his subject as a person, he shows a wholly carnal creature reduced to the properties of mass and weight. If in reality the model possesses personal dignity, enjoys a rich spiritual life or perhaps has a pleasant personality, Freud doesn't show it.[18]

Freud's paintings of nudes fulfill at least Nussbaum's conditions 2, 3, 5, and 7 for objectification. They treat the persons they

depict as inert, violate their boundaries, and deny their autonomy and subjectivity. It is not clear, however, whether the other criteria for objectification are met—whether these images imply ownership or negate their models' individuality. Ironically, perhaps because of the very particularity of the bodies he depicts (like the 'grotesquely fat model' of *Lion Carpet*), they have some separateness and distinctness. The individuals are not treated as fungible or interchangeable precisely because of the artist's attention to their fleshy particularity. Each has a particular configuration of bodily features that seems to fascinate the artist—particularly the people who are large or even gross in their body size, with 'mountains and gullies of flesh'.

Let me reiterate that even if Freud is tried, found guilty, and hanged on charges of either sexual or visual objectification in his work, this need not mean he is a bad person or bad artist. That is a separate matter for his biographers to address. (On his behalf we should note that he speaks of painting not 'from' but rather 'with' his nude models; he says that, 'The painting is always done very much with their co-operation.'[19]) But his nudes do fail to meet my proposed criteria for subjectification. Of course, portraiture in my sense may not have been Freud's aim. (His own understanding of portraiture appears to be unusual given his claim that, 'Everything is autobiographical and everything is a portrait.'[20]) There are significant differences between the depiction of people in Freud's nude images and in his other paintings, where he often does show distinct individuals. Consider his recent controversial portrait of Queen Elizabeth II. Although this portrait is unflattering in Freud's typical way, it can hardly be said to deny Her Majesty's subjectivity, individuality, or autonomy. To the contrary, she appears to be a strong if stubborn ruler with a wealth of experience under her belt (or should I

say, crown). And so, too, Freud's portraits of his mother treat her as a subject in a very different way from his paintings of the nudes, a topic I shall return to below.

At the other end of the spectrum, as an example of artistic renderings that succeed at subjectification, I would cite some of Rembrandt's paintings of both his first wife, Saskia, and his second wife, Hendrickje Stouffels. Art historians generally regard these as examples of especially loving (even if sometimes nude and erotic) portraits. They manifest an altogether different attitude toward their subject than Freud's. Simon Schama offers insightful comments on Rembrandt's portraits of his wives and compares them favorably with the objectifying depiction that Rembrandt's contemporary, Rubens, did of his own wife, Helene Fourment. Saskia seems very much a living and unique person in her portraits, whether shown as Rembrandt's young betrothed in a casual straw hat (1633), holding a flower (1641), merry (*Saskia Laughing*, 1633), or as Flora, goddess of spring flowers (1634). Many critics have also praised Rembrandt's painting of his second wife, *Hendrickje Bathing* (1655), for its sensuality and intimacy.[21]

Rembrandt's depictions measure up well against my proposed list of subjectifying behaviors. They may even meet all seven of the criteria. In his drawings and paintings, Rembrandt treats the women who were his successive wives as ends and not means. (Again, this is a comment about Rembrandt's *renderings* and not about his own actual behavior.[22]) In paintings Rembrandt endorses these women's autonomy, presents them as active and alive, as unique and irreplaceable. He respects their boundaries and shows them as beings who cannot be owned. Does he endorse their subjectivity? Schama would no doubt answer yes; he does so through the effective ways in which the images

portray the subjects' feelings in private moments. Their reflective emotions are especially evident in the paintings in which Rembrandt used these women as models for biblical stories, highlighting Bathsheba's sadness and Susanna's horror.

We can now consider my answer to the question of how artists manage to depict persons as subjects. For this, their portraits must refuse to treat sitters as things or tools that are mere means to some end. 'Subjectification' is achieved in representations that show their sitters as independent beings that cannot be owned. They are unique and irreplaceable, active and autonomous, with intact physical boundaries. There may be cases in which an artist fulfills some but not all of the conditions for subjectification; then I would say that their portraits manifest a degree of both subjectification and objectification. To see in more detail how my proposed framework actually works, next I will discuss more examples illustrating portraits of intimacy.

Parents

When artists paint their parents, many feelings come into play, sometimes including love and respect, but also perhaps ambivalence or resentment. Parents in images can be treated as symbols of experience, wisdom, and mortality. Or they may represent fearsome figures of domination and control (as has been suggested about de Kooning's paintings of women as threatening monsters with sharp protruding breasts and vicious teeth). If an artist depicts someone as *just* a symbol, then this is itself a kind of subordination of that individual to serve an end. It may not be sexual objectification but it is still objectification. But this seems

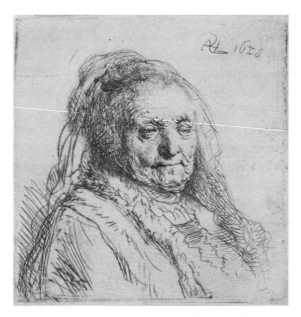

Fig. 6.1 *An elderly woman* (1628) Rembrandt van Rijn. Thought to be among the artist's depictions of his own mother.

to be more of a risk in depictions of children, as we shall see in my next section.

Rembrandt's paintings of his mother share the same subjectifying features evident in the pictures he did of his wives.[23] He may have used his mother for the image *An Old Woman Reading* (1631) and for the biblical prophetess Hannah (1631). Even though Rembrandt in some sense 'used' his mother here (just as he used his wife as the models for his biblical paintings) such use does not violate the principles of behavior I set out above. It is still respectful and Rembrandt even seems to connect the women's own subjectivity with that of the character they represent.

More recently, both David Hockney and Lucian Freud have done multiple images of their mothers. Among Hockney's works are two paintings of his parents that give some indications of their relationship and of his feelings about them. *My Parents* from 1975 and 1977 (see Plate 9) share similar compositions, showing his mother on the left and father to the right, separated by an end table topped by a vase of tulips and a small mirror. In the earlier, unfinished version, Hockney is reflected in the mirror, as if to show that he is both the creator and the created of this pair. He is not present in the mirror of the later image. These paintings use physical space to hint at some psychological distance separating the couple. Hockney's father is absorbed in reading, paying no attention to the other two, and so they seem to highlight the artist's relationship with his mother.[24] She sits primly with legs together and hands folded in her lap, gazing back out at the artist.[25]

Perhaps because he was closer to his mother, or because she outlived his father, Hockney did many more portraits of her. One commentator writes, 'David Hockney has stated that if people consider the portraits of his mother his best works, then it is probably because she is the one he knows best.'[26] In some of his works she looks personable and witty. A little smile lingers on her mouth and we can notice her twinkly eyes in the multiplication of her features in the Polaroid collage image he did of her, *Mother I, Yorkshire Moors, August 1985 #1*. The image also features a jaunty polka-dot jabot at her neck. A very different mood characterizes Hockney's photo-collage *My Mother, Bolton Abbey, Yorkshire, Nov. 82* (1982). The somber setting in a graveyard with ruins of the abbey in the background is echoed in his mother's pensive face and distanced expression, as she gazes off to the side. The muted colors of gray, brown, and green complement the

dull blue of her raincoat. It is natural to interpret this collage as a meditation on mortality, but I do not feel that Hockney is forcing his mother into any symbolic straitjacket. Some of the relevant meditating is going on inside her, which should not surprise us given that she is an elderly woman. The artist remains at a respectful distance from her thoughts.

In a later image, this time a painting done in 1988–9, there is something unsettling about his mother's face. She is an attractive woman, nicely dressed with well-curled white hair and bright blue eyes. But the eyes that look straight out at the viewer do not seem to see us. As one critic puts it,

> In the portrait of Laura Hockney from 1988–89, the artist's mother is painted with eyes that are pensive and slightly blurred, although at first sight she seems to be looking straight at the viewer. It is not possible to establish contact with her . . . [27]

The eerie feeling this painting evokes may echo what the painter felt in looking at his mother and realizing that he was losing her. There often is sadness in ageing, and the painting expresses that poignancy. But the fact that we cannot quite establish the nature of her subjectivity here does not mean that she is inert. Rather, the artist conveys that his mother retains her own unique perspectives, moods, and thoughts.

Like Hockney, Lucian Freud did numerous paintings and drawings of his mother, particularly in the period following his father's death in 1970, when she fell into a very severe depression. Freud's style is quite different from Hockney's, of course, but in some of these images his mother also seems distant in an unsettling way. Her depression is especially evident in various images that show her lying in bed, unaware of the world around her or of her son's artistic efforts. Freud explains why he did

Fig. 6.2 *The Painter's Mother* (1982), Lucian Freud. Among the many paintings and etchings in which the artist depicted his mother.

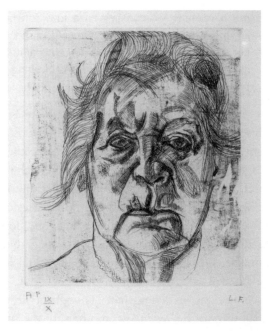

these images: 'I started painting her because she had lost interest in me...I couldn't have if she'd been interested. She barely noticed, but I had to overcome avoiding her.'[28]

Dorment, the writer who was so critical of Freud's treatment of the large woman shown in *Lion Carpet*, contrasts such images with the depictions of Freud's mother. The painting *Large Interior W9* (1973) juxtaposes Lucie Freud with a nude model. Dorment comments,

> Wearing her tweed suit and sensible shoes, she [Freud's mother] is painted with affection and accorded a dignity very different from his treatment of the nude on the couch in the background. This

much younger woman lies on a low iron bed with a blanket around her lower body, her big eyes raised to the ceiling, and her arms locked behind her head. Freud paints her just as carefully as he does his mother, but he tells us nothing about her. It is her body and her pose that interests him, not her personality.[29]

There is more subjectification, then, in Freud's depictions of his mother than in his nude models. This is not simply because she is not shown nude (horrors!—especially for a grandson of Sigmund Freud). The paintings and etchings of her are not flattering, but they do not do what some of Freud's paintings of other women do, violate her boundaries or treat her as inert. Even when she appears inactive, her condition seems to speak of sadness and does not amount to sheer bodily passivity. His mother is portrayed as a unique individual with an interior life, even if it is a melancholy, depressed one. So Jeffrey St Clair seems right in saying that, 'Though far from sentimental, the paintings of his again [sic] mother are the most humane works Lucian Freud has produced to date.'[30]

Children

The subjectification process is different in portraits of babies and children. Very small children resemble animals in that they are not able to pose for portraits, since they lack an understanding of art as a symbolically meaningful activity. But the ability to pose is an interesting one because we might well debate when it begins and what it involves. If babies or children simply are placed in position in visual images like small mannequins on display for specific purposes, they are being treated as objects, not subjects.

On the other hand, if a young child's pose betrays too much sophistication for its age, this suggests that inappropriate coaching or even coercion has gone on. The challenge of depicting children in the nude or scantily dressed involves special risks of sexual objectification. Such treatment is common for little girls, in particular, since they become sexualized at increasingly early ages. Treatment of girls as budding Lolitas is the sort of thing that bothers many people (and rightly so, to my mind) about children's beauty contests like those attended by murder victim Jon-Benet Ramsay.

Above I mentioned a different sort of risk of objectification in portraits of children: they are often treated for their symbolic value. Their little faces and bodies seem so fraught with meaning and future significance. They are often used to symbolize fruit-fulness, immortality, fragility, innocence, and goodness (or in rare cases, the opposite). Treating children as mere symbols reduces their role to that of tools rather than regarding them as individual subjects. This is reminiscent of some depictions of animals that I discussed in Chapter 1 above, when a pack of hounds are shown, for example, to denote the extent of a wealthy nobleman's property.

Perhaps surprisingly, some of the criteria in my list do not apply so clearly to the analysis of objectification in depictions of children. Babies and very young children lack the sort of autonomy that is characteristic of adults—this is reflected in social practices holding parents responsible for many aspects of their lives. And it also can seem natural, and not insidious, to regard babies as lacking clear physical boundaries at a time in their lives when they are still too young to move about on their own or clean and feed themselves. Surely images of babies who are naked, suckling at the breast, or being bathed

in public are not objectifying even if they manifest blurred bodily boundaries between mother and infant or violate the babies' privacy in a way not normally acceptable for older children and adults.

Many of the most famous paintings of young children from the early modern period fail at subjectification primarily because of a cultural context which treated children primarily as valuable property of their parents. Painters were commissioned by royal patrons to depict the children as inheritors of the kingdom. Sometimes even very young girls were painted in wedding portraits when plans were made for their future to secure political alliances. Small children or babies were shown as future rulers garbed in majestic clothes. An amusing instance of this in London's National Portrait Gallery shows the future King of England, Charles II, as a somber and stately little fellow. At the delicate age of fourth months, this 'little man' is propped up so that he appears to be sitting on a small throne wielding a little rattle as if it were a scepter. He just manages to maintain a dignified royal visage despite his chubby cheeks. The only truly childlike thing in the portrait (whose artist is unknown) is the way the baby grabs the ears of a young spaniel in front of him (a dog of the sort that was later to bear his name).

In cases like this one, no matter the skill of the artist, a kind of objectification occurs because the children are depicted as tools of the state, as little beings slotted into future political roles. This may be why commentators describe some of Goya's royal children as 'doll-like'.[31] Often royal children were shown in art as miniature adults,[32] as is done, for instance, in Velázquez's portrait of the Infanta Margarita or of the young Baltasar Carlos on horseback.[33] It is revealing to contrast these official and stiff portraits with the image of the little boy shown in Velázquez's

marvelous painting of a boy with an old woman frying eggs (*Old Woman Frying Eggs*, 1618). The boy waits to one side, holding a gourd and flask of wine. He is pensive, absorbed in his own thoughts at which we can only guess: is he hungry and waiting for the egg to be cooked, or taking a break from waiting on the masters of the household? In any case, he has a unique subjectivity that engages our interest.

Shearer West explains how the social role of children evolved along with their renderings in portraits. 'Given the high death rate among children in Europe in the medieval and early modern period, children were considered a precious but fragile part of family life.'[34] Although early portraits focused on children's importance to the dynastic line, in the seventeenth century this began to change, as 'portraits of parents and children became less formal and concentrated more frequently on social or personal connections between different generations'.[35] The eighteenth century saw a continued emphasis on familial ties, and with Rousseau's growing influence, children were shown as more playful. Nineteenth-century images placed more emphasis on children's innocence and beauty, but even in some of these paintings the children occupied symbolic roles, for example, being used to refashion the tarnished image of a risqué woman by depicting her as a loving mother.[36]

Gainsborough painted multiple images of his daughters. Although they are beautiful renderings of lovely little girls, his paintings, like many other eighteenth-century images of children, are still heavily loaded with symbolism. For example the yellow butterfly draws attention to the transience of childhood in his painting of the two girls walking on a garden path (see Plate 10). The girls indicate both childhood's innocence and the danger of temptations and threats (in the form of a thistle under

the butterfly). The entire scene is fraught with meaning that runs deeper than the surface. One reviewer explains,

> This moment of childhood is an enchanted theatre. The bright light on the children's faces lifts them out of a darker background like stage lighting. They have slipped, in the eyes of their doting father, out of the garden and into fairyland. Gainsborough enfolds his daughters in a folkloric woodland, where it's getting dark, but they are illuminated by his looking.[37]

I would make the same comment about Gainsborough's daughters that I have about Hockney's painting of his mother. Even if the artist uses images of these people to express feelings about childhood or the ageing process, this does not amount to wholesale subordination of his loved ones to some greater symbolic purpose. These images can still be upheld as successful examples of subjectification.

Some of the greatest depictions of children in art were done by the American expatriate artist Mary Cassatt (1845–1926). Her images display her acute awareness of the distinctive nature of women's lives and of the work involved in mothering. Cassatt was pro-Suffrage, an independent woman who rejected the expected roles of wife and mother. She made her own way in the art world in France and became successful, exhibiting with the Impressionists.[38] Among her paintings were many depicting either her friends or the women of her family with their children.

In Cassatt's portraits, women are typically shown in the midst of an activity that engages them: conversing, reading, sharing tea, gazing at the theatre through their opera glasses, sewing, contemplating the fireplace, doing tapestry work or embroidery, fixing their hair, picking fruit, hemming a dress, licking an envelope, etc. These depictions are respectful toward their subjects,

portraying them as distinct, autonomous individuals with inner lives. The same point holds true in some of Cassatt's portraits of young children, as with *Children Playing on a Beach* (1886).[39] Sometimes, instead, she conveys the children's conscious states by showing that they are bored, in the way children can be when forced into polite adult company. In *Little Girl in a Blue Armchair* (1878), the beautifully dressed girl wears pretty shoes with shiny buckles, but splays open her legs in a most unladylike fashion. She appears trapped in the gorgeously decorated blue sitting room, wishing that she could go outdoors and get dirty.

Cassatt often shows mothers caring for their young children in ways that bring out the children's dependency and need for physical contact. In *Mother Combing a Child's Hair* (1879), the mother firmly holds up the little girl's head with a hand under her chin. The skin tones stand out against the white sheets, and the mother's arms form a graceful line continuous with the child's legs and bare feet. Like Cassatt's other images, this painting conveys a strong sense of the tactile delights of children's soft flesh. Often in these works mothers hug or kiss their children, as in *Goodnight Hug*, 1880, *Mother's Kiss*, 1890–1, and *Maternal Caress*, 1890–1. In *Mother and Child—Young Thomas and His Mother* (1895), the woman kisses the child's shoulder with her nose buried against his skin. Griselda Pollock comments,

> Mothers love to bury their faces in exquisitely soft, sweet-smelling infant flesh...This print [*Mother's Kiss*] offers an image of passion reawakened in the mother and her recovered memories from childhood. The position of the two heads are those of lovers about to kiss. The woman's eyes are closed...the mother hugs the naked baby to her with an intensity that is almost painful. Its little face, by contrast, registers only joyous delight in being there.[40]

Besides emphasizing the sensuality of mother–child embraces, Cassatt also uses compositional techniques to fuse the two partners. Like other Impressionists, Cassatt was particularly struck by Japanese prints and she borrowed from their graphic patterns to work on flattening space in her own prints. She uses color and design to blend together woman and child. In *The Bath* (1891) the limbs of mother and child form a circle completing one another. In *Young Woman Carrying a Nude Baby* (1890), the mother has drawn back a curtain to look outward (see Plate 11). She holds a naked child with her left hand and arm and the angle shows us this child's back and sturdy little bottom. The image creates a blending of their two faces in profile, as if the back of the child's head could almost be that of the mother.

Today Cassatt's paintings of mothers and children are often regarded as beautiful but romanticized. She does not show children having tantrums with their little faces red with rage; her families are white, healthy, and upper-class. So does she 'objectify' only a particular vision of childhood? It would be unfair to criticize Cassatt for highlighting only some aspects of the intimacies of mother–child relations. During her life Cassatt was often criticized for choosing 'ugly' models. And her depictions do meet the criteria for subjectifying behavior in the list I developed above. They show subjects who are unique and autonomous, with intact physical boundaries, with their own thoughts and feelings, pursuing activities and interests.

In the century since Cassatt painted, there have been many changes in our conception of childhood. Sigmund Freud's influence led to broader recognition of children's sexuality, and he and psychologists like Jean Piaget also studied children's cognitive and moral development. These kinds of cultural factors make it unlikely that an artist today could get away either with

a Gainsborough-style meditation on the innocence of childhood or with Cassatt's celebrations of the sensual delights of mother–child intimacy. Two contemporary artists who have created interesting bodies of work depicting babies and children with a clear recognition of their potentials for moral evil and sexuality are the South African/Dutch painter Marlene Dumas and American photographer Sally Mann. While both women have made powerful images of their young subjects, they have also run risks of objectification in work that sometimes crosses the line. This occurs either through subordinating their subjects to an ideological message (as in Dumas's work) or through violating their subjects' boundaries and autonomy (as in Mann's case). (As before, I remind readers that my discussion focuses on how these artists treat subjects *in their artworks*, and not on what the facts are about their lives and their morality as the real human beings that they are.)

Dumas grew up in South Africa under apartheid and her work addresses the human potential to be inhuman to our fellows. Even her paintings of young subjects aim to show that they can carry in them the seeds of future wrongdoing. Her children are symbolic messengers of doom. One reviewer has described one of Dumas's paintings of a young girl in *The Painter* as a 'demon-seed offspring'. And besides this there is *The Wild Child*, which

depicts an unclothed, straggle-haired girl, hunkered down and viewed from behind, whose face, as it peers back at us over her shoulder, is a composite of sunken-eyed death mask, pre-human visage and pubescent witch's scowl.[41]

It is not only Dumas's children or girls who evoke hints of witchy danger and beastliness. Even her babies are unsettling. Another reviewer calls the infant in her painting *The Baby* (1985)

'almost repellent . . . an alien encounter'.[42] These remarks apply equally well to a mosaic work Dumas created in 1986 titled *Fear of Babies*. This assemblage of twelve separately framed images of babies emphasizes a strangeness in their facial features. The babies squint or grin wickedly; one seems to have a black eye and others have oddly distorted features, such as bulbous cheeks. The overall effect of the mosaic upon viewers is to prompt the inference that babies are strange and alien beings. Dumas confirms that she 'was really trying to express the enormity of a new being coming into this world. It's not a pet or a toy. It's not a Pampers baby. It's this new life with all the potential for evil and good.'[43]

The dual potential that Dumas is so insistent upon, even in newborns, is foregrounded in another of her groupings made up of four vertical panels with paintings of babies. In these huge images the babies are more than (adult) life-sized. The vertical positioning makes them appear to be standing so that they can confront us directly as we stand before them. It is strange to see such young babies in an erect pose because it makes us notice that in fact their little bodies are strange, with bowed legs, swollen bellies, tiny shoulders, and clenched fists. But it is their faces that are particularly haunting. One baby's head is turned to the side but with an eye that peers back at us suspiciously. Another baby smirks, as if perceiving and judging our innermost nature. These infants are all unnerving. A reviewer commented, 'It is difficult to walk away from that gallery thinking that babies are something cute and cuddly.'[44]

Are Marlene Dumas's paintings of babies and children objectifying? I would say yes. She is not really trying to render the unique personalities of her young subjects. Even though they have distinct physical presences and *some* kind of independent

consciousness, they seem to share just one psychological state: an ominous or even malevolent one, attributed to them by the artist through her selection of pose and depiction of their features and expressions. Dumas goes overboard in showing us the flip side of Mary Cassatt's enticing, luscious babies. Any mother in her right mind would run screaming from these alien and monstrous beings.

I have discussed Dumas's work here even though she was not actually painting or drawing her own children (she has a daughter), primarily because her art offers such an interesting and unusual case of the representation of children and babies. Dumas works from photographs, which may facilitate the kind of distance that her images exploit. Her paintings objectify children by using them to serve a larger viewpoint—she makes them all into symbolic vehicles of evil. When we consider instead a photographer-mother who depicts her own children, as Sally Mann did, things are different. On the one hand, there is a clear quality of intimacy and knowledge, but on the other hand, it becomes harder to retain the separation that I have insisted upon between the treatment of subjects in *making* the images and their treatment *in the images* themselves. Here, as with Dumas, objectification is a danger since Mann seems to have used her children as means to her artistic ends.

Mann is presenting a complicated portrait not just of her individual children but of a certain sort of childhood, from the perspective of a mother enjoying its unique moments while recognizing their fleetingness. Her images depict her children during episodes of play, interacting with nature and participating in family gatherings. Many of the images show them, like most children, playing games, hanging out with friends, dressing up, or going swimming. They are just generally engaged in the

typical activities of childhood, as it transpires in a particular setting in rural Virginia. There are strong narrative dimensions in Mann's pictures of her children. It appears from some of the images (and is substantiated in Mann's remarks) that she scripted or directed the children in certain ways that were needed to achieve the compositions she sought. The fact that she was using a large-format camera with a tripod implies that the children were typically not caught unawares; they would usually know when she was photographing them. (But at times one of them, especially the younger girl Virginia, is shown asleep, and hence obviously unaware.)

An artistic vision is evident in the photographs—these are more than family album snapshots. On the one hand there is an Edenic quality to the children's direct participation in the world of nature that surrounds them. But this same nature contains threatening aspects too, highlighted in images that show a child near a dead deer, or holding a dead fox or skinned squirrels. Mann's large, toned, and fairly dark prints deepen the Southern Gothic expressive dimension of her images. She seems to delight in the macabre, and not just in the pictures with dead animals. *The Two Virginias* (1991) is composed so that we look down the length of a bed with the flowing white hair of an elderly lady in the foreground. She is lying on her back, her face not visible, with a little girl asleep in the background. The two Virginias are each sleeping with one arm up in the air, creating a lovely visual rhyme. But the stiffness of the grandmother's fingers, combined with her neatly arrayed long white locks, are suggestive of a corpse, which renders the idea of the little girl lying in bed with her quite chilling.

The major risk of objectification in Mann's images arises because so many of them feature child nudity and sexuality.

There are many pictures of naked little children in this book; they run around in the nude far too much and far too late in life. Jessie is shown nude in images done of her at ages 6, 7, and 8. (One of my students who saw the book asked, 'Where were these people living? Were they hippies, or what?') Child nudity may be fine, especially if you live in the country, but it is not generally tolerated once the little people are past a certain age, let alone when a number of adults are present, as in *Hayhook* (1989). Sometimes Mann heightens erotic tensions with her composition, as in *Rodney Plogger at 6:01* (1989), which shows naked young Virginia with two large male hands clasped across her chest. Though the gesture may be protective, it looks controlling, especially given that she is held between the man's bare, hairy thighs. *Night-Blooming Cereus* (1988) depicts a girl's upper body, naked except for long stems that place two giant cereus blossoms right where her breasts will be when she matures. The image is lovely, although it employs rather clichéd flower symbolism. But the little girl who posed for this photograph with the flowers placed just so was being invited to experience an awareness of sexuality beyond her years. An unfortunate objectification occurs here as Mann uses this little person to convey her own artistic message.

The most problematic of the images in Mann's book *Immediate Family* is one that shows her son Emmet rather than either of her daughters. This photograph, titled *Popsicle Drips* (1985), depicts a little boy's naked torso cut off between knees and nipples. Allusions are made here both to classical sculpture (the boy's stance has an elegant *contrapposto* twist and his skin is marble-white) and to the well-known images that photographer Edward Weston did of his son Neil's naked torso in the 1920s. However, these references are jarringly interrupted by the

pattern of dark drips concentrated between his navel and thighs. It is unlikely that any little boy, however messy, would wind up with so many accidental drips in just this region of his anatomy— and none elsewhere. In the black and white image, the dark spatters look disturbingly like blood. Learning from the title that they are instead Popsicle juice does not improve things, because thoughts of licking can only be perverse when evoked by an image centered on a boy's thighs and genitals. While the image is striking, I would not hesitate to label it an objectification. Mann shows no interest in Emmet as a subject with his own autonomy and the intrusive focus of her camera here violates his privacy and physical boundaries.

I mentioned earlier that because of the circumstances in which these images were made and because they are photographs and not paintings, it is hard to preserve the distinction I am committed to between what images do and show and what occurs in real life. Obviously, in some of the images in *Immediate Family*, Mann's children were old enough to pose and participate knowingly in the photographic process. From the pictures themselves we can judge that at times they were able to do so, as when little Jessie vamps with a candy cigarette in her hand. And perhaps at some points the children must have refused, as is implied, for example, by the picture titled *The Last Time Emmet Modeled Nude* (1987), in which he is decorously covered by standing in water up to his loins. Still, even a child's willingness to pose cannot help rescue a parent from charges of objectification if there are doubts about the child's autonomy. (This is the same problem that arises when eager parents of little beauty queens claim that their daughters 'love the competitions'. The whole context is what is coercive.) Working with an artist mother over many years might have been fun for Mann's children, but there may also

have been some coercion involved, because young children like these are still dependent upon their parents.

In fact, Sally Mann's daughter Jessie has commented in later life about having been the subject of so many of her mother's photographs. She says that the experience of the mother–child bond was complicated by the artist–subject bond, adding that

> Maybe it was a harder childhood—or more complicated—than other children have. But, the other side of the coin is, we *enjoyed* being photographed. It gave us a sense of beauty. When you're around an artist all the time, you're always reminded of what's beautiful and what's special, and you can't forget it.[45]

My response to this comment is the same as the point made earlier about little girl beauty queens. It is difficult to defend the position that their choices to participate in competitions that objectify and hyper-sexualize them at a young age are autonomous. And so even if, like Jessie Mann, they comment later on that they enjoyed the process, their opinion does not cancel out the fact of their objectification.[46] Sally Mann is like any other stage mom (or dad) using a child as means to an end.

Lovers

Many artists have depicted their wives, husbands, or lovers in the nude, often with erotic overtones. Examples of these sorts of portraits will serve as the final illustration of how to apply my proposed criteria for subjectification. We have already considered the cases of Lucian Freud and Rembrandt. Next I plan to discuss Pierre Bonnard, who repeatedly painted his wife Marthe bathing and at her toilette. After that I will then move on to two

cases involving photographers, first, Alfred Stieglitz's numerous portraits of his wife Georgia O'Keeffe, and second, Robert Mapplethorpe's images of the men with whom he shared a common sexual milieu.

The nude is an established artistic genre, usually distinguished from the portrait by saying that a portrait depicts a specific individual, whereas a nude depicts a model who illustrates a generic human. Subjectivity is not crucial for the nude because it is someone whose specific identity is not of interest. The artist means to study the human form rather than the 'air' or personal characteristics of an individual person. This is not to say that the body of the nude is inert or thing-like. Kenneth Clark in his classic book *The Nude: A Study in Ideal Form* (1956), explains that the nude is an image 'not of a huddled and defenseless body, but of a balanced, prosperous, and confident body, the body re-formed'. To call something a nude is to elevate it by highlighting its artistic heritage and links with the classical past—with nudes from painters like Botticelli or sculptors from Praxiteles to Michelangelo. Thus it is not surprising that one effective strategy used in defending Mapplethorpe's images of naked men in the Cincinnati obscenity trial over his works involved comparing his photographs with classical nudes.[47]

Pierre Bonnard met the woman he eventually married, Marthe de Mélingy (an assumed name) in 1893 when she was working as a model. He did over 380 paintings of her. They married in 1925 and in that year he began a series of paintings of her in the bathtub, where she spent hours each day, perhaps due to tuberculosis, a skin disease, depression, or a combination of all of these. Bonnard's paintings of his wife bathing or toweling herself dry are both beautiful and eerie. Despite the intimacy of the situation, and the fact that this is a man painting the body

of a woman he presumably knows well, she remains aloof and alien in the images. Often her face is not shown or recognizable. She may be depicted from the back, as in *Large Yellow Nude* (1931), or as she bends over leaving just the top of her head visible (*The Bathroom*, 1932).[48]

Some of the implied distance in the images stems from their repeated, self-referential use of multiple framing devices. As John Elderfeld, the curator of a major Bonnard retrospective in 1998, notes, these devices include screens, partitions, shutters, windows, doors, table-tops, and mirrors. Or the painter uses odd angles that problematize our angle of vision on her body. These devices, along with occasional insertions of odd fragments of the painter's own body such as a slipper or bathrobe off to one side, serve to emphasize the distance between the two spouses, despite the surface intimacy of the situation. As another critic puts this point, 'Bonnard may be seen to be more demanding of his spectators than the decorative allure of his works might suggest. Sometimes the world they reflect is one in which we may find it hard to discover a position for ourselves. The very failure or absence of relationship is often what the gaudiness of the colors seems to express.'[49]

Marthe's image is often fragmented. It appears only partially in a mirror (as in *The Bathroom Mirror*, 1901), or it may be multiplied, offering different angles on her nakedness. This occurs, for example, in *Nude in Light (Bottle of Cologne)* (1907). In this striking painting, Marthe stands with her back arched so that her breasts are upthrust. She holds a perfume bottle, translucent and backlit, and is posed to anoint herself, lost in sensual pleasures of the experience. Her body is slim and beautiful, and the painter offers us two views of it. We see her from the back, with golden flesh, and also reflected in a mirror that

shows her body from neck to thighs and turns her skin a more ghostly bluish-white.

The criteria I have proposed above would prompt the conclusion that a painter who obsessively shows his wife naked with fragmented body parts is objectifying her, treating her as a mere means to express and evoke sexual interest. In addition, in all of the later bathtub paintings she is shown as inert and passive, meeting another of Nussbaum's criteria for objectification. And perhaps Bonnard also continually violated Marthe's privacy. Richard Dorment sees it this way, asking, 'How can the mystery on which allure depends be maintained in the strange, claustrophobic relationship that Marthe must have had with her husband? She couldn't even close the bathroom door without him trotting in, paper and pencil in hand.'[50] To top this off, the feminist art historian Linda Nochlin adds the following funny comment:

> I am also so repelled by the melting of flesh-and-blood model into the molten object of desire of the male painter that I want to plunge a knife into the delectable body-surface and shout, 'Wake up! Get out of the water and dry off. Throw him into the bathtub!'[51]

But it would be premature to stamp all of these paintings with the objectification label. Or at least, they do not satisfy *all* of Nussbaum's criteria for objectification. I mentioned in laying out these criteria that in some cases the artistic renderings of a subject might fulfill some but not all of the listed conditions. On the plus side, Bonnard does not seem to reject Marthe's autonomy in these images or deny her subjectivity, and even though they do not reveal her facial features, her body is unique and distinctive. Marthe seems absorbed in herself and her own

sensual experiences. Although she must have known what her husband was doing in some sense, she never appears to be posing for him. She goes about her own business. The description that comes to mind of her slender, lithe body is 'feline', a label that is instructive. Some commentators say that she leans over toward her own flesh in some paintings like a cat about to lick itself clean. Like a cat, she manifests grace but also mystery and inaccessibility. Although *Nude in Light* does afford the viewer two angles on Marthe's delectable body, it also evokes her own pleasures in that body as she enjoys the sensual spray of scent across her throat.

This indecisive verdict on Bonnard's paintings of his wife will only be extended when we turn to the latest images in the series, in which she is shown lying under water in a full-length bathtub (something recently introduced in French plumbing at the time). Several of these paintings were done after her death in 1942. He kept showing her as ageless, as if trying to sustain her life and their relationship.[52] This is true, for example in the most famous of these images, which was also the last one he made, *Nude in the Bathtub with Small Dog* (1941–6) (see Plate 12). The little dog on the bathmat beside her may symbolize the painter himself and his fidelity to her. These paintings again evoke mixed, even contradictory reactions. The bathtub is indisputably coffin-like and leads some viewers to suggest that Bonnard's difficult marriage led him to depict Marthe as if dead from anger and resentment. She is said to lie in 'white porcelain tombs made incandescent by the gold and violet light reflecting off the surfaces of the tiles and the water . . . [and is] suspended between being and non-being'.[53] Or, 'Marthe looks embalmed in formaldehyde, her features dissolving before our eyes.'[54]

But not everyone agrees with these assessments. Some interpret the images more positively, as in the commentary on *The Bath* (1925) on the Tate website, which says that it seems 'as if the painting were a silent expression of sorrow for Marthe's plight'.[55] Richard Dorment also sees the bathtub paintings as depictions of Bonnard's memory of passion:

> ... in them she also looks like Titian's Danae, as showers of golden light cascade down her remembered body. In the way in which the nude crosses her slim legs at the ankle to emphasise the V of her pubis, it's not death I see but a renewal of desire. Now that she is no longer present in his life, these pictures are once again saturated in desire—or rather Bonnard's metaphor for desire, light and colour.[56]

Merlin James suggests a more radical line here, that Bonnard created multiple images of his wife in an attempt to get closer to this woman who was absorbed in difficult mental and physical illnesses with an 'intense solipsism'. James's proposal is intriguing, because he suggests that in these images the artist sought to create a kind of fused identity between himself and his wife. She becomes like him, a kind of artist, as shown up in the ways in which she scrubs or anoints herself, with 'small tubes of lotion like paint tubes, addressing a mirror or other panel which has the presence of a canvas before her...'. And to complement this rendering, Bonnard depicts himself in the same bathroom, often also naked, mirrored, and fragmented. His face and upper torso are framed in the mirrors in the same bathroom where her jars of ointment line the shelf on the mirror in front of him. James comments,

> He tends in fact not to meet his own gaze, but to be looking elsewhere—surely in a sense at Marthe... So Bonnard's nudes of

Marthe are themselves, on many levels, self-portraits. That is, they are portraits of her as him, and him as her.... They are tragic paintings because, given her incapacity to relate to anything but herself, Bonnard, to have her attention, must become her.[57]

There is no simple answer to the question about whether Bonnard's paintings of Marthe objectify her. Yes and no. I have kept saying that we should focus on the depictions and what they reveal rather than on the facts of the relationship behind them. But in this case it is difficult to ignore the relevance of some of the biographical details, such as Marthe's illness and the fact that she had died before he did some of the bathtub paintings. I am inclined to say that these are portraits of intimacy in the sense that they make manifest a man's somewhat conflicted, complex emotions toward the particular woman who was his muse, model, and wife. True, some images objectify her by treating her body either in whole or in part as an object of erotic delight. And she is not as individuated or her character clearly revealed as we generally expect of successful portraits—a fact underlined by the blurriness of her face in most of the paintings. Still, she is a distinct, separate individual with a high degree of subjectivity. In fact the real issue here is that neither the artist nor we as viewers can quite grasp that subjectivity, because it remains elusive.

My next example involves another male artist who did multiple depictions of his wife, but this time it is a photographer, Alfred Stieglitz. Stieglitz met Georgia O'Keeffe in 1917 after she had sent some of her drawings to him through a friend for his evaluation. Impressed, he had hung them in his avant-garde gallery, 291, but without first getting her permission. She confronted him about this, but what began as a somewhat stormy interaction soon led to artistic collaboration, a love affair, and

eventually, marriage (in 1924). Their relationship was intense but not always smooth. 'Stieglitz's portrait of O'Keeffe, her role in its making, how it shaped critics' views of her work, and her response to their interpretations continue to be points of endless contention and fascination.'[58] Stieglitz made hundreds of portraits of O'Keeffe between 1918 and 1937. The images are quite varied. Among them are many pictures that are fairly standard for portraits, in the sense of showing her head and torso. They tend to emphasize her elegant bone structure and her distinctive style of dress, like her mannish hats and black clothes. In some images she looks independent to the point of arrogance, as in *A Portrait (14)*, 1923, which is shot from below so as to emphasize that she is tall and powerful. In others she seems softer, more vulnerable and even dreamy (as in *A Portrait, (4)*, 1918, or *A Portrait (6)*, 1919).

Other pictures Stieglitz made of O'Keeffe are frankly erotic and depict dissociated bodily parts including her torso, breasts, and abdomen. As with Bonnard's fragmented visions of Marthe, these are obvious candidates for the charge of objectification since they zero in on body parts rather than treating the person as a whole. Here too, though, as with Bonnard's paintings of Marthe or Sally Mann's *Immediate Family*, the existence of a series or multitude of images done in the context of an intimate personal relationship indicates that a deeper and perhaps more mixed assessment is required. The body-parts pictures are only a portion of the assembled record of an intimate relationship that went on for years. No one portrait can correctly be understood as standing on its own; O'Keeffe said, 'His idea of a portrait was not just one picture. His dream was to start with a child at birth and photograph that child in all of its activities as it grew to be a person and on throughout its adult life. As a portrait it would be

Fig. 6.3 *Georgia O'Keeffe: A Portrait* (1918), Alfred Stieglitz. One from the artist's depictions of O'Keeffe as muse, model, and fellow artist (and, later, wife). Photograph, palladium print. image (sight): 23.2 x 18.7 cm (9 1/8 x 7 3/8 in.), framed: 59.1 x 48.3 x 2.5 cm (23 1/4 x 19 x 1 in.). Photo: © Museum of Fine Arts, Boston 2010.

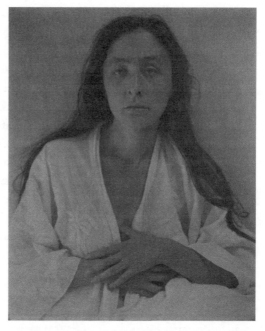

a photographic diary.' Perhaps the most erotic photograph Stieglitz did of O'Keeffe is not one that shows her breasts, like *Portrait (2)* (1918), but one in which she appears slightly disheveled, *Portrait (1)* (1918). Here she draws a filmy nightgown across herself, and looks as if just sitting up after satisfying sex. She is clearly an independent and autonomous subject, even if she is just as clearly seen through the metaphorical lens of the photographer's desire.

Many of the O'Keeffe portraits show only her hands. It seems improbable that portraiture would succeed if it shows only someone's appendages without any further individuating details—we do usually expect to see faces in portraits. But

Stieglitz revels in O'Keeffe's hands and shows them as distinct-
ive, elegant and sensual, with graceful long fingers and expres-
sive power. Even if they engage in a stereotyped female activity
like sewing, these hands belong to someone who is an artist in
her own right, a painter whose skills rest in them. The fact that
O'Keeffe was also an artist is salient in assessing Stieglitz's series
of portraits of her because in posing, unlike Mann's children,
she would have had a fairly clear sense of what her partner was
aiming at, even if she did not have specific expertise with his
medium. She was aware of having nice hands (she said, 'My
hands had always been admired since I was a little girl').
Of course, Stieglitz did script and direct her, but since she
was an adult, she was not being coerced. Rather, she was a
co-creator. She wrote later,

> He wanted head and hands and arms on a pillow—in many
> different positions. I was asked to move my hands in many differ-
> ent ways—also my head—and I had to turn this way and that....
> Stieglitz had a very sharp eye for what he wanted to say with the
> camera...[59]

Stieglitz's portraits of O'Keeffe make an interesting contrast
with my next and final illustration of portraits of intimacy, the
works of Robert Mapplethorpe. A juxtaposition between these
two men might seem surprising since there were so many
differences in their work (except for the fact of their both being
photographers). Whereas Stieglitz portrayed his wife over a
period of many years, Mapplethorpe is known in part for the
controversial images that form a record of a certain gay S&M
subculture in the early 1970s and 1980s, before the ravages of
AIDS. Stability and lengthy relationships were far from the norm
here. But there are commonalities if we pause to reflect. Unlike

Sally Mann, each of these men depicted adults in their work, people with a fully-formed capacity for autonomy and consent. Each man created erotic imagery of fragmented body parts but supplemented that with other photographs that showed subjects as wholes—fully active persons with bodies intact, even complete with recognizable heads (unlike Bonnard's wife). And although works by both Stieglitz and Mapplethorpe sometimes treated their subjects as items of intense sexual interest, they did not reduce them to objects who were mere means to an end. This last claim might be disputed in Mapplethorpe's case, and so I will take that up now in more detail.

My discussion of Mapplethorpe will not pretend to be complete, in that I will not attempt to discuss the full range of his images. In addition to his many photographs of flowers, he did a number of portraits of his friends (for example, of Patti Smith) as well as self-portraits. My focus is on those among Mapplethorpe's photographs that look like good candidates for the objectification label because of their concentration on body parts, especially large (and preferably black) penises. But as with Stieglitz and Bonnard, we should not rush to conclusions. It is salient that his models were lovers or friends who knew him as part of their 'scene'. Arthur Danto emphasizes this point in his book *Playing with the Edge: The Photographic Achievement of Robert Mapplethorpe*. Danto comments,

> ... those were real people who had put themselves in that way in front of the camera ... They clearly trusted the artist, who recorded the extremity of their sexual being with an uninflected clarity and candor, and who, given the physical constraints of the photographic session, had to have shared a space with them as well as a set of values, since he showed himself as a participant in the same form of life.[60]

The trust and mutuality of these photographs, according to Danto, indicate that Mapplethorpe's images of other men are also self-portraits of a sort. 'The photographer reveals himself through the way he shows the world. The photograph is accordingly an intermingling, as complex as the intermingling between body and soul, between object and subject.[61]

Because these images depict rational adults they cannot be said to exemplify many among Nussbaum's list of behaviors typical of objectification. Mapplethorpe was not violating his subjects' boundaries if they permitted his record as a kind of witnessing. They obviously knew he was photographing them— these are not stolen snapshots. Insofar as the images illustrate activities that satisfy or heighten their desires, their subjectivity is being recognized. Their autonomy is confirmed by the fact that they consented to the use of their full names, as in photos *Melody and Paul Wadina* (1988) or *Brian Ridley and Lyle Heeter* (1979). The same point holds true in the case of *Mark Stevens (Mr. 10½)* (1976); the measurement given as part of the title is presumably that of his large male member, highlighted in the image by him holding it placed upon a pedestal like a sculpture in its own right.

But on the minus side, some of the images do appear to fetishize body parts, not just for erotic but for a certain sort of aesthetic end. In these cases the photographs manifest a form of objectification in that they fail to acknowledge the subject's uniqueness or individuality. This charge has to be made against the notorious *Man in Polyester Suit* (1980), depicting a man's torso cropped from below the neck to the knees, his giant penis spilling from the opened zipper of the titular suit. Danto responds to Richard Howard's remark in the catalog essay that Mapplethorpe aestheticized the phallus by calling this 'disappointingly as

reductive and mechanistic an attitude as that which thematizes big breasts in women'.[62]

A less overtly sexual example of objectification involves Mapplethorpe's photographs of body-builder Lydia Cheng. Danto sees no problem here. He writes that 'this awkward perspective was consented to, and addressed by the artist with the subject's full knowledge and cooperation. Cheng is being treated as an end not as a means, and there is not the slightest sense of obscenity, let alone pornography.'[63] In her biography of Mapplethorpe, Patricia Morrisroe reports that these images were objectifying, because, 'She was merely a body to him, and a headless one at that.'[64]

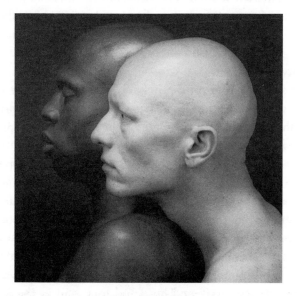

Fig. 6.4 *Ken Moody and Robert Sherman* (1984), Robert Mapplethorpe. A study in male physiognomy that emphasizes physical closeness.

In many images, however, unlike in these examples, Mapplethorpe seems to observe and show an interest in the intimate relationships among his subjects. These images can be fascinatingly complex and not reductive, as in *Ken Moody and Robert Sherman* (1984). This photograph juxtaposes two bald male heads shown in profile, one black and one white. Susan Gubar calls it a 'thrilling' image and adds that it 'meditates on the serious intent shared by its subjects' hauntingly interlaced subjectivities, an intensity of vision that highlights their vulnerability as the object of our gaze'.[65] Gubar's comment is odd, however, since intensity of vision usually makes a portrait subject *less*, rather than *more*, vulnerable to a viewer's gaze. Another writer, Dennis Flannery, offers a different account of the power of this image, which is 'difficult to forget, to turn away from, and even more, difficult to read ... The photograph is frightening to the extent that it represents naked male human proximity with such ambiguous intensity ... '[66]

Some details may prove helpful here. Ken Moody was a bodybuilder Mapplethorpe often photographed, but who refused to be shot with full frontal nudity.[67] In *Ken Moody* (1983), he is posed with his back to us. He wears a thong that permits us to admire his beautiful back and firmly defined buttocks. The allusions to sculpture are brought out by his *contrapposto* pose as well as the odd way in which his arms appear cut off at the shoulders, making him resemble an ancient masterpiece damaged after millennia. Moody had alopecia, a condition that causes complete hair loss—of eyebrows along with the hair on top of one's head. It seems obvious that Mapplethorpe was delighted with his model's body and head and used him in the *Ken and Robert* picture to highlight strong visual effects by juxtaposing his bald black head with another one, also hairless, but very white.

Flannery suggests that Mapplethorpe's art manifests a certain queer aesthetic that reflects the nature of relationships in his community at the time. Intimacy was understood very differently from any definition derived from idealized conceptions of a monogamous relationship between members of a heterosexual couple who are most likely married. In the gay S&M community of New York in the 1970s and 1980s, that sort of intimacy was neither socially permitted nor actively sought. This point must be taken account in any adequate assessment of objectification in Mapplethorpe's work. Flannery's proposal is a simple but rich one: he thinks that images like the one of Ken and Robert show two people who comprise a *pair* and not a *couple*. A 'pair' involves two things or people conjoined in an accidental way, in contrast to a 'couple', understood as a more fated, stable, and coherent norm. Depictions of couples (and we might add, of mothers and children) tend to presuppose a notion of intimacy involving long-term knowledge, but perhaps also signaling conformity and sentimentality. (Flannery does not mention the other emotional risks in long-term marriages, such as resentment and claustrophobia—which come to mind since we have just examined Bonnard's paintings of Marthe.[68])

On this line of interpretation, Ken Moody and Robert Sherman in the photograph that bears their names are a *pair* rather than a *couple*. They need not be seen as lovers, but rather as two men brought together by circumstance, or perhaps just by the coincidence of visual resemblance. The placement of their heads in parallel, one behind the other, is pleasing because of its visual parallelism. The image engages viewers because it simply is not evident how these two are related to each other, if at all. Ken's eyes are closed while Robert's eyes look forward; Robert is in the front, and Ken just behind him. Is this a subliminal message

about race, a visual quirk, or what? I do not find the image 'frightening', as Flannery did, but fascinating. Each man enhances the other, but they look off to the side and not at one another. Their subjectivity is mysterious and they remain independent, despite their physical proximity. I would not count this image as an objectification, even while admitting the fact Mapplethorpe, like any artist working in black and white photography, would clearly relish the sheer visual juxtaposition of these two heads.

The same point about the *pair* applies to an image that shows Ken with a different white man, *Ken and Tyler* (1985). The two men are standing, facing to their right (our left), though here only their bodies are shown and not their heads. The men's nude bodies are aesthetically appealing, and their long lean limbs are stippled with light from Venetian blinds. They hold their arms up beyond the top of the picture frame, enabling us to relish the sinuous curves comprising their backs, buttocks, and legs. Each assumes an identical, balletic stance with his left foot just lifted off the ground. Though the image tastefully conceals their genitals, it is still erotically suggestive because Ken approaches Tyler from behind, as if preparing for a sexual embrace.

Of course, many of Mapplethorpe's images go beyond erotic hints to the full thing, so to speak. Even if we agree to speak in such cases of 'pairs' and recognize that 'normal' marital fidelity in a heterosexual context was just not the aim, there still seem to be risks of objectification. Recall the behaviors listed by Nussbaum. Do Mapplethorpe's most overt and controversial images treat the persons they show as means, deny their autonomy, show them as inert, replaceable and not unique, violate their boundaries, present them as things to be owned, or deny their subjectivity? Few of these conditions are met.

They depict adults[69] and the participants in the scenes they show—a man urinating into another's mouth, fisting a lover, or holding his partner in chains—have presumably agreed to the activities shown as well as to their being photographed. These men are far from inert, and subjectivity is attested in that they appear to be pursuing their own desires. We might be tempted to think that some boundaries are being violated, but again, these are adults and presumably consenting ones; the violation in question provides them erotic enjoyment. And even Mapplethorpe's fragmented photographs of aestheticized phalluses cannot be said to present them as mere things to be owned. They are enticing organs of pleasure that merit celebration. Perhaps they are interchangeable, a charge that might be the one thing on Nussbaum's list of objectifying behaviors that is applicable here.

But we should remember that in discussing the equally omnivorous sexual atmosphere of Hollinghurst's novel *The Swimming-Pool Library*, Nussbaum reached the tentative conclusion that sometimes fungibility might be morally benign or even good if it reveals a democratic sexual interest in other bodies. She does, however, express a worry about that example, one that I think also applies to Mapplethorpe's photographs. This is that they 'focus intently on hypermasculine characteristics of musculature and penis size, which presumably are not equally distributed among all citizens of this world...'.[70] A world in which some bodies (and penises) are clearly better than others is not the open-ended democratic paradise that she considers potentially benign. So although objectification in the sense of a happy attitude toward interchangeably attractive sexual parts might be acceptable, it is probably just not achievable.

It would be remiss not to acknowledge that in his case, as in Freud's, the nudes and sexually explicit images might never have been intended to be portraits in my sense. Thus Mapplethorpe might have conceded that many of these images do not concentrate on enabling us to come to know or have a strong sense of the person being depicted in any roles other than aesthetic or erotic ones. I did consider it important to discuss his works focusing on male nudes since, like Dumas's paintings of babies, they provide a strong counterpoint to more standard expectations and norms in the depiction of intimate relationships.

Conclusion

In this chapter I have examined artists' portraits of people they are closest to—parents, children, lovers, surveying a variety of factors that are relevant when an artist succeeds at rendering subjectivity. (As I have said repeatedly, my concern is with representations and not with the biographical details behind them.) To provide a theoretical framework for discussing subjectivity in intimate portraiture, I used Martha Nussbaum's analysis of objectification. I derived from her account a list of behaviors *opposite* to those on her list, assuming that these could reasonably be regarded as behaviors contributing to subjectification. This new list included treating the portrayed person or persons as an end and not a means; endorsing their autonomy; presenting them as active and alive; showing them as unique and irreplaceable; respecting their boundaries; treating them as beings who cannot be owned; and endorsing their subjectivity.

Some examples of depictions that must be called objectifications given this framework included Lucian Freud's nudes, Marlene Dumas's babies, some of Sally Mann's photographs of her children, and some of Robert Mapplethorpe's photographs zeroing in on male genitalia, as well as his pictures of body-builder Lydia Cheng. Subjectification was achieved, on the other hand, in the records of ongoing relationships that some artists did over years with their loved ones, as in Hockney's and Freud's paintings of their mothers, Stieglitz's photographs of O'Keeffe, many of Mapplethorpe's depictions of pairs, and the paintings that Bonnard and Rembrandt did of their wives. This also applied to portraits done of children by Mary Cassatt and Gainsborough.

The major threats to success at rendering personhood involve an overly heavy use of symbolism, fragmentation of body parts (typically done with an erotic aim), an emphasis on passivity and inertness, and violation of boundaries. Working with children poses a special risk to artists because of potential problems of coercion and their lack of full autonomy. Objectification in non-sexual cases may not always be morally bad. Perhaps, for example, even if Dumas, Velázquez, Gainsborough, or Cassatt treat babies as the means to a symbolic end, this might be in order to serve a morally good purpose, say, reminding us all of the human potential for evil and cruelty (or for love and growth). Similarly, there are nudes by Mapplethorpe and Freud, and perhaps some of those done by Bonnard and Stieglitz, that involve an objectification of body parts through fragmentation. This may reflect an interest in human flesh or form that is not sexual but rather, aesthetic. Treating a person as a mere means to an end in this sense—as an object of aesthetic contemplation—is not as problematic as using them as a slave or sexual servant.

(But one might reasonably decide to think twice before agreeing to be such a person's muse or object of beauty!) If it does not involve coercion, ownership, or a violation of boundaries, I do not think that aesthetic objectification is immoral. Despite this qualification, such objectification will always interfere with the aim of portraiture: rendering persons in their full and complete subjectivity.

The Fallen Self

Introduction

In Chapter 3 above I promised to return to the topic of the alleged disappearance of the self, a disappearance proclaimed in the title of Raymond Martin and John Barresi's book *The Rise and Fall of Soul and Self* (2006). If portraits aim to reveal something essential about a person, but persons have somehow managed to disappear, then the fate of portraiture looks dire. And indeed there have been assaults on the enterprise of portraiture in the higher echelons of the art world—although on a popular level the genre has never faded and is indeed flourishing.

Martin and Barresi are serious in speaking of 'the fall' of the self. (Their chapter on this is even titled 'Paradise Lost'.) They date this fall back to the second half of the twentieth century as a partial aftermath of the Second World War. What has disappeared is the self of modernism, comprising two fundamental components, the conscious Cartesian ego and the autonomous Kantian moral agent. What has vanished is the old notion or ideal of a self that is unified, has ongoing self-awareness, and

can serve as a rational base of decision-making and moral responsibility. Various factors have helped erode the role of such notions in contemporary life, according to Martin and Barresi. Among these is the so-called 'decentering' of the self described in terms of semiotics and psychoanalytic theory by thinkers like Saussure, Lacan, Foucault, and Derrida. These thinkers theorize that the self has become divided as we all seek definition from external sources, whether in cultural practices, the interpretations of expert scientists, or the incessant longing to find completion in others.

Others also questioned the unified self by focusing on multiple and sometimes conflicting aspects of identity such as race, ethnicity, gender, social class, and sexual orientation. Here the key theorists are civil rights activists like W. E. B. DuBois and Frantz Fanon, and various feminists who allegedly attacked the ideal of the self 'on the grounds that it is motivated by a patriarchal political agenda'.[1] The post-colonial and postmodern self is fragmented, dispersed among pre-existing, competing symbol systems that might formerly have seemed to capture it. It has multiple kinds of allegiance and is at the mercy of diverse forces pulling it in different directions.

This is only a partial account of the reasoning behind Martin and Barresi's claim that the self has fallen. Psychologists, philosophers, and neuroscientists have also put the concept of the self under such scrutiny that it has begun to fracture and lose its theoretical force. I will postpone addressing these further complications until the next and final chapter of my book, the Epilogue. We already have seen enough to grasp the challenge to the enterprise of portraiture. Persons, according to Martin and Barresi, have been dissolved into diverse systems of signifiers or fragmented due to their allegiances with multiple groups.

Translated into portraiture, these shifts would lead us to expect a proliferation of imagery that shows people as mere surfaces or signs. Or, portraiture will depict a person as the location for diverse sorts of identity, emphasizing the artificial constructions of gender, race, or ethnicity and leaving no inner core at the root of things. In the first part of my chapter below I will consider the evidence in recent decades of art practices that does appear to indicate such skeptical 'evacuations' of the self into different layers of signs, images, or stereotypical affiliations—or into what theorist Jean Baudrillard would label the realm of 'simulacra'.[2]

In contrast to the above option, however, recent decades have seen another approach in portraiture to the evolving nature of persons and selves. My second section below will address this alternative stance, which involves foregrounding and exposing the self until nothing secret remains. I have in mind the confessional and autobiographical works of some artists—intriguingly, often younger women artists—such as Nan Goldin and Tracey Emin. In this sort of work everything is fair game as the self is laid bare for all to see. Art reveals and explores drug use, rape, domestic violence, and the messy details of one's sexual liaisons. Perhaps the self is divided and has multiple allegiances, but everything will be laid bare for the public to examine, and so once again no privileged independent core self remains at the center of a person's identity. Questions of morality or of privileged Cartesian self-knowledge become irrelevant when other people are granted as much access to the self as the artist has.

A third and quite different artistic option to conveying the fragile nature of the modern self is to abandon traditional representational methods in favor of new ones made possible by emerging scientific technologies. On this approach too, the

Cartesian ego and Kantian moral self are dispensed with, but this time in favor of the 'truer' or more 'objective' information gleaned from scientific scrutiny. Scientific imaging devices can now provide alternative views of a person, both inside and out. Biometric techniques are already used to guarantee security. They aid in passport screening (handprints, face recognition systems, and iris scans), identify criminals (voice prints and DNA samples), and help screen out suspected terrorists (the Israeli security employ 'SPOT' (Screening Passengers by Observation Technique), an application of Paul Ekman's facial action coding system).[3] Identification by DNA is so well developed that it can stand up in court, and it sometimes frees people who have served decades of time for crimes it turns out they did not commit. DNA printing thus surpasses even the greatest artist's or finest camera's ability to record a person's individuality.

Adopting such technologies, some artists have created new kinds of portraits, as Marc Quinn did in 2001 of British geneticist Sir John Sulston by presenting a framed image of his DNA. Another artist in this mode is Gary Schneider, who employed a range of methodologies in collaborations with scientists to produce his 1998 exhibition and 1999 book *Genetic Self-Portrait*. I will discuss these and other examples of new scientific approaches to capturing persons in my third and final section below.

It will probably not surprise readers to hear that I do not accept Martin and Barresi's argument that the self has fallen. By examining artworks that appear to support their claim—whether by eroding persons into signs, revealing them so fully that they have no core or secrets, or translating them into privileged sorts of objective data—I will be able to clarify my own reasons for rejecting the 'fallen self' thesis.

Disappearing Selves

This section of my chapter will address kinds of portrait practices that seem to support Martin and Barresi's idea that the self has disappeared into broad public systems of signs and signifiers. It will be useful to distinguish the artists taking this approach into two subgroups, and for clarity's sake I will focus on just a few examples in each case. Both subgroups include artists whose work presents the self as a mere image with nothing behind it. In doing this the artists tend to work by recycling or reworking previously created images. In the first group they choose as their portrait subjects quite famous and publicly visible people such as politicians and movie stars, recirculating their images after artistic intervention. I have in mind, of course, Andy Warhol, and also Gerhard Richter and the younger American artist Elizabeth Peyton. In the second group are artists who depict themselves, but always while employing masks or disguises drawn from the media or from art history. My examples of this group will be Cindy Sherman and Yasumasa Morimura. My general aim is to show that despite the influence of these artists and despite shifts in portrait practices in art of recent decades, the claim that the resulting images show the fallen self is not substantiated.

Let me begin with the 'everything is surface' approach of Andy Warhol. Warhol was famous for deflecting questions about the purpose and meaning of his art with notorious remarks such as, 'I feel the less something has to say the more perfect it is.'[4] His immense output spanned a wide variety of subject matters or themes as well as mediums and genres, from paintings, drawings, and prints to films. Warhol is especially well known for his multiple silk-screened and brightly colored prints of celebrities like Marilyn Monroe, Elvis Presley, and Jackie

Kennedy. His own self-portraits are also famous and typically employ the same style, produced in multiples with bright color washes. Perhaps less well known but still prominent are the numerous silk-screen multiple prints he made based on media images showing scenes of death and disasters, including the electric chair, car crashes, suicides, the atomic bomb, and race riots. Just what Warhol meant by these more somber images is unclear. Despite his own general pose of superficial blank vapidity, Warhol's work has been seen as a form of social criticism. One critic comments, 'Warhol's work is epic in ambition, sober and grave in its execution.' The death and disaster series in particular 'demolishes the popular misconception of Warhol as a celebrant or critic of trivial consumer culture'.[5]

Perhaps because of the artist's statements and personality, or perhaps because of the work itself, Warhol has inspired a wide swath of theoretical writing and criticism. Many construe him as a Pop artist primarily reacting to the heroic models of creativity by artists like Jackson Pollock that typified Abstract Expressionism. Other writers, as we have just seen, discern social messages in his work and regard him as a critic of consumer society. Thus Arthur Danto claims that Warhol's works 'remain political' because they concretize 'the American soul, *mis a nu*'.[6] And yet at the same time Warhol has also been treated as a clever advocate of new forms of capitalism, someone well aware of how to commercialize his 'brand' successfully by creating mass production in his studio 'The Factory'. There are also accounts that explain Warhol in the terms of queer theory by focusing on his admiration for women movie stars from Shirley Temple onward with a focus on his outsider status. And yet another approach to his work frames it as a product of his particular ethnic and religious background, to explain his fascination with

the iconic figures of current society like Jackie and Liz Taylor. Thus Jennifer Dyer has written that he presents powerful icons, 'but they are icons of the mundane rather than the divine. Warhol's art iconologically treats the mundane as the divine.'[7]

There were two main stages of Warhol's production of portrait-like images. In the earlier stage he produced most of the multiple screen-print images he is now known for (along with, of course, the Campbell soup cans and Brillo boxes). His first multiple images were of Marilyn Monroe just after her suicide in 1962, along with multiples of Elizabeth Taylor, mostly using press photos from the previous decade. In the second period during the 1970s Warhol accepted commissions (at the rate of $20,000 each) and produced numerous individual portraits of people who had the money to pay for the product.[8] These too were often photo-based. He liked to use Polaroid photos as well as the sequential images shot by penny photo booths. At various stages along the way, of course, the artist also produced self-portraits. Even in art school at Carnegie Tech in Pittsburgh where he grew up Warhol was producing multiple sketches of himself, sometimes engaged in naughty behaviors such as picking his nose.[9]

The Marilyn and Liz paintings are obviously about celebrity and glamour. Working from previously published newspaper and magazine photographs, Warhol managed to blow up and play with idiosyncrasies of the original print medium such as blurs, grain, or highlights, which became magnified in the screen prints he created. He used vivid colors to highlight particular aspects of these women such as their hair or lips with exaggerated yellows or blacks, crimson red stains on the lips, blue eye shadow, etc. Cecile Whiting describes these images as resisting any implication of an interior life or private self for the celebrity

being shown: 'Warhol's paintings are at odds with the popular mythology according to which a star's "true" identity lies trapped within a public image.' She explains that after Monroe's suicide the media played up the sad nature of her private life, but Warhol countered this tendency with his multiples which focused only on the surface, the public view.[10]

As celebrity images, the Liz and Marilyn paintings function in just the same way as some of Warhol's other works do. Even political figures like Lenin and Mao are all treated as advertisements for a culture, way of belief, or 'life-style', to use the new term that came into usage at the time.[11] Speaking about the Mao image, a curator writes,

> The portrait of Mao is not based on political views or propaganda. As they express no personal feelings or opinions beyond those inherent in the initial choice of subject, Warhol's works force us to deal with them primarily as painted surfaces. Understanding the paradoxical levels of reality and artificiality in our culture, Warhol can manipulate these questions in terms of art, which has its own reality.[12]

Even Mao looks glamorous in Warhol's version, with his nice cheekbones and blue eye shadow!

In effect, Warhol's style managed to equate all persons, regardless of gender, belief system, or role in life. Processed by his technique, they all come out 'Warholized', *trés chic* but blank. As Dyer remarks, 'the figures presented have a disturbing passivity ... The viewer gazes at a subject that is pure surface flatness—neither a mirror nor a deep pool. For instance, viewers learn little about Elvis Presley or themselves through Warhol's magnification of him in *Elvis I* and *II*, 1964.'[13] Dyer's response is probably a natural and widespread reaction

to the homogenizing tendency of Warhol's visual style. However, to counter this, an alternative reading of at least some of his images sees them as delving beneath the surface. This more sympathetic construal has been given, in particular, for Warhol's multiple images of Jacqueline Onassis, in, say, *16 Jackies* (1964) or *Jackie (The Week That Was)* (1963). Critic Mark Francis writes that these 'seemingly innocuous' paintings can prove 'complex and disturbing' and even calls the *Marilyn Diptych* (1962) 'tragic'.[14] Thomas Crow has interpreted the images of Marilyn, Jackie, and Elizabeth Taylor as 'a stark, disabused, pessimistic vision of American life, produced from the knowing rearrangement of pulp materials'. And Crow felt this was true especially for the Marilyns, which show 'a certain distance and reserve'.[15]

I disagree with Crow and the 'deep feeling' interpretation. That is, I continue to think that Warhol's images of celebrities really do not have any depth or psychological penetration. When they seem to convey sympathy or suggest an inner life, this is just because we are so familiar with the subjects that we tend to read their tragedies into any version of their faces, even without seeing indicators in the works themselves. *The Week That Was 1*, for example, utilizes rather stark contrasts between Jackie's pre-assassination 'happy' faces in the pillbox hat to other well-known images of her taken during scenes of mourning and at her husband's funeral. The same technique of harsh juxtaposition is used in *16 Jackies* with each row alternating between four repeated pre- and post-assassination images. We do much the same when we see photographs of people who died tragically young like Princess Diana or John Kennedy, Junior. In a few cases of Warhol's paintings like his multiples of the boxing champion Mohammed Ali, just to see a picture of his face with

its visible record of injuries and damage *is* to feel some degree of pity (even apart from how one views his rather notorious personality). Something like this is what is cueing our response to Warhol's Jackies and Marilyns. This point will be reinforced, I hope, when I compare Warhol's work with that of the next artist I will discuss, Gerhard Richter, who took a different tack in his Jackie painting.

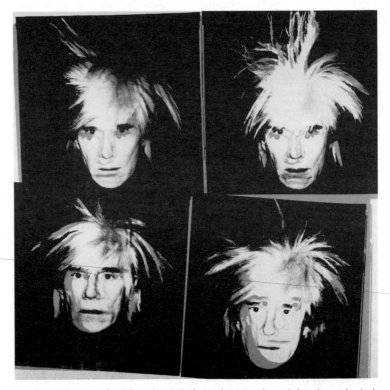

Fig. 7.1 *Self-Portrait* (1986) Andy Warhol, emphasizing the artist's unique physical features.

Warhol's self-portraits present a similar kind of challenge: are they actually revealing or do they too stay at the surface, just as the artist maintained? His book *The Philosophy of Andy Warhol (From A to B and Back Again)* is full of such gems as, 'I'm sure I'm going to look in the mirror and see nothing. People are always calling me a mirror and if a mirror looks into a mirror, what is there to see?',[16] or 'I never fall apart because I never fall together.'[17] Done in the frozen style of fixed-face presentation typical of his celebrity pictures, Warhol's self-portraits present little expressivity or intimations of subjectivity and inner life. Instead, 'Warhol only parades a characteristic distance and refusal of any humanist depth of feeling.'[18]

But once again, there are readings that construe some at least from among Warhol's self-images as more revealing.[19] One critic argues that Warhol's very late self-portraits show

an admission of angst that had been gradually emerging since the late 1970s: there is a suggestion of pain and fear in the eyes which, reduced to black balls pierced by a pinpoint of reflected light, glare out with haunted intensity, and this is reciprocated in the lipless void that forms the mouth and the sunken cheeks across which the skin is stretched. These cadaverous resonances are underscored by the framing. And why does the hair stand on end, as if electrified by fear?... Is this Warhol's autobiographical invocation of Munch's *The Scream*?[20]

So what should we conclude in the end about Warhol's portraits and self-portraits? Has the self disappeared into a system of signs, into surfaces without depth? Warhol's work is hard to interpret. It is tempting to throw up one's hands in agreement with the claim that, 'Warhol's indecipherability is constitutive, if not intentional.'[21] Most commentators do at least agree in seeing

Warhol as an important forerunner of postmodernism. His manipulation of already circulated images paved the way for the sort of postmodern ideas articulated in Baudrillard's seminal article 'The Precession of Simulacra'.[22] Andy's Liz and Marilyn are prime examples of the point Baudrillard makes about how the *simulation* of beauty has become more real than the reality of beauty. Images have become definitive of glamour and beauty in a way that no real person can live up to. In addition, Warhol's choice of mechanical means of production and reproduction foreshadowed subsequent postmodern skepticism about the possibility of any real artistic originality.

Like many postmodernists, Warhol also manifested skepticism about the self, if by that term we refer to certain romanticized or idealized notions of the self as a site for personal expression and the search for an identity. He would indeed have been skeptical about Kant's idea of the self as an autonomous moral agent. After all, Warhol was the man whose slogan was, 'I think everyone should be like everyone else.' For this reason Frederic Jameson contrasted Warhol with an earlier more Romantic artist like Edvard Munch in 'Postmodernism, or the Cultural Logic of Late Capitalism', where he described Warhol as discrediting thematic issues of modernism such as 'anomie, solitude, social fragmentation, and alienation'.[23] In other words, Warhol was not engaged in any post-Romantic agonizing over self-definition. In Warhol's case a combination of factors do tend to support Martin and Barresi's claims about the fallen self: his rejection of the notion of an ideal self, of the effort to convey subjectivity, and of traditional notions of artistic creativity.[24] Taken together, these lead inevitably to the conclusion that Warhol's work is not actually portraiture in anything like the traditional sense.[25]

If all artists were like Warhol, then probably this would indicate that both the self and portraiture are dead. But this is not the case, as will emerge when I turn to my next example. And as we have seen, there are even critics who find elements of personal and emotional expression in many of Warhol's works. It should also be noted that when he gave the 'celebrity treatment' to people who commissioned his portraits in the 1970s, this did not *ipso facto* transform those individuals into public faces whose private selves had become lost. This suggests that the typical famous person shown in a Warhol painting was someone who already experienced strong public–private tensions, but that such a situation was non-standard rather than the norm. Being glamorized by a Warhol treatment would not magically mean that one's personal life had become lost.

It is no surprise that Gerhard Richter, the next artist I want to examine, has been compared to Warhol, since he too often uses photographs as the basis for paintings and has chosen to depict scenes derived from sensationalistic stories covered in the mass media. (This was particularly so earlier in Richter's career.) He has done paintings based on his own collection of photographs, encompassing both family album snapshots and others clipped from various news media. Like Warhol, Richter has also done paintings or series of paintings based on photographs of famous people, as with his *48 Portraits* depicting (mostly) nineteenth-century intellectuals.[26]

Richter's techniques, however, are quite different from Warhol's. He creates a new painting and does it by hand, using projections from the photograph on a wall as his starting point. Thus there is more of an artistic intervention in the media image, and this shows up in the results as well as in the process. But perhaps this superficial difference has minimal effect. Richter too

has commented on the importance of surfaces, the lack of depth behind his images, and on the equality of various types of subject matter in his works. He maintains that the use of photographs is a distancing device, as is his blurring. In a remark that could be something straight out of Warhol's mouth, Richter says, 'I blur things in order to make everything equally important and equally unimportant.'[27]

The comparisons with Warhol are particularly apt in cases where Richter painted the same or similar subjects, as with his Jackie Kennedy image *Woman with Umbrella* (1964). Though the title does not actually identify the woman as Jackie, she is readily recognizable. She holds an umbrella in her left hand and has her hand clasped to her face with the other. One review sees this painting as so ambiguous as to be emotionally neutral:

> One of his first experiments of this kind was *Woman with Umbrella* (1964). The subject is deliberately anonymous, and the facial expression open to interpretation (is she laughing, crying or sneezing?). Yet this is an image of Jackie Kennedy based on a newspaper photograph taken soon after the assassination of John F Kennedy. The painting emphasizes that meaning in portraits is what we bring to them, rather than something inherent in the image.[28]

But I beg to differ. It is very difficult to view this as 'just' a picture of a woman about to sneeze. Because there is such a natural tendency to identify the person in the picture, the image is fraught with emotion. Jackie's hand is raised to her face to hide a scream of grief, almost as if seeking to cover her eyes as well. There are a number of reasons, some difficult to pin down, why Richter's images based on news photographs are more emotionally affecting, less flat and impassive, than Warhol's. For Richter

the self has not been erased as it has in Warhol's. Some of the emotional effect of works like *Woman with Umbrella* stems from Richter's peculiar blurring technique. Also, he produces images that stand alone rather than in multiplication, which tends to deaden things by calling attention to itself as an aesthetic fillip. As Warhol said, 'The more you look at the same exact thing, the more the meaning goes away and the better and emptier you feel.'[29] The size matters as well. Richter's Jackie painting is 160 by 95 cm or roughly 63 by 37 inches, 5 by 3 feet. Warhol made his images at various sizes, but one of the *16 Jackies* is roughly 80 by 64 inches. This in effect reduces her face in the overall display, whereas in Richter's image she is larger and more significant. At the opposite extreme sometimes Warhol made his Marilyn images quite large, another kind of distancing technique. In either case Warhol's works are not as close to a human-size scale, and this tends to have a deadening impact on them. As a critic has noted,

> For Warhol and fellow Pop artists, reproducing images from popular culture was the visual means for expressing detachment from emotions, an attitude they regarded as characteristic of the 1960s. Like droning newscasts, repetition dissipates meaning and with it the capacity of images to move or disturb.[30]

A further factor that distinguishes the two artists is that in Richter's transformations, the tragic protagonists are seen primarily in somber shades of black, white, and gray, emerging against the pure white of a void, and not with the circus-like bright colors Warhol used. A commentator has assessed the effect:

> Barnett Newman called gray the color of tragedy. And so it is in Richter's work, but more likely the color of the representation

of tragedy, or the world as represented by photographs, the preponderance of which (at least in newspapers) were black and white until recently...[31]

Woman with Umbrella does manifest some color, but it is just ghostly washes of pink, yellow, green, and orange. The pink works, I would suggest, to evoke memories of Jackie's pink pillbox hat and suit on the day her husband was shot.

Richter's blurring technique also creates different emotional responses from the peculiarities engendered by Warhol's silk-screen processing. Whereas Warhol's multiple prints appear to highlight chance or random effects in enlarging already-grainy images, Richter's blurring feels more personal, hands-on, and purposeful. It also evokes a temporal dimension, since a blurred image is like something seen only indistinctly as in a vague memory.[32] There is a dreamy aura to his images, which seem rather nostalgic. Richter does create multiples, but in his case the images form a series in a kind of accumulation of different people treated formally in the same way, rather than by variation and repetition of the same image. The people in Richter's photo-based portraits tend to be depicted in a way that makes their dark features stand out as a sort of chorus arrayed on the images' surfaces as they parade across walls or up and down stairwells. Thus Benjamin Buchloh describes the people in *48 Portraits* as 'tightly locked into the frame and closely compressed onto the surface'.[33]

Again like Warhol, Richter has covered images of crime in the news. But unlike Warhol, he painted both the criminals and victims, sometimes raising questions about which is the right label, as with his *October 18, 1977* series covering the prison suicide by hanging of various members of the Baader-Meinhof

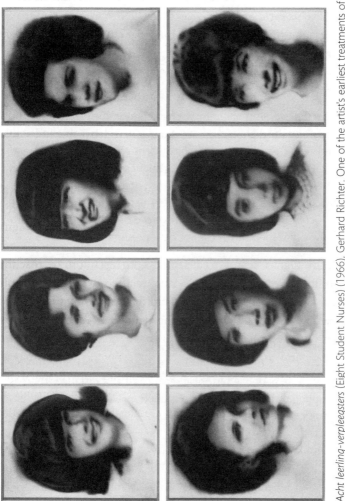

Fig. 7.2 *Acht leerling-verpleegsters* (Eight Student Nurses) (1966), Gerhard Richter. One of the artist's earliest treatments of illustrations from shocking news stories.

terrorist gang (in deaths that were suspected to have been orchestrated by the state). An especially powerful work by Richter is his *Eight Student Nurses* from 1966, based on newspaper photographs printed over screaming headlines when the eight young women were victims of the grisly rapist-murderer Richard Speck in Chicago. Commenting on this work Dennis Baird has written,

> Given the sterile, institutional character of the source photographs, and the highly schematic manner in which Richter painted them...one would expect *Eight Student Nurses* to be cold and static. On the contrary, the affecting but unsentimental tenderness of these paintings comes not just from one's knowledge that the subjects all suffered violent, senseless, early deaths, but from the way Richter's subtle erasures and reversed distancing point toward lost lives that themselves cannot be represented.[34]

Arthur Danto seems to disagree with this sort of reaction which interprets Richter's blurring technique as emotionally loaded. Instead of poignancy, Danto sees a certain kind of distance in Richter's work. Thus he writes,

> But like Warhol, whom he resembles in profound ways, he evolved a kind of self-protective cool that enabled him and his viewers to experience historical reality as if at a distance. There is something unsettlingly mysterious about his art.... One often has to look outside his images to realize the violence to which they refer.[35]

We can now return to the question of whether Richter's paintings of people in the news-image based pieces are 'portraits' or, instead, mere surface images like Warhol's that withhold any intimations of a self or inner life. I think we already have our answer. While on the one hand Richter's photograph-based

paintings do explicitly refer or allude to the status of the images being depicted *as* images which are already in circulation and familiar, on the other hand they maintain a sense of the persons who have been implicated or even trapped in the circumstances that led to their being so depicted and displayed. There is more sympathy in the rendering, and this in turn suggests a greater conviction of the real-ness and independent psychological existence of the individuals being rendered (even if that remains unknowable or mysterious). Richter's work also shows more than Warhol's a role for the artist himself as a subject or self. It is more expressive and also conveys the artist's sensibility in perceiving and conveying things about the people he chooses to paint. Many critics, including Danto, assess Richter's work as a deep and sustained meditation on the goals of painting[36] and its survival in relation to photography.[37] Although ambivalent, Richter does seem to be advocating some role for an ongoing tradition of painting. Daniel Baird explains that, 'For Richter, the free-hand drawing and painting of an object uncritically introduces subjectivity, style, and value judgments about both art and the world he is determined to question.'[38]

The third artist I want to discuss is someone who has also done numerous images of celebrities based on photographs. However, Elizabeth Peyton's work is different from that of the preceding artists in several ways. Gender is one obvious factor, and this distinction does make a difference in her case: that is, she shows special interest in and expertise at rendering images of the attractive, sexually androgynous men of recent pop culture, particularly men from the world of rock and roll like Kurt Cobain, Elvis Presley, Liam Gallagher of Oasis, and more. Another difference is that Peyton's works are more transformative of original photographs. They do not render the medium of the

original work, like the grain magnified in Warhol's silk-screens, nor do they replicate the black-and-white tonalities that Richter so often uses. Rather, her works are small paintings in jewel-like colors that have even prompted some critics to compare her to Matisse.[39]

One critic comments further on the transformations in Peyton's paintings:

> The photographic source remains visible as the underlying form in Warhol's portraits, while for Peyton the photo, following its compositional contribution, as she puts it, has 'got to get lost.' Warhol often chose photos that had been created specifically for publicity. Peyton looks for more candid records of life's small details.[40]

Peyton's work is also much more emotionally engaged than that of Warhol or Richter. It is unabashedly romantic; she betrays signs of a sort of adolescent crush or fascination with the men she portrays. Peyton likes to depict the people she shows at a point just on the cusp of fame, often as a sort of late adolescent, not-quite-finished version of who they will become. She is known also for depicting young men who have complicated or tragic relationships with their mothers, like Elvis or young British Prince Harry. The effect of Peyton's work is to lend more substance to a vision of these so-often visible and heavily scrutinized figures. A final factor is that her paintings are surprisingly small. This leads to an intimate, one-on-one engagement, as with a personal snapshot of someone you were once close to.

> It is this authenticity that makes her paintings so alive and personal. Often we can feel we share that intimacy with these famous subjects and Peyton has an uncanny knack for enshrining the most memorable, and thus most enduring, aspects of a personality and allowing us to feel somehow connected to those subjects.[41]

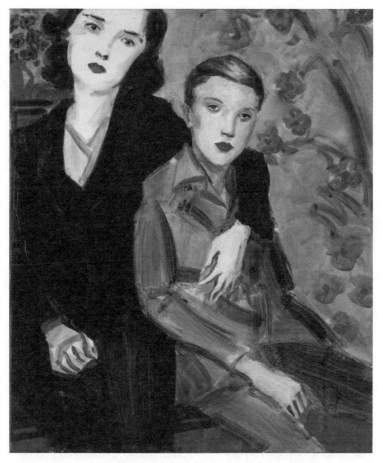

Fig. 7.3 *Gladys and Elvis* (1997), Elizabeth Peyton. One of the artist's depictions of famous men with their mothers.

Peyton is among a younger generation of artists credited with returning the art world to an interest in figurative painting during the 1990s. Her peers are sometimes listed as people like John Currin and Lisa Yuskavage. Inevitably, Peyton shows signs

of having lived through the reign of postmodernism in art theory during the 1980s, especially in her use of prefabricated imagery. But she cannot be called a postmodern artist for any of the reasons I listed above in favor of regarding Warhol, say, as a forerunner of this movement. Peyton has not rejected an interest in the self, a search for authenticity, originality in her artistic handling of her work, or the representation of the people she depicts as having interesting interior lives.

I now turn to the second subgroup of artists who employ previously existing imagery in their portraiture. They are often listed among the premier postmodern portrait artists. My examples here are Cindy Sherman and Yasamusa Morimura. As I said above, works by this group are also generally taken to shed doubt on theories of the identity of the self or any belief in it whatsoever. But the artists do not express this view by their use of pre-published imagery that, like Warhol's work, reduces celebrities and others alike to blank surfaces lacking interior life. Instead, Sherman and Morimura engage with either actual imagery or stereotypical and familiar *kinds* of imagery while creating self-portraits that support a view of the self as a mask or disguise, a mere repetition or instantiation of something that has gone before. Whether there is anything underneath the mask is disputable and may vary from case to case. Sherman and Morimura work mainly with photographs.

Cindy Sherman's work has taken different directions in the decades since she first rose to fame with her series titled *Untitled Film Stills* (1977–80). Still, her basic approach has stayed much the same.[42] She takes photographs of herself in which she assumes various disguises or poses using wigs, clothing, make-up, props, and so on. In none of these cases is she really creating (or trying to create) a self-portrait in the classic sense that I explored in Chapter 5,

where an artist explores the self and its ongoing developments. Instead her portraits depict various *types* of women, whether the early B-movie actresses of her first well-known series or, in later series, horror movie victims (1994), figures from art history like the Mona Lisa (*History Portraits*, 1988–90), or most recently, somewhat vulgar middle-aged women trying to forestall age and recapture their youth and beauty. Some of the women enacted by Sherman seem to exhibit an emotional state or mood, but in most the image is ambiguous so that the person's face is hard to read.

The women in Sherman's images are herself in a sense but not *really* so; they are fictional people endowed by the artist's imagination with more or less identity according to how successfully they have been rendered. Critic Jerry Saltz calls her work 'some sort of Kabuki freak show. She's there but not there.' He also writes wittily and I am afraid aptly that 'Cindy Sherman's is the face that launched a thousand theories.' The most standard theories are those from feminists and postmodernists who read the works as critiques of women's gender roles and/or of the possibility of achieving an authentic identity in the late twentieth and early twenty-first century.[43]

Sherman's most recent work on the middle-aged women is her strongest for some time. While her art history images strike me as rather repetitive and poor jokes, her newer works show wonderful signs of skilful enactment as well as intriguing and subtle composition. Furthermore, despite their often wicked form of parody, they are simply more humane and touching than Sherman's early work. Saltz seems to concur, by saying that the new pictures have 'psychological weight and empathetic power . . . Inner lives radiate from these pictures. [Sherman has] joined her characters in this human comedy. After all these years, she's one of us.'

Fig. 7.4 *Self-Portrait—After Marilyn Monroe* (1996), Yasumasa Morimura. One from a series in which the artist poses as famous movie stars or celebrities.

Yasamasa Morimura, like Cindy Sherman, has created a multitude of images in which he photographs himself masquerading in complex ways. He is perhaps best known for two series of works, the film actresses and the art history works. In the former series done in black-and-white, the Japanese photographer has posed himself in imitations of glamour shots of the famous women of Hollywood, ranging from Greta Garbo and Ingrid Bergman to Marilyn Monroe and Audrey Hepburn. There is at one and the same time something ludicrous and touching about his face as he assumes these roles. They involve obvious plays with gender and also, of course, with ethnicity and ideals of beauty, as the specificity of this man with his large nose and dark almond eyes cannot be hidden under all the pancake makeup.

Morimura's art historical interventions are, to my mind, more intriguing than his Hollywood put-ons and also more interesting than the similar work of Cindy Sherman's. Morimura creates elaborate reconstructions of famous paintings by Manet, Goya, Velázquez, Kahlo, and others. He then inserts himself as the model, sometimes in more than one role (playing both Olympia and her black maid, for example). Such works can have something of the element of a silly joke, but can evoke a sheer fascination with how well it has been done. Morimura's selection of minor details is often very entertaining—like his use of a Hello Kitty figurine in place of the screeching black cat at Olympia's feet. In addition, some of his interventions are more strange, such as inserting his face into many of the sunflowers in one of Van Gogh's famous still lifes, or the fact that in his recreation of Rembrandt's *The Anatomy Lesson of Dr Tulp*, he portrays not only the famous surgeon and all of his observers, but even the dead patient being dissected! Morimura has also lampooned some of the icons of postmodernist art including Warhol, Richter, and

even Cindy Sherman. He re-enacted one of her untitled film stills, giving it the title *To My Little Sister for Cindy Sherman* (1998). Still, as with some of Sherman's images, the joke can become repetitious. As one critic comments, 'It is easy to dismiss Morimura's work as little more than a punch line delivered to the point of overkill.'[44]

Morimura's newer work, like Sherman's, has taken a more interesting direction with greater depth and, I would say, humanity. He has begun to re-create famous photographs from recent political history in scenes in which he portrays men this time, and not women. There is a wide range of people depicted here that goes back to Lenin and Hitler and forward to some of the more notorious news scenes from the 1960s and 1970s, such as Lee Oswald being shot (he portrays Oswald), Mishima's failed coup in Japan in 1970, or the famous photo of an officer holding a gun to the head of a Viet Cong man he is about to execute (he plays the victim).

In these works the artist is doing more than just rehearsing issues about the nature of imagery or the evanescent nature of identity in the postmodern period. He is creating art with a deeper personal and political meaning. In an interview he says,

> History is public memory, and my recollections are personal. When historic images provoke recollection, sometimes it causes a commotion in me. When I catch such a moment, it stimulates my enthusiasm for expression, my enthusiasm to produce something that is my idea of 'beauty.'[45]

Let me briefly sum up the discussion of Sherman and Morimura in this section of my chapter. Like the artists in the previous section, these two create work that addresses issues about identity and the challenges to it posed by an ever-increasing

realm of familiar images. The works of Sherman and Morimura vacillate between promising to reveal identity while concealing it at the same time. Whereas work by the first group of artists suggests that the surface is all there is, the frequent use of masks by these two artists does allow for some possibility that a 'true' self lies beneath all the façades. And, furthermore, even in the first group, as we saw, an adherence to the use of public images does not altogether foreclose possibilities of an ongoing interest in the inner self. Just as I would not refer to most of Warhol's celebrity multiple silk-screens as 'portraits' in my sense, neither would I use this term for the works of Sherman and Morimura. These are works done with a sophisticated set of references to existing kinds of imagery, including portraits, but for other purposes and not from an interest in probing the nature of the person, whether that of others or of themselves. Their works explore issues about the public presentation of persons, but bypass traditional concerns of portraiture. Doing this does not make the works less good, of course, but neither does it provide support for a universal claim of the sort Martin and Barresi have advanced that the self has disappeared or fallen into disuse.

Exposed Selves

If the self has been under attack as dissolving into mere surface appearances or being fragmented into publicly circulated images, this will be news to the next two artists I want to discuss, Nan Goldin and Tracey Emin. Each of them creates work in a highly personal, confessional, let-it-all-hang-out mode that makes self-revelation the name of the game. Although their art looks like the exact opposite of the sort I just surveyed, they can also be

seen to dovetail in a surprising way. Suppose that Warhol did in fact manage to blur the public/private line by making portraits that only showed the public self of people who, he implied, really had no private self propping things up. Writing about his work, Cecile Whiting said that the artist 'actively transformed the mass media's interplay between the public and the private self into a purely aesthetic phenomenon'.[46] In effect, and perhaps ironically, the confessional artists also undermine the public/private divide but from the opposite end of the spectrum, by making what are typically the most private aspects of life accessible and visible in their art.

Nan Goldin first became famous for her series of work done from 1979 to 1986 titled *The Ballad of Sexual Dependency*. Although this series was published as a book, she usually exhibited it in the form of a 45-minute slide show incorporating hundreds of images. Goldin's book helped prompt the acceptance of color images within fine-art photography and also contributed to what became known as a 'snapshot aesthetic', featuring images shot in low available light rendering slices of life as they happened rather than being well crafted and carefully composed. In 2003, *The New York Times* nodded to her work's impact, explaining that Goldin had 'forged a genre, with photography as influential as any in the last twenty years'.[47] The work's subject matter was the punk-ish Bowery milieu in New York City featuring Goldin's friends and acquaintances. She recorded episodes from daily life that included explicit sexual encounters, gay relationships, and the dramatics of drag queens, and also drug use. Many of the people shown in her images died of either drug overdoses or AIDS. Dispirited, Goldin moved to Europe where she lived in Berlin and Paris. She continued rendering her daily life and even recorded images of domestic abuse and her

bruised and blackened face after she had been violently beaten by her then-boyfriend.

In 2004–6 Goldin created and exhibited a new work, *Sisters, Saints, & Sybils*, which revisited some disturbing events of both her own life and that of her mentally ill sister, who had committed suicide by throwing herself under a train when Goldin was still a young girl. Critic Robert Ayers writes that 'Throughout her career, she has used photography as what she once famously called "the diary I let people read." '[48] The work was described as very painful for viewers and the artist commented later that it did not serve as an effective exorcism of her emotions. This runs counter to remarks she has made elsewhere about the role of recording scenes in her life: 'Yes, photography saved my life. Every time I go through something scary, traumatic, I survive by taking pictures.'[49]

Goldin's work is a sort of complex and ongoing self-portrait in which she is placed in the context of an entire milieu. Larry Qualls has noted that Goldin worked in the tradition of documentary photography, but with the difference that she herself was involved in the lives she was documenting.

> When she photographed herself with eyes blackened from a beating, she was defining herself not just as a journalist-chronicler of the scene in which she was involved but also as a performer who was making no attempt to act out a role like Cindy Sherman. She is not an actor analyzing another's text, but one of those people like Spalding Gray using their own lives as the canvas. Her works are performances of her autobiography.[50]

Goldin's work is very revealing both of herself and of others, sometimes too much so for comfort. It shows people shooting up, masturbating, and having sex (including herself). Her camera is ubiquitous and her drive to record things omnivorous. Thus

Henry M. Sayre is right to speak of 'Nan Goldin's obsessive photographing—her camera so much with her that it has become, she says, "as much a part of my everyday life as talking or eating or sex": it is, she says, "as if my hand were a camera" . . . '[51]

But the process of recording absolutely everything turns the private self into a publicly viewable one where it is implied everything is equally important, all grist for the mill. As I noted in the introduction to this section above, this is an inverse of Warhol's strategy of blurring the private/public line with his celebrity images. Her work would also support analyses like Baudrillard about the blurring between life itself and mediated versions of it. He wrote that, 'the more closely the real is pursued with colour, depth and one technical improvement after another, the greater does the real absence from the world grow.'[52]

Critic Mark Zimmermann remarks that Goldin's work shows a 'nervous anxiety for self-reference of our age' and demonstrates 'voyeur-friendly exhibitionism'. But he says, 'In too many lesser works, Goldin mires her images in a terse, sub-artistic haze, the suffering tamed by the camera's myopic stare, the emotion distilled, somewhat anhydrous, by elaboration.'[53] With the label 'myopic' Zimmermann implies that the lives in question have become so closely observed that their meaning threatens to vanish. This is surely not Goldin's intention, since she wants her work to function politically. She says, 'First, it is about gender politics. It is about what it is to be male, what it is to be female, what are gender roles . . . Especially *The Ballad of Sexual Dependency* is very much about gender politics, before there was such a word, before they taught it at the university.'[54]

The nature of Goldin's self-portraiture is interestingly related to some of the serial self-portraiture I considered in Chapter 5 above. Without exaggeration we could regard her as a successor

of Frida Kahlo, only someone who goes even farther in fore-grounding events of pain, suffering, humiliation, and isolation in her life, as well as the high points of love and unity with others. There are strong narrative dimensions in the art of both women. Not surprisingly, Goldin has stated, 'My genius, if I have any, is in the slideshows, in the narratives. It is not in making perfect images. It is in the groupings of work. It is in relationships I have with other people.'[55] The self has a definite importance and clear existence for Goldin in a way that does not accord with Martin and Barresi's claims that it has fallen. But there is still something disturbing about the extent to which she allows for public scrutiny of that self. I think we can explain this by remembering a point I noted in Chapter 3 above about how portraiture requires a kind of revelation. Portraiture does try to show who or what a person is really like 'on the inside', so to speak. It does so while at the same time recognizing that people always wear masks in some sense, the sense analyzed by David Velleman and Richard Brilliant. Brilliant said, 'Apparently, people impersonate as a normal condition of their social existence.'[56] And Velleman[57] noted that 'self-presentation is not a dishonest activity, since your public image purports to be exactly what it is: the socially visible face of a being who is presenting it as a target for social interaction.'[58] The point being urged upon us here is that the notion of a private self which is revealed in portraiture becomes dubious if everything is made public and all pretence of social interaction are dropped. We shall see something similar in the case of the next artist I want to discuss, Tracey Emin.

Tracey Emin (b. 1963) first became known for her work *Everyone I Have Ever Slept With 1963–1995*, shown as part of the *Sensation* exhibit which originated in 1997 at the Saatchi Gallery in London and traveled later to the Brooklyn Museum in

New York, where it famously was attacked by then-mayor Rudy Giuliani. Emin's piece took the form of an open blue tent with embroidered names sewn across the inside listing all the people with whom the artist had slept—some in the slangy sense of having had sex with, others in the more literal sense of literally sharing a bed with, such as her little brothers and even the two fetuses she had had aborted. Along similar lines, Emin's *My Bed* installation in 1999 was literally made by displaying her own actual bed complete with stained sheets and a lot of messy debris on the floor, including used condoms, stained underwear, dirty slippers, cigarette packets, etc. Emin cites Egon Schiele as an important influence and this is not surprising given that artist's own tendencies toward a lurid sexual exhibitionism in his work. Though much of Emin's work is autobiographical, as we have seen, some of it is not. She has also done monoprints, sometimes including text, often with characteristic misspellings.[59]

A lot of Emin's fame stems from her willingness to engage in sexual self-exposure. She was selected to be England's representative at the 2007 Venice Biennale, at which she exhibited paintings showing her legs and vagina. Similarly in her work *I've Got It All* (2000) Emin showed herself,

> legs splayed on a red floor, clutching banknotes and coins to her crotch. Made at a time of public and financial success, the image connects the artist's desire for money and success and her sexual desire (her role as consumer) with her use of her body and her emotional life to produce her art (the object of consumption).[60]

Emin *has* done non-sexualizing images of herself, for example, alone and reflective in a bath. She also made a 2005 work titled *Death Mask*, which was a bronze cast of her own head, done during life rather than waiting until after death. However, most

of her work does appear to fall into the category of self-exhibition and she seems to show no shame. This has led Kieran Cashell in his recent book *Aftershock* to speak of her under the heading of 'Fearless speech', using a term given theoretical significance by Foucault, who celebrated it as 'frankness in speaking the truth'.[61] Cashell summarizes a number of negative responses to Emin's work that take the basic line that it is both too exhibitionistic or self-promoting ('solipsistic') and involves too little intervention to turn it into art. For example, Paula Smithard has complained that 'she has left little space for any distance to observe and register herself'.[62] Cashell's defense of Emin is to say that her work is not meant to be understood or treated as a traditional kind of art involving aesthetic distance. Rather, 'it demands a certain subjective engagement'.[63] The art requires viewers to have an emotional and moral response to it and this in itself makes it significant as art, Cashell argues.

Interestingly, although Emin's art does seem to put herself very much on display, at least some critics have also regarded it as a *searching* for herself. Melanie McGrath says that in it 'you see the artist struggling to *reach* herself, compelled by her own self-consciousness to fail and compelled by the self-same thing to begin again'.[64] Cashell seems to agree with this view since he sees in the work an emphasis on solitude and loneliness. Thus her open tent signifies a 'metaphysically isolated self, withdrawn from a hostile external environment, sheltered behind vulnerable yet durable walls'.[65] The open but empty tent, like the unmade and unoccupied bed, speaks of an absence and of a person seeking a place for herself. He sees the artist's work as involving a sincere self-examination that might lead to self-transformation.[66]

Self-exposure in the works of Nan Goldin and Tracey Emin does look like a sort of blurring of the public/private line.

It resembles what Baudrillard wrote about in assessing the very first 'reality TV' show, *An American Family*, a documentary which depicted the lives of a putatively 'average' American family, the Loud family, over a period of seven months, filmed in 1971 and screened on PBS in 1973.[67] Baudrillard described the show and the family as a metaphor for 'the dissolution of TV into life, the dissolution of life into TV'. In both cases the artist creates self-portraiture with a strong narrative dimension which does not necessarily involve simply depictions of herself. The portrait process extends to include friends, objects, and broad experiences of living. Such a comprehensive approach does leave little to the viewer's imagination. I find the work of both artists interesting, though in truth I do not care for it much. The point to be made here is that clearly neither artist is willing to dispense with the useful notion of the self, since self-exposure is their goal. Indeed their work could hardly succeed if it were not counter to the norm. Most people continue to preserve social façades and keep aspects of their private lives private—not everyone yet lives in the realm of reality TV. If everyone was willing to use the camera to record all of their most intimate moments there would be no interest in exhibiting them in art galleries. Goldin and Emin presuppose the more usual attitudes toward the self prevail in order for their own non-standard attitudes to be worthy of attention.

Scientific Selves

I now turn to the third and last of newer artistic practices that might seem to erode the self of traditional portraiture and modernist theory, the use of scientific technologies to provide

greater and more objective access to a no-longer-mysterious inner core of a person. As I mentioned in the introduction above, British artist Marc Quinn did a 'Genomic Portrait' of the pioneering geneticist Sir John Sulston in 2001. The work combined realistic photographs of the scientist with a sample of his DNA mounted in agar jelly and framed in stainless steel. The presentation itself, using shiny modern materials like glass and steel, evoked the laboratory atmosphere in which the subject had made his mark. By combining two forms of representation, Quinn meant to stimulate thoughts in viewers about the nature of identity and multiple forms in which it may be revealed. (This is, recall, the very same artist who had become famous a decade earlier for a self-portrait of his head made from five litres of his own blood, exhibited in a special case that kept it frozen.[68]) Marc Quinn said about his newer work,

> What I like about my portrait of John Sulston is that, even though in artistic terms it seems to be abstract, in fact it is the most realist [*sic*] portrait in the Portrait Gallery since it carries the actual instructions that led to the creation of John. It is a portrait of his parents, and every ancestor he ever had back to the beginning of Life in the universe. I like that it makes the invisible visible, and brings the inside out. With the mapping of the Human Genome, in which John played such a vital role, we are the first generation to be able to see the instructions for making ourselves. This is a portrait of our shared inheritance and communality as well as of one person.[69]

DNA portraiture is no longer the preserve of the wealthy and famous. A website called 'Think Geek' enables anyone to purchase a portrait displaying a sample of one's DNA set against a colorful background (you can choose the color) and mounted in

a glass frame—provided you submit a cheek swab and can afford the $149.99 price tag. 'It's art! It's you!', the website proclaims. It goes on to state what might be obvious in upbeat promotional terms:

Your deoxyribonucleic acid is what makes you the unique snow-flake you are. The genetic dance of Adenine, Thymine, Guanine and Cytosine, in infinite combinations, has its own beauty. With the advent of forensic electrophoresis, your own beautiful genetic makeup can be your own personalized art.[70]

The gushing tone of the 'Think Geek' website must be tempered by more skeptical responses like that which one of my friends had to this idea, 'Just don't let your health insurance agent see it.' My friend's reaction reflects a reasonable fear of scientific technologies becoming a threat since they facilitate decision-makers' access to our putatively private information. The Human Genome Project has shown that one's DNA is a program for both development and failure, since if decoded fully, it can reveal your future risks of costly diseases like cancer or schizophrenia. This portends ominous surveillance systems that will prompt genetic screening, selective abortion, and insurance rationing, to name just a few. Surveillance is already a reality and not just a future threat. During the pandemic of the H1N1 virus (swine flu) it became common for full body temperature scans to be used at airports like the one in Mexico City, and for schools to take children's temperature across the globe, precautions that might seem invasive to many. Blood and urine tests are commonly used to check for alcohol and drug abuse in employees, parolees, and athletes. Fears of state and police access to one's 'private' bodily information have long formed a basis for paranoid plots in science fiction tales. For example, the 1997 film

Gattaca featured an 'in-valid' hero, a person born through natural processes rather created by genetic engineering, whose DNA revealed his physical flaws. He nevertheless aimed to succeed in his ambition to become an astronaut and concealed his flaws by borrowing DNA from someone who had been the product of the state's ideal engineering system.

Most of us are familiar with a diverse array of scientific imaging technologies. Even if we do not yet possess a picture of our own DNA, we have probably seen such images on TV in programs like *Law & Order* or *CSI*. Also familiar are ultrasounds of fetuses, dental and other bodily part X-rays, fMRI brain scans, electrocardiograms, lung scans, mammograms, and so on. Such scientific routes to assessing the nature and health of persons abound, and although some of their codes may be difficult for an ordinary viewer to decipher, they make eminent sense to physicians, dentists, airport security screeners, and crime lab technicians. Despite their potentially benign or healing uses in medicine, such methods inevitably also bear ominous associations due to their links with dubious ancestor technologies of diagnosis and control ranging from phrenology to various visual typologies that categorized criminals and the insane.

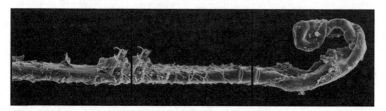

Fig. 7.5 *Hair* (1997), from *Genetic Self-Portraits* by Gary Schneider. An example of the artist's use of scientific techniques for self-representation.

Taking on all of this baggage, artist Gary Schneider confronted some of the more sinister aspects of scientific imaging in his *Genetic Self-Portrait*. Schneider's project, in an exhibition and a book, presented images based on scientific renderings of cells, a tiny patch of dried blood, chromosomes, parts of his DNA sequence, dental X-rays, handprints, iris and retinal photographs, and enlarged electron microscope images of his hair and sperm. The artist printed versions of all of these sorts of images as gelatin silver and platinum-palladium prints with manipulation of aspects such as their color, size, and layout. In many cases Schneider worked side-by-side with the scientists who had the relevant expertise and equipment in order to obtain the image he desired. The technologies listed in his credit section include photogram, radiogram, transmission electron microscope, fluorescent light microscope, fundus camera, and scanning electron microscope.

Schneider has explained why he included a mix of relatively low-tech images in his project, such as hand prints that were photograms, a method of camera-less photography dating back to the time of Fox Talbot. The artist says that at one point the images in his show 'seemed too generic', and so,

> It was with the addition of my hand prints that the portrait moved from a harvesting of my biological information to an emotional response to the Human Genome Project. I wanted the portrait to be an act of faith inside my anxiety of stepping into the unknown of future biology.[71]

A possible reason for Schneider to feel anxiety about the potential implications of the images gathered for this project was the inclusion of a picture of the tumor suppressor gene on Chromosome 11. This is apparently where something had gone wrong in his mother's case, leading to her death from lung

cancer at a time not too long before Schneider launched his *Genetic Self-Portrait*. In an essay included at the back of the book, medical imaging expert Bettyann Holtzmann Kevles writes,

> The images he created from his own tumor-suppressor gene became more abstract as he worked with them in the darkroom, but their personal significance as a possible inherited trait was always concrete. Schneider understood that in the process of making this new work he might discover something in his genes that could affect his life in a very real way, such as finding a tumor or a heredity [*sic*] disease, but he was determined to face those risks acknowledging that art is a part of life.[72]

It can be jarring to look through Schneider's book, because so many of the images make the familiar strange.[73] Our bodies have aspects that seem alien and impossible to grasp as part of our very selves. This is particularly true in the greatly enlarged abstract light and dark patterns of prints Schneider made of his buccal mucosa cells, showing their nucleus and mitochondria. By comparison, it is a relief to encounter more familiar kinds of images that are recognizable. We possess a key that can orient us to the bodily location and size of the parts shown, for example, in dental X-ray, hand prints, ear photograms, and iris prints. Even the vastly enlarged sperm in one picture depicts something we are now familiar with from biology textbooks and sex education classes. (Schneider comments that the scientist he collaborated with 'said that each of my sperm is unique . . . I made a portrait of a sperm.'[74])

A fascinating alternative but also ambitious project featuring another kind of genetic scrutiny has been undertaken by the Mexican artist Gabriel de la Mora. In 2007 he constructed a series

of portraits of nineteen members of his family, *Memory III, 10-24-07*. These are also not portraits in anything like a traditional sense, although in some ways they are pictorial and revealing. There are actually three distinct depictions of each member of de la Mora's family: a computer-generated image of their cranium (which looks basically like a drawing of a skull), their signature, and their thumbprint. Each image is mounted on paper in a Lucite box. All fifty-seven images are displayed on a long panel laid out with nineteen images across and three deep. Now comes the kicker: though the images look at first glance like pen or pencil drawings, each image is actually constructed out of *hair* meticulously collected from the individual being depicted and arranged in the desired pattern.

This exhibit prompts the viewer to ponder identity as it is displayed in three distinct forms, with yet a fourth form serving as the medium. And furthermore, all of the participants are related. (Presumably if some portions of their hair retained the follicles, DNA tests could verify this.) What one winds up noticing about these images are the small ways in which they slip outside the box of quasi-scientific categorization. For example, we can see the whorls of each person's thumbprints very clearly, so well that perhaps they could be used for crime scene analysis; but at the same time, small bits of the hair tend to stray away from the orderly arrangement, like tiny insect legs creeping out on their own erratic paths. We can try to imagine reconstructions of the people's faces from their varyingly shaped craniums. Strangely, the one type of identifier used here that is the least pictorial can actually seem the most personally revealing: the signature. These hair-drawn copies of individual's handwriting also betray erratic insect-leg stray squiggles, and signatures themselves show more signs of personality than either thumbprints

or skulls. Some look like the signatures of very formal elderly people, others the awkward scrawls of young children; some show their writers to be sloppy but opinionated, etc.

In the introductory essay on Schneider's work, curator Ann Thomas writes, 'Gary Schneider's *Genetic Self-Portrait* challenges the traditional definition of the portrait, and revises our understanding of what it means to be revealed before the camera's lens, by juxtaposing the visible and the invisible, the message and its embodied characteristics.'[75] Thomas compares Schneider's project to an earlier work, Robert Rauschenberg's life-size print *Booster* (1967) which was a large print involving a self-portrait of the artist's entire skeleton made from a series of X-rays. This comparison is instructive. Commentary about the Rauschenberg piece sounds very much like what Thomas is now saying about Schneider's work. For example,

Technically a breakthrough in the scale and complexity of fine art prints, *Booster* also represents a personal summation by the artist. In this work Rauschenberg evaluates the ability of technology to create increased engagements with the viewer (looking inside his body invites a sort of intimacy different from traditional self-portraiture) as well as to embrace specific qualities of his era and his place in the world in general.[76]

To the list of techniques used by Schneider and Rauschenberg we can add yet another route to self-revelation and intimacy: there has even been a portrait project including fMRI images or brain scans. Under the clever title, 'Me, Myself, and MRI' the exhibit was shown in Bradford (England) at a photography gallery. The work included multi-media depictions of six individuals, combining photographs and interviews with brain scans. As with the Schneider imagery, an element of threat hung over

the participants due to the diagnostic potentials of this imaging technology:

> the brain scans presented a problem of principle, as one in ten usually reveal an unexpected feature or anomaly. All six participants had to consent to their GP being informed should anything like that arise. All members of the project had to sign a confidentiality agreement.[77]

Do any or all of these new sorts of images really function well as portraits? In a few cases, they seem to come close and to have become accepted. Many people now start off their baby's photo album with ultrasound images done during pregnancy. And despite their strangeness we can make out in such pictures the general form of a baby with head, arms, and legs. But in general, I am skeptical. To deny that these sorts of works are portraits is, of course, not to say anything about their quality or artistic significance. In each case the artist has tried to do something revolutionary, something that broke the mold, so to speak, and they deserve credit for this if nothing else. Artistry was manifested, also, in how Rauschenberg mounted, printed, and showed his X-rays (with other imagery juxtaposed, such as astrological charts), as in the care with which Schneider executed and displayed his prints. I defend my denial, even so, by referring back to my initial definition of what a portrait is: it is an image that presents a recognizably distinct individual who has emotional or conscious states, and who is able to participate in the creative process by posing.

None of the artists I have briefly mentioned here—Quinn, Rauschenberg, Schneider, de la Mora—did art that employed fMRI images, which might literally have been able to reveal not just the person's unique individual brain but also their emotional

state. Scientists claim that, for example, brain scans can show whether a person is in love with his or her spouse. Imagine the portrait possibilities this opens up! However we should keep in mind what M. R. Bennett and P. M. S. Hacker call the 'mereological fallacy' of neuroscience, taking the parts to stand for the whole.[78] It is not the brain that perceives, acts, thinks, experiences pain, or feels emotions—it is, rather, the person who has this brain.

In considering the array of new methodologies used for portraiture, the key words that figure into my requirements are not so much concerns about a person or their brain rendering consciousness or emotions, but that a portrait be 'recognizable' and involve 'posing'. The subjects did of course in some sense 'pose' for the images made of them by Quinn, Schneider, and Rauschenberg: they allowed the techniques to be processed so that images could be made. But they could not do much to control the result or to project a self-conception. Nor are these people recognizable in the results to anyone other than a trained specialist. Even in those cases, *identification* through laboratory processing is not the same thing as *recognition*. One's biological makeup is not one's personality. I have a prosthetic hip, but I do not think that an X-ray that reveals this really conveys very much about my physical self, nor do I think that my DNA shows my personality, or that an fMRI taken at one moment in time shows much about my emotional life. Of course at the same time it is true that much art, especially modern art, does require viewer intelligence and familiarity with relevant depictive codes. We can think briefly of some Picasso portraits to see the point. In his portrait of Daniel-Henry Kahnweiler (1910) we can discern elements that are clearly representational and depict his suit, arm, and head.[79] But the picture plane is so fractured that the

person is not actually recognizable here, even if we have enough of the 'code' to know that this is meant to be a cubist portrait. By comparison, think of some of his other portraits, such as the famous one of Gertrude Stein (1905). Due to the mask-like features of her face here the image was reportedly difficult for people to 'get' at the time; however, just as the artist forecast, we have now become able to see the resemblance and we can infer aspects about the woman depicted in the painting. There are some biologically endowed abilities of face recognition that can still function in viewing the Gertrude Stein portrait but cannot for the Kahnweiler.

Along these same lines, enlarged pictures of cells or X-rays of skeletons simply do not provide us with the normal, biologically based form of visual recognition that we use to discern a person's identity in any ordinary sense of the term. Nor do fMRI images of the brain convey emotions to normal viewers by triggering our innate abilities to read emotional expression, even if the expert interpreting the image can determine by activity in the hypothalamus a state of arousal of some sort now exists. Por- traiture depends on what we can call more analog kinds of information, information processed by our eyes in interaction with ordinary-sized objects from the environments around us.

New kinds of portraiture can be compared to other forms of scientific imaging techniques. We can see, for example, from the rings of a tree how old it is, and thus learn things about it, but this is not the same thing as seeing a picture or sculpture of the tree that helps us get a sense of its individual kind and its 'look', any more than a weather map shows us the things we can glean by looking at the sky and clouds. Similarly, the plan of a building or map of a city provide important information that we use to navigate, but these are eventually supplemented by other forms

of direct acquaintance as we get acquainted with a place and gain a 'feel' for it.[80] If anyone has tried using Google Earth technology, they might have shared my sense of wonder, but also of a strange disjunct, when the graphic map displayed on the computer screen is suddenly transformed into a photograph that shows streets and buildings from a ground-level perspective. This is the same disjunct of switching from an iris scan to a painting of someone's eyes, or from a DNA sample to a person's portrait done in marble or bronze.

Interestingly, the dream of knowing someone through interpreting a code that contains all of the secrets to their identity is not something new or unique to our time. Variations have emerged before in human history, and to describe one of them might highlight some of the issues I have been grappling with above. There is a significant but not very well known sect of Islam, the Hurufi sect, which originated in the fourteenth century with the Persian Sufi mystic Fazlallah, a follower of the poet Rumi. He articulated the view that letters of the alphabet (of various alphabets, in fact, Arabic as well as Persian) have mystical meanings and that these same letters can be found embodied in the features of people's faces. Thus every human face can be 'read' through its combination of key features as a compressed message comprising certain letters. In principle one can decipher mystical messages in people's faces. Eventually Fazlallah was executed and, when the Hurufi sect was persecuted in Iran, it crossed into Turkey's Anatolia where it later became quite influential, especially among the Janissaries. The Turkish novelist Orhan Pamuk (to whom I owe acquaintance with this sect) includes mention of it in his complex and mysterious novel *The Black Book*. There he describes its poet Nesimi, a successor of Fazlallah, by saying that he

likened a feature and a beauty spot on his sweetheart's face to a letter and a period, the letter and the period to a sponge and pearl in the bottom of the sea, himself to a diver who dies for the sake of the pearl, the diver who voluntarily dives into death to a lover seeking God, and so, coming full circle, likened his sweetheart to God (and for this he was punished by being flayed and his body cut into seven parts).[81]

Now, obviously (I hope), I do not invoke this comparison with Hurufism in order to contend that contemporary scientific technologies can only provide a sort of esoteric, mystical knowledge of human identity. Rather, my point is that entry into the decoding system required to interpret and 'get' such images is restricted to an elite set of individuals and is very likely barred to the majority of ordinary people. Thus even if we were all to proudly display our 'snowflake uniqueness' in the form of DNA portraits purchased from 'Think Geek', I do not expect that our mutual understanding of each other would be advanced, nor would the need for the individual eye of the artistic portrait-maker evaporate.

Conclusion

Is it true, as Martin and Barresi allege, that the self has 'fallen' or disappeared? No. My chapter has explored three very different kinds of artistic practices that seem to challenge traditional ideals of portraiture as well as the modernist notion of a self-aware moral agent at the core of a person's identity. In each case however, there is more remaining of this traditional self than first meets the eye. First I discussed the artists who create portraiture in which the self disappears into a stream of prefabricated

familiar images, whether from the media or from art history. Warhol provides the strongest example of someone whose work would probably fit with the fallen self view. But other artists using recycled images still show a strong interest in basic aspects of human nature such as emotional responses to traumatic situations, vanity, love, etc. Peyton and Richter's people can be attractive, hopeful, or tragic, and even in Warhol's case, the fact that some celebrities have difficulty separating private from public lives does not indicate that everyone does, or that ordinary people have come to lack selves. Similarly I traced developments in the masquerades of both Sherman and Morimura that indicate some concern with inner lives can still be found in their work.

As for the second and third sorts of approaches I discussed, I believe we must reach parallel diagnoses. Confessional art if anything foregrounds the self rather than negating or questioning it. At most what this art does is disrupt traditional public–private distinctions, but at the same time it relies on them in order to achieve its desired effects of provoking the audience to get attention. Art using scientific technologies can be of greater or lesser interest according to how it is made and displayed, but it is not likely to replace or destroy traditional portraiture. Only experts can come to know things about people by reading their brain scans or DNA printouts, and these do not show us the sorts of things about a person's inner life or 'air' that have always stimulated our engagement both with other persons and with their portraits. That there may be a publicly observable self as manifested by their cellular structure is not a threat to ordinary persons and their ordinary forms of self-awareness. The predictive power of DNA still does not extend to preventing the self from having autonomy and responsibility as a Kantian moral agent.

Persons and selves do still exist, and portraiture still has a leg to stand on, despite the many approaches that have been tried in art over the last five decades. But this does not mean that things are simple. What makes something a successful portrait is still mysterious and philosophically perplexing. The most basic problem that can be raised about the relation between portraits and persons is this one: how can something that is an artefact or object ever succeed at capturing a person who is a living being, a subject? I call this the 'paradox of portraiture'. The components for resolving the paradox have been laid out already in this book, but I will devote the Epilogue to a discussion of this problem and how artists manage to overcome it.

Epilogue

The Paradox of Portraiture

The goal of portraiture is strange, if you think about it. In creating a portrait, the artist shapes an inanimate object in some medium that purports to represent a person—a being with a distinctive soul, essence, or 'air' (to use Roland Barthes' descriptive term). A material *object* is used to capture or convey a person, who is a *subject*. I call this the paradox of portraiture. Is the goal of portraiture ever achieved? Would success require an animistic belief in the magical powers of artists and artworks?

Recognizing this worry, Richard Brilliant has compared portraits to carnival-hall mirrors. He says that, 'like trick mirrors, or even conventional ones, portraits . . . shape the psychological process that implicates the viewer, as a respondent, in answering the question posed by the portraitist, "Who is 'the You' that I am looking at and how may I know it?"'[1]

My book has provided components to resolve the paradox of portraiture without recourse to magic or mirror tricks. To be sure, there is often something mysterious about portraits—they can depict people who look alive and who appear to look back at us. But there are deep yet non-mysterious ways in which portraits can and do function to convey subjectivity.

Objects and Subjects

The key to dissolving the subjective/objective paradox is to dissolve the sharp distinction between objects and subjects. Several sources lead to this conclusion, and I am drawing here from the varied fields of pragmatism, phenomenology, and evolutionary psychology.[2] Human beings who are of course subjects, are also objects, with bodies as well as minds. And, vice versa, many objects have a kind of meaningfulness that renders them 'subjective' because they are used by humans in meaningful ways within communicative contexts. Such objects range from toothbrushes to computers, from automobiles to pianos. Sculptures, paintings, and other sorts of artworks are among these meaningful artefacts, physical objects that come laden with their own kind of subjectivity and meaning.

Philosophers in the last several decades have proposed varied accounts of the meaningful nature of the artefacts that we call art. Their frameworks have varied from the language-reading account of Nelson Goodman and the 'seeing-in' theory of Richard Wollheim to the 'make-believe' hypothesis of Kendall Walton.[3] These accounts are similar in one basic way: they presuppose that innate human abilities and needs are fulfilled in the creation and ongoing use of artworks. An artwork is simply *different* from an object that has not been in any way molded or shaped by human (minds and) hands. It has acquired meaning within a cultural context that facilitates the communication of purposes.

John Dewey in *Art as Experience* (1934) developed a pragmatist theory of art which held that the basic human purpose of art is to foster certain sorts of *experience*. An 'experience' for Dewey is psychological or mental but it is always also embodied.

He wrote, 'Because every experience is constituted by inter-action between "subject" and "object," between a self and its world, it is not itself either merely physical nor merely mental, no matter how much one factor or the other predominates.' Dewey held that all human activities include both elements, material and mental. As an instance of purposive human activity, art must always blend the subjective with the objective. The artist makes manifest emotions and ideas in a physical or created artefact. And in turn, the object evokes psychological responses or experiences in the audience. Dewey explained: 'The actual work of art is what the product does in and through experience. An esthetic product results only when ideas cease to float and are embodied in an object. Works of art exist only in *acts*.'[4]

Dewey's account would make sense to many artists who have expressed a similar understanding of how their works function. For example, David Hockney has remarked, 'What an artist is trying to do for people is bring them closer to something, because of course art is about sharing: you wouldn't be an artist unless you wanted to share an experience, a thought.'[5]

Like pragmatists, phenomenologists emphasize the embodied nature of consciousness and perception. In 'Eye and Mind' (1960), Maurice Merleau-Ponty contended that seeing is not the magical activity of a disembodied soul—it does not transpire in a brain that is somehow fed a series of visual experiences (as the Cartesian mind might be).[6] Instead, seeing is embodied, and it enables us to interact with an exterior world:

I have only to see something to know how to reach it and deal with it, even I do not know how this happens in the nervous system. My moving body makes a difference in the visible world, being a part of it; this is why I can steer it through the visible.[7]

As physical beings, we are visible both to ourselves and to others. Merleau-Ponty considers this visibility important, commenting, 'My body simultaneously sees and is seen . . . It is a self, not by transparency, like thought . . . my body is a thing among things; it is one of them. It is caught in the fabric of the world, and its cohesion is that of a thing.'[8] He calls this fact of our own visibility 'the other side' of our power of looking.

Merleau-Ponty made many astute observations about artists, both in 'Eye and Mind' and in his earlier essay 'Cézanne's Doubt' (1945).[9] For example, he quoted with approval Cézanne's statement that, 'The landscape thinks itself in me, and I am its consciousness.'[10] He also cites Valéry, who said, 'The painter takes his body with him,' adding to this his own remark, 'Indeed we cannot imagine how a mind could paint.'[11]

Turning to a contemporary phenomenologist, we can find a similar emphasis on the important role of our body and of our varying senses, including tactile and kinesthetic ones, in the work of film theorist Vivian Sobchack. Sobchack goes even further than Merleau-Ponty in emphasizing the reciprocity between perceivers and objects, or the blending of the two. She points out that in physical suffering we sometimes experience what it is for our bodies to become material objects. We feel, as she puts it, 'what it subjectively feels like to be objective' (*Carnal Thoughts*, 316). This experience has broad implications:

It is our own reversibility as subjects and objects that provides us the material, corporeal foundation for the possibility of recognizing— and caring for—material objects external to our selves, be they other animate beings or inanimate worldly things.[12]

Sobchack believes that some films can convey a sense of what she calls 'the transparent alterity of material things'. By this

somewhat abstruse phrase she means to refer to the possibility of our becoming aware through a physical, fleshly experience of higher states of being in which the ego gets lost or dissolved. As an example she cites the beautiful meal with its sublime sensual pleasures at the climax of the film *Babette's Feast* (1987). In this dining scene, she observes, ' "flesh" is shared literally by human beings and worldly things in their mutual incorporation.'[13] *Babette's Feast* and other films—and, I would argue, portraits— show how humans can be transported into and among the realm of the physical both by 'higher' and 'lower' experiences (where 'lower' might include, say, a film or portrait's attention to processes of disease and decay, as with Kahlo's work or Cézanne's skull-like self-portraits).

Yet another dimension is added to our understanding of art by psychologists and evolutionary biologists, namely, its role in human evolutionary fitness and survival. Creating and interacting with art has been crucial to humans' cognitive functioning. Ellen Dissanayake, in several books beginning with *What Is Art For?* (1988), notes the universality of art among human cultures and argues that the best way to summarize its importance for our species is with the simple phrase 'making special'. We humans simply have an ability to enjoy the aesthetic dimensions of things we do or interact with—whether singing lullabies to children, chanting or dancing in ritual worship of the gods, decorating our bodies, homes, and tools, or making what Western culture has come to call 'fine art'.

Like Dissanayake, Michael Tomasello studies human cognitive and social development with an eye to its evolutionary roots. In *The Cultural Origins of Human Cognition* (1999) he argues that what has helped humans advance beyond other species is our ability to comprehend our fellows as like-minded individuals

with their own intentions and emotions. From a relatively young age, beginning at nine months to a year old, human infants develop 'social referencing' abilities: they can follow the direction of interest and emotional involvement of other people as cues about how to understand and react to things in the external world. Children learn to comprehend the 'intentional affordances' of artefacts with an understanding that 'opens up the possibility of symbolic play'.[14] Humans can transmit a skill and learn it from others without needing to work it out for themselves over and over again in each new generation. Cultural artefacts, including visual symbols and artworks, are both the means and the result of such transmission.[15]

In developed countries with high literacy rates, children often begin to comprehend books by reading (or being read to) from simple illustrated story-books. Artworks, including portraits, are like such picture-books in that they are *meant to be understood*; or as Dewey would say, they succeed at expressing and evoking experiences. Our response to the sophisticated artefacts of art history is just as natural as children's responses to picture-books. We can simply *see* that a sculpture or painting is meant to be a portrait of someone, just as a child sees that an elephant in the Babar stories is engaged in specific activities.

People use symbols in order to attract and engage the attention of other human beings. In a variety of contexts artists create images that draw our attention and prompt us to infer their intent and what is being communicated. Of course, for a person to come to interpret an artwork by someone like Picasso or Richter may call for specific and highly developed knowledge, but nevertheless, the processes involved are basic ones innate in most normal people. If we encounter an object that someone else created in order to communicate with us, we quite naturally

try to grasp what that person meant by the work and how it is supposed to be 'used' (or, in the case of an artwork, seen or experienced).

Tomasello's discussion reinforces the phenomenologists' point that people are already, in our very nature, both subjects and objects. We are seen by those around us in the world because we are visible creatures with bodies. Other people constantly make inferences about our mental and emotional states by observing our behavior, facial expressions, body language, and verbal communications. From infancy on we look in particular at people's faces as the primary guide to who those people are. As philosopher David Velleman puts it in his recent book *Self to Self*, 'the face is also the primary medium for deliberate self-presentation'.[16] It is not surprising that portraiture so often focuses on the face. Art historian James Elkins concurs, writing,

> A face, in the end, is the place where the coherent mind becomes an image. We need to assume that a face or an artwork is the product of a single imagination or a single mind in order to comprehend it as a face or as an artwork.[17]

Let me sum up my resolution to the paradox of portraiture. The claim that people are themselves (or, I should say, ourselves) objects is complemented by the claim that physical things can sometimes also be meaningful artefacts. In such cases the objects have become subjective. Many physical objects in our environments are not inert things that are 'merely' physical. They are laden with significance. This is particularly true of objects that have been fashioned for artistic purposes, whether just in 'making special' (as in the tattoos enhancing the traditional Maori or contemporary pop star) or in shaping complex artefacts that will

engage sophisticated viewers with well-developed aesthetic interests.

Human agents have made portraits for various purposes, among which is the desire to show others what someone looks like or, more deeply, who that person is, or what sort of person they are. We respond with our innate (and sometimes also developed and educated) abilities to comprehend these artistic intentions. We use portraits to learn about people, to see how someone looked, and beyond this, to infer how they felt and what they were like. We see in a portrait how one human being saw and interpreted another human being. Portraits show us, to use Merleau-Ponty's phrasing, 'the inside of the outside and outside of the inside'.[18] We can also see portraits as objects that have been 'made special' so as to serve not just a use function of decoration or record-keeping but also to fulfill aesthetic aims with features such as design, composition, style, expressive power, and artistic viewpoint. Since the possibility of being subjective is a common feature of a vast multitude of objects that surround us, it should no longer seem so mysterious that portraits can and often do appear to us to be living and endowed with powers of animation and expression. And among a world of meaningful objects, portraits are among the most engaging of all because they reveal to us subjects in which we are all inevitably interested: persons.

FURTHER READING

Chapter 1. Animals

Marc Bekov. *The Emotional Lives of Animals*. New World Library; First Trade Paper Edition, 2008.

John Berger. 'Why Look at Animals?' In *About Looking*. New York: Pantheon, 1991.

Edgar Peters Bowron, et al. *Best in Show: The Dog in Art from the Renaissance to Today*. New Haven and London: Yale University Press, 2006.

Charles Darwin. *The Expression of the Emotions in Man and Animals*. Definitive Edition, Introduction, Afterword, and Commentaries by Paul Ekman. New York and Oxford: Oxford University Press, 1998.

Daniel Dennett. *Kinds of Minds*. Weidenfeld & Nicolson, 1996.

David de Grazi. *Taking Animals Seriously: Mental Lives and Moral Status*. Cambridge: Cambridge University Press, 1996.

David Hockney. *David Hockney's Dog Days*. London: Thames & Hudson; repr. edn., 2006.

Randy Malamud. *Reading Zoos: Representations of Animals and Captivity*. New York: NYU Press, 1998.

Jeffrey Moussaieff Masson. *When Elephants Weep: The Emotional Lives of Animals*. Peaslake: Delta, 1996.

Mary Midgley. *Beast and Man: The Roots of Human Nature*. London and New York: Routledge, rev. edn., 1995.

Bob Mullan and Garry Marvin. *Zoo Culture: The Book about Watching People Watch Animals*, 2nd edn. Urbana and Chicago: University of Illinois Press, 1999.

Richard Sorabji. *Self: Ancient and Modern Insights about Individuality, Life, and Death*. Chicago: University of Chicago Press, 2006.

William Wegman. *Man's Best Friend*. New York: Harry N. Abrams, 1999.

Chapter 2. Contact

Roland Barthes. *Camera Lucida: Reflections on Photography*. Trans. Richard Howard. New York: Farrar, Straus and Giroux, 1981.

Hans Belting. *The End of the History of Art?*, trans. Christopher S. Wood. Chicago: University of Chicago Press, 1987.

—— *Likeness and Presence: A History of the Image before the Era of Art*, trans. Edmund Jephcott. Chicago and London: University of Chicago, 1994.

Ernst Kitzinger. 'The Cult of Images in the Ages before Iconoclasm'. *Dumbarton Oaks Papers* 8 (1954), 85–150; repr. in Kitzinger, *The Art of Byzantium and the Medieval West*. Bloomington: Indiana University Press, 1976.

Patrick Maynard. *The Engine of Visualization: Thinking through Photography*. Ithaca, NY, and London: Cornell University Press, 1997.

—— 'The Secular Icon: Photography and the Functions of Images'. *Journal of Aesthetics and Art Criticism*, 42 No. 2 (1983), 155–69.

Jan Stuart and Evelyn Sakakida Rawski. *Worshiping the Ancestors: Chinese Commemorative Portraits*. Freer Gallery of Art: Arthur M. Sackler Gallery, Smithsonian Institution in association with Stanford University Press, 2001.

John Tagg. *The Burden of Representation: Essays on Photographies and Histories*. Amherst, Mass.: University of Massachusetts Press, 1993.

Michael Tomasello. *The Cultural Origins of Human Cognition*. Cambridge, Mass.: Harvard University Press, 1999.

Alan Trachtenberg. 'Likeness as Identity: Reflections on the Daguerrean Mystique'. In Graham Clarke, ed., *The Portrait in Photography*. London: Reaktion Books, and Seattle: University of Washington Press, 1992.

Susan Walker. *Greek and Roman Portraits*. London: British Museum Press, 1995.

Kendall Walton. 'Transparent Pictures: On the Nature of Photographic Realism'. *Critical Inquiry*, 11 (1984).

—— *Marvelous Images: On Values and the Arts*. Oxford: Oxford University Press, 2008.

Shearer West. *Portraiture*. Oxford: Oxford University Press, 2004.

Chapter 3. Individuality

Katherine Hoffman. *Concepts of Identity: Historical and Contemporary Images and Portraits of Self and Family*. Boulder, Colo.: Westview Press, 1996.

John Locke. *An Essay Concerning Human Understanding*. Clarendon Edition of the Works of John Locke, ed. Peter H. Nidditch. Oxford: Clarendon Press, 1979.

Raymond Martin and John Barresi. *The Rise and Fall of Soul and Self: An Intellectual History of Personal Identity*. New York: Columbia University Press, 2006.

Michel de Montaigne. *The Complete Essays*. Ed., trans., and introd. M. A. Screech. New York: Penguin, 1993.

Marya Schechtman. *The Constitution of Selves*. Ithaca, NY: Cornell University Press, 1996.

Jerrold Seigel. *The Idea of the Self: Thought and Experience in Western Europe since the Seventeenth Century*. Cambridge: Cambridge University Press, 2005.

Charles Taylor. *Sources of the Self: The Making of Modern Identity*. Cambridge: Cambridge University Press, 1989.

J. David Velleman. *Self to Self: Selected Essays*. Cambridge: Cambridge University Press, 2005.

Chapter 4. Expression

Wendy Bellion. 'The Mechanization of Likeness in Jeffersonian America', <http://web.mit.edu/comm-forum/papers/bellion.html>. *MIT Communications Forum*, posted 19 December 1999.

Jonathan Cole. *About Face*. Cambridge, Mass., and London: MIT Press, 1998.

Frederick Cummings. 'Charles Bell and the Anatomy of Expression'. *The Art Bulletin*, 46 No. 2 (1964).

Charles Darwin. *The Expression of the Emotions in Man and Animals*. Definitive Edition, Introduction, Afterword, and Commentaries by Paul Ekman. New York and Oxford: Oxford University Press, 1998.

Paul Ekman. *Emotions Revealed: Recognizing Faces and Feelings to Improve Communication and Emotional Life*. New York: Times Books, 2003.

—— and Wallace V. Friesen. *Unmasking the Face: A Guide to Recognizing Emotions from Facial Expressions*. Cambridge, Mass.: Malor Books, 2003.

Lucy Hartley. 'Universal Expressions: Darwin and the Naturalization of Emotion'. In *Physiognomy and the Meaning of Expression in Nineteenth-Century Culture*. Cambridge: Cambridge University Press, 2001.

Hayes Peter Mauro. 'Duchenne: Discourses of Aesthetics, Sexuality and Power in Nineteenth-Century Medical Photography'. *Athanor* 18 (2000).

Jennifer Montagu. *The Expression of the Passions: The Origin and Influence of Charles Le Brun's Conférence sur l'expression générale et particulière*. New Haven and London: Yale University Press, 1994.

Melissa Percival and Graeme Tyler, eds. *Physiognomy in Profile: Lavater's Impact on European Culture*. Newark: University of Delaware Press, 2005.

August Sander Archiv and Susanne Lange. *August Sander: People of the 20th Century*, 7 vols. New York: Harry N. Abrams, 2002.

Allan Sekula. 'The Body and the Archive'. In Richard Bolton, ed., *The Contest of Meaning: Critical Histories of Photography*. Cambridge, Mass.: MIT Press, 1992, pp. 344–79.

Ellis Shookman, ed. *The Faces of Physiognomy: Interdisciplinary Approaches to Johann Caspar Lavater*. Columbia, SC: Camden House, 1993.

Bill Viola. *The Passions*. Los Angeles: Getty Publications, 2003.

Frans B. M. de Waal. 'Darwin's Legacy and the Study of Primate Visual Communication'. In Paul Ekman, Joseph J. Campos, Richard J. Davidson, and Frans B. M. de Waal, eds., *Emotions Inside Out: 130 Years after Darwin's* The Expression of the Emotions in Man and Animals. New York: New York Academy of Sciences, 2003.

Leslie A. Zebrowitz. *Reading Faces: Window to the Soul?* Boulder, Colo.: Westview Press, 1998.

Chapter 5. Self-Knowledge

Daniel Dennett. 'The Self as a Center of Narrative Gravity'. In F. Kessel, P. Cole, and D. Johnson, eds., *Self and Consciousness: Multiple Perspectives*. Hillsdale, NJ: Erlbaum, 1992.

Joseph Leo Koerner. *The Moment of Self-Portraiture in German Renaissance Art* Chicago: University of Chicago Press, 1993.

Alasdair MacIntyre. *After Virtue: A Study in Moral Theory*. Notre Dame: University of Notre Dame Press, 1981.

Maurice Merleau-Ponty. 'Cézanne's Doubt'. In Galen A. Johnson, ed., *The Merleau-Ponty Aesthetics Reader*. Evanston, Ill.: Northwestern University Press, 1994.

Steven Platzman. *Cézanne: The Self-Portraits*. Berkeley and Los Angeles: University of California Press, 2001.

Michael Podro. *Depiction*. New Haven: Yale University Press, 1998.

Marya Schechtman. *The Constitution of Selves*. Ithaca, NY: Cornell University Press, 1997.

Galen Strawson. 'Against Narrativity'. *Ratio* NS 17 (4 December 2004).

J. David Velleman. 'Narrative Explanation'. *The Philosophical Review*, 112 No. 1 (January 2003), 1–25.

—— *Self to Self: Selected Essays*. Cambridge: Cambridge University Press, 2005.

Joanna Woods-Marsden. *Renaissance Self-Portraiture*. New Haven and London: Yale University Press, 1995.

Chapter 6. Intimacy

Richard Brilliant. *Portraiture*. Cambridge, Mass.: Harvard University Press, 1991.

Ellen Dissanayake. *Art and Intimacy: How the Arts Began*. Seattle and London: University of Washington Press, 1999.

Anne Eaton. 'A Sensible Anti-Porn Feminism'. *Ethics*, 117 (July 2007), 674–715.

Melissa Harris. 'Daughter, Model, Muse: Jessie Mann on Being Photographed'. *Aperture*, 162 (2001).

Robert Hughes. *Lucian Freud Paintings*. London: Thames and Hudson, 1997.

Catharine MacKinnon. 'Human Sexuality: A Feminist Political Approach'. In James H. Geer and William T. O'Donohue, eds., *Theories of Sexuality*. New York: Plenum Press, 1987.

Martha Nussbaum. 'Objectification'. *Philosophy and Public Affairs*, 24 No. 4 (Fall 1995), 249–91.

Griselda Pollock. *Mary Cassatt: Painter of Modern Women*. London and New York: Thames and Hudson, 1998.

Chapter 7. The Fallen Self

Daniel Baird. 'Gerhard Richter: Forty Years of Painting'. *The Brooklyn Rail* (March–April 2002).

Kieran Cashell. *Aftershock: The Ethics of Contemporary Transgressive Art*. London and New York: I. B. Tauris, 2009.

Jennifer Dyer. 'The Metaphysics of the Mundane: Understanding Andy Warhol's Serial Imagery'. *Artibus et Historiae*, 25 No. 49 (2004), 33–47.

Raymond Martin and John Barresi. *The Rise and Fall of Soul and Self: An Intellectual History of Personal Identity*. New York: Columbia University Press, 2006.

Jerry Saltz. 'Sherman's March of Time'. *New York* (1 December 2008), 76–7.

Gary Schneider. *Genetic Self-Portrait*. Syracuse, NY: Light Work, 1999.

Nadia Tscherny. 'Elizabeth Peyton'. *Art in America* (February 2009).

Cecile Whiting. 'Andy Warhol, the Public Star and the Private Self'. *Oxford Art Journal*, 10 No. 2 (1987), 58–75.

Epilogue

John Dewey. *Art as Experience*. New York: Penguin, 2005; originally published 1934.

Ellen Dissanayake. *Art and Intimacy: How the Arts Began*. Seattle and London: University of Washington Press, 1999.

James Elkins. *The Object Stares Back: On the Nature of Seeing*. San Diego, New York, London: Harvest Books (Harcourt), 1996.

Maurice Merleau-Ponty. 'Cézanne's Doubt' and 'Eye and Mind'. In Galen A. Johnson, ed., *The Merleau-Ponty Aesthetics Reader: Philosophy and Painting*. Evanston, Ill.: Northwestern University Press, 1993, pp. 59–75 and 121–49.

Vivian Sobchack. *Carnal Thoughts: Embodiment and Moving Image Culture*. Berkeley and Los Angeles: University of California Press, 2004.

Michael Tomasello. *The Cultural Origins of Human Cognition*. Cambridge, Mass. and London: Harvard University Press, 1999.

J. David Velleman. *Self to Self: Selected Essays*. Cambridge: Cambridge University Press, 2005.

NOTES

Chapter 1

1. Norbert Schneider, *The Art of the Portrait: Masterpieces of European Portrait Painting* (Cologne, London, et al.: Taschen, 2002), 10.
2. See Eric Scigliano, 'Through the Eye of an Octopus: An Exploration of the Brainpower of a Lowly Mollusk', *Discover*, published online 1 October 2003: <http://discovermagazine.com/2003/oct/feateye>.
3. On lower animals not seeming very lovable or cuddly, see Randy Malamud, *Reading Zoos: Representations of Animals and Captivity* (New York: NYU Press, 1998), 43.
4. Mark Fletcher, producer and director, *Voyage of the Lonely Turtle*, Nature, PBS (2007).
5. For some intriguing thoughts about animal individuality, see Bob Mullan and Garry Marvin, *Zoo Culture: The Book about Watching People Watch Animals*, 2nd edn. (Urbana and Chicago: University of Illinois Press, 1999). See especially chapter 1, 'Humans in Animal Skin'. They discuss how certain animals in zoos are simply there as representatives of species, whereas other animals are regarded as individuals and receive names. These can operate in curious ways, however. At Sea World, there are actually three different killer whales named 'Shamu' who take turns in the performances. Each whale actually has its own name and is referred to by that name by the trainers and staff, but not to the public. 'Any of the whales at Sea World can represent Shamu and whaleness', p. 23.
6. See Daniel Dennett, *Kinds of Minds* (London: Weidenfeld & Nicolson, 1996); and also David de Grazi, *Taking Animals Seriously: Mental Lives and Moral Status* (Cambridge: Cambridge University Press, 1996).
7. Richard Sorabji, *Self: Ancient and Modern Insights about Individuality, Life, and Death* (Chicago: University of Chicago Press, 2006), 4.
8. Jeremy Bentham, *An Introduction to the Principles of Morals and Legislation* (Oxford: Clarendon Press, 1907; first published 1789), 311.
9. Joseph LeDoux, *The Emotional Brain: The Mysterious Underpinnings of Emotional Life* (New York: Touchstone, 1996), 301.

10. Both quotes in this paragraph are from LeDoux, ibid. 302.

11. Rocco J. Gennaro, 'Higher-Order Thoughts, Animal Consciousness, and Misrepresentation: A Reply to Carruthers and Levine', chapter 3 of *Higher-Order Theories of Consciousness* (Amsterdam: John Benjamins, 2004).

12. See again Gennaro on Carruthers.

13. Temple Grandin, 'Animals Are Not Things: A View on Animal Welfare Based on Neurological Complexity'. On-line at <http://www.grandin.com/welfare/animals.are.not.things.html>, no date; accessed 1 November 2009. Grandin also writes that sufficient attention to animal capacities would require not only that some animals have legal protections against pain and suffering but that they be given sufficient stimulation. All this is based on the neurological evidence. 'As nervous system complexity increases, the animal needs increasing amounts of protection from society to insure that it does not suffer from pain, fear or a lack of environmental and social stimulation.'

14. See also Marc Bekov, *The Emotional Lives of Animals* (New World Library; First Trade Paper edn., 2008)); also see Jeffrey Moussaieff Masson, *When Elephants Weep: The Emotional Lives of Animals* (Peaslake: Delta, 1996).

15. Quoted in Charles Darwin, *The Expression of the Emotions in Man and Animals*, Definitive Edition, Introduction, Afterword and Commentaries by Paul Ekman (New York and Oxford: Oxford University Press, 1998), 144.

16. Anna Petherick for *National Geographic News*, 3 February 2006, on-line at <http://news.nationalgeographic.com/news/2006/02/0203_060203_brain.html>. Accessed 1 November 2009.

17. The theme of a portrait as a complex negotiation of actions of displaying oneself or of depicting the act of observing another person on display is central to Michael Podro's book *Depiction* (New Haven and London: Yale University Press, 1998). I shall have more to say about this topic in later chapters, especially in Chapter 6, Intimacy.

18. Of course there are unusual phenomena in which animals, both chimpanzees and elephants, are taught to draw or paint, in some sense. Whether such work manifests real aesthetic preferences is controversial, as is the issue of whether there is any occasion on which such art is representational or depicts a figure. Most likely the answer to both questions is no. For more information on elephant paintings (a charitable enterprise organized by the former Soviet artists Komar and Melamid), see 'Painting Elephants Get Online Gallery', Hillary Mayell for *National Geographic News*, 26 June 2002, on-line at <http://news.nationalgeographic.com/news/2002/06/

0626_020626_elephant.html>; accessed 13 March 2007. On the case of a chimpanzee's drawings, see James Elkins, *The Object Stares Back: On the Nature of Seeing* (New York et al.: Harvest, 1996), 229–33.

19. See Darwin, inset note from the editor, Ekman: 'Parker said . . . that Darwin does not mention that some individual orangutans, chimpanzees, and gorillas show evidence that they recognize the [mirror] image as their own, whereas monkeys do not' (Darwin, *Expression of Emotions*, 141).

20. Jerry Adler, 'Vanity, Thy Name Is . . . Dumbo? An elephant passes the "mirror test" ', *Newsweek*, 13 November 2006 issue, on-line at <http:// www.msnbc.msn.com/id/15563300/site/newsweek/>.

21. See Adler, ibid., and also Mary Midgley, *Beast and Man: The Roots of Human Nature* (London and New York: Routledge, rev. edn., 1995), 218 ff.

22. I set aside here other controversies and examples, such as the satin bowerbird's complex decorated bowers, etc.

23. See the interesting summary of five kinds of anthropomorphism that have been distinguished by psychologist Randall Lockwood, reported in Mullan and Marvin, *Zoo Culture*, 13 ff. Malamud cites discussions in favor of anthropomorphism which argue that scientific objectivity is itself misleading, *Reading Zoos*, 36 ff.

24. Jill Greenberg, *Monkey Portraits* (Boston and New York: Bullfinch Press, 2006).

25. Berger, 'Why Look at Animals?' in *About Looking* (New York: Pantheon, 1991), 19.

26. Comte de Buffon's 44-volume *Histoire Naturelle* (*Natural History*) (1749–1803); see <http://www.getty.edu/museum/conservation/partnerships/oudry/>.

27. On Rubens's *Hippopotamus and Crocodile Hunt*, see David Rosand, 'Rubens' Munich Lion Hunt, Its Sources and Significance', *Art Bulletin* (1969).

28. Hockney, *David Hockney's Dog Days* (London: Thames & Hudson; repr. edn., 2006); emphasis mine.

29. On Picasso's images of sleeping women, see Leo Steinberg, 'Picasso's Sleepwatchers', in *Other Criteria: Confrontations with Twentieth-Century Art* (New York et al.: Oxford University Press, 1972), 93–114.

30. Nicholas Penny, 'Lucian Freud: Plants, Animals, and Litter', *The Burlington Magazine*, 130, No. 1021 (1988), 290–5.

31. Wegman, quoted in Kevin Conley, *Salon*, on-line at <http://dir.salon.com/story/people/bc/2000/02/08/wegman/index.xml>. See also James Gardner, 'Woof Woof at the Whitney: Photographer William Wegman; Whitney Museum, New York, New York', *National Review*, 27 April 1992, on-line

at <http://www.findarticles.com/p/articles/mi_m1282/is_n8_v44/ai_12091752>; and Susan McHugh, 'Video Dog Star: William Wegman, Aesthetic Agency, and the Animal in Experimental Video Art', Introduction to William Wegman, *Man's Best Friend* (New York: Harry N. Abrams, 1982), 7–11.

32. Wegman, quoted in Gardner, 'Woof Woof at the Whitney'.

33. Sanford Schwartz, 'The Lovers', *New York Review of Books*, 30 No. 13 (18 August 1983); on-line at <http://www.nybooks.com/articles/article-preview?article_id=6130>; accessed 1 November 2009.

34. Edgar Peters Bowron, 'An Artist's Best Friend: Dogs in Renaissance and Baroque Painting and Sculpture', 7. From Bowron et al., *Best in Show: The Dog in Art from the Renaissance to Today* (New Haven and London: Yale University Press, 2006), 1–37.

35. Ibid. 29.

36. Ibid. 20, 23.

37. William Secord, 'The Purebred Dog in Art: Eighteenth and Nineteenth Centuries', in Edgar Peters Bowron et al., *Best in Show: The Dog in Art from the Renaissance to Today*, 102.

38. Walter A. Liedtke, 'Velazquez, Olivares, and the Baroque Equestrian Portrait', *The Burlington Magazine*, 123 No. 942 (1981), 528–37.

39. Alena M. Buis, ' "... where the horse serves only as a grand base for the elevation of the ruler": Anthony van Dyck's Equestrian Portraits of Charles I', *Concordia Undergraduate Journal in Art History*, 1 (June 2005), on-line at <http://art-history.concordia.ca/cujah/issue01/Buis.htm>; accessed 1 November 2009.

40. Jonathan Jones, 'Whistlejacket, George Stubbs', *The Guardian*, 22 April 2000, <http://arts.guardian.co.uk/portrait/story/0,,739699,00.html>; accessed 1 November 2009.

41. 'Stubbs's colossal, almost three-metre-high painting depicts a horse as a solitary and splendid individual, with no people in the picture, no landscape, just a surrounding void that focuses our attention on the rearing racehorse—his shiny flanks, flying mane, brown eye looking back at us.... It is a romantic study in solitude and liberty, freeing Whistlejacket from the bridles and whips that surrounded him in life to gallop in unlimited abstract space' (Jones, ibid.).

Chapter 2

1. Roland Barthes, *Camera Lucida: Reflections on Photography*, trans. Richard Howard (New York: Farrar, Straus and Giroux, 1981), 109. There is a kind of paradox here: when a person's air is captured by an image, that person

did not plan for that to happen: 'the air expresses the subject, insofar as that subject assigns itself no importance'. In the revelatory image of essence, 'suddenly the masks vanished: there remained a soul, ageless but not timeless' (ibid.).

2. Kendall Walton, 'Transparent Pictures: On the Nature of Photographic Realism', *Critical Inquiry*, 11 (1984), 251.

3. 'We can *see* our loved ones again [in photographs], and *that* is important to us' (Walton's emphasis), ibid. 253.

4. On Roman portraits see Shearer West, *Portraiture* (Oxford: Oxford University Press, 2004), 21–2; she also addresses the ancient Rome practice of using death masks.

5. See Jan Stuart and Evelyn Sakakida Rawski, *Worshiping the Ancestors: Chinese Commemorative Portraits* (Freer Gallery of Art: Arthur M. Sackler Gallery, Smithsonian Institution in association with Stanford University Press, 2001).

6. Patrick Maynard, *The Engine of Visualization: Thinking through Photography* (Ithaca and London: Cornell University Press, 1997).

7. Ibid. 238–9. This comparison between photographs and icons has been noted by others, but has not yet been as fully investigated as it could be. See Hans Belting, *Likeness and Presence: A History of the Image before the Era of Art*, trans. Edmund Jephcott (Chicago and London: University of Chicago Press, 1994), esp. 53: 'The analogy of today's photography seems appropriate. Priority was given not to art itself or to the artist's invention but to the utmost verisimilitude. This attitude takes us to the heart of the early use of images. The beholder was in touch with the real presence in, and the healing power of, the image. These could be guaranteed, however, only by an exact match between likeness and original, the intervention of an artist being unwanted.'

8. Actually this is a line spoken by one of the characters (Veronica) in the dialogue Maynard invented in 'The *Secular Icon*: Photography and the Functions of Images', *Journal of Aesthetics and Art Criticism*, 42 No. 2 (1983), 155–69, see p. 165.

9. Maynard, *Engine of Visualization*, 247.

10. Hans Belting, *Likeness and Presence: A History of the Image before the Era of Art*, trans. Christopher S. Wood (Chicago: University of Chicago Press, 1994).

11. Charles Barber, 'From Transformation to Desire: Art and Worship after Byzantine Iconoclasm', *Art Bulletin*, 75 (1993), 7–16. See also Robert S. Nelson, 'The Discourse of Icons, Then and Now', *Art History* 12 (1989), 144–57; Robin Cormack, *Painting the Soul: Icons, Death Masks and*

Shrouds (London: Reaktion Books, 1997); Robert Ousterhout and Leslie Brubaker, eds., *The Sacred Image East and West* (Urbana and Chicago: University of Illinois Press, 1995); Ernst Kitzinger, 'The Cult of Images in the Age before Iconoclasm', *Dumbarton Oaks Papers*, 8 (1954), 83–150; reprinted in W. Eugene Kleinbauer, ed., *The Art of Byzantium and the Medieval West: Selected Studies by Ernst Kitzinger* (Bloomington and London: Indiana University Press, 1976), 90–156. See also Leslie Brubaker, 'Icons before Iconoclasm?' in *Morfologie sociali e culturali in Europa fra Tarda Antichità e Alto Medioevo, Settimane di Studio del Centro Italiano di Studi sull' Alto Medioevo* 45 (Spoleto Presso La Sede del Centro, 1998), 1215–54.

12. See also Michael Tomasello, *The Cultural Origins of Human Cognition* (Cambridge, Mass.: Harvard University Press, 1999), esp. 89 f. Social self-consciousness, Michael Tomasello argues, is part of a social evolutionary process basic to our very humanness (pp. 84–6).

13. From Byzantines Net, <http://www.byzantines.net/moreinfo/icons InTheBCC.htm>.

14. I am indebted to Sara Rappe for discussions of the role of theurgy in Neoplatonism and its continuing influence into the Byzantine period.

15. Maynard here quotes Ernst Kitzinger, 'The Cult of Images in the Ages before Iconoclasm', *Dumbarton Oaks Papers*, 8 (1954), 85–150; repr. in Kitzinger, *The Art of Byzantium and the Medieval West* (Bloomington: Indiana University Press, 1976); see also Kitzinger, *Byzantine Art in the Making: Main Lines of Stylistic Development in Mediterranean Art, 3rd–7th Century* (Cambridge, Mass.: Harvard University Press, 1977), 104–5 and 118–19.

16. Vladimir Lossky, *The Mystical Theology of the Eastern Church* (London: James Clarke, 1957), p. 189 quoted in Maynard, *Engine of Visualization*, 243.

17. Barber (giving an exposition of the view of Thomas F. Mathews), 'From Transformation to Desire', 8, 14.

18. Belting comments that beauty didn't matter in an icon; rather, correctness did; *Likeness and Presence*, 47.

19. 'Gerhard Richter, The Day is Long', interviewed by Robert Storr, *Art in America* (January 2002), 121.

20. See Belting, *Likeness and Presence*, 42. Also see <http://www.byzantines. net/moreinfo/iconsInTheBCC.htm>: 'One of the most important icons transferred to Kiev was Our Lady of Vladimir. It was believed that this icon had powers that could benefit the town. It was carried onto the battlefield in the hopes of bringing additional protection, carried in processions, and called upon to bring rain to the country.'

21. See 'The First Crying Icon from Chicago', at <http://www.pitt.edu/~ocfellow/icons.html#jcsinai>; and see 'Miracles ~ Icons Crying, Drinking Milk, Shedding Blood, Shedding Oil', at <http://www.crystalinks.com/weepingstatues.html>.

22. Belting, *Likeness and Presence*, 4; see also p. 53.

23. Ibid. 56.

24. Ibid. 49.

25. See the official website at <http://www.sancta.org/>.

26. See Lois Parkinson Zamora, *The Inordinate Eye: New World Baroque and Latin American Fiction* (Chicago and London: University of Chicago Press, 2006), 52–7.

27. See Belting, *Likeness and Presence*, 53; also, see 'Shrine of the Miracle Tortilla', at <http://www.roadsideamerica.com/attract/NMLAKtortilla.html>. The Virgin on a cookie sheet appeared in the cafeteria of Pugh Elementary School in Houston on Ash Wednesday, February 2007, and was covered by a variety of local media.

28. Belting, *Likeness and Presence*, 485–6.

29. Ibid. 53.

30. Maynard, 'Secular Icon', 166; he cites Kitzinger here as his source.

31. Ibid. 159, n. 10.

32. Kendall Walton, 'On Pictures and Photographs: Objections Answered', in Richard Allen and Murray Smith, eds., *Film Theory and Philosophy* (Oxford: Clarendon Press, 1997), 72; repr. in Walton, *Marvelous Images: On Values and the Arts* (Oxford: Oxford University Press, 2008), 117–32.

33. Walton, 'Transparent Pictures', 261.

34. See West, *Portraiture*, 26–7.

35. See ibid. 27.

36. See Tonya M. Lambert, 'Imperial Women: A Study in Public Images', review in *Canadian Journal of History*, April 2003. Also see Susan E. Wood, *Imperial Women: A Study in Public Images 40 B.C. –A.D. 68* (Leiden: E. J. Brill, 1999).

37. Susan Walker, *Greek and Roman Portraits* (London: British Museum Press, 1995), 96–7. See also Harriet I. Flower, *Ancestor Masks and Aristocratic Power in Roman Culture* (Oxford: Oxford University Press, 1997), 257–8.

38. Walker, *Greek and Roman Portraits*, 19–20.

39. Ibid. 77.

40. West, *Portraiture*, 65.

41. See the Metropolitan Museum's website: <http://www.metmuseum.org/toah/hd/jucl/ho_42.11.30.htm>.

42. See Jenna Curry, 'Sculpted Stones', *Art and Antiques* (May 2009), 208; this article cites Kenneth Lapatin, the curator of the Getty exhibit *Carvers and Collectors: The Lasting Allure of Ancient Gems*.

43. See Sixten Ringbom, *Icon to Narrative: The Rise of the Dramatic Close-up in Fifteenth-Century Devotional Painting* (Doomspijk: Davaco, 2nd edn., 1984).

44. Stephen Lloyd, *Portrait Miniatures from the National Galleries of Scotland* (Edinburgh: National Galleries of Scotland, 2004), 15.

45. She had died at age 17; ibid. 21–3.

46. Carlyle was a strong proponent of founding the National Portrait Galleries in England and Scotland, 1856 and 1882; he held that a decent portrait was better than 'half a dozen written "biographies" ' (Lloyd, *Portrait Miniatures*, 25).

47. Wendy Bellion, 'The Mechanization of Likeness in Jeffersonian America', <http://web.mit.edu/comm-forum/papers/bellion.html>.

48. Ibid.

49. Quoted ibid.

50. See Daphne Foskett, *Miniatures: Dictionary and Guide* (Antique Collectors' Club, 1987); Dale Johnson, *American Portrait Miniatures: In the Manney Collection* (New York: Harry N Abrams, Inc., 1991); and Sue McKechnie, *British Silhouette Artists and their Work 1760–1860* (London: P. Wilson for Sotheby Parke Berne, 1978).

51. Alan Trachtenberg, 'Likeness as Identity: Reflections on the Daguerrean Mystique', in Graham Clarke, ed., *The Portrait in Photography* (London: Reaktion Books, and Seattle: University of Washington Press, 1992), 177.

52. 'Interview with Anthony Minghella', by Ingrid Sischy, December 2003, <http://www.findarticles.com/p/articles/mi_m1285/is_11_33/ai_11111 4552/pg_3>, accessed 6 June 2006.

53. John Tagg, *The Burden of Representation: Essays on Photographies and Histories* (Amherst, Mass.: The University of Massachusetts Press, 1993), 37; see also chapter 1, 'A Democracy of the Image: Photographic Portraiture and Commodity Production', 34–59.

54. See West, *Portraiture*, 59–62 ('The Portrait as Proxy and Gift').

55. Tagg, *The Burden of Representation*, 39, 43.

56. I am indebted to John Matturri for knowledge of this; private communication.

57. See Santayana, in Vicki Goldberg, ed., *Photography in Print: Writings from 1816 to the Present* (Albuquerque: University of New Mexico Press, 1988), 260.

58. Lianne McTavish, 'Picturing the Dead', *CMAJ* 166 No. 13 (2002); McTavish mentions one little girl shown as if still playing her drums.

59. John Matturri, 'Traces of Mortality: The Nature of Representation in Photographic Tombstones', Paper presented at the Annual Meeting of the Association for Gravestone Studies, Amherst College, June 1987 (references omitted).

Chapter 3

1. See Roy Strong, *The English Icon: Elizabethan and Jacobean Portraiture* (London: Routledge & Kegan Paul, 1969), and *Gloriana: The Portraits of Queen Elizabeth I* (London: Thames and Hudson, 1987).

2. Richard Brilliant, *Portraiture* (Cambridge, Mass.: Harvard University Press, 1991), 103.

3. E. H. Gombrich, *The Story of Art*, 3rd edn. (Oxford and New York: Phaidon, 1978), 293.

4. Erwin Panofsky, 'What is Baroque?' (1934), in *Three Essays on Style*, ed. Irving Levin (Cambridge: MIT Press, 1993), 45, 75.

5. Richard Sorabji, *Self: Ancient and Modern Insights about Individuality, Life, and Death* (Chicago: University of Chicago Press, 2006); Charles Taylor, *Sources of the Self: The Making of Modern Identity* (Cambridge, Mass.: Harvard University Press, 1989); Marya Schechtman, *The Constitution of Selves* (Ithaca, NY: Cornell University Press, 1996); Raymond Martin and John Barresi, *The Rise and Fall of Soul and Self* (New York: Columbia University Press, 2006); David Velleman, *Self to Self, Selected Essays* (Cambridge: Cambridge University Press, 2006). See also Katherine Hoffman, *Concepts of Identity: Historical and Contemporary Images and Portraits of Self and Family* (Boulder, Colo.: Westview Press, 1996).

6. See also Daniel Dennett, 'Conditions of Personhood', in A. O. Rorty, ed., *The Identities of Persons* (Berkeley and Los Angeles: University of California Press, 1976). Dennett lists six conditions of personhood: rationality, intentionality, adopting and reciprocating certain attitudes with respect to others, the capacity for verbal communication, self-consciousness.

7. Jerrold Seigel, *The Idea of the Self: Thought and Experience in Western Europe since the Seventeenth Century* (Cambridge: Cambridge University Press, 2005), 5.

8. Hilary Putnam, 'Brains in a Vat', in Putnam, *Reason, Truth, and History* (New York: Cambridge University Press, 1982). For an overview of the argument and its significance, see Lance P. Hickey, 'The "Brain in a Vat" Argument', Internet Encyclopedia of Philosophy, <http://www.iep.utm.edu/brainvat/#H5>, last updated 22 October 2005.

9. See Seigel, *Idea of the Self*, 97–8.
10. Locke, *Essay*, 2.27.9; emphasis in the original.
11. West, *Portraiture*, 22.
12. Ibid. 23.
13. West explains that a greater effort to show that the internal was linked to the external began with physiognomy, ibid. 32–3.
14. The painter was to create a later equestrian portrait as well as a portrait of him, now in the Prado, in hunting dress.
15. See Enriqueta Harris, 'Velázquez's Portrait of Prince Baltasar Carlos in the Riding School', *The Burlington Magazine*, 118 No. 878 (May 1976), 266–73 and 275.
16. See Harris, ibid. 272; see also *Art Book Velázquez* (London et al.: Dorling Kindersley, 1999).
17. Harris, 'Velázquez's Portrait of Prince Baltasar Carlos', 271.
18. West, *Portraiture*, 40.
19. The story is often told of how Picasso replied to someone who criticized his portrait of Stein for not looking like its subject, 'It will'; see the commentary on this painting at the Metropolitan Museum website, <http://www.metmuseum.org/works_of_art>.
20. On the difficulty of representing the mind and what goes on in the mind, see Brilliant, *Portraiture*, 75–6. He says, 'The artificiality of portraiture as a method of packaging individuals in neat containers of personhood is often much more obvious in less agreeable instances of representation' (83).
21. Sorabji, *Self*, 8.
22. Taylor, *Sources of the Self*, 131.
23. Michel de Montaigne, *The Complete Essays of Montaigne* (1588), trans. Donald M. Frame (Stanford, Calif.: Stanford University Press, 1943), 3: 13, p. 821.
24. See also West on self-portraiture in relation to autobiography, *Portraiture*, 178–9; also see her remarks on Renaissance self-fashioning according to Greenblatt, ibid. 17, n. 6.
25. Taylor, *Sources of the Self*, 178.
26. Ibid. 181.
27. Ibid. 182.
28. See also Brilliant's discussion of Dürer's and Holbein's portraits of Erasmus, *Portraiture*, 72 ff.
29. Joseph Leo Koerner, *The Moment of Self-Potraiture in German Renaissance Art* (Chicago and London: University of Chicago Press, 1993), 67.

30. Taylor, *Sources of the Self*, 375; for criticisms of Taylor's take on Herder, see Seigel, *Idea of the Self*, 332.

31. West, *Portraiture*, 29.

32. Taylor, *Sources of the Self*, 469.

33. See Deborah Davis, *Strapless: Madame X and the Scandal That Shocked Belle Epoque Paris* (London: Penguin Group, 2003).

34. Albert Boine, 'Sargent in Paris and London: A Portrait of the Artist as Dorian Gray', in Patricia Hills et al., *John Singer Sargent* (New York: Whitney Museum, 1986), 74–109; see especially the quoted remark from de Fourcaud, top p. 91. Also see the discussion of Sargent's painting *The Daughters of Edward D. Boit* (1882), p. 78.

35. Richard Avedon, 1980; quoted on the Richard Avedon Foundation website, <http://www.avedonfoundation.org>, accessed 13 August 2009.

36. Richard Avedon, 1994; Richard Avedon Foundation website, at <http://www.avedonfoundation.org>, accessed 13 August 2009.

37. See Seigel, *Idea of the Self*, 36–8 ff.

38. Brilliant, *Portraiture*, 104.

39. See Brilliant on Frans Hals's *Officers and Sergeants of the St George Civic Guard* (*c*.1639), ibid. 50 ff.

40. Alois Riegl, *The Group Portraiture of Holland*, trans. Evelyn M. Kain and David Britt (Los Angeles: Getty Research Institute, 1999). See also Harry Berger, Jr., *Man, Marriage, and Mischief: Rembrandt's Night Watch and Other Dutch Group Portraits* (New York: Fordham University Press, 2007).

41. Catherine M. Soussloff, *The Subject in Art: Portraiture and the Birth of the Modern* (Durham, NC: Duke University Press. 2006), 32.

42. See David Ross Smith, 'Dutch Double and Pair Portraits in the 17th Century', Columbia University Ph.D. dissertation (1978), 336.

43. Brilliant, *Portraiture*, 89.

44. Ibid. 56–8.

45. Ibid. 115.

46. Ibid. 15.

47. Michael Tomasello, *The Cultural Origins of Human Cognition* (Cambridge, Mass.: Harvard University Press, 2001), 89.

48. Ibid. 90 (footnote omitted).

49. Velleman, 'The Genesis of Shame', in *Self to Self*, 53.

50. Ibid. 54.

51. See Hugh Belsey, *Love's Prospect: Gainsborough's Byam Family and the 18th Century Marriage Portrait* (Bath: Holburne Museum of Art, 2001).

52. See Kate Retford, *The Art of Domestic Life: Family Portraiture in 18th Century England* (New Haven: Yale University Press, 2006).

53. See ibid. ch. 3, 'The Art of Motherhood' and ch. 4, 'The Art of Fatherhood',

54. See Martin Postle, *Thomas Gainsborough* (Princeton: Princeton University Press, 2002 and London: Tate Gallery, 2002), 71.

55. See e.g. Sander Gilman, *Seeing the Insane* (Lincoln, Neb.: University of Nebraska Press, 1996).

56. Gardner, with Richard Tansey, *Art Through the Ages*, 7th edn. (New York: Harcourt, 1980), 737.

57. For discussion of such enterprises, see Sander Gilman, *Disease and Representation: Images of Illness from Madness to AIDS* (Ithaca, NY: Cornell University Press, 1988); John Tagg, *The Burden of Representation: Essays on Photographies and Histories* (Amherst: University of Massachusetts Press, 1988); and Allan Sekula, 'The Body and the Archive', in Richard Bolton, ed., *The Contest of Meaning: Critical Histories of Photography* (Cambridge, Mass. and London: MIT Press, 1989), 343–79; originally published in *October*, 39 (Winter 1986).

58. For discussion of Sander see West, *Portraiture*, 27–8.

59. <http://www.masters-of-fine-art-photography.com/02/artphotogallery/texte/sander_text.html>, accessed 18 August 2009.

60. See Christopher M. Lyman, *The Vanishing Race and Other Illusions: Photographs of Indians by Edward S. Curtis* (Washington, DC: Smithsonian, 1982). See also Mick Gidley, *Edward S. Curtis and the North American Indian, Incorporated*, Cambridge Studies in American Literature and Culture (Cambridge: Cambridge University Press, 2000); and J. C. Scherer, 'You Can't Believe Your Eyes: Inaccuracies in Photographs of North American Indians', *Studies in the Anthropology of Visual Communication*, 2 No. 2 (1975), 67–79.

61. See also S. Elizabeth Bird, ed., *Dressing in Feathers: The Construction of the Indian in American Popular Culture* (Boulder, Colo.: Westview, 1996).

62. Cathy Robbins, 'Collecting Indians', *Voice of San Diego*, on-line at <http://www.voiceofsandiego.org/articles/2006/11/16/opinion/01robbinscurtis.txt>; accessed 19 August 2009.

63. Press release for exhibition, Fiona Tan: *Countenance* 5 April–29 May, Museum of Modern Art, Oxford; online at <http://www.modernartoxford.org.uk/Press/53>, accessed 18 August 2009.

64. Adrian Searle, 'Who Are You?', *The Guardian*, 12 April 2005, <http://www.guardian.co.uk/culture/2005/apr/12/1>, accessed 18 August 2009.

65. Joel Snyder, 'Setting the Record Straight', in Fiona Tan, *Correction*, curated by Francesco Bonami and Julie Rodrigues Widholm (Chicago: Museum of Contemporary Art, 2004), 26.

66. Jean Dykstra, 'Fiona Tan at the New Museum of Contemporary Art', *Art in America* (November 2005), <http://findarticles.com/p/articles/mi_m1248/is_10_93/ai_n15860934/>, accessed 18 August 2009.

67. Marya Schechtman, 'Comments on Cynthia Freeland', manuscript, commentary delivered at Pacific Division American Philosophical Association meeting, Vancouver, British Columbia, April 2009.

68. Barthes, *Camera Lucida*, 110.

Chapter 4

1. See H. L. MacCurrie, 'Aristotle and Quintilian: Physiognomical Reflections', in Allan Gotthelf, ed., *Aristotle on Nature and Living Things: Philosophical and Historical Studies* (Pittsburgh and Bristol: Mathesis Publications and Bristol Classical Press, 1985), 359–66.

2. Frederick Cummings, 'Charles Bell and the Anatomy of Expression', *The Art Bulletin*, 46 No. 2 (1964), 192.

3. Leonardo da Vinci, in *Leonardo on Painting*, ed. and trans. Martin Kemp and Margaret Walker (New Haven and London: Yale University Press, 1989), 144. See also P. Meller, 'Physiognomical Theory in Renaissance Heroic Portraits', in *Studies in Western Art: Acts of the Twentieth International Congress of the History of Art* (Princeton: Princeton University Press, 1963), ii. 53–69. See also M. Kwakkelstein, *Leonardo da Vinci as a Physiognomist: Theory and Drawing Practice* (Leiden: Primavera Pers, 1994).

4. Edwin M. Todd, *The Neuroanatomy of Leonardo da Vinci* (Santa Barbara: Capra Press, 1983).

5. See Jennifer Montagu, *The Expression of the Passions: The Origin and Influence of Charles Le Brun's Conférence sur l'expression générale et particulière* (New Haven and London: Yale University Press, 1994), 65.

6. See ibid.; also see Thomas Kirchner, *L'Expression des passions: Ausdruck als Darstellungsproblem in der französischen Kunst und Kunsttherorie des 17. und 18. Jahrhunderts*, Berliner Schriften zur Kunst (Mainz: P. von Zabern, 1991).

7. All quotations are from Montagu's translation of Le Brun, pp. 127–8.

8. Ibid. 18.

9. Ibid. 20.

10. Ibid. 90. 'So by the end of the 18th century Le Brun's method of deducing the expressions by reasoning from a few assumptions as to the

psychological and physiological mechanism of the human body was discredited, and the way open for more scientific and anatomical, and later, psychological, investigations', ibid. 102.

11. Ibid. 100.

12. On its influence, see Line Cottegnies, 'Codifying the Passions in the Classical Age: A Few Reflections on Charles Le Brun's Scheme and its Influence in France and in England', <http://www.etudes-episteme.org/ ee/file/num_1/ee_1_art_cottegnies.pdf>. Even though it was generally to be dismissed as excessive and rigid in the eighteenth century, more vigorously so in England than in France, its influence in these two countries was profound and enduring. It has thus often been seen as a major source for the visual rhetoric that eventually led to the pathetic style in the arts, in the theatre and even, to a certain extent, in the fiction of the neoclassical age. This essay describes a controversy between Le Brun and de Piles who advocated the ability of an individual genius through grace to capture and render passions, rather than depending on any alleged system. The controversy was familiar to artists in England like Hogarth who alluded to it. He also mentions that 'James Parsons tries to emulate Le Brun with a rationalistic treatise on physiognomy, *Human Physiognomy Explain'd* (London, 1747).' This essay also provides a good account of the relationship between the expression of passions on stage and in visual art and their mutual interaction (in the sense that students of each were advised to study masters of the other).

13. Amy M. Schmitter, Review of Montagu, *The Expression of the Passions*, *The Journal of Aesthetics and Art Criticism*, 54 No. 4 (1996), 384–6, at 385.

14. According to one review, Montagu's 'chapter 8 examines how 19th-century psychological, physiological and evolutionary theories ultimately undermined Le Brun's most fundamental assumptions, thereby destroying the *Conférence*'s authority'; see Anthony Colantuono, review of Montagu, *The Art Bulletin*, 78 No. 2 (1996), 356–8 at 357.

15. Nils K. Oeijord, *Why Gould Was Wrong* (Bloomington, In.: iUniverse, Incorporated, 2003), 73.

16. Christoph Sigrist, ' "Letters of the Divine Alphabet": Lavater's Concept of Physiognomy', in Ellis Shookman, ed., *The Faces of Physiognomy: Interdisciplinary Approaches to Johann Caspar Lavater* (Columbia, SC: Camden House, 1993), 25–39; on Leibniz's influence, see esp. p. 29.

17. See esp. Siegfried Frey, 'Lavater, Lichtenberg, and the Suggestive Power of the Human Face', pp. 64–103 of Shookman, *Faces of Physiognomy*.

18. Ross Woodrow, 'Lavater and the Drawing Manual', in Melissa Percival and Graeme Tyler, eds., *Physiognomy in Profile: Lavater's Impact on European Culture* (Newark: University of Delaware Press, 2005), 71–93 at 71.

19. For example, it appeared in a version 'illustrated by more than eight hundred engravings accurately copied and some duplicates added from originals executed by or under the inspection of Thomas Holloway; translated from the French by Henry Hunter' (London: Printed for John Murray, No. 32 Fleet Street: H. Hunter, D.D. Charles's Square and T. Holloway, No. 11, Bache's-Row, Hoxton, 1789–98).

20. Frey, 'Lavater, Lichtenberg, and the Suggestive Power of the Human Face', 68.

21. See Wendy Bellion, 'The Mechanization of Likeness in Jeffersonian America', <http://web.mit.edu/comm-forum/papers/bellion.html>; *MIT Communications Forum*, posted 19 December 1999.

22. See Judith Wechsler, 'Lavater, Stereotype, and Prejudice', in Shookman, *Faces of Physiognomy*, 104–25.

23. Ellis Shookman, 'Pseudo-Science, Social Fad, Literary Wonder: Johann Caspar Lavater and the Art of Physiognomy', in Shookman, *Faces of Physiognomy*, 1–24 at 23. The reference is to Schopenhauer, 'Physiognomy', in *Religion: A Dialogue and other Essays*, ed. and trans. T. B. Saunders (London: Swan Sonneschein, 1890), 77–8.

24. See John House, 'Toward a "Modern" Lavater? Degas and Manet', in Percival and Tyler, *Physiognomy in Profile*, 180–97. House also points out the increasing influence of new urbanization upon conceptions of various popular 'types' and comments on how such types were depicted in the two French artists' works. House argues that Degas did not go so far as Manet did to undermine these kinds of stereotypes; Manet's paintings, such as *A Bar at the Folies-Bergère*, could be 'a maze of uncertainties and ambiguities', p. 192.

25. Frey, 'Lavater, Lichtenberg, and the Suggestive Power of the Human Face', 101; on Lichtenberg's publication, see p. 65, n. 4.

26. Robert M. Young, *Mind, Brain and Adaptation in the Nineteenth Century: Cerebral Localization and Its Biological Context from Gall to Ferrier*, ch. 3 (online version at <http://www.human-nature.com/mba/chap3.html>. 'Bain's analysis of the emotions is extremely disappointing. His list of the "special emotions" is a pot-pourri of the psychological, philosophical, and physiological issues of the day, and any attempts to make a coherent position from its disparate parts consistently fail.'

27. Website, Biography of Sir Charles Bell, NNDB, <http://www.nndb.com/people/118/000100815/>, accessed 31 October 2009.

28. Lucy Hartley, *Physiognomy and the Meaning of Expression in Nineteenth-Century Culture* (Cambridge: Cambridge University Press, 2001), 79.

29. Stanley Finger, *Origins of Neuroscience* (Oxford University Press <http://webperso.easyconnect.fr/baillement/lettres/duchenne/duchenne.html>). See also Hayes Peter Mauro, 'Duchenne: Discourses of Aesthetics, Sexuality and Power in Nineteenth-Century Medical Photography', *Athanor*, 18 (2000).

30. Rejlander, footnote omitted, quoted in Prodger, 'Appendix II: Photography and *The Expression of the Emotions*', in Charles Darwin, *The Expression of the Emotions in Man and Animals*, Definitive Edition, Introduction, Afterword and Commentaries by Paul Ekman (New York and Oxford: Oxford University Press, 1998), 408–9.

31. Figure 22, p. 246, in Darwin, *Expression*.

32. See Hartley, ch. 5, 'Universal Expressions: Darwin and the Naturalization of Emotion', in *Physiognomy and the Meaning of Expression*, 142–79. The principles are summarized by Hartley on pp. 156 ff. See also Darwin, *Expression*.

33. Hartley, ibid. 144; the reference is to Richards, *Evolutionary Theories of Mind and Behaviour* (Chicago: University of Chicago Press, 1987), 231.

34. See Elizabeth A. Phelps, 'The Interaction of Emotion and Cognition: Insights from Studies of the Human Amygdala', in Lisa Feldman Barrett, Paula M. Niedenthal, and Piotr Winkielman, *Emotion and Consciousness* (New York and London: The Guilford Press, 2005), 51–66.

35. Daniel Lundqvist and Arne Ohman, 'Caught by the Evil Eye: Nonconscious Information Processing, Emotion, and Attention to Facial Stimuli', in *Emotion and Consciousness*, 101.

36. Ekman, 'Darwin, Deception, and Facial Expression', in Paul Ekman, Joseph J. Campos, Richard J. Davidson, and Frans B. M. de Waal, *Emotions Inside Out: 130 Years after Darwin's* The Expression of the Emotions in Man and Animals (New York: New York Academy of Sciences, 2003), 205.

37. See Lundqvist and Ohman, 'Caught by the Evil Eye', 97–9 ff. Also see Frans B. M. de Waal, 'Darwin's Legacy and the Study of Primate Visual Communication', in Ekman et al., *Emotions Inside Out*, 7–31; and also, in the same volume, 'The Discrimination of Faces and Their Emotional Content by Chimpanzees', 56–78.

38. Lundqvist and Ohman, 'Caught by the Evil Eye', 99.

39. Ibid. 105. They proceed to comment that 'threatening and friendly faces are segregated for differential processing at an early, subcortical level of visual processing'. See also Richard J. Davidson, 'Darwin and the Neural Bases of Emotion and Affective Style', in Ekman et al., *Emotions Inside Out*, 316–36.

40. Lundqvist and Ohman, 'Caught by the Evil Eye', 107.
41. Jonathan Cole, *About Face* (Cambridge, Mass. and London: MIT Press, 1998), 6. Also see Leslie A. Zebrowitz, *Reading Faces: Window to the Soul?* (Boulder, Colo.: Westview Press, 1998).
42. See Cole, *About Face*, 51; he references Oliver Sacks, *The Man Who Mistook His Wife for a Hat*. This point is also made in L. A. Parr, 'The Discrimination of Facial Expressions and their Emotional Content by Chimpanzees (*Pan troglodytes*)', in Ekman et al., *Emotions Inside Out*, 56–78.
43. Parr, 'Discrimination of Facial Expressions', 71.
44. Cole also mentions some recent scientific disagreement about the basic emotions, including the view of Panksepp that there are three fundamental emotion systems: 'one for exploration or expectation and desire; one for flight, fear, and horror; and a third for offense, anger and rage through sadness, crying, and sorrow to grief and panic', ibid. He cites J. Panksepp, 'Toward a General Psychobiological Theory of Emotions', *The Behavioral and Brain Sciences* 5 (1982), 407–67.
45. Paul Ekman and Wallace V. Friesen, *Unmasking the Face: A Guide to Recognizing Emotions from Facial Expressions* (Cambridge, Mass.: Malor Books, 2003), 170. See also Paul Ekman, *Emotions Revealed: Recognizing Faces and Feelings to Improve Communication and Emotional Life* (New York: Times Books, 2003).
46. Ekman and Friesen, *Unmasking the Face*, 22.
47. Ibid. 10–11.
48. Such methodologies have been critically addressed by various authors, including Allan Sekula, 'The Body and the Archive', in Richard Bolton, ed., *The Contest of Meaning: Critical Histories of Photography* (Cambridge, Mass.: MIT Press, 1992), 344–79; John Tagg, *The Burden of Representation: Essays on Photographies and Histories* (Amherst, Mass.: The University of Massachusetts Press, 1993); and Sander Gilman, *Disease and Representation: Images of Illness from Madness to AIDS* (Ithaca, NY: Cornell University Press, 1988).
49. See e.g. the massive work of August Sander on Germans, August Sander Archiv and Susanne Lange, *August Sander: People of the 20th Century*, 7 vols. (New York: Harry N. Abrams 2002).
50. See Peter Galison, 'Judgment against Objectivity', in Caroline A. Jones and Peter Galison, eds., *Picturing Science/Producing Art* (New York: Routledge, 1998), 327–59. He writes, 'The changing ideals of objectivity reformed both pictorial practice and the scientific persona itself. As such, objectivity exists

within history and not outside it' (351). He also cites as a major conclusion of his article that 'mechanical objectivity, the nineteenth century's vision of a rock-bottom facticity for the objects with which science works, is a time-specific, hard-won, and contingent category' (355).

51. Ekman and Friesen, *Unmasking the Face*, 144.

52. Ekman, *Emotions Revealed*, p. xv.

53. Ibid. 15.

54. Ibid. 190–1 ff.

55. Colantuano writes, 'Le Brun's thinking clearly reflects the 17th-century definition of the pictorial "figure"—whether the full human form, the face, or any other image—as a visible metaphor, the embodiment of a universal, incorporeal Idea in a carefully proportioned arrangement of shapes, lines, and colors.' This was, again according to Colantuano, a key idea for Poussin. He references R. McRae, ' "Idea" as a Philosophical Term in the Seventeenth Century', *Journal of the History of Ideas*, 26 (1965), 175–90, n. 12, p. 358.

56. See Cummings, 'Charles Bell and the Anatomy of Expression', 192. Cummings adds the point that this shift was also prompted by the Germans Sulzer, Herder, and Schlegel, and had influences, in England, upon Alison's *Essays* of 1790. See ibid. 193.

57. Ibid. 198.

58. Ibid. 201. Also, 'Bell's final goal, then, was to raise painting to the level of a liberal art by providing a scientific groundwork, a goal which places him within a tradition extending back at least to Alberti' (203).

59. Cummings explains, 'One of the most important contributions of nineteenth century art and art theory was the breakdown of the hierarchy of genres and the valuation of works of art, regardless of subject matter, on the basis of their special qualities or their impact as visual images', ibid. 197.

60. John Walsh, 'Emotions in Extreme Time: Bill Viola's *Passions* Project', in Bill Viola, *The Passions* (Los Angeles: Getty Publications, 2003), 42–3; previous quotation from p. 269.

61. Bill Viola, in 'A Conversation, Hans Belting and Bill Viola', in Viola, *The Passions*, 201.

62. For further discussion, see Jenefer Robinson, *Deeper than Reason: Emotion and its Role in Literature, Music, and Art* (Oxford: Clarendon Press, 2005).

63. See Cynthia Freeland, 'Piercing to our Inaccessible, Inmost Parts: The Sublime in the Works of Bill Viola', in Chris Townsend, ed., *The Art of Bill Viola* (London: Thames & Hudson, 2004), 25–45.

64. See e.g. Richard Dorment's review, 'Insufferable Passions', *Daily Telegraph*, 22 October 2003; on-line at <http://www.telegraph.co.uk/arts/main. jhtml?xml=/arts/2003/10/22/babill22.xml>; accessed 19 June 2006.

65. Theodor Adorno is a particularly well-known critic who takes such a line; for an account, as well as a response, see Noël Carroll, *A Philosophy of Mass Art* (Oxford, 1998).

Chapter 5

1. See Michael Podro, *Depiction* (New Haven: Yale University Press, 1998).

2. *Matisse on Art*, ed. Jack D. Flam (University of California Press; rev. edn., 1995), 222, 151.

3. Thus those who, due to brain damage, experience a loss of perception of the face as such, or of the ability to perceive the facial expression of emotions, tend to experience various sorts of psychological damage. See Cole, *About Face*.

4. Arthur Wheelock, Jr., 1997, quoted in Susan Fegley Osmond, 'Rembrandt's Self-Portraits', *The Arts*, January 2000; on-line at <http://www.worldandi. com/specialreport/rembrandt/rembrandt.html>; accessed 1 November 2009.

5. Advocates of narrative theories of the self include not just philosophers but also prominent psychologists such as Jerome Bruner and Oliver Sacks. Sacks says, for example, that, 'Each of us constructs and lives a "narrative"...this narrative *is* us, our identity.' Similarly, Bruner has claimed that 'The self is a perpetually rewritten story...in the end, we *become* the autobiographical narratives by which we "tell about" our lives.' See Oliver Sacks, *The Man Who Mistook His Wife for a Hat* (Austin, Tex.: Touchstone, 1985) and Jerome Bruner, *Making Stories: Law, Literature, Life* (Cambridge, Mass.: Harvard University Press, 2003).

6. Alasdair MacIntyre, *After Virtue: A Study in Moral Theory* (Notre Dame, In.: University of Notre Dame Press, 1981), especially ch. 15, 'The Virtues, the Unity of a Human Life and the Concept of a Tradition', 190–209.

7. Dennett also writes, 'Our tales are spun, but for the most part we don't spin them; they spin us. Our human consciousness, and our narrative selfhood, is their product, not their source.' See Daniel Dennett, 'The Self as a Center of Narrative Gravity', in F. Kessel, P. Cole, and D. Johnson, eds., *Self and Consciousness: Multiple Perspectives* (Hillsdale, NJ: Erlbaum, 1992); also available on-line at several locations including <http://cogprints.org/266/0/ selfctr.htm>.

8. 'The understanding provided by narrative should be attributable to the nature of narrative itself—to that in virtue of which a recounting of events qualifies as a story. A description of events qualifies as a story in virtue of its power to initiate and resolve an emotional cadence in the audience.' J. David Velleman, 'Narrative Explanation', *The Philosophical Review*, 112 No. 1 (January 2003), 1–25.

9. Velleman, 'The Self as Narrator', in *Autonomy and the Challenges to Liberalism: New Essays* (Cambridge: Cambridge University Press, 2005), 56–76.

10. Marya Schechtman, *The Constitution of Selves* (Ithaca, NY: Cornell University Press, 1997), 97, 93.

11. This may involve some differences with Velleman, who writes, 'So when I describe the inner narrator as a unified self, I am not speaking of the temporal unity that joins a person to his past and future selves; I am speaking of agential unity, in virtue of which a person is self-governed, or autonomous. In my view, autonomy is not related to personal identity in such a way that a single entity plays the role of self in both phenomena: that which makes us self-governed is not that which makes us self-same through time,' Velleman, 'The Self as Narrator', in *Self to Self*, 223 (footnote omitted).

12. Schechtman, *Constitution of Selves*, 114. Velleman makes a similar point, though he may in the end be more skeptical about 'total' narratives than Schechtman is. He says, 'In my view, however, we tell many small, disconnected stories about ourselves—short episodes that do not get incorporated into our life-stories.' Velleman, 'The Self as Narrator', in *Self to Self*, 222.

13. Schechtman, *Constitution of Selves*, 119.

14. Ibid. 134; see also 120, 132.

15. Ibid. 102; see Schechtman, *Constitution of Selves*, 99–105.

16. Ibid. 105.

17. See Peter Lamarque, 'On Not Expecting Too Much from Narrative', *Mind and Langauge*, 10 No. 4 (September 2004); and Galen Strawson, 'Against Narrativity', *Ratio* NS 17 (4 December 2004).

18. There has been some overlap, notably from Velleman. Paul Ricouer is one proponent of the narrative self-constitution view who spends considerable time on issues about narrative structure and form. See Ricouer, *Time and Narrative* (Chicago: University of Chicago Press, 1984).

19. Velleman's discussions more or less fused these two concerns: since what counts as a narrative connection for him is something that resolves an emotional cadence, closure flows from this.

20. Noël Carroll, 'On The Narrative Connection', *Beyond Aesthetics: Philosophical Essays* (New York: Cambridge University Press, 2001), p. 126.

21. Carroll, 'Narrative Closure', *Philosophical Studies*, 135 (2007), 1–15.

22. Ismay Barwell, 'Understanding Narrative and Narrative Understanding', *Journal of Aesthetics and Art Criticism*, 67 No. 1 (Winter 2009), 49–59.

23. Feagin here cites Michael Bratman's view of the self in 'Reflection, Planning, and Temporally Extended Agency', *Philosophical Review*, 109 No. 1 (January 2000), 44. See Susan Feagin, 'Narratives and Human Agency', manuscript, 2009. See also by Feagin, 'On Noël Carroll on Narrative Closure', *Philosophical Studies*, 135 (2007), 17–25. For critical discussion of many of these issues—the definition of narrative, narrative connection, narrative closure, and Velleman's account of the latter, see Paisley Livingston, 'Narrative and Knowledge', in *Journal of Aesthetics and Art Criticism*, 67 No. 1 (Winter 2009), 25–36.

24. Compare this to the circularity that Velleman is concerned with in his critique of Dennett: 'Note that this claim places significant constraints on the conception of narrative coherence on which I can rely. One might have thought that whether an action would make for a coherent continuation of Gilbert's story ultimately depends on whether he has reason for taking it. My claim, however, is that whether Gilbert has reason for taking an action ultimately depends on whether it would make for a coherent continuation of his story. Because I make the latter claim, I cannot adopt the former in order to explicate narrative coherence, *since my account would then become viciously circular: narrative coherence cannot ultimately depend on rational justification if rational justification ultimately depends on narrative coherence.*' Velleman, 'The Self as Narrator', in *Self to Self*, 219 (emphasis mine).

25. See West, *Portraiture*, 12.

26. See Kate Retford, *The Art of Domestic Life: Family Portraiture in 18th Century England* (New Haven: Yale, 2006), 67.

27. Hugh Belsey, *Love's Prospect*, exhibition catalogue, The Holburne Museum of Art (Bath, 2001), 10–11; he also cites Margaret Ann Hanni, *The Marriage Portrait in 18th Century England* (Ann Arbor: University of Michigan Press, 1996), 234–5.

28. Joseph Leo Koerner, *The Moment of Self-Portraiture in German Renaissance Art* (Chicago: University of Chicago Press, 1993), p. 67.

29. Joanna Woods-Marsden, *Renaissance Self-Portraiture* (New Haven and London: Yale University Press, 1995).

30. Osmond, 'Rembrandt's Self-Portraits'.

31. Ibid.

32. See n. 4 above.

33. Steven Platzman, *Cézanne: The Self-Portraits* (Berkeley and Los Angeles: University of California Press, 2001), 12–13.

34. Osmond, 'Rembrandt's Self-Portraits'.

35. West acknowledges that self-portraiture in general began in the western European tradition at around the same time as autobiography, but she questions the comparison, suggesting that self-portraiture captures only moments and so a series of them would be (as in the case of David Hockney) a series of such frozen moments; see West, *Portraiture*, 178–80.

36. 'By using the self-portraits as a platform or vantage point from which to reconsider Cézanne, the viewer can better understand one of the great artistic personalities and careers of the nineteenth century.' Platzman, *Cézanne*, 21.

37. Ibid. 26.

38. Ibid. 92.

39. Ibid. 162.

40. Ibid. 170.

41. Ibid. 151–2.

42. On the concerns with death and mortality, see ibid. 187–91.

43. 'Cézanne's painting suspends habits of thought and reveals the base of inhuman nature upon which man has installed himself. This is why Cezanne's people are strange, as if viewed by a creature of another species ... Nor did Cézanne neglect the physiognomy of objects and faces; he simply wanted to capture it emerging from the color. Painting a face "as an object" is not to strip it of its "thought." ' Maurice Merleau-Ponty, 'Cézanne's Doubt', in Galen A. Johnson, ed., *The Merleau-Ponty Aesthetics Reader* (Evanston, Ill.: Northwestern University Press, 1994), 66.

44. Platzman, *Cézanne*, 20.

45. Ibid. (my emphasis).

46. Ibid. 20–1.

47. Sharyn R. Udall, 'Frida Kahlo's Mexican Body: History, Identity, and Artistic Aspiration', *Woman's Art Journal*, 24 No. 2 (Autumn 2003–Winter 2004), 10–14 at p. 10.

48. Liza Bakewell, 'Frida Kahlo: A Contemporary Feminist Reading', *Frontiers: A Journal of Women Studies*, 13 No. 3 (1993), 181.

49. See Ted Cohen, 'Identifying with Metaphor: Metaphors of Personal Identification', *The Journal of Aesthetics and Art Criticism*, 57 No. 4 (Autumn 1999), 399–409.

50. Bakewell, 'Frida Kahlo', 171.

51. And the reverse is also true, that her works incorporate words and verbal phrases more than most self-portraits or paintings typically do.

52. This is true not only in humans but in monkeys. See Anna Petherick, 'Brain Has "Face Place" for Recognition, Monkey Study Confirms', *National Geographic News*, 3 February 2006.

53. See Joseph LeDoux, *The Emotional Brain: The Mysterious Underpinnings of Emotional Life* (New York: Simon & Schuster, 1996).

54. This is, obviously, a huge topic; for the best recent discussion of how pictures and words differ, see Nelson Goodman, *Languages of Art* (Indianapolis: Hackett Publishing, 1976).

55. For discussion of the role of illustrations in making points and having artistic status of texts, see Thomas E. Wartenberg, *Thinking on Screen: Film as Philosophy* (London and New York: Routledge, 2007), 38–44.

56. Michael Tomasello, *Cultural Origins of Human Cognition*, 84–6.

57. Strawson, 'Against Narrativity', *Ratio* NS 17 (4 December 2004), 428–52.

58. Ibid. 447.

59. Ibid. 431.

60. Barbara Tversky, 'Narratives of Space, Time, and Life', *Mind and Language* 10, No. 4 (September 2004), 380–92.

61. Again, see Tversky on narratives of time and place. Also see Richard A. Etlin, 'Aesthetics and the Spatial Sense of Self', *Journal of Aesthetics and Art Criticism*, 56 No. 1 (Winter 1998), 1–19.

Chapter 6

1. Currin, quoted in Calvin Tomkins, 'Raw Art', *The New Yorker*, 28 January 2008.

2. For more, see The Guerrilla Girls, *The Guerrilla Girls' Bedside Companion to the History of Western Art* (New York et al.: Penguin, 1998).

3. Leo Steinberg, 'The Algerian Women and Picasso at Large, in *Other Criteria: Confrontations with Twentieth-Century Art* (New York et al.: Oxford University Press, 1972), 125–234.

4. Carol Duncan, 'The MoMA's Hot Mamas', *Art Journal* 48 (Summer 1989); repr. in Carolyn Korsmeyer, ed., *Aesthetics: The Big Questions* (Malden, Mass. et al.: Blackwell, 1999).

5. Catharine MacKinnon, 'Human Sexuality: A Feminist Political Approach', in James H. Geer and William T. O'Donohue, eds., *Theories of Sexuality* (New York: Plenum Press, 1987).

6. Catharine MacKinnon, *Only Words* (Cambridge, Mass.: Harvard University Press, 1993), 25.

7. The Guerrilla Girls, *The Guerrilla Girls' Bedside Companion*.

8. Martha Nussbaum, 'Objectification', in *Philosophy and Public Affairs*, 24 (Fall 1995), 249–91. See also Anne Eaton, 'A Sensible Anti-Porn Feminism', *Ethics* 117 (July 2007), 674–715.

9. Nussbaum, 'Objectification', 274.

10. Ibid. 290.

11. MacKinnon, 'Human Sexuality', 172–3.

12. Arthur Danto, *Encounters and Reflections: Art in the Historical Present* (New York: Noonday Press, Farrar Straus Giroux, 1990), 328.

13. Jeffrey St Clair, 'Flesh and Its Discontents: The Paintings of Lucian Freud', *CounterPunch*, 5 April 2003; on-line at <http://www.counterpunch.org/stclair04052003.html>.

14. Robert Hughes, *Lucian Freud Paintings* (London: Thames and Hudson, 1997), 7, 19. Catherine Lampert speaks about the 'apprehensive atmosphere' of his paintings which convey a feeling of the 'tantalising strain of night behaviour'; see Lampert, *Lucian Freud, Recent Work* (New York: Rizzoli, 1993), 18.

15. John Russell, *New York Times* (1983); quoted by Hughes in *Lucian Freud Paintings*, 19.

16. Freud, quoted ibid. 20.

17. John Spurling says that 'the paintings show … grotty, lumpy, unadorned physicality of life, without any apparent moral comment'. 'Profile, Lucian Freud: Portrait of the Artist as a Happy Man', *The Independent*, 13 December 1998.

18. Richard Dorment, 'Lucian and His Women', *Daily Telegraph*, 1 June 2002; on-line at <http://www.telegraph.co.uk/culture/art/3578401/Lucian-and-his-women.html>.

19. Hughes, *Lucian Freud Paintings*, 20.

20. Lucian Freud, quoted in Judith James, 'David Hockney: A Lifetime in Portraits', 15 March 2007, *The Independent*, downloaded PDF file from website, p. 1.

21. Schama writes of this painting, 'He admires her evidently not as a possession but for her self-possession, and he catches her, sidelong as it were, in an act of self-absorption'; Simon Schama, *Rembrandt's Eyes* (New York: Alfred A. Knopf, 1999), 554.

22. Perhaps he was not a nice man or good husband, and in fact there is evidence that he did not always treat the women in his life well; see

Schama, *Rembrandt's Eyes*, 542–50. But that issue is not my concern here.

23. He also painted his father in 1630 (see Schama, *Rembrandt's Eyes*, 279–80, 241); the *Seated Old Man* (*c.*1626) is also possibly Rembrandt's father.

24. Nannette Aldred comments that the painting works to highlight the artist's relationship with his mother, since they exchange looks, with 'his father's attention elsewhere'. Nannette Aldred, 'Figure Paintings and Double Portraits', in Paul Melia, ed., *David Hockney* (Manchester and New York: Manchester University Press, 1995), 68–88; the quoted passage is from p. 83.

25. Marco Livingstone, 'Sitting for Hockney', in *David Hockney: Painting on Paper* (London: Annely Juda Fine Art, 2003).

26. Alan Woods, 'Photo Collage', in Melia, ed., *David Hockney*, 111–31.

27. Skagen Museum (Denmark) website (no author credited), Essay for exhibition *My Mother*, <http://www.skagensmuseum.dk/index.php?id=1374&L=2>; accessed 29 October 2009.

28. Freud, quoted in Jeffrey St Clair, 'Flesh and Its Discontents: The Paintings of Lucian Freud', *Counterpunch*, 5 April 2003, <http://www.counterpunch.org/stclair04052003.html>.

29. Richard Dorment, 'Lucian and His Women', *Daily Telegraph*, 1 June 2002; on-line at <http://www.telegraph.co.uk/culture/art/3578401/Lucian-and-his-women.html>.

30. Jeffrey St Clair, 'Flesh and Its Discontents'.

31. See Janis Tomlinson, *Goya, 1746–1828* (London: Phaidon Press, 1994), 65.

32. West, *Portraiture*, 133.

33. Schneider, *Art of the Portrait*, 148–9.

34. West, *Portraiture*, 116.

35. Ibid. 117.

36. As was done, for example, by Joshua Reynolds in his portrait *Georgiana, Duchess of Devonshire and her Daughter, Lady Georgiana Cavendish*, 1784; see Martin Postle, ed., *Joshua Reynolds: The Creation of Celebrity* (London: Tate Publishing, 2005), 134.

37. Jonathan Jones, 'Portrait of the Week: *The Painter's Daughters Chasing a Butterfly*, Thomas Gainsborough (c1756)', *Guardian*, 23 March 2002; on-line at <http://www.guardian.co.uk/culture/2002/mar/23/art>.

38. See Nancy Mowl Mathews, *Mary Cassatt: A Life* (New Haven and London: Yale University Press, 1994), and Griselda Pollock, *Mary Cassatt: Painter of Modern Women* (London and New York: Thames and Hudson, 1998).

39. See also the discussion by Pollock, *Mary Cassatt*, 132, which remarks on how this image has been compared to Velázquez's painting of the Infanta Margarita.

40. Ibid. 177.

41. Richard Vine, Review of Exhibition of Marlene Dumas at Jack Tilton— New York, New York *Art in America,* October 1994; on-line at <http://findarticles.com/p/articles/mi_m1248/is_n10_v82/ai_15821923/>.

42. From 'Marlene Dumas at The Saatchi Gallery', <http://www.saatchi-gallery.co.uk/artists/marlene_dumas.htm>.

43. 'Marlene Dumas in dialogue with Gavin Jantjes 1996', Amsterdam, 15 December 1996, in *A Fruitful Incoherence: Dialogues with Artists on Internationalism* (London: Institute of International Visual Arts, 1998), 50–63; on-line at Iniva.com.

44. Laura Lark, 'Review of Marlene Dumas, Measuring Your Own Grave', *Glasstire: Texas Visual Arts Online,* May 2009; on-line at <http://glasstire.com/index.php?option=com_content&task=view&id=3323>.

45. Melissa Harris, interview, 'Daughter, Model, Muse: Jessie Mann on Being Photographed', *Aperture* 162 (2001). See also Noelle Oxenhandler, '*Nole me Tangere*: The Family Photographs of Sally Mann', *Nerve,* 28 September 1998, <http://www.nerve.com/Dispatches/Oxenhandler/Mann/>.

46. Jessie Mann has said, 'When the flap about my mother's work occurred what shocked me most was that the public rarely thought to assume that we might have really enjoyed make [*sic*] art with our mother.' Jessie Mann Interview, *Eight Diagrams* (Blog), 26 April 2007, <http://wayneyang.wordpress.com/2007/04/26/jessie-mann-interview/>.

47. Danto emphasizes that the images' strong content was not appropriately acknowledged during defenses of the work at the Cincinnati obscenity trial that focused on its formal merits. See Arthur C. Danto, *Playing with the Edge: The Photographic Achievement of Robert Mapplethorpe* (Berkeley et al.: University of California Press, 1996).

48. Linda Nochlin, 'Bonnard's Bathers', *Art in America* (July 1998).

49. Steve Edwards and Paul Wood, eds., *Art of the Avant-Gardes* (New Haven and London: Yale University Press, 2004), 128.

50. Richard Dorment, 'The Hidden Secrets of Bonnard's Art', *Daily Telegraph,* 14 February 1998, <http://www.telegraph.co.uk/culture/4712016/The-hidden-secrets-of-Bonnards-art.html>.

51. Nochlin, 'Bonnard's Bathers'. Nochlin's feminist wrath is not appeased by the observation some have made of how Bonnard treated himself in this

same period in self-portraits. 'Yet all of these questioning, sardonic self-portraits still mark the masculine self as the controlling, creating subject, despite their pathos. The image of Bonnard does not melt into inchoateness, literally becoming part of the background, as does that of Marthe in so many of the bather paintings.' 'In short, there is something abject and sinister about Bonnard's late bathers. It is significant that Bonnard's work is at its most provocative when he kills off or mutilates his subject: Marthe dismembered or floating in deathlike passivity is the heroine of his most exciting canvases.'

52. Anna Hammond, 'Pierre Bonnard: An Interview with John Elderfield, *MoMA* 1 No. 3 (June 1998), 13.

53. Sarah Whitfield, 'Fragments of an Identical World', in Whitfield, *Bonnard* (New York: Harry N. Abrams, 1998).

54. Christopher Benfey, 'Bathroom Beauty: Pierre Bonnard's Voyeuristic Obsession', Slate, 28 June 1998, <http://www.slate.com/id/2926/>. He is commenting on *Nude in the Bath* (1936).

55. Commentary on *The Bath* (1925), <http://www.tate.org.uk/servlet/View-Work?workid=1311>.

56. Dorment, 'The Hidden Secrets of Bonnard's Art'.

57. Merlin James, 'Bonnard, London and New York', *Burlington Magazine*, 140 No. 1141 (April 1998), 278–81.

58. Jennifer A. Greenhill, Review of Sarah Whitaker Peters, *Becoming O'Keeffe*, *The Early Year*, et al., *Archives of American Art Journal, The Smithsonian Institution*, 40 Nos. 3–4 (2000), 32–8; quote from p. 37.

59. Georgia O'Keeffe, 1978, quoted in commentary on the Metropolitan Museum Website concerning the photograph by Stieglitz, *Georgia O'Keeffe* (1918), <http://www.metmuseum.org/works_of_art/collection_database/photographs>; accessed 30 October 2009.

60. Danto, *Playing with the Edge*, pp. 9–10.

61. Ibid. 47.

62. Ibid. 132.

63. Ibid. 31.

64. Ibid. 291. The point can be disputed, since he did produce some images depicting her that showed her head as well as her body.

65. Susan Gubar, *Racechanges: White Skin, Black Face in American Culture* (Oxford: Oxford University Press, 2000), 49.

66. Dennis Flannery, ' "Queer" Photography and the "Culture Wars": Robert Mapplethorpe's Queer Aesthetic of the Pair', in David Holloway and John Beck, eds., *American Visual Cultures* (London: Continuum, 2005), 266–7.

67. Patricia Morrisroe, *Mapplethorpe: A Biography* (New York: Da Capo, 1997), 290. She reports that the artist was involved with a number of the men whom he photographed, including more than 75 per cent of those shot for *The Black Book*; see p. 305.

68. For more reflections, see David Velleman, 'Love as a Moral Emotion', in Velleman, *Self to Self*, 70–104.

69. I am ignoring the few examples he did of children.

70. Nussbaum is actually describing Richard Mohr's examples of a variety of gay porn images here; see 'Objectification', 287.

Chapter 7

1. Raymond Martin and John Barresi, *The Rise and Fall of Soul and Self: An Intellectual History of Personal Identity* (New York: Columbia University Press, 2006), 268.

2. See Jean Baudrillard, 'Simulacra and Simulations', from Jean Baudrillard, *Selected Writings*, ed. Mark Poster (Stanford, Calif.: Stanford University Press, 1988), 166–84.

3. Eric Lipton, 'Threats and Responses: Screening; Faces, too, are Searched as U.S. Airports Try to Spot Terrorists', *The New York Times*, 17 August 2006; accessed 29 August 2009.

4. Andy Warhol, quoted in Anne Rorimer, 'Andy Warhol's Mao, 1973', *Bulletin of the Art Institute of Chicago* (1973–1982), 69 No. 3 (May–June 1975), 407.

5. Mark Francis, 'Andy Warhol, Berlin and London', *The Burlington Magazine*, 144 No. 1187 (February 2002), 123.

6. Jennifer Dyer, 'The Metaphysics of the Mundane: Understanding Andy Warhol's Serial Imagery', *Artibus et Historiae*, 25 No. 49 (2004), 33–47, at p. 34.

7. Ibid. 35.

8. See Cecile Whiting, 'Andy Warhol, the Public Star and the Private Self', *Oxford Art Journal*, 10 No. 2 (1987), 73–4.

9. Blake Stimson, 'Andy Warhol's Red Beard', *The Art Bulletin*, 83 No. 3 (September 2001), 527–47.

10. See Whiting, 'Andy Warhol, the Public Star and the Private Self'.

11. For a different view, see Benjamin Buchloch and Rainer Crone: 'He politically and culturally problematizes traditional conceptions of the significance of iconography by repeatedly presenting contemporary icons as meaningless.' Quoted in Dyer, 'The Metaphysics of the Mundane', 34.

12. Rorimer, 'Andy Warhol's Mao, 1973', 407.

13. Dyer, 'The Metaphysics of the Mundane', 34.

14. Mark Francis, 'Andy Warhol: Berlin and London', *The Burlington Magazine*, 144 No. 1187 (February 2002), 122–4, at p. 123.

15. Thomas Crow, quoted in David E. James, 'The Unsecret Life: A Warhol Advertisement', *October*, 56 (Spring 1991), 21–41, at p. 27.

16. Whiting, 'Andy Warhol, the Public Star and the Private Self', 70.

17. *The Philosophy of Andy Warhol (From A to B and Back Again)* (New York: Harcourt Brace Jovanovich, 1975), 81.

18. James, 'The Unsecret Life', 35.

19. It has also been claimed that Warhol's self-images straddle both options, self-disclosure and self-concealing: 'Andy Warhol's self-portraits are rarely an exercise of uncompromising honesty, but rather an art of disguise and deception in which—like an actor—he plays roles. However, many works are a mix of both, telling us all and nothing about himself. An exception [is] some of the polaroid photographs, which seem to reveal a troubling fragility of the artist as a human being and as a man, in search of his own identity.' Sean Kelly and Edward Lucie-Smith, *The Self-Portrait: A Modern View* (London: Sarema, 1987), 24.

20. David James, 'The Unsecret Life', 20.

21. Branden W. Joseph, 'One-Dimensional Man', Review of recent Warhol books and exhibit, *Art Journal*, 57 No. 4 (Winter 1998), 105–9, at p. 106.

22. Baudrillard, 'The Precession of Simulacra', in *Simulacra and Simulation*, trans. Sheila Faria Glaser (Ann Arbor: University of Michigan Press, 1995), 1–42; see also Jean Baudrillard, 'Simulacra and Simulations', in *Jean Baudrillard, Selected Writings*, ed Mark Poster (Stanford, Calif.: Stanford University Press, 1998), 166–84.

23. James, 'The Unsecret Life', 35.

24. Dyer presents a positive interpretation of the meaning of repetition, which inevitably will involve small variations: 'Warhol's imperfections are ironical: they attest to the finite, fallible, and mundane nature of the artist. His imperfections expose the artist as a blundering rather than masterful creator' (Dyer, 'The Metaphysics of the Mundane', 41). She adds, 'Insofar as there is a subject involved in the accidents it's a communal subject, the Factory. He's a free subject emphasizing spontaneity' (ibid. 43).

25. Whiting writes, 'We hesitate to call Warhol's paintings of these women [Liz and Marilyn] "portraits" [because of] their inherent incompatibility with the rhetoric of high-art portraiture' ('Andy Warhol, the Public Star and the Private Self', 58).

26. See Benjamin H. D. Buchloh, 'Divided Memory and Post-Traditional Identity, Gerhard Richter's Work of Mourning', *October*, 75 (Winter 1996), 60–82 for more discussion and analysis. He sees Richter as responding to Warhol's 'apparently romantic and nihilistic heroicization of the criminal with the emphatic affirmation of a bourgeois liberal-humanist belief in the civilizing presence of historical figures, taken as models of conduct and achievement' (78).

27. Quoted in Daniel Baird, 'Gerhard Richter: Forty Years of Painting', *The Brooklyn Rail* (March–April 2002).

28. Vicky Richardson, *Blueprint*, <http://www.blueprintmagazine.co.uk/index.php/art/gerhard-richters-portraits/>.

29. Warhol 1975, quoted in Robert Williams, *Art Theory: An Historical Introduction* (London: Wiley-Blackwell, 2004), 234.

30. Comment on Walker Art Center website, author unidentified, <http://collections.walkerart.org/item/object/422>.

31. Donald Goddard, 'Gerhard Richter: Forty Years of Painting', *New York Art World* (2001).

32. Gertrude Koch speaks of the artist's techniques, including the blur, as providing a 'seamless shift between different modes of spatialization and temporalization' (Gertrud Koch, 'The Richter-Scale of Blur', *October*, 62 (Autumn 1992), 135).

33. Buchloh, 'Divided Memory', 81.

34. Baird writes, '*Eight Student Nurses* might be taken as a confirmation of Benjamin Buchloh's view that Richter uses bland photographs in order to demonstrate the irrelevance of painting after Duchamp and in the age of mechanical reproduction. Nothing could be farther from the truth ... Richter does not self-hatingly reject oil painting, but systematically deflates it to the status of just another material, and, like Robert Ryman in a way, forces us to rethink the notion of the "painterly." ' Baird, 'Gerhard Richter: Forty Years of Painting'.

35. Arthur Danto, 'History in a Blur', in *Unnatural Wonders: Essays from the Gap between Art and Life* (New York: Farrar, Straus and Giroux, 2005), 181.

36. Apparently Richter was impelled to create his painting *Eight Student Nurses* in 1966 after seeing work by Andy Warhol on *Thirteen Most Wanted Men* in 1964. He also explained the arrangements as due to observing photojournalistic techniques, something Buchloh questions in his article (p. 81). Richter maintains that the use of photographs is a distancing device as is his blurring.

37. Peter Osborne, 'Painting Negation: Gerhard Richter's Negatives', *October*, 62 (Autumn 1992), 106. See also note 4, pp. 106–7, on the connections between photography, identity, and death.

38. Baird, 'Gerhard Richter: Forty Years of Painting'.

39. Nadia Tscherny comments, 'As rendered by Peyton, the subjects possess a certain individual presence even though most share the same fashionably androgynous physical type and cool, if not effete, temperament. The transformative power of her vision becomes especially apparent when a photographic source is compared to the painting it inspired. A dowdy black-and-white shot, for example, of the child Elvis Presley with his mother, seated before a sad floral backdrop, metamorphoses in Peyton's hands into a soigné family portrait before a Matissean background of stunning chromatic appeal.' (Nadia Tscherny, 'Elizabeth Peyton', *Art in America*, February 2009.)

40. Ibid. 102.

41. <http://www.saatchi-gallery.co.uk/artandmusic/?ccid=321&from_cid=150&cid=150>.

42. The exception is her *Sex Pictures* series from 1992 using dummies and dolls.

43. Saltz also mentions 'all the academic blather about how she critiques the male gaze' (Jerry Saltz, 'Sherman's March of Time', *New York* (1 December 2008), 76–7.)

44. <http://courses.washington.edu/hypertxt/cgi-bin/12.228.185.206/html/contexts/remakes.html>.

45. Kay Itoi, 'Season of Passion', <http://www.artnet.com/magazineus/features/itoi/itoi12–6–06.asp *Artnet*/>.

46. Whiting, 'Andy Warhol, the Public Star and the Private Self', 66.

47. Lynne Tillman, 'A New Chapter of Nan Goldin's Diary', *New York Times* (16 November 2003).

48. <http://www.artinfo.com/news/story/13609/nan-goldin/>, Nan Goldin, Robert Ayers, published 27 March 2006.

49. 'If I want to take a picture, I take it no matter what', Nan Goldin Interview, *toby ladra por todo, yo escribo en el blog* (blog), <http://ahitobyya.blogspot.com/2007_02_01_archive.html>, 2 February 2007.

50. Larry Qualls, 'Performance/Photography', *Performing Arts Journal*, 17 No. 1 (January 1995), 26–34, at p. 31.

51. Henry M. Sayre, 'Scars: Painting, Performance, Photography, Pornography, and the Disfigurement of Art', *Performing Arts Journal*, 16 No. 1 (January 1994), 64–74, at p. 71.

52. Jean Baudrillard, *The Consumer Society: Myths and Structures*, trans. Chris Turner (London, Thousand Oaks, Calif., and New Delhi: Sage, 1998), 122.

53. Marc Zimmermann, 'Review, Nan Goldin and Lyle Ashton Harris', *Performing Arts Journal*, 19 No. 1 (January 1997), 38–45, at p. 45.

54. 'Nan Goldin interviewed by Adam Mazur and Paulina Skirgajllo-Krajewska', FotoTapeta, <http://fototapeta.art.pl/2003/ngie.php>.

55. Ibid.

56. Brilliant, *Portraiture*, 89.

57. Velleman, 'The Genesis of Shame', *Self to Self*, 54. He concludes, 'You thus have a fundamental interest in being recognized as a selfpresenting [*sic*] creature, an interest that is more fundamental, in fact, than your interest in presenting any particular public image' (55).

58. Ibid. 54. 'Even aspects of your image that aren't specifically meant to be recognized as such are not necessarily dishonest. There is nothing dishonest about choosing not to scratch wherever and whenever it itches. Although you don't make all of your itches overt, in the manner of a dog, you aren't falsely pretending to be less itchy than a dog; you aren't pretending, in other words, that the itches you scratch are the only ones you have … Not being recognized as a self-presenter would entail not being acknowledged as a potential partner in conversation, cooperation, or even competition and conflict' (pp. 54–5).

59. Emin's monoprints are a well documented part of her creative output. These unique drawings represent a diaristic aspect and frequently depict events from the past, for example, *Poor Love* (1999), *From The Week of Hell '94* (1995) and *Ripped Up* (1995), which relate to a traumatic experience after an abortion or other personal events as seen in *Fuck You Eddy* (1995) and *Sad Shower in New York* (1995) which are both part of the Tate's collection of Emin's art.

60. Elizabeth Manchester, discussion of Tracey Emin's *Monument Valley* (1995–7), Tate Collection website, <http://www.tate.org.uk/>, November 2004.

61. Kieran Cashell, *Aftershock: The Ethics of Contemporary Transgressive Art* (London and New York: I. B. Tauris, 2009), 123–57; the Foucault quote is from p. 128.

62. Smithard, quoted in Cashell, ibid. 126.

63. Ibid. 127.

64. Quoted ibid. 130–1.

65. Ibid. 131.

66. Ibid. 154–5.

67. For more, see Jeffrey Ruoff, *An American Family: A Televised Life* (Minneapolis: University of Minnesota Press, 2002); Pat Loud and Nora Johnson, *Pat Loud: A Woman's Story* (New York: Coward, McCann & Geoghegan, 1974); and Mark Andrejevic, *Reality TV: The Work of Being Watched* (Lanham, Md.: Rowman & Littlefield Publishers, Inc., 2003).

68. Martin Kemp, 'Artists on Science: Scientists on Art', *Nature*, 434 (17 March 2005) 308–9; published on-line 16 March 2005.

69. Press release, National Portrait Gallery, London; on-line at <http://www.npg.org.uk/about/press/genomic-portrait.php>; accessed 29 August 2009.

70. <http://www.thinkgeek.com/homeoffice/gear/b42e/>, accessed 28 August 2009.

71. Gary Schneider, *Genetic Self-Portrait* (Syracuse, NY: Light Work, 1999), unpaginated.

72. Bettyann Holtzmann Kevles, 'Portrait without the Camera Face', in Schneider, *Genetic Self-Portrait*, unpaginated.

73. Schneider's original exhibit would have been interesting to see and no doubt would have carried greater impact than his book, mainly to appreciate how the size affected the look of many of the images. The size given for the ear prints, for example, is fairly large, 36×29 inches. This sort of print is done by making a negative from the photogram and then printing it as a positive. Schneider comments that, 'The exhibition prints looked like constellations . . . ' In black and white these prints, like the hand prints, reproduce light according to deposits of sweat and heat on the emulsions. Prints like these ear and hand prints do seem to humanize the body of work as a whole by providing something more familiar and recognizable than some of the other cell images.

74. Schneider, *Genetic Portrait*, unpaginated.

75. Ann Thomas, 'The Portrait in the Age of Genetic Mapping', in Schneider, *Genetic Self-Portrait*, unpaginated.

76. Henry Art Gallery, <http://www.henryart.org/exhibitions/show/26>; accessed 29 August 2009.

77. Jim Greenhalf, 'Scan-tastic look inside the brain', *Telegraph and Argus*, 9 April 2009, <http://www.thetelegraphandargus.co.uk/search/4278663.Scan_tastic_look_inside_the_brain/>; accessed 29 August 2009.

78. M. R. Bennett and P. M. S. Hacker, *Philosophical Foundations of Neuroscience* (Oxford: Blackwell Publishing, 2003).

79. Marcia Pointon, 'Kahnweiler's Picasso, Picasso's Kahnweiler', in Joanna Woodall, ed. and introd., *Portraiture: Facing the Subject*

(Manchester and New York: Manchester University Press, 1997), 189–202, at pp. 190–1.

80. See Svetlana Alpers on the complexity of differentiating maps from other sorts of pictorial images in seventeenth-century Dutch art, in *The Art of Describing: Dutch Art in the Seventeenth Century* (Chicago: University of Chicago Press, 1984).

81. Orhan Pamuk, *The Black Book*, trans. Guneli Gun (San Diego et al.: Harvest Books, 1994), 261.

Epilogue

1. Richard Brilliant, *Portraiture* (Cambridge, Mass.: Harvard University Press, 1991), 141.

2. John Dewey, *Art as Experience* (New York: Penguin, 2005; originally published 1934); Maurice Merleau-Ponty, 'Cézanne's Doubt' and 'Eye and Mind', in Galen A. Johnson, ed., *The Merleau-Ponty Aesthetics Reader: Philosophy and Painting* (Evanston, Ill.: Northwestern University Press, 1993), 59–75 and 121–49; Vivian Sobchack, *Carnal Thoughts: Embodiment and Moving Image Culture* (Berkeley et al.: University of California Press, 2004); Michael Tomasello, *The Cultural Origins of Human Cognition* (Cambridge, Mass. and London: Harvard University Press, 1999); Ellen Dissanayake, *Art and Intimacy: How the Arts Began* (Seattle and London: University of Washington Press, 1999) and *What Is Art For?* (Seattle and London: University of Washington Press, 1988).

3. Nelson Goodman, *Languages of Art* (Indianapolis: Hackett Publishing, 1976; first published 1968); Richard Wollheim, *Painting as an Art* (Princeton: Princeton University Press, 1987); Kendall Walton, *Mimesis as Make-Believe: On the Foundations of the Representational Arts* (Cambridge, Mass. and London: Harvard University Press, 1990).

4. *Art as Experience*, 251.
 'It is the same with the philosophic thinker. There are moments when he feels that his ideas and ideals are finer than anything in experience. But he finds himself obliged to go back to objects if his speculations are to have body, weight, and perspective. Yet in surrendering himself to objective material he does not surrender his vision.' Ibid. 280.
 'The significance of art as experience is, therefore, incomparable for the adventure of philosophic thought.' Ibid. 309.

5. David Hockney, *David Hockney Portraits* (New Haven: Yale University Press, 2006), quoted in preface by Sarah Howgate, p. 12.

6. Merleau-Ponty, 'Eye and Mind', 121–49.
7. Ibid. 124.
8. Ibid. 124–5, *passim*.
9. 'Cézanne's Doubt', 59–75.
10. Ibid. 67.
11. Ibid. 123.
12. Sobchack, *Carnal Thoughts*, 288; see especially ch. 12, 'The Passion of the Material: Toward a Phenomenology of Inter-Objectivity', pp. 286–318.
13. Ibid. 299.
14. Tomasello, *Cultural Origins of Human Cognition*, 86.
15. Ibid. 84–6.
16. Velleman, *Self to Self*, 58.
17. James Elkins, *The Object Stares Back: On the Nature of Seeing* (New York: Harvest, 1996), 103.
18. Merleau-Ponty, 'Eye and Mind', in *The Merleau-Ponty Aesthetics Reader*, 126.

INDEX